GW00776477

EXECUTIVE ESCAPES

WEEKEND

edited by Martin Nicholas Kunz

teNeues **manager magazin**
Wirtschaft aus erster Hand

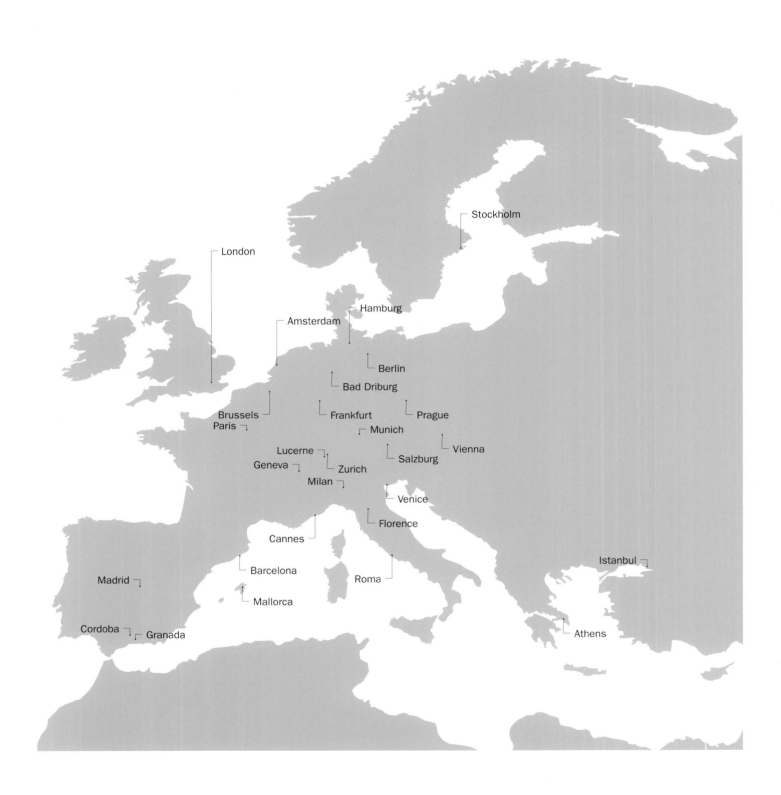

Stockholm

London

Hamburg

Amsterdam

Berlin

Bad Driburg

Brussels

Frankfurt

Prague

Paris

Munich

Vienna

Lucerne

Geneva

Zurich

Salzburg

Milan

Venice

Cannes

Florence

Barcelona

Roma

Istanbul

Madrid

Mallorca

Cordoba

Granada

Athens

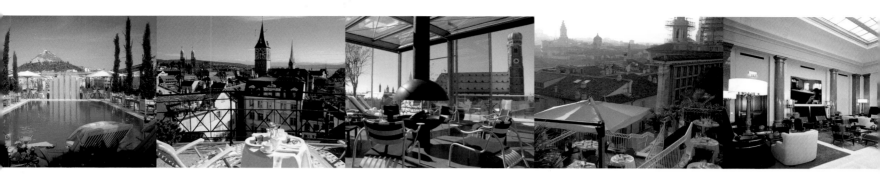

Introduction

A change of scene and a respite from the fast pace of life are important. In many cases, a weekend is already sufficient. The traveler can unwind, explore new areas, receive new impressions and then return to everyday life, revivified and relaxed. It is no coincidence that short trips and flying visits, ranging from trips to lively metropolises to remote hideaways, are becoming more and more popular. Especially when they are upgraded with a stay at a hotel of extraordinary luxury.

The hotels presented in this book are within a two- to three-hour flight from Germany, so that the hurried traveler can pack his bags on the Friday morning and start the vacation trip right from his office. Therefore, only hotels situated in Europe were selected for this book. From North to South, from East to West: you will find weekend destinations in Sweden as well as in Turkey, Greece, the Czech Republic or Spain. These days, you actually do not have to travel around the world in order to discover new cultures: you can indulge in the hotel's culinary specialties, which are often inspired by Mediterranean cuisine. This also holds true for its spas, which often invite you to relax with Asian therapies. Overall, the decoration and service of most of these hotels are inspired by foreign influences.

All of the hotels presented here are characterized by their individuality. They are located in historic villas, in former factories, of which the industrial aesthetics were carefully complemented with aspects of contemporary design, or in conceptually designed, new buildings. These buildings are often the works of renowned architects. They applied their own style, but also implemented regional or local particularities in their architecture—no matter if antique or contemporary accents. This can be observed not only in the lobby, which is often representative of the particular hotel's style, but also in the different rooms. In many of the hotels, no room looks like the other: sometimes, the rooms' decoration is an homage to an artist or a certain stylistic period.

The well-conceived design patterns are partly even applied in the wellness area, where rooms welcome the guests with different colors, matching their chosen activity—be it treatments, fitness or swimming. Other hotels rather put the emphasis on intellectual activities and have an own library at their guests' disposal. Some hotels even host various art exhibitions on their premises.

In addition to the hotels' aesthetic and intellectual appeal, a friendly and courteous service is offered, conveying a feeling of comfort, but nevertheless ensuring privacy. Thus, guests can feel at home, but at the same time enjoy amenities that one's own residence does not provide.

Elke Roberta Buscher

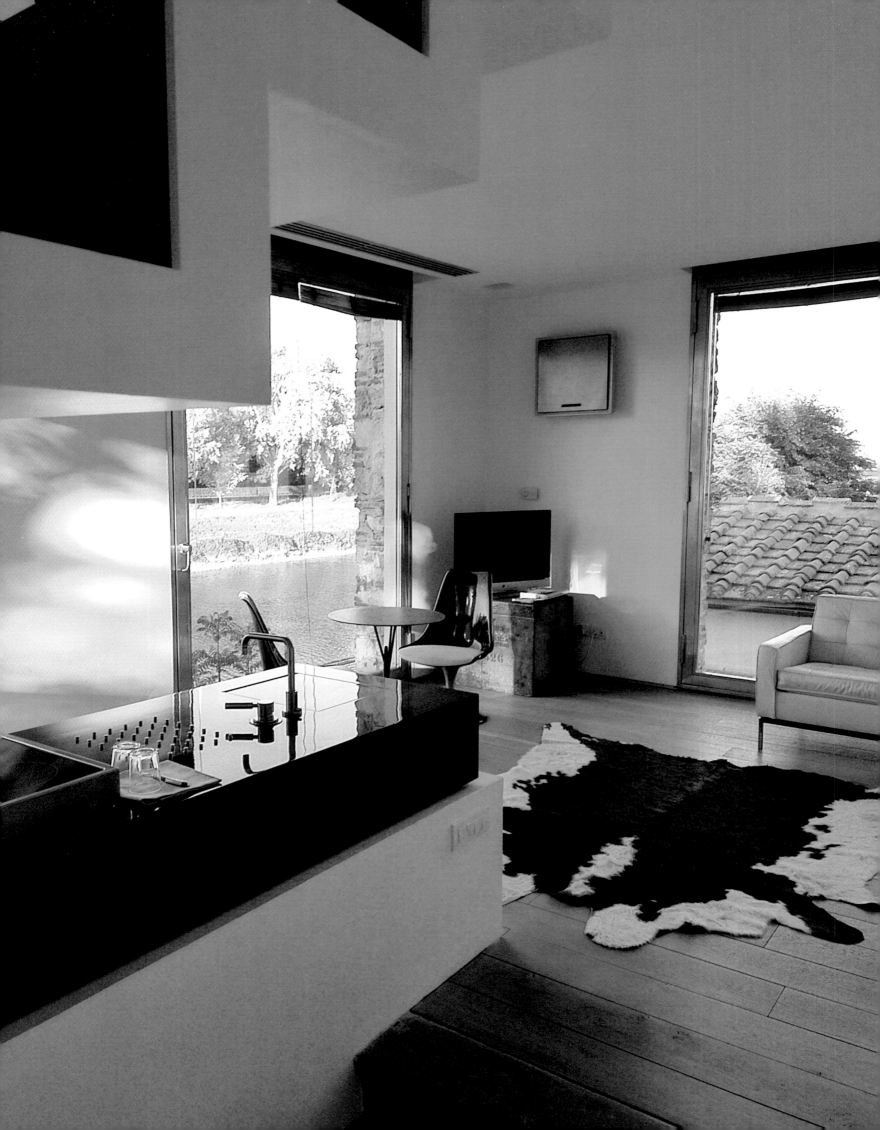

Einleitung

Tapetenwechsel und Erholung sind wichtig – und oft reicht dafür schon ein Wochenende. Der Reisende darf ausspannen, fremde Gegenden erkunden, neue Eindrücke gewinnen und dann erfrischt in den Alltag zurückkehren. Nicht von ungefähr erfreuen sich Kurztrips und Stippvisiten, sei es in quirligen Metropolen, sei es in abgelegenen Hideaways, wachsender Beliebtheit. Zumal, wenn sie durch den Aufenthalt in einem Hotel von besonderem Luxus veredelt werden.

Die hier vorgestellten Hotels sind alle in zwei bis drei Flugstunden von Deutschland aus zu erreichen, damit der eilige Gast noch am Freitag die Koffer packen und vom Büro direkt an sein Urlaubsziel gelangen kann. So sind für dieses Buch ausschließlich Hotels in Europa ausgewählt worden. Nord oder Süd, Ost oder West. Ein Wochenendziel in Schweden ist ebenso vertreten wie in der Türkei, in Griechenland, in Tschechien oder Spanien. In der Tat muss man heute nicht mehr um die halbe Welt reisen, um andere Kulturen kennen zu lernen. Das betrifft die Gastronomie der Häuser, die gerne mediterran beeinflusst ist. Und es erstreckt sich auf die Spas, die häufig mit fernöstlichen Therapien für Entspannung sorgen. Auch die Hotels im Ganzen lassen sich bei Einrichtung und Service von fremdländischen Einflüssen inspirieren.

Sämtliche hier vorgestellten Luxushotels zeichnen sich durch ihre Individualität aus. Sie befinden sich in historischen Villen, in ehemaligen Fabriken, deren Industrieästhetik schonend mit modernem Design kombiniert wurde, oder in eigens konzipierten Neubauten. Dabei waren meist angesehene Architekten am Werk. Sie folgten ihrem eigenen Stil, integrierten aber auch regionale oder lokale Besonderheiten in die Architektur – ob antik oder modern. Das gilt nicht nur für die oftmals repräsentative Lobby, sondern auch für die einzelnen Zimmer: In vielen Hotels gleicht kein Zimmer dem anderen; manchmal ist die Einrichtung sogar einem Künstler oder einer Stilepoche gewidmet.

Mitunter setzt sich das durchdachte Design bis zum Wellness-Bereich fort, wenn die Gäste in Räumen mit verschiedenen Farben empfangen werden, je nachdem, ob ihnen der Sinn eher nach Anwendungen, Fitness oder Schwimmen steht. Andere Hotels setzen mehr auf geistige Betätigung und stellen ihren Gästen die hauseigene Bibliothek zur Verfügung. Wieder andere laden regelmäßig zu wechselnden Kunstausstellungen in ihren Räumen.

Zum ästhetischen Blickfang und dem intellektuellen Anspruch der Hotels kommt ein freundlicher und zuvorkommender Service, der für Wohlbefinden sorgt und trotzdem ein Gefühl des Privaten vermittelt. So können sich die Gäste heimisch fühlen und zudem Annehmlichkeiten genießen, die die eigenen vier Wände nicht bieten.

Elke Roberta Buscher

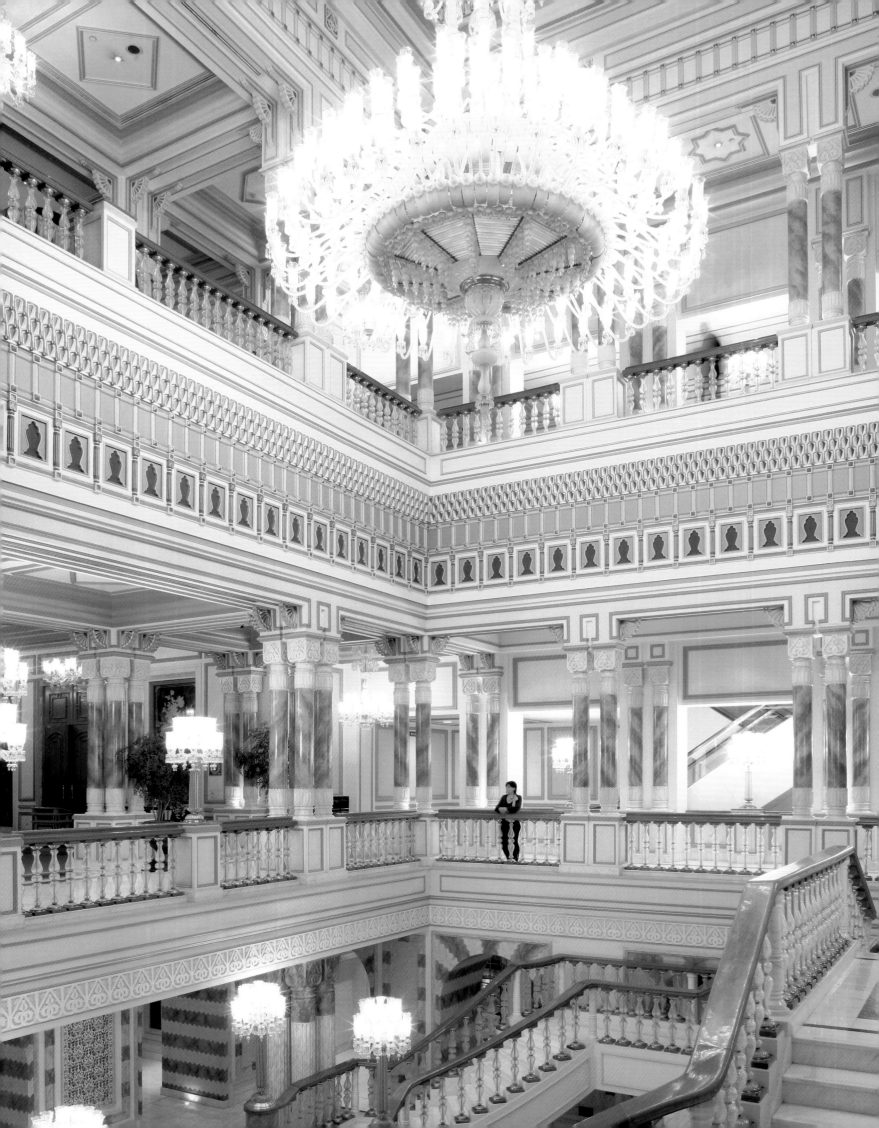

Introduction

Le changement d'air et la détente ont leur importance – et souvent il suffit d'y consacrer un week-end. Le voyageur peut se reposer, découvrir des terres inconnues et recueillir de nouvelles impressions. Bref, avant de reprendre sa vie quotidienne, il se sera refait une santé. Ce n'est pas par hasard que les visites éclairs et les voyages courts connaissent de plus en plus de succès, que ce soit à destination de métropoles animées ou de havres de paix éloignés. Ce genre de voyages fait beaucoup d'heureux, à fortiori quand il comporte un séjour dans un hôtel particulièrement luxueux.

Les hôtels présentés dans ce livre se trouvent tous à deux ou trois heures de vol au départ de l'Allemagne. Ainsi, le visiteur pressé pourra faire ses valises vendredi même et rallier sa destination de vacances une fois sorti du bureau. Seuls ont donc été retenus des hôtels se situant sur le territoire européen. Nord, sud, est, ouest, tout y est : direction la Suède, la Turquie, la Grèce, la République tchèque ou encore l'Espagne, ce ne sont pas les destinations week-end qui manquent. En effet, à l'heure actuelle, plus besoin de faire le tour du monde pour partir à la découverte d'autres cultures. Car celles-ci sont finalement à portée de main, à commencer par la gastronomie des hôtels avec ses accents méditerranéens. De leur côté, les spas offrent des thérapies venues d'Extrême-Orient pour se détendre. Même quand on regarde la physionomie des hôtels, on s'aperçoit que leur aménagement et service s'inspirent d'influences exotiques.

L'ensemble des hôtels de luxe ici présentés se caractérise par leur individualité. Ils se situent dans des villas historiques, dans des anciennes usines dont l'esthétique industrielle a été mêlée avec douceur à un design moderne, ou encore dans des bâtiments neufs spécialement conçus à cet effet. Bon nombre de ces réalisations sont l'œuvre d'architectes prestigieux qui, tout en restant fidèles au style qui est le leur, n'ont pas hésité à apporter à l'architecture des particularités régionales et locales aussi bien anciennes que modernes. Cela ne concerne pas seulement le hall souvent représentatif, mais aussi les chambres. Dans beaucoup d'hôtels, les chambres se suivent, mais ne se ressemblent pas et parfois, le décor intérieur est même dédié à un artiste ou à un style d'une époque.

Il arrive que ce design sophistiqué se prolonge jusqu'à l'espace wellness : les visiteurs sont alors accueillis dans des pièces aux couleurs différentes suivant qu'ils privilégient les traitements, le fitness ou la natation. D'autres hôtels misent davantage sur l'exercice intellectuel et mettent la bibliothèque de la maison à la disposition de leurs hôtes. Sans oublier ceux qui proposent régulièrement des expositions temporaires dans leurs locaux.

A la valeur esthétique et la qualité intellectuelle des hôtels vient s'ajouter un service avenant et attentionné qui favorise le bien-être tout en communiquant une notion de vie privée. Résultat : les hôtes se sentent comme chez eux tout en profitant des plaisirs que le propre chez-soi ne peut leur procurer.

Elke Roberta Buscher

Berns Hotel
Stockholm, Sweden

When the hotel Berns opened in the center of Stockholm in 1863, it was nothing but a restaurant. Today, it is a boutique hotel with 65 rooms with parquet flooring; dark cherrywood furniture contrasts with floral white linen. Some of the rooms have a balcony with a view of the courtyard. The nightlife in the Berns, popular among locals as well, is a must for the guests of the hotel: it boasts a large dance floor, three differently themed bars and a small club in the basement.

Bei seiner Eröffnung im Jahr 1863 war das Hotel Berns im Zentrum Stockholms nur ein Restaurant – heute ist es ein Boutique-Hotel mit 65 Zimmern. Diese sind mit Parkett ausgelegt; dunkle Kirschholzmöbel kontrastieren mit blütenweißer Bettwäsche. Einige der Zimmer haben einen Balkon mit Blick auf den Hof. Ein Muss für die Gäste ist das auch bei Stockholmern beliebte Nachtleben im Berns, denn es bietet für jeden etwas: eine große Tanzfläche, drei unterschiedlich ausgerichtete Bars und einen kleinen Club im Keller.

Quand il ouvrit ses portes en 1863, l'hôtel Berns, situé dans le centre ville de Stockholm, n'était qu'un restaurant – aujourd'hui c'est un hôtel boutique pourvu de 65 chambres. Dans les chambres, toutes parquetées, des meubles en merisier contrastent avec des draps d'un blanc éblouissant. Certaines chambres offrent un balcon donnant sur la cour. Sous aucun prétexte, il ne faudra manquer la vie nocturne au Berns, également très appréciée par les Stockholmois. Là, chacun peut y trouver son compte, puisque l'hôtel est pourvu d'une grande piste de danse, de trois bars aménagés de façon différente et d'un petit club dans ses sous-sols.

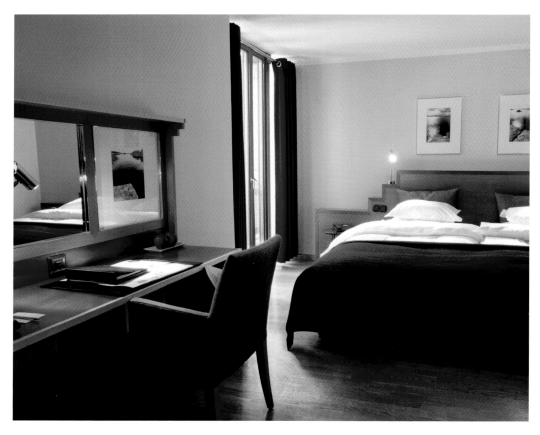

The rooms are decorated with furniture made of precious wood.

Die Zimmer sind mit Möbeln aus edlem Holz ausgestattet.

Les chambres sont aménagées avec des meubles en bois précieux.

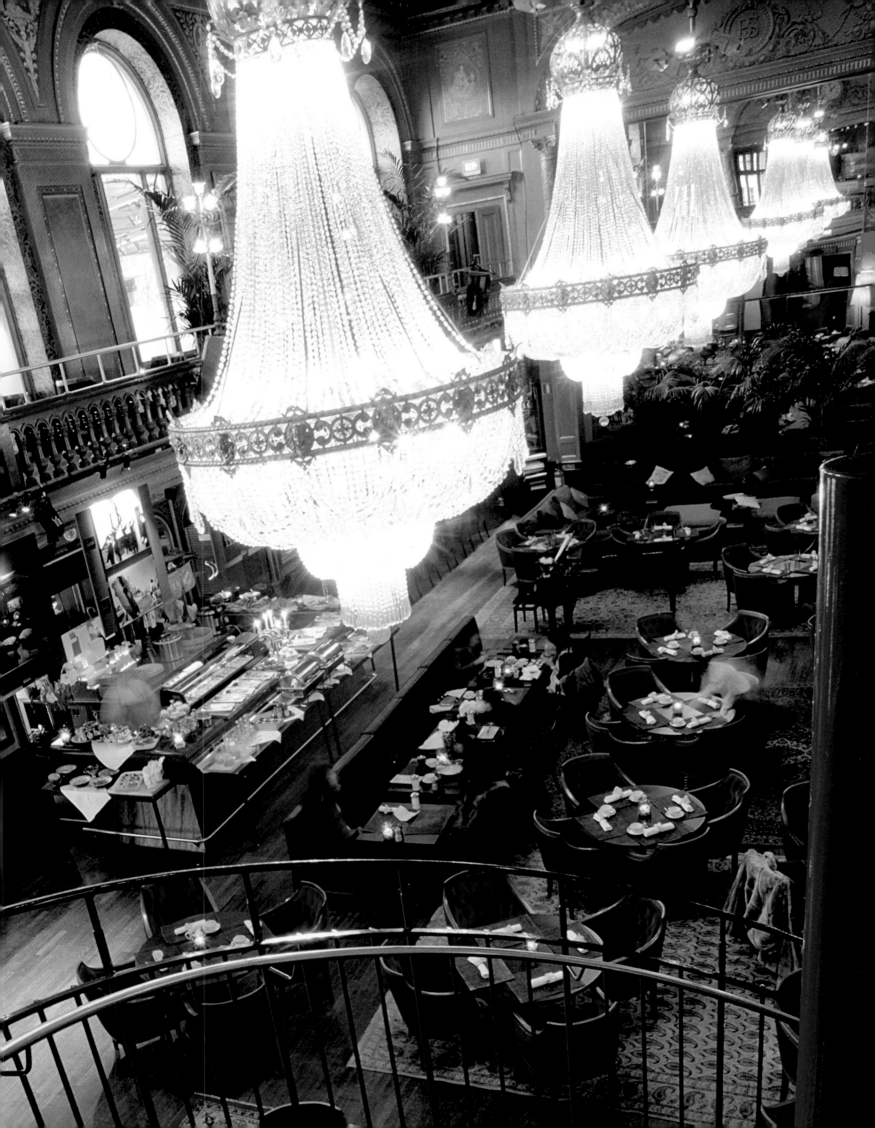

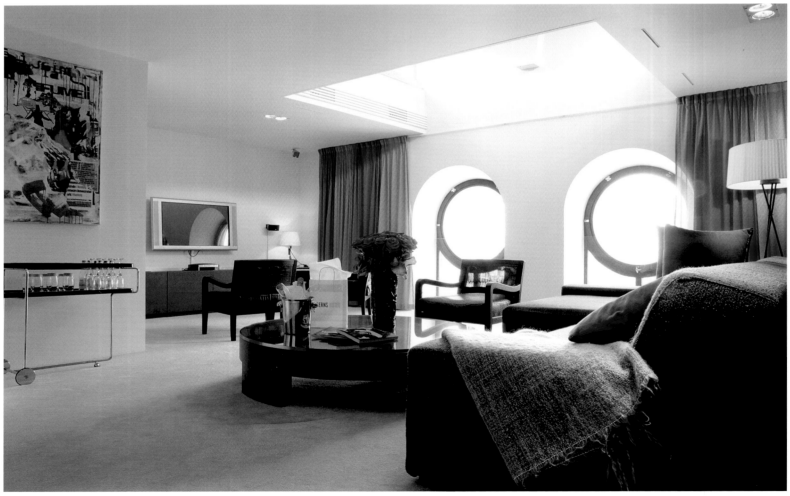

The bar and the lounge are popular hangouts.

Bar und Lounge sind beliebte Treffpunkte.

Lieux de rendez-vous appréciés : bar et lounge.

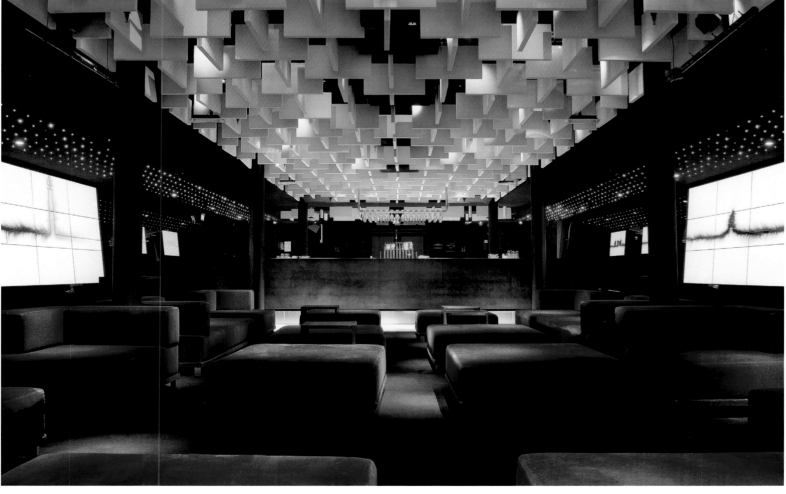

Blakes Hotel

London, United Kingdom

Located in the quiet quarter of South Kensington, Blakes Hotel is divided in two Victorian town houses. Here, stylistic elements of Western are mixed with elements of the Far Eastern culture. Many Indian, Chinese and Japanese antiques adorn the assembly rooms and the 48 guest rooms. Each room was decorated individually, though the big beds and the ample marble bathrooms are standard equipment. The restaurant serves a fusion of Thai and Mediterranean cuisine. In good weather, meals are served on the roof terrace.

Im ruhigen Stadtteil South Kensington liegt das Blakes Hotel, verteilt auf zwei viktorianische Stadthäuser. In diesen treffen westlicher und fernöstlicher Stil aufeinander: Zahlreiche indische, chinesische und japanische Antiquitäten zieren die Gemeinschaftsräume und die 48 Zimmer. Zwar sind alle unterschiedlich gestaltet – auf große Betten und geräumige Marmorbäder muss man aber in keinem verzichten. Das Restaurant verbindet thailändische und mediterrane Küche und serviert seine Speisen bei schönem Wetter auf der Dachterrasse.

Le Blakes Hotel, réparti sur deux maisons de ville victoriennes, se situe dans South Kensington, un quartier calme de Londres. Cet hôtel marie un style occidental à un style extrême-oriental : de nombreuses antiquités indiennes, chinoises et japonaises ornent les salles communes ainsi que les 48 chambres. Celles-ci sont toutes agencées de façon différente, mais dans aucune ne fut renoncé aux grands lits et aux salles de bains en marbre spacieuses. Le restaurant propose une cuisine méditerranéenne et thaïlandaise et sert les repas sur la terrasse du toit, quand le temps le permet.

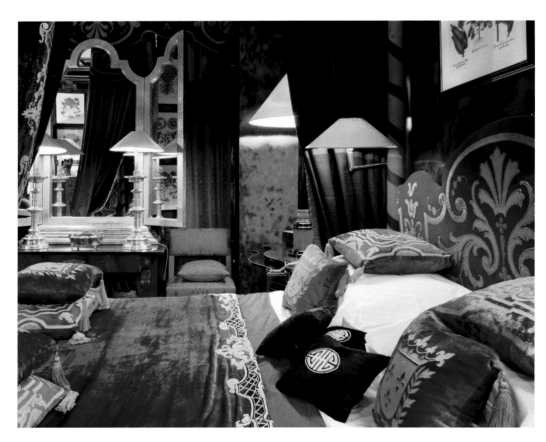

Each room is individually decorated and has its very own style.

Jedes Zimmer ist individuell in einem anderen Stil eingerichtet.

A chaque chambre un aménagement dans un style qui lui est propre.

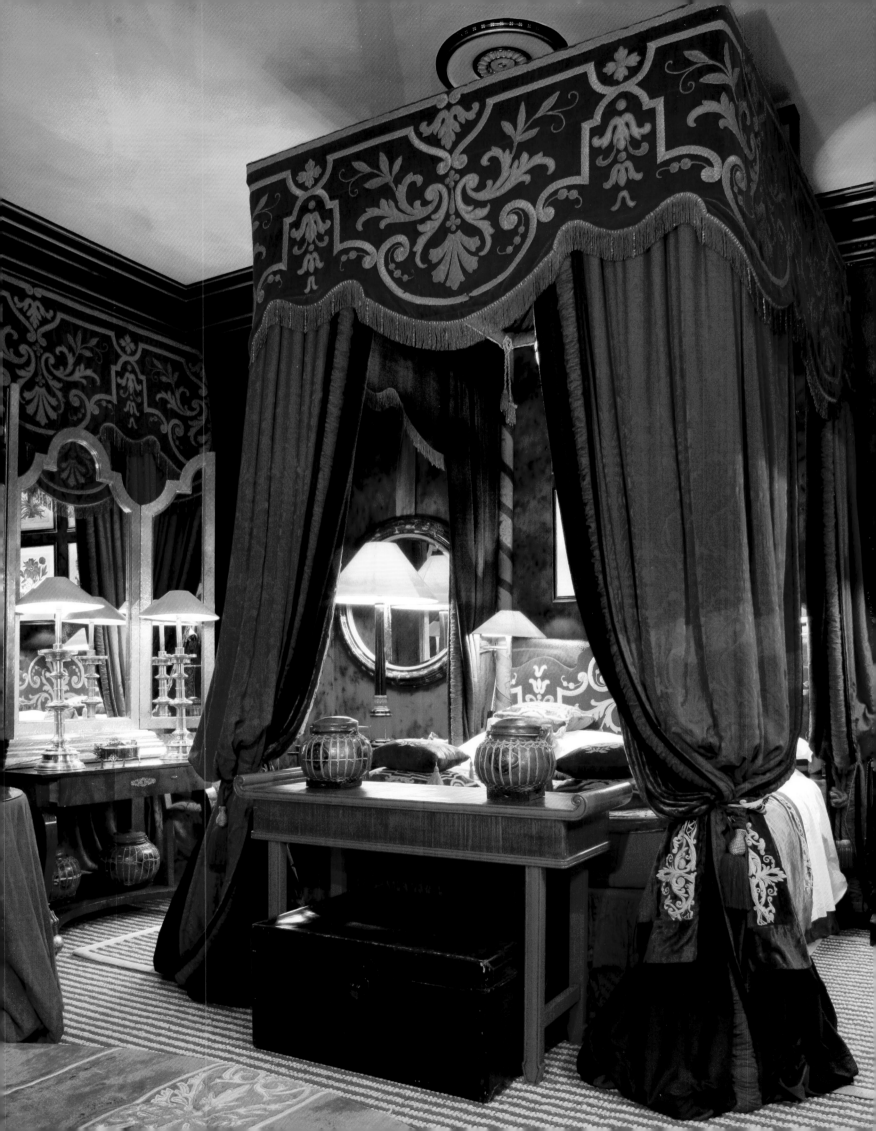

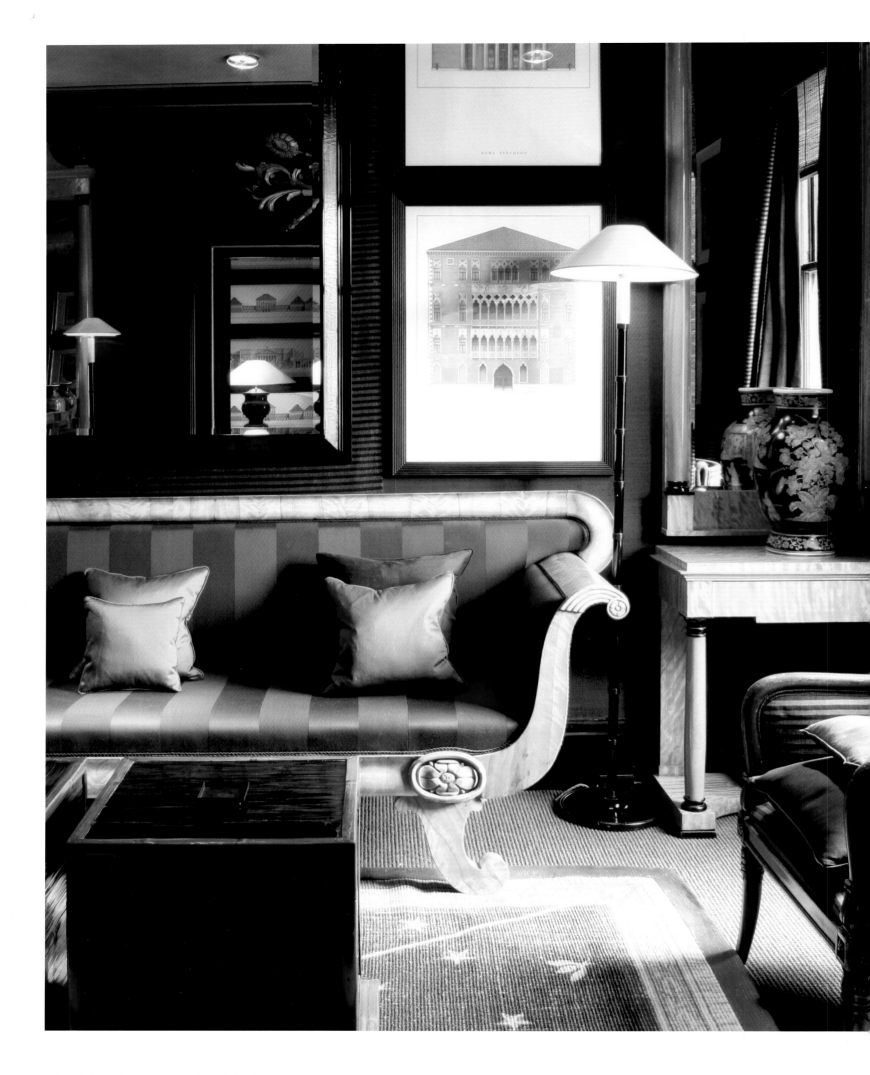

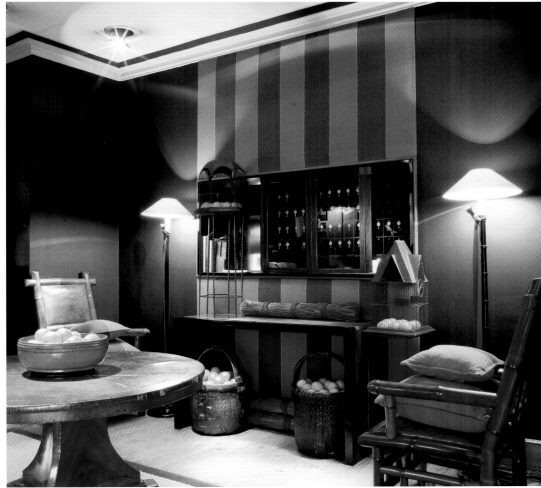

Many rooms are decorated with antiques from the Far East.

Viele Räume sind mit fernöstlichen Antiquitäten geschmückt.

Bon nombre de pièces sont ornées d'antiquités venues d'Extrême-Orient.

The Berkeley

London, United Kingdom

The Berkeley is housed in a travertine-faced French Regency-inspired building in Knightsbridge near Hyde Park. The dramatic architecture blends the old and the new in a luxurious, modern building with a splendid rooftop swimming pool. All of the 214 rooms are individually designed in soothing, classic contemporary style; some are spectacular penthouse suites with their own conservatory terraces and others with saunas or balconies.

The Berkeley ist in einem vom Stil der französischen Régence inspirierten Gebäude mit Travertinfassade in Knightsbridge nahe des Hyde Parks untergebracht. Die spektakuläre Architektur verbindet Altes mit Neuem zu einem luxuriösen, modernen Gebäude mit einem herrlichen Schwimmbad auf dem Dach. Alle 214 Zimmer sind individuell in einem beruhigenden, klassisch-zeitgenössischen Stil gestaltet worden; darunter sind einige eindrucksvolle Penthousesuiten mit eigenen Wintergartenterrassen, andere haben Saunen oder Balkons.

The Berkeley se trouve dans un bâtiment à Knightsbridge à proximité de Hyde Park, dont la façade en travertin est inspirée du style régence français. L'architecture dramatique marie l'ancien et le récent dans un luxueux immeuble moderne avec une superbe piscine sur le toit. Chacune des 214 chambres a été aménagée individuellement dans un style contemporain reposant et classique ; quelques unes sont des suites de toit spectaculaires avec des terrasses privées, tandis que d'autres disposent de saunas ou de balcons.

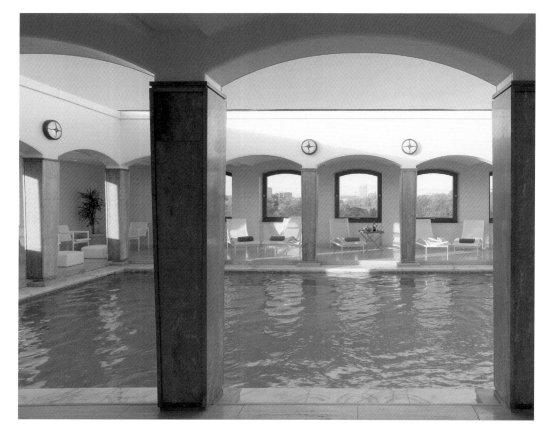

The hotel has an indoor and an outdoor pool.

Das Hotel verfügt über einen Pool im Innen- und Außenbereich.

L'hôtel dispose d'une piscine intérieure et extérieure.

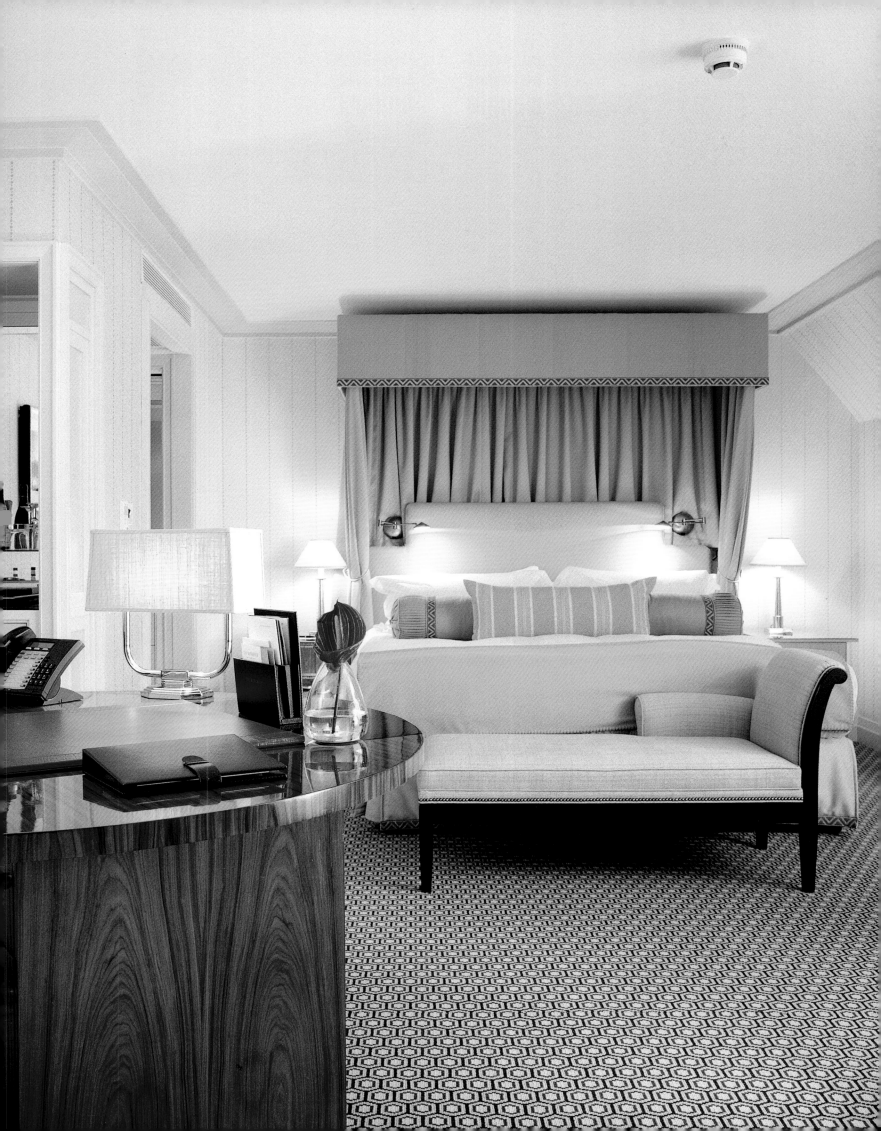

The **214** rooms are individually decorated.

Individuelle Einrichtung für jedes der 214 Zimmer.

Aménagement individuel pour chacune des 214 chambres.

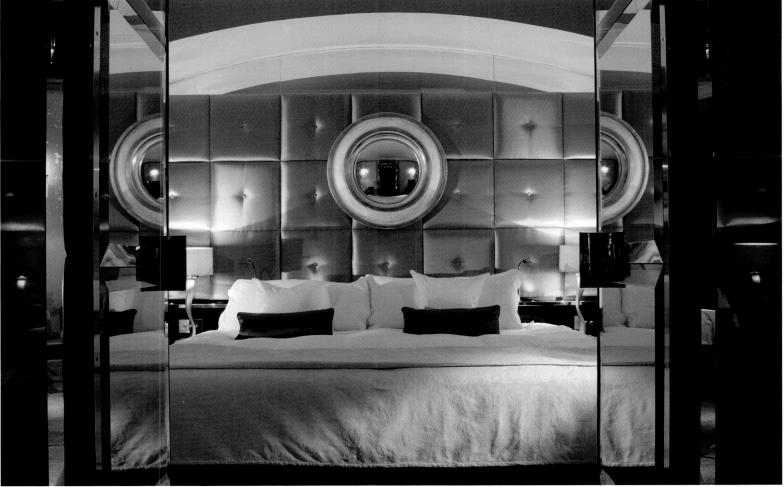

Claridge's
London, United Kingdom

A true grand dame on the London hotel circuit situated in the fashionable West End, Claridge's underwent a groundbreaking renovation in 2006. While the changes are extensive, the hotel has retained its turn-of-the-century look and continues to feel more like an elegant apartment building than a hotel. Designed with an elegant blend of art deco touches mixed in with Edwardian and French influences, the majestic Claridge's is as splendid today as it was when it first opened its doors in 1854.

Als wahre Grand Dame des Londoner Hotelgewerbes im eleganten West End wurde das Claridge's 2006 grundlegend renoviert. Obwohl die Veränderungen sehr weitreichend waren, hat das Hotel sein Aussehen aus der Zeit der Jahrhundertwende bewahrt und vermittelt immer noch eher das Gefühl eines eleganten Appartementgebäudes als das eines Hotels. Das majestätische Claridge's ist mit seiner eleganten Mischung aus Art déco mit edwardianischen und französischen Einflüssen heute noch genauso glanzvoll wie 1854, als es erstmals seine Türen öffnete.

Une vraie Grande Dame parmi les hôtels londoniens et situé dans le West End chic, le Claridge's a subi en 2006 une rénovation de fond en combles. Bien que les modifications soient nombreuses, l'hôtel a gardé son look de fin de siècle et ressemble d'avantage à un immeuble d'appartements élégants qu'à un hôtel. Conçu avec un mélange élégant d'art déco et d'influences edwardiennes et françaises, le majestueux Claridge's est aujourd'hui aussi splendide qu'il ne l'a été lorsqu'il a ouvert pour la première fois ses portes en 1854.

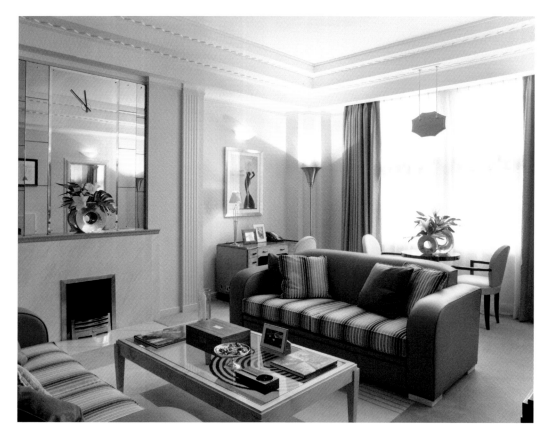

The hotel combines art deco design with contemporary comfort.

Das Hotel verbindet Art-Déco-Design mit modernem Komfort.

Dans cet hôtel, le design art déco s'allie au confort moderne.

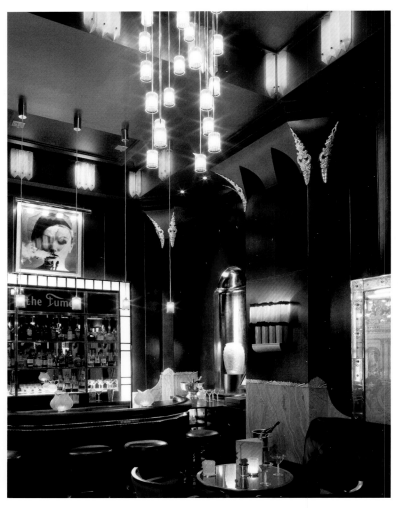

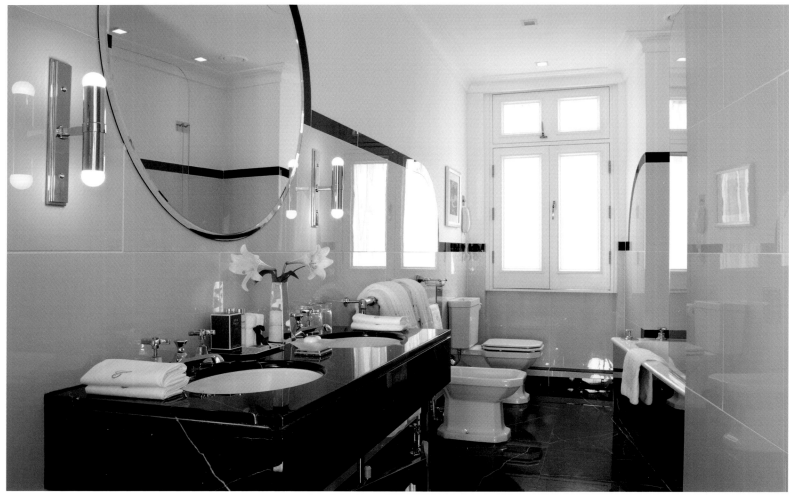

The interior is characterized by antiques from different eras.

Antiquitäten verschiedener Epochen prägen das Innere.

Des antiquités issues d'époques différentes caractérisent l'intérieur.

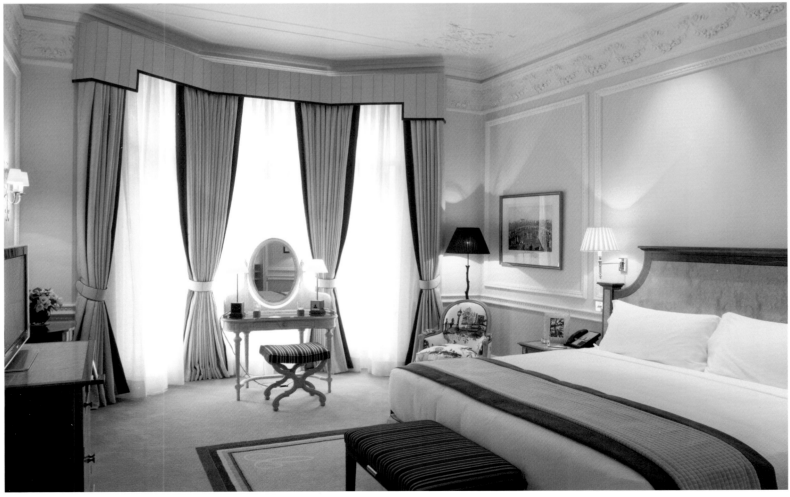

The Lanesborough

London, United Kingdom

Ideally located in Knightsbridge, The Lanesborough was restored to its white-stucco grandeur under the supervision of experts and artisans from the Georgian Society, The Royal Fine Arts Commission, and English Heritage. 95 rooms, including 43 suites, incorporate handsome furnishings: armoires, desks, and selected works of art that blend seamlessly with the modern technology of a contemporary hotel.

Das idyllisch in Knightsbridge gelegene Lanesborough erhielt durch eine Renovierung unter der Aufsicht von Experten und Künstlern der Georgian Society, der Royal Fine Arts Commission und des English Heritage seine alte Pracht und seinen weißen Stuck zurück. Die 95 Zimmer, einschließlich der 43 Suiten, sind mit edlem Mobiliar eingerichtet: Kleiderschränke, Schreibtische und ausgewählte Kunstwerke passen sich nahtlos in die moderne Technologie eines zeitgemäßen Hotels ein.

Avec sa situation idyllique à Knightsbridge, le Lanesborough a retrouvé sa grandeur et ses stucs blancs suite à une rénovation réalisée sous l'égide d'experts et d'artisans de la Georgian Society, de la Royal Fine Arts Commission et de l'English Heritage. 95 chambres, dont 43 suites, contiennent de beaux meubles : armoires, bureaux et objets d'arts sélectionnés qui intègrent sans le moindre problème la technologie d'un hôtel moderne.

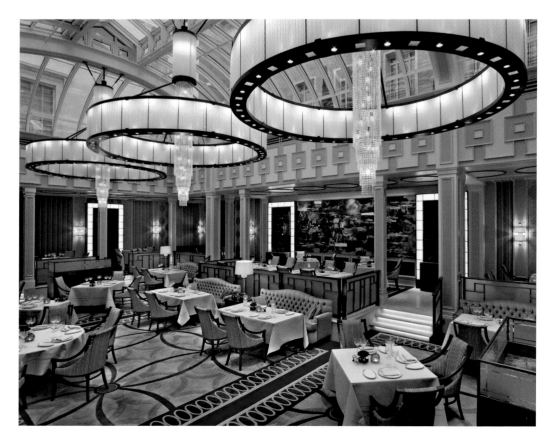

Breakfast is served in "Apsleys" restaurant.

Im Restaurant „Apsleys" wird das Frühstück serviert.

Le petit déjeuner est servi dans le restaurant « Apsleys ».

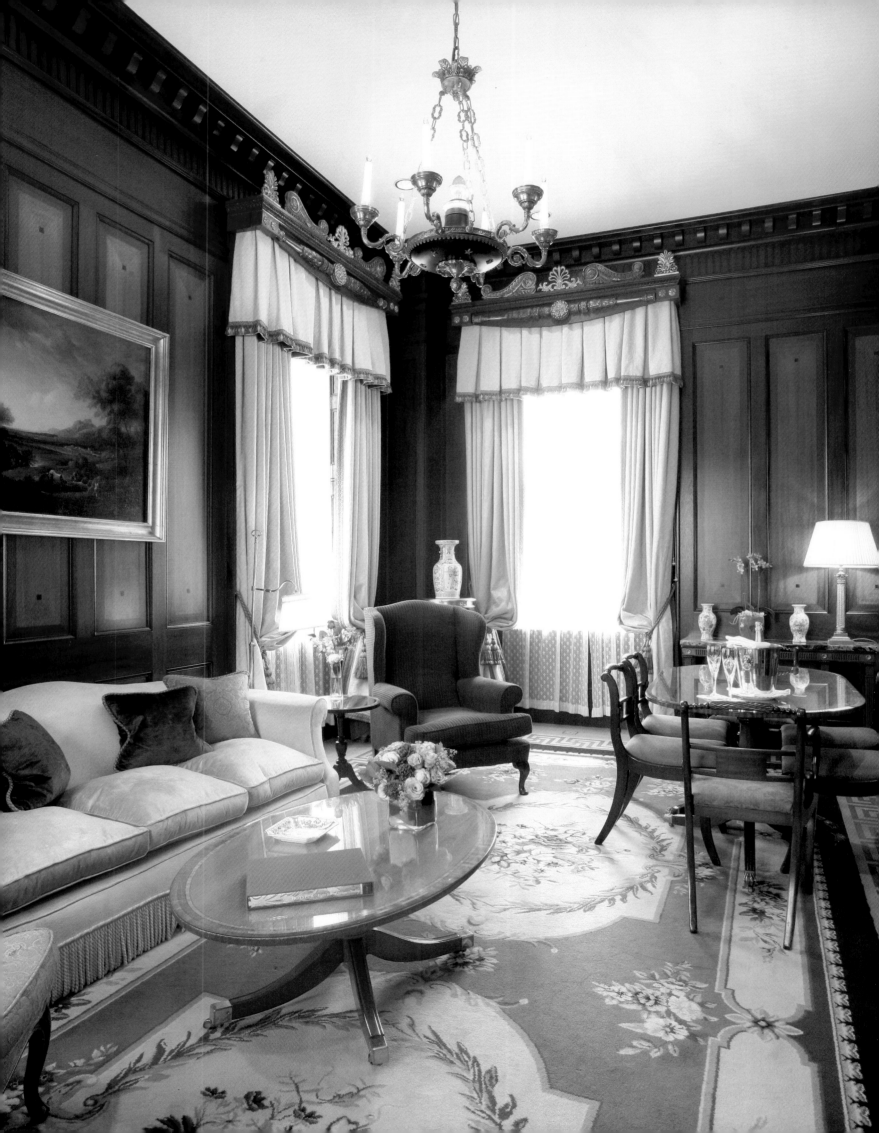

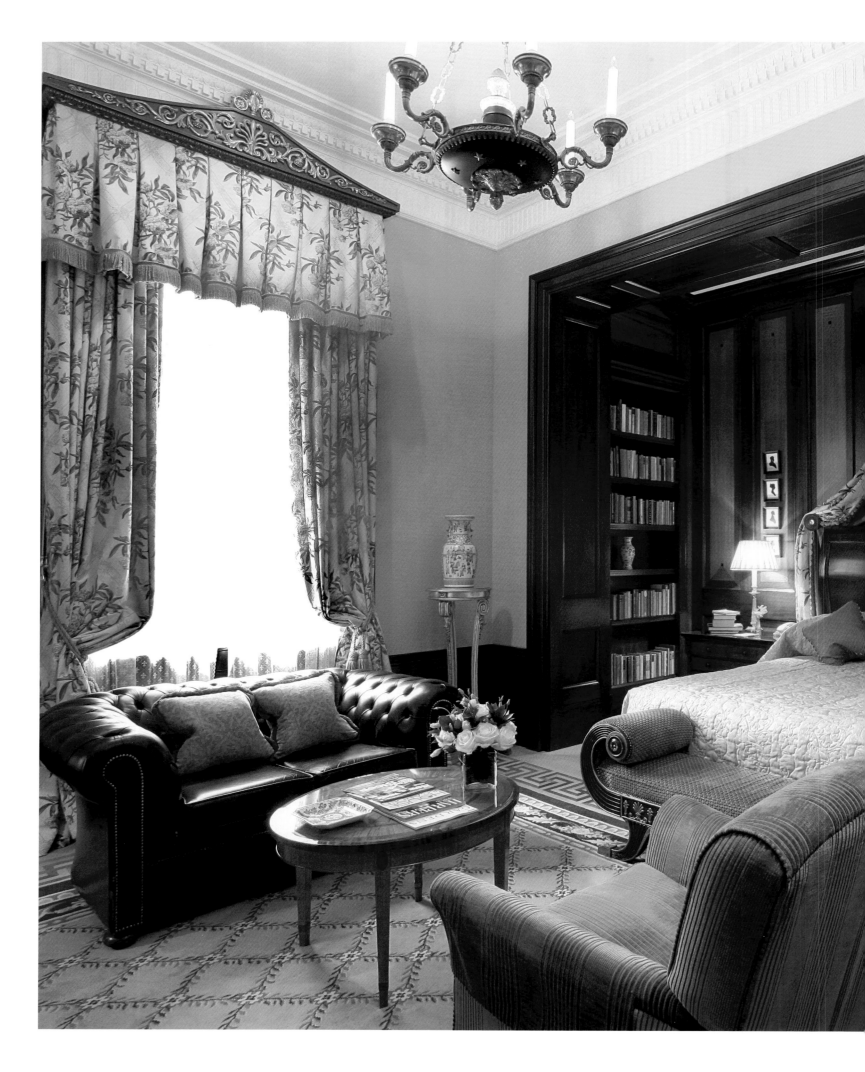

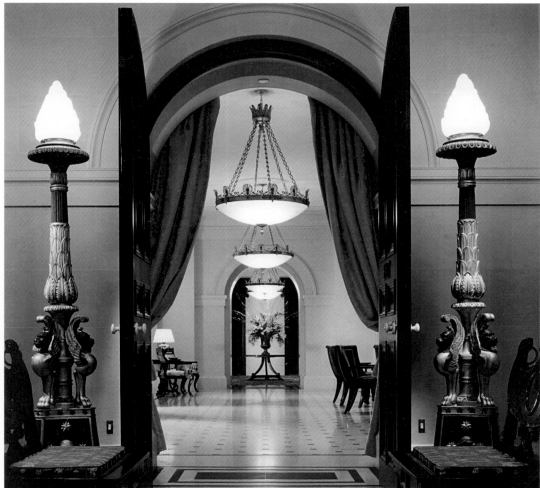

19th-century furniture emphasizes the historic character of the building.

Mobiliar aus dem 19. Jahrhundert unterstreicht den historischen Charakter des Gebäudes.

Le mobilier du XIX^{ème} siècle souligne le caractère historique du bâtiment.

Hotel de Filosoof

Amsterdam, The Netherlands

The Hotel de Filosoof near the Vondel Park lives up to its name: each of the 38 rooms in the three 19th-century buildings is individually decorated and is accordingly devoted to either a famous poet, a thinker or a philosophic script. This theme is also emphasized by quotes on the wall, books, paintings or the use of certain colorings. There is, for instance, a red room hinting at Nietzsches "Morgenröte," which means "red of dawn." According to the theme, rooms are decorated either lavishly or in more of a minimalistic way. This hotel hosts regular readings.

Das Hotel de Filosoof in der Nähe des Vondelparks wird seinem Namen gerecht: Jedes der 38 Zimmer in den drei Häusern aus dem 19. Jahrhundert ist individuell eingerichtet und einem berühmten Dichter oder Denker oder einer philosophischen Schrift gewidmet. Betont wird dies unter anderem durch Zitate an der Wand, durch Bücher, Gemälde oder bestimmte Farbtöne. So gibt es ein rotes Zimmer, mit Bezug auf Nietzsches „Morgenröte". Je nach Thema überwiegt minimalistisches oder üppiges Design. Regelmäßig finden Lesungen statt.

Situé non loin du Vondelpark et installé dans trois demeures du XIXème siècle, l'Hotel de Filosoof, porte bien son nom : en effet, chacune des 38 chambres, aménagée de façon personnalisée, est dédiée à un poète célèbre, un penseur ou à un texte philosophique. Ceci s'exprime, entre autre, par des citations parcourant les murs, par des livres, des peintures ou certaines teintes de couleur. C'est ainsi qu'il y a une chambre rouge, par allusion au « Morgenröte » (« aurore ») de Nietzsche. Selon le thème choisi, le design est minimaliste ou exubérant. Des lectures y ont régulièrement lieu.

The walls are adorned with quotes from famous philosophers.

Zitate berühmter Philosophen zieren die Wände.

Sur les murs, des citations de philosophes célèbres.

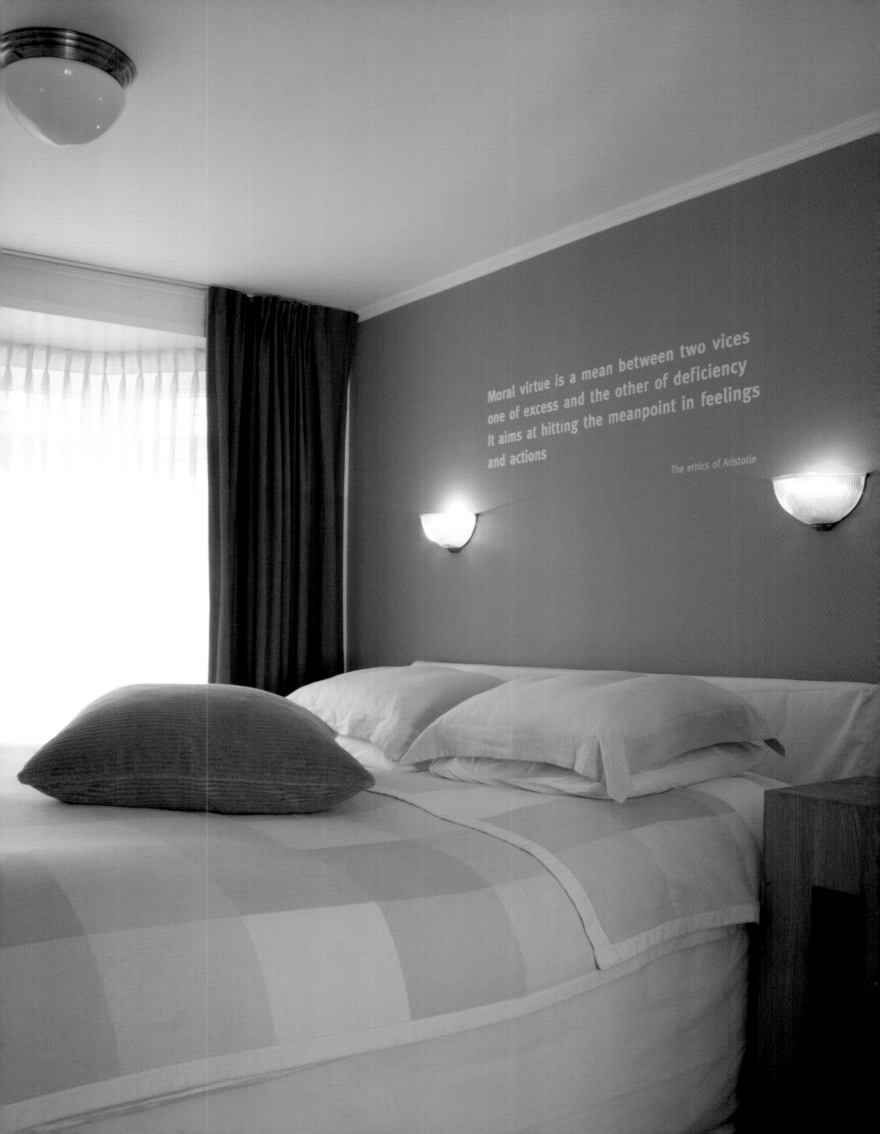

Moral virtue is a mean between two vices
one of excess and the other of deficiency
It aims at hitting the meanpoint in feelings
and actions

The ethics of Aristotle

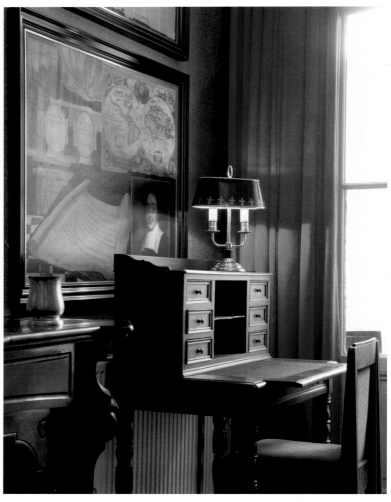

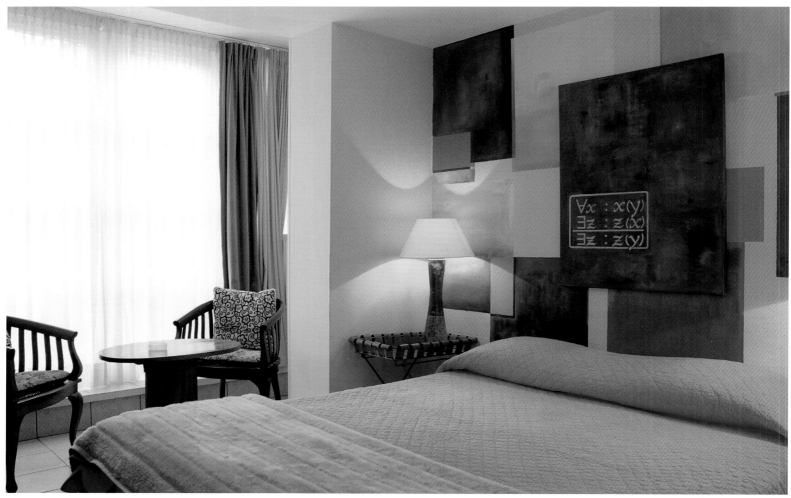

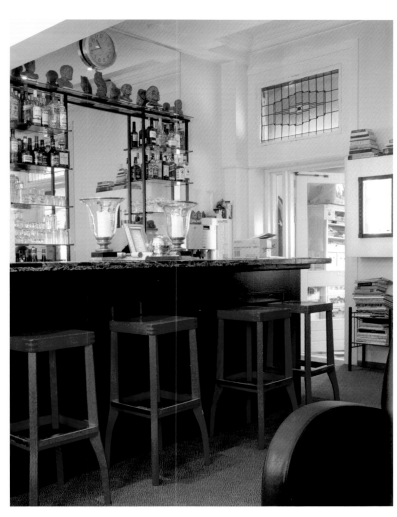

In the evening, the bar invites guests to an aperitif.

Am Abend lädt die Bar des Hauses zu einem Aperitif.

Le soi, le bar de la maison invite à prendre un apéritif.

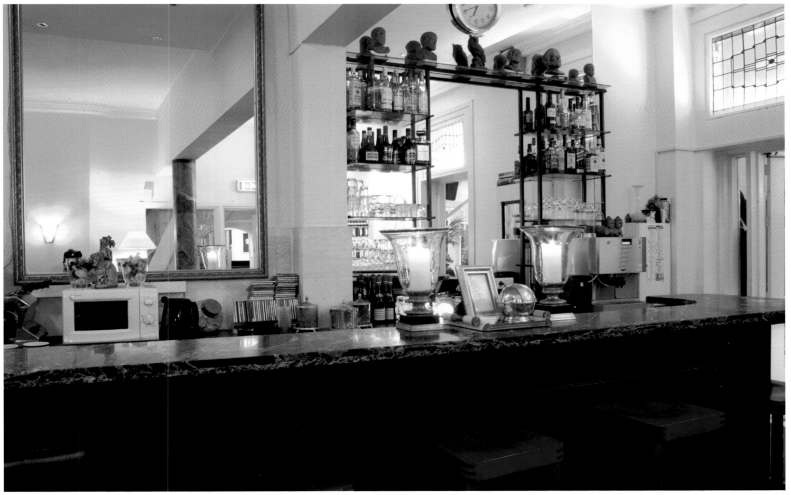

Hotel Pulitzer, a Luxury Collection Hotel

Amsterdam, The Netherlands

Hotel Pulitzer, a Luxury Collection Hotel, is spreading over 25 houses of the 17th and 18th century. It is therefore big enough to accommodate 230 rooms and suites, all varying in size and decoration. Depending on the position, guests either have a view of a canal or the beautiful gardens and courtyards, in which the art gallery is situated. Here, various annual exhibitions take place. Guests dine in the historic dining room "De Apotheek," a former pharmacy. In good weather, meals are also served in the courtyard.

Das Hotel Pulitzer, a Luxury Collection Hotel, verteilt sich auf 25 Häuser aus dem 17. und 18. Jahrhundert. Dadurch bietet es Platz für 230 Zimmer und Suiten, die sich alle in Größe und Einrichtung unterscheiden. Je nach Ausrichtung blickt man entweder auf eine Gracht oder auf hübsche Gärten und Innenhöfe, in denen auch die Kunstgalerie untergebracht ist. Hier finden jedes Jahr mehrere Ausstellungen statt. Bei schönem Wetter kann man auch im Hof essen, sonst wird im historischen Speisesaal „De Apotheek" serviert, einer ehemaligen Apotheke.

L'Hotel Pulitzer, a Luxury Collection Hotel, est composé de 25 maisons datant du XVIIème et du XVIIIème siècle. C'est ainsi qu'il offre 230 chambres et suites à l'agencement et la superficie divers. Selon l'orientation, l'hôte a vue sur un canal, sur de beaux jardins ou des cours intérieures dans lesquelles on a également installé la galerie d'art. Ici, plusieurs expositions sont organisées chaque année. Quand le temps le permet, il est possible de manger dans la cour, mais sinon, les repas sont servis dans une salle à manger empreinte d'histoire, jadis ancienne pharmacie et aujourd'hui surnommée « De Apotheek ».

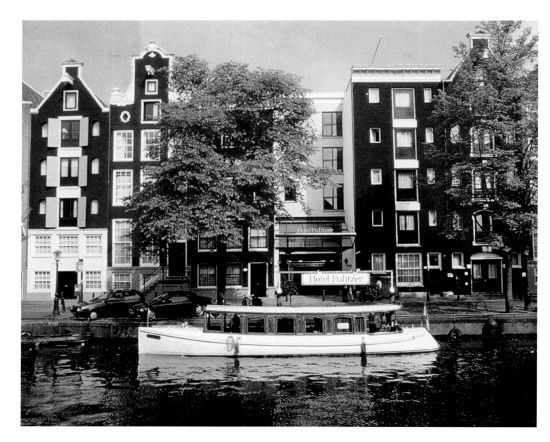

The Hotel Pulitzer is located directly by a canal.

Das Hotel Pulitzer liegt direkt an einer Gracht.

L'Hotel Pulitzer se situe directement au bord d'un canal.

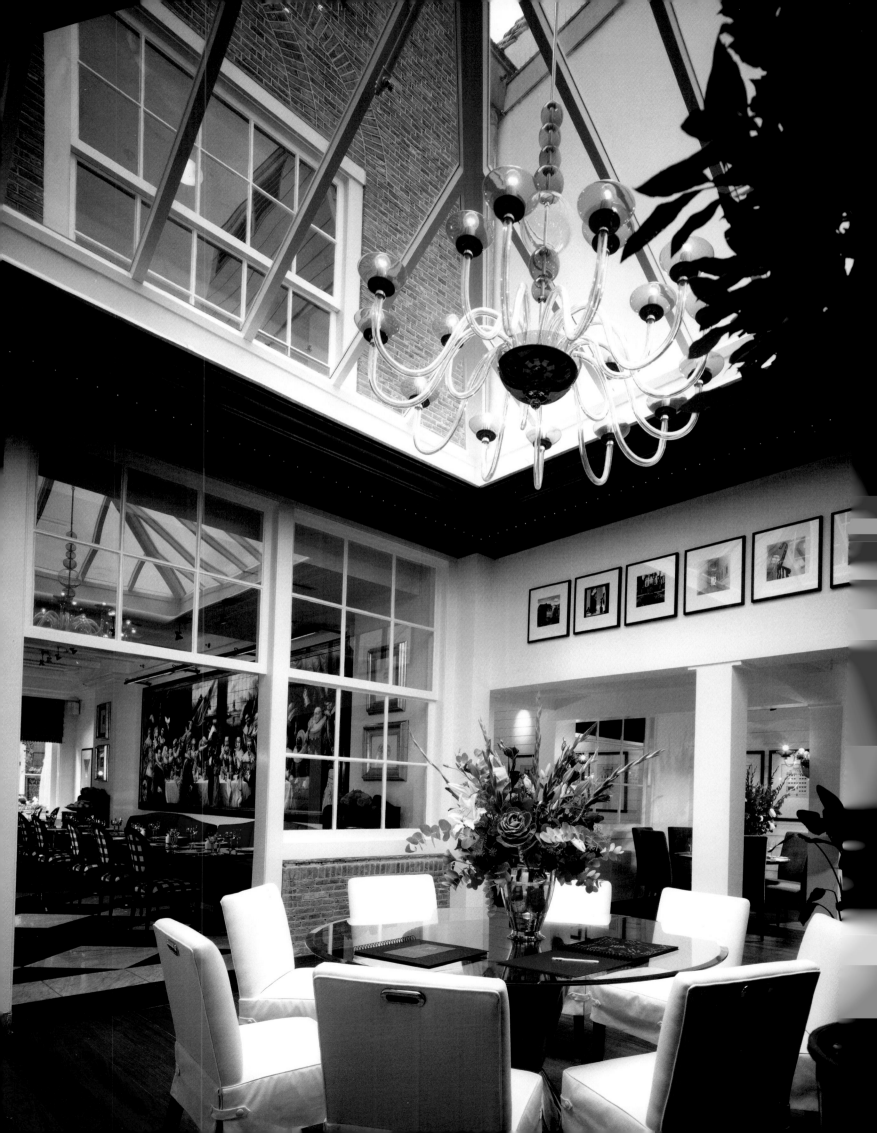

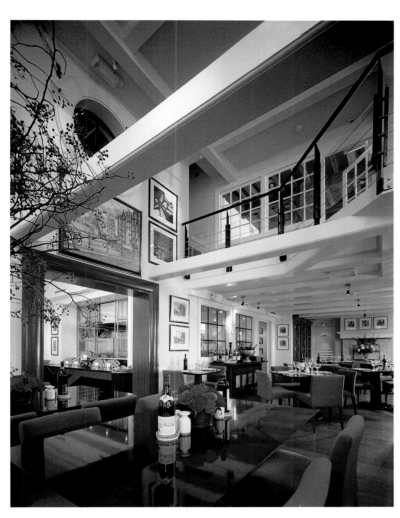

Inside, guests will find many works of art.

Im Haus entdeckt man viele Kunstgegenstände.

La maison abrite de nombreux objets d'art.

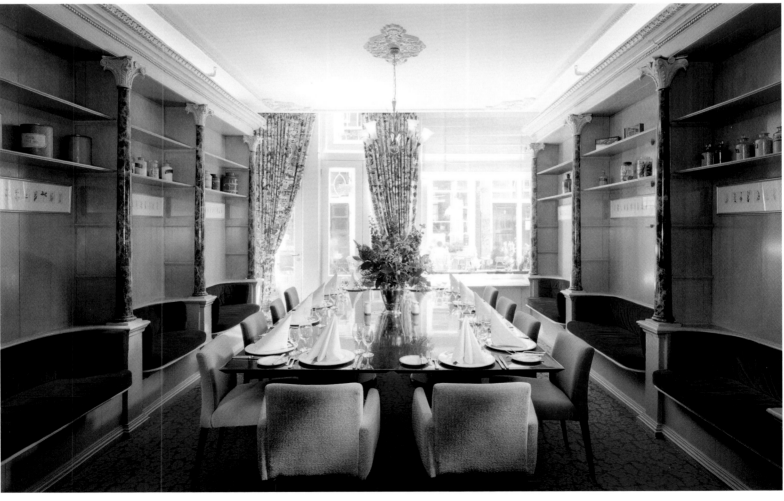

Hotel Amigo

Brussels, Belgium

In the 16th century, the house which today accommodates hotel guests served as a prison. The residents of Brussels took a liking to the fact that the unpopular Spanish rulers called the house "friend" (Flemish vriend) instead of prison (Flemish vrunte). And thus the name Amigo has remained with the stately red brick building with its renaissance facade situated only a few steps away from Brussels' famous Grand Place. Thanks to renovation works in 2002, today nothing is left to remind the guests of the previous role of the distinguished luxury hotel whose design is clearly marked by famous designer Olga Polizzi.

Im 16. Jahrhundert logierten in dem stattlichen Backsteinbau nicht die Gäste der Stadt, sondern die der Justiz. Den Brüsselern gefiel es, dass die ungeliebten spanischen Machthaber die Bezeichnung des Gebäudes irrtümlich mit „Freund" (flämisch: vriend) statt korrekt mit „Gefängnis" (flämisch: vrunt) übersetzten. Und so ist der Name „Amigo" dem Luxushotel mit der Renaissance-Fassade, das nur wenige Schritte von Brüssels berühmten Grand Place entfernt liegt, erhalten geblieben. An seine frühere Bestimmung erinnert seit der Renovierung 2002 nichts mehr. Unübersehbar ist die Handschrift der Designerin Olga Polizzi.

Les bruxellois d'autrefois appréciaient que les souverains espagnols qu'ils détestaient traduisent le nom flamand du bâtiment « vrunte » (prison) qui servait de prison au 16ème siècle par « ami » (en flamand vriend). C'est ainsi que le nom Amigo est resté à cette bâtisse impressionnante en briques rouges avec sa façade renaissance, qui est située à proximité de la fameuse Grand Place bruxelloise. Dans cet hôtel de prestige, plus rien ne rappelle son utilisation antérieure depuis sa rénovation en 2002. La touche de la décoratrice Olga Polizzi est évidente.

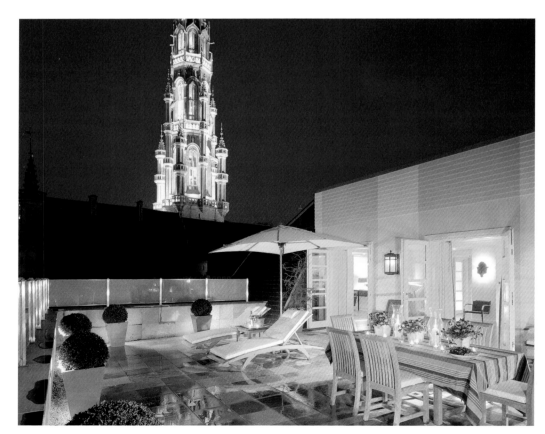

The Grand Place with the gothic city hall is only a few steps away.

Der Grand Place mit dem gotischen Rathaus ist nur wenige Meter entfernt.

A quelques pas de là se situe la Grande-Place avec l'hôtel de ville gothique.

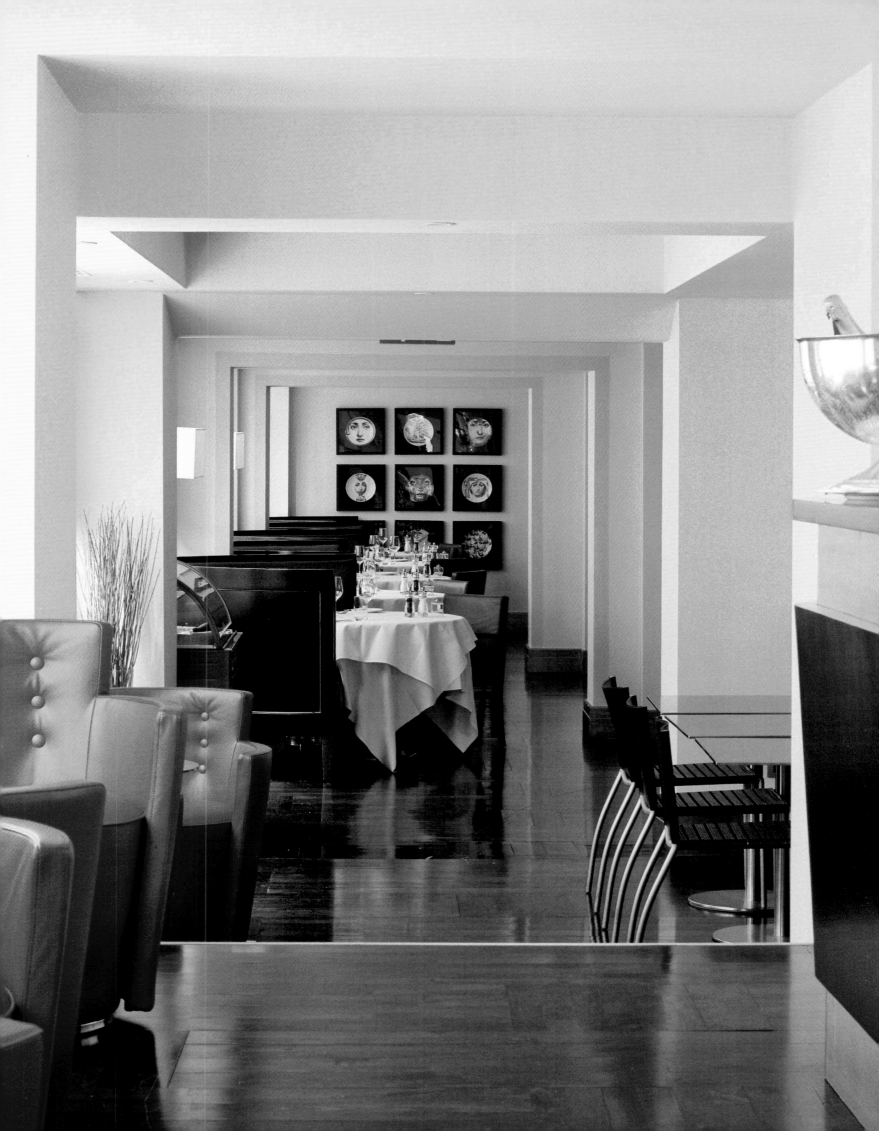

Illustrations and paintings of famous writers hang on the walls of the bar.

An den Wänden der Bar hängen Zeichnungen und Fotografien berühmter Schriftsteller.

Des canevas et des photographies d'écrivains célèbres ornent les murs du bar.

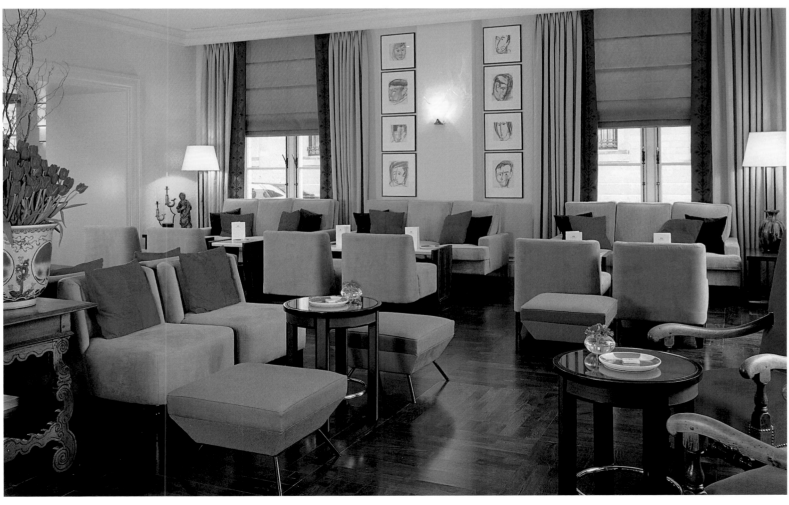

Royal Windsor Hotel Grand Place

Brussels, Belgium

The recently refurbished Royal Windsor Hotel is located right beside the central Grand Place, and is therefore the ideal starting point to explore the Belgian capital. The five-star hotel with its more than 266 rooms and suites offers its guests an attentive and personal service. Since the refurbishment, the hotel has been provided with a state-of-the-art equipment. Nevertheless, all the enhancements do not take anything away from the elegance of this hotel. Among other places, guests are allowed to dine in the hotel's own library.

Gleich bei der zentralen Grand Place liegt das frisch renovierte Royal Windsor Hotel und ist damit ein idealer Ausgangspunkt für die Entdeckung der belgischen Hauptstadt. Das Fünf-Sterne-Hotel bietet seinen Gästen in über 266 Zimmern und Suiten einen aufmerksamen und persönlichen Service. Seit der Renovierung verfügt das Haus über eine hochmoderne Ausstattung. Dabei bleibt die Eleganz trotz aller Neuerungen erhalten. Speisen dürfen die Gäste unter anderem in der hauseigenen Bibliothek.

Récemment rénové, le Royal Windsor Hotel se trouve à quelques pas de la centrale Grand-Place et constitue en cela un point de départ idéal pour découvrir la capitale belge. Cet hôtel cinq étoiles, équipé de 266 chambres et suites, offre à ses hôtes un service personnalisé et attentionné. Depuis qu'elle a été rénovée, la maison dispose d'un équipement ultramoderne sans que ces nouveautés n'aient rien enlevé à l'élégance du lieu. Les hôtes peuvent les prendre, entre autre, dans la bibliothèque de l'hôtel.

Twelve rooms of the hotel were designed by Belgian fashion designers.

Belgische Mode-Designer entwarfen zwölf Zimmer des Hotels.

Douze chambres de l'hôtel ont été conçues par des stylistes de mode belges.

Every room is painted in a different color.

Jeder Raum hat eine unterschiedliche Farbe.

Une couleur différente dans chaque chambre.

Louis C. Jacob

Hamburg, Germany

The Louis C. Jacob hotel in Hamburg has been in business for over 200 years; it is located in the city's suburbs at the River Elbe, and ever since it opened, its guests have been enjoying the spectacular view at the port and ships passing by—a view which cannot only be admired from the multiple award-winning restaurant, but also from most of the 85 rooms and suites. All rooms have natural stone bathrooms as well as high-quality carpets and oak floor boards. The color schemes, however, are different in every room. The rooms, hall and restaurant boast over 500 paintings and pieces of graphic art by artists from Northern Germany.

Seit mehr als 200 Jahren empfängt das Hotel Louis C. Jacob in den Hamburger Elbvororten seine Gäste. Schon damals bewunderten sie die Sicht auf Hafen und Schiffe. Und zwar nicht nur vom mehrfach ausgezeichneten Restaurant, sondern auch von den meisten der 85 Zimmer und Suiten. Alle sind mit Bädern aus Naturstein, hochwertigen Teppichen und alten Eichenholzdielen ausgestattet, unterscheiden sich aber in ihrer Farbgebung. In den Zimmern, der Halle und dem Restaurant hängen mehr als 500 Gemälde und Grafiken norddeutscher Künstler.

Situé sur les bords de l'Elbe dans un quartier d'Hambourg, l'hôtel Louis C. Jacob reçoit ses hôtes depuis plus de 200 ans et, à cette époque on admirait déjà sa vue sur le port et sur les bateaux. L'hôtel est en effet doté d'une vue imprenable, et ce, non seulement du restaurant, par ailleurs récompensé à plusieurs reprises, mais aussi de la plupart des 85 chambres et suites de l'hôtel. Celles-ci sont toutes équipées de salles de bains en pierres naturelles, de tapis luxueux et de parquets en chêne et ne se distinguent les unes des autres que par leur coloris. Plus de 500 peintures et graphiques d'artistes de l'Allemagne du Nord décorent les chambres, le hall et le restaurant.

The hotel Jacob opened as early as 200 years ago.

Schon vor mehr als 200 Jahren öffnete das Hotel Louis C. Jacob seine Türen.

L'hôtel Jacob ouvrit ses portes il y a plus de 200 ans.

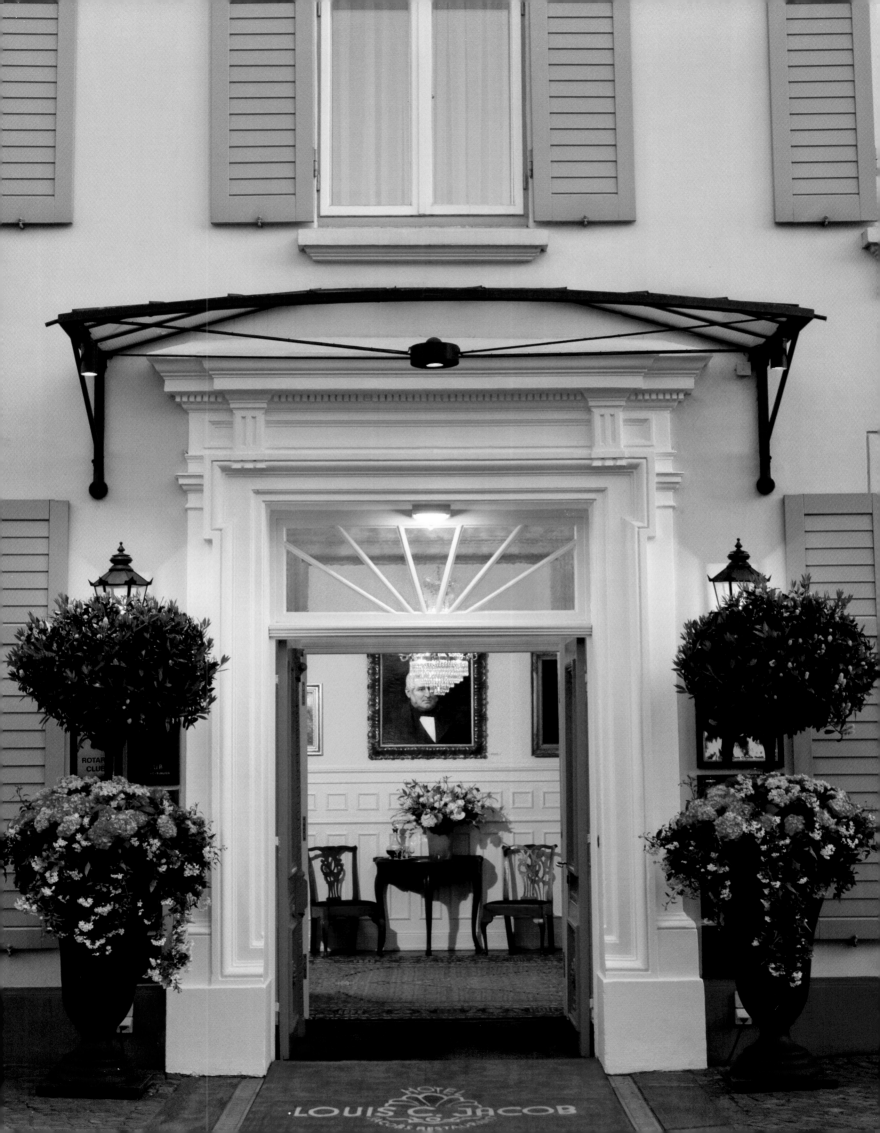

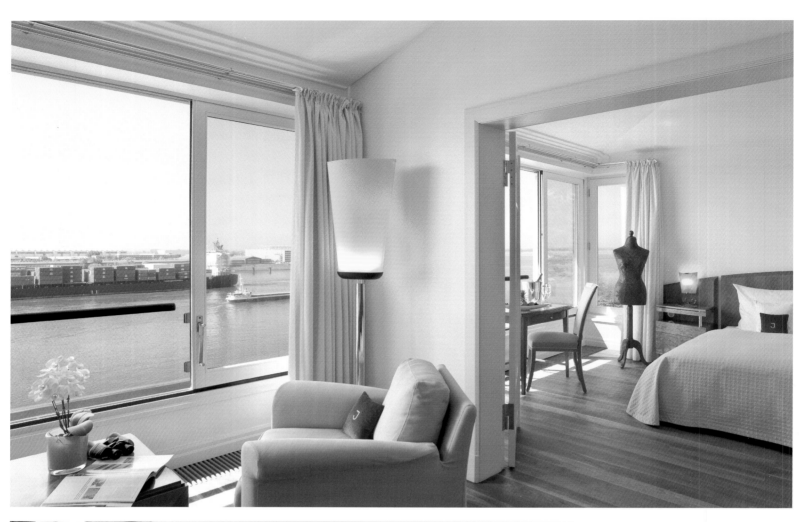

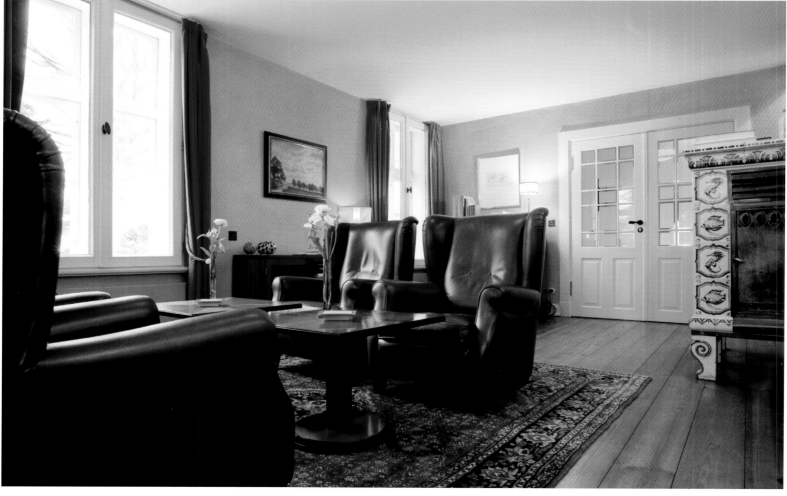

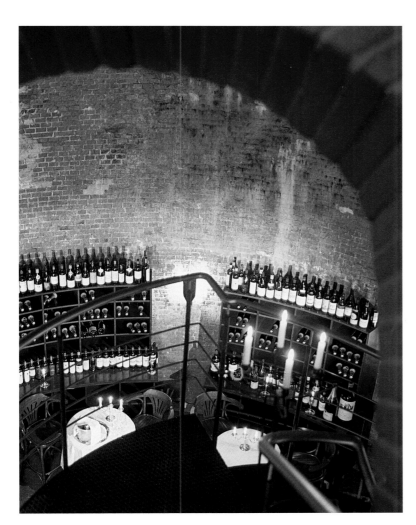

Most rooms have a nice view of the harbor and the River Elbe.

Die meisten Zimmer bieten einen schönen Blick auf den Hafen und die Elbe.

La plupart des chambres s'ouvrent sur le port et l'Elbe.

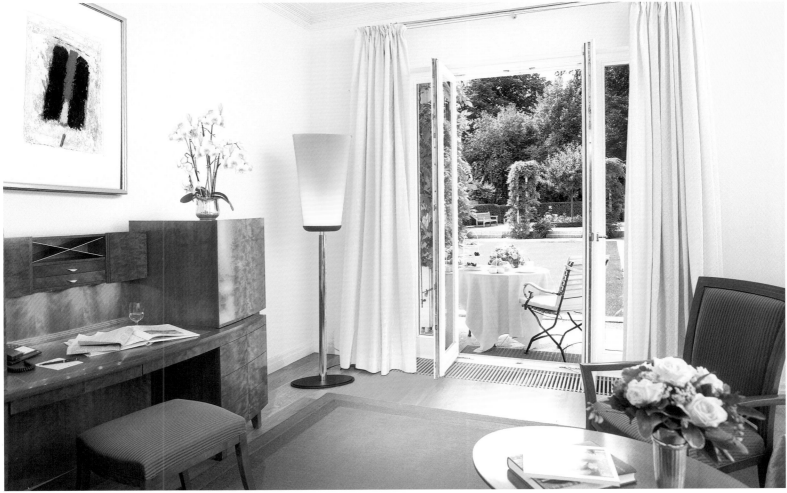

SIDE Hotel
Hamburg, Germany

The SIDE hotel was built in 2001 and designed by architect Jan Störmer while the puristic interior design, which prefers light colors, carries the fingerprint of Italian designer Matteo Thun. All 168 rooms are dominated by warm and light colors. There are ten suites which are painted completely white; however, colored decorations give each suite its own individual touch. The spa is designed in refreshingly strong colors, in orange, yellow, and green. From the Sky Lounge on the eight floor guests can enjoy the marvelous view over the rooftops of Hamburg.

Neben dem Architekten Jan Störmer war der Italiener Matteo Thun am Bau des SIDE Hotels im Jahr 2001 beteiligt – er zeichnet für die puristische und am Licht ausgerichtete Inneneinrichtung verantwortlich. In allen 168 Zimmern des Hauses beherrschen helle Töne und warme Farben das Gesamtbild; zehn Suiten präsentieren sich ganz in weiß, farbliche Akzente sorgen für Individualität. Erfrischend bunt ist das Spa konzipiert: in Orange, Gelb und Grün. Von der Sky-Lounge im achten Stock bietet sich ein Blick über die Dächer Hamburgs.

Aux côtés de l'architecte Jan Störmer, l'italien Matteo Thun a grandement contribué à la construction de l'hôtel SIDE en 2001 en le dotant d'une décoration intérieure épurée et axée sur la lumière. Les tons clairs et les couleurs chaudes marquent de leur empreinte l'ensemble des 168 chambres. La blancheur est omniprésente dans dix suites, tandis que des touches de couleur créent de l'individualité. Avec sa coloration rafraîchissante alliant l'orange, le jaune et le vert, le spa a tout pour plaire. Du haut du sky lounge au huitième étage, on peut profiter de la vue sur les toits de Hambourg.

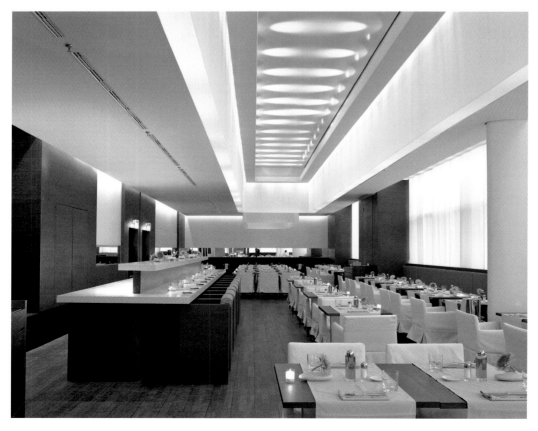

The puristic design of Matteo Thun extends throughout the whole hotel.

Das puristische Design Matteo Thuns zieht sich durch das gesamte Haus.

Le design épuré de Matteo Thun, élément récurrent de la maison.

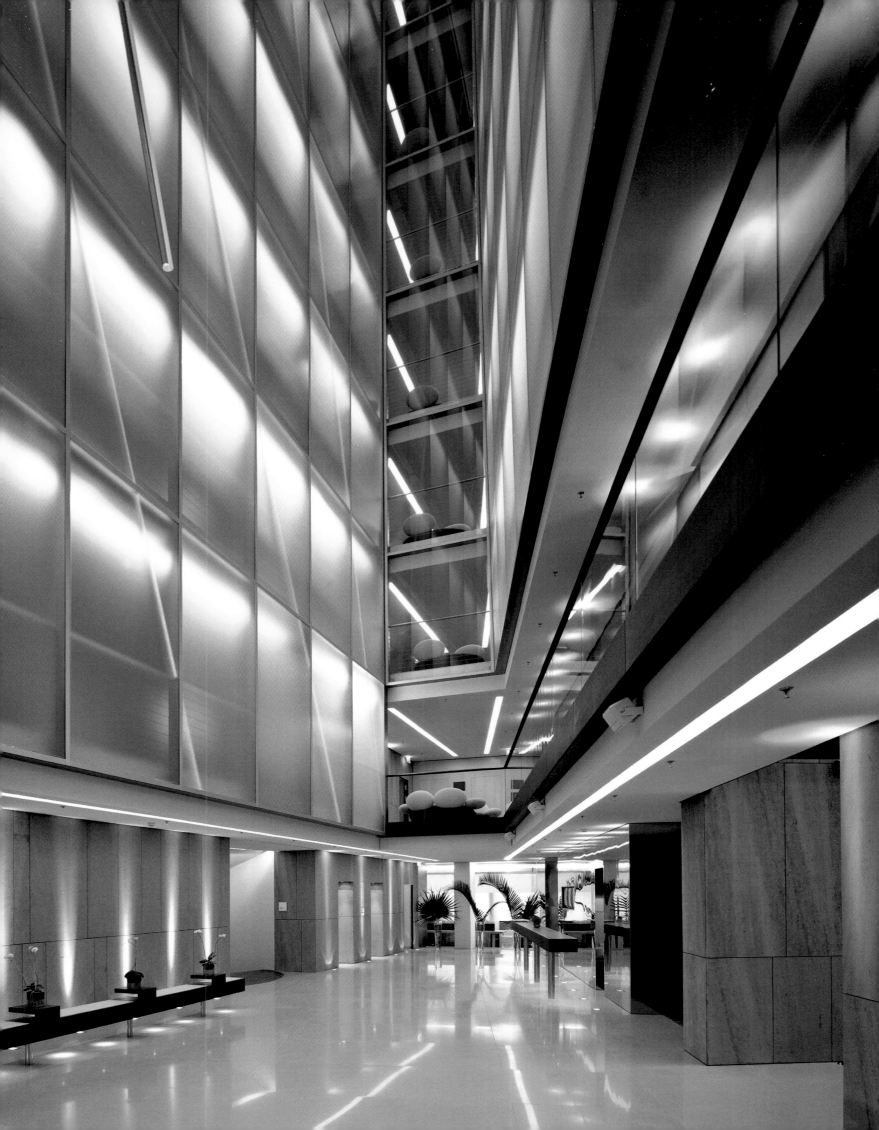

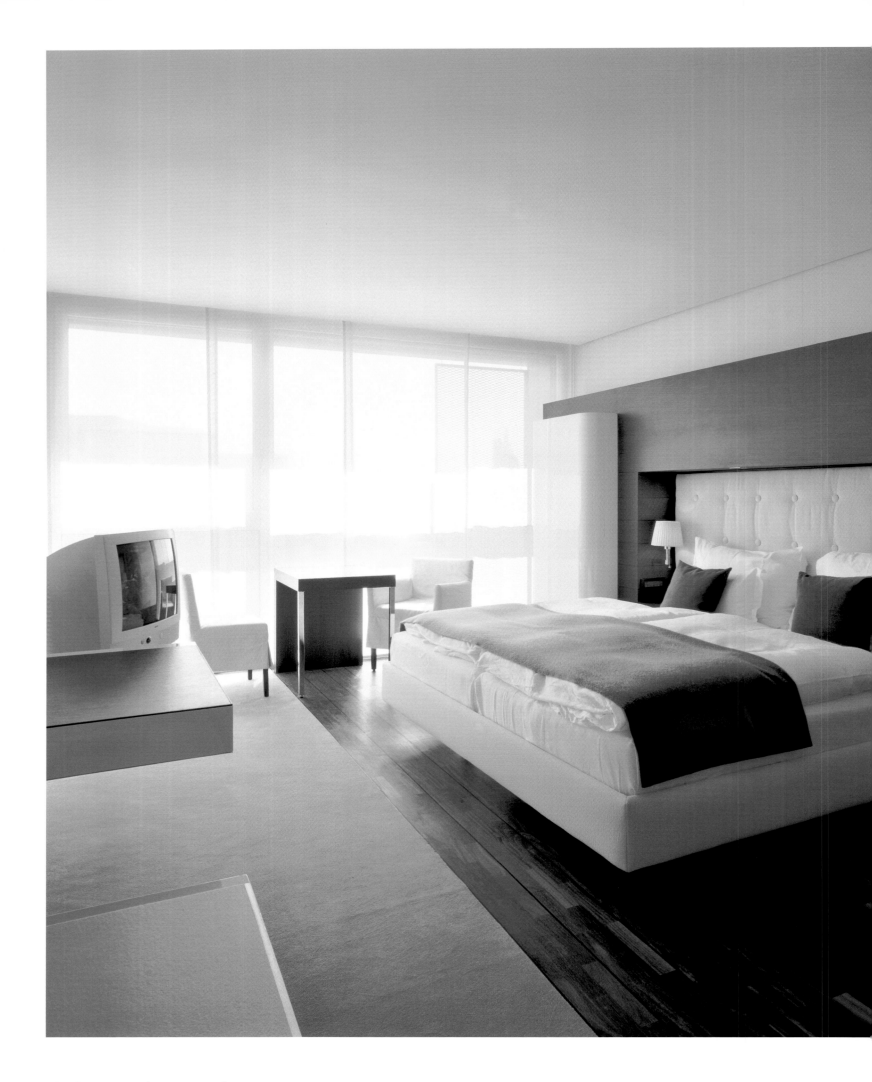

Depending on the incidence of light, the rooms are furnished in either light or dark colors.

Je nach Lichteinfall sind die Zimmer eher dunkel oder hell möbliert.

Selon l'incidence de la lumière, les meubles de chambre seront plutôt sombres ou clairs.

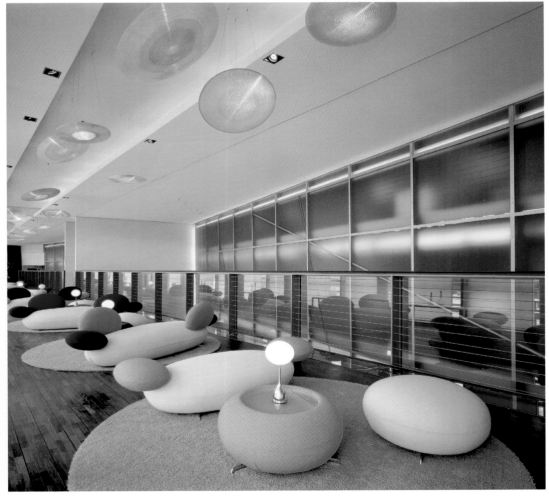

Adlon Kempinski

Berlin, Germany

The first Hotel Adlon was opened in 1907 on the same site and with the same name. Sponsored by Emperor Wilhelm II, it constituted the German reply to the legendary luxury hotels of London and Paris. The complex, which was reconstructed after the fall of the Berlin Wall, directly taps into this tradition: with magnificent halls, palace-like rooms and multiple award-winning restaurants. And still today, international VIPs from the political, cultural, and entertainment scene spend the night here.

Am selben Platz und unter gleichem Namen eröffnete 1907 das erste Hotel Adlon. Protegiert von Kaiser Wilhelm II. stellte es die deutsche Antwort auf die legendären Luxushotels von London und Paris dar. Der nach dem Mauerfall wieder errichtete Komplex knüpft nahtlos an diese Tradition an: mit prunkvollen Hallen, palastartigen Räumen und hoch dekorierten Restaurants. Und auch heute übernachten hier wieder die internationalen Größen aus Politik, Kultur und Unterhaltungsbranche.

Le premier hôtel Adlon a ouvert ses portes au même endroit et sous le même nom en 1907. Sous l'égide de l'Empereur Guillaume II, il constituait la réponse allemande aux légendaires hôtels de luxe de Londres et de Paris. Ce complexe reconstruit après la chute du mur poursuit cette tradition sans rupture : des halls fastueux, des chambres dignes d'un palais et des restaurants ayant obtenu bon nombre d'étoiles. De nos jours, il accueille de nouveau les personnages importants de la politique, de l'art et du divertissement.

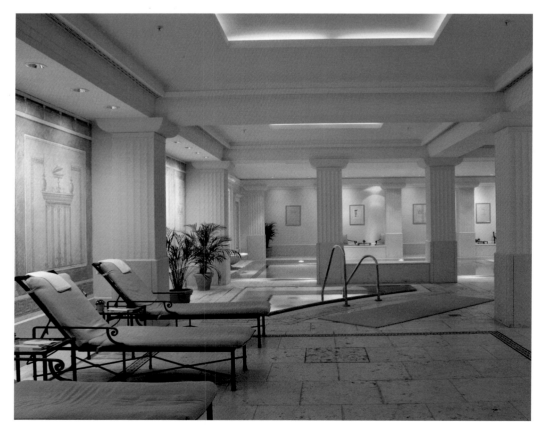

The pool and sauna area caters to your recreational needs.

Für Entspannung sorgt die Pool- und Saunalandschaft.

L'espace piscine et sauna assure la détente.

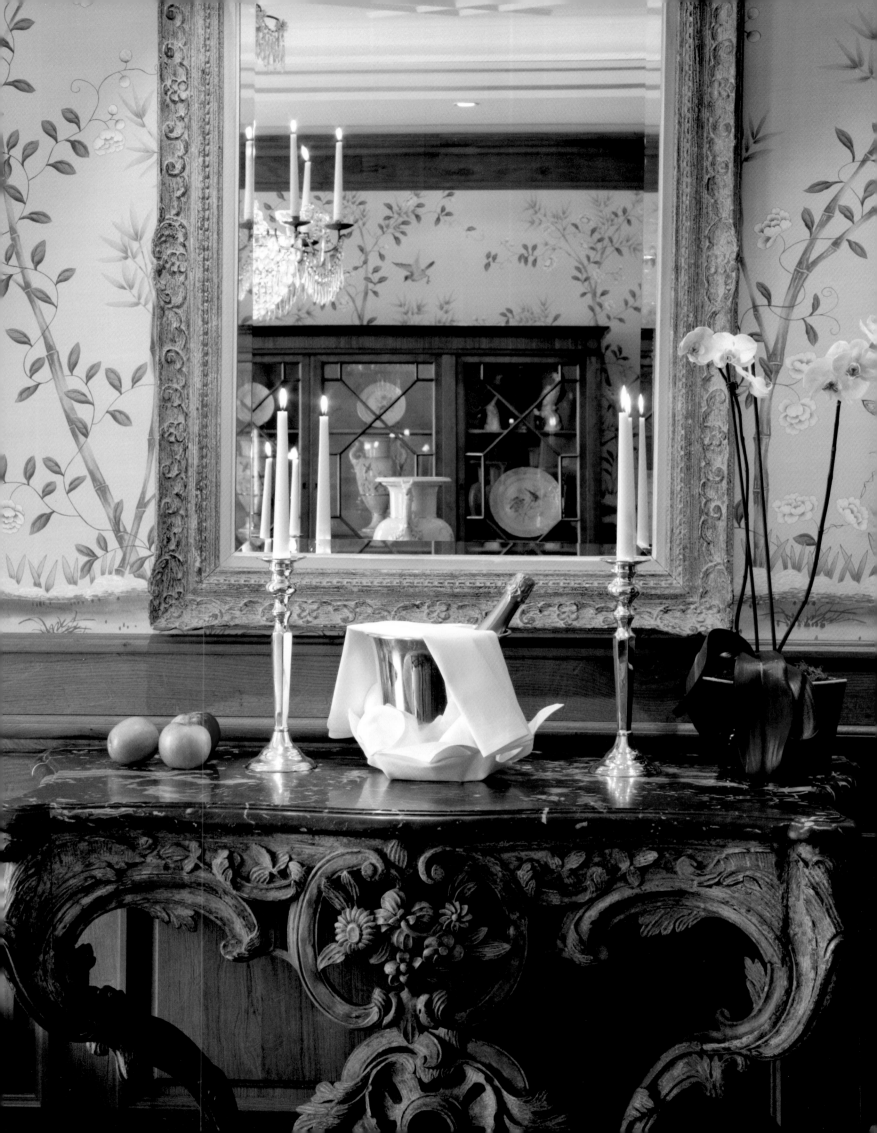

Hotel de Rome

Berlin, Germany

The Hotel de Rome is located right next to the State Opera House in a 19ᵗʰ-century building, which formerly was a bank. For the interior design, not only the 146 rooms are furnished with contemporary equipment, but already in the lobby guests will find oversized seating furniture, lamps and opulent flower arrangements. The high walls of the hotel are lined with works of art. From the restaurant, guests can overlook the terrace, where the meals are served in summer. Very Extraordinary: The swimming pool, 65 feet long, is located in the jewelry room of the former vault.

Direkt an der Staatsoper, in einem ehemaligen Bankgebäude aus dem 19. Jahrhundert, befindet sich das Hotel de Rome. Im Inneren sind allerdings nicht nur die 146 Zimmer modern eingerichtet – bereits in der Lobby empfangen übergroße Sitzmöbel und Lampen sowie riesige Blumenbouquets die Gäste; Kunst schmückt die hohen Wände. Vom Restaurant blickt man auf die Terrasse, auf der im Sommer das Essen serviert wird. Extravagant: Das 20 Meter lange Schwimmbad befindet sich im Juwelenraum des ehemaligen Tresors.

Aménagé dans une ancienne banque datant du XIXᵉᵐᵉ siècle, l'Hotel de Rome se trouve juste à côté de l'Opéra national. À l'intérieur, ce ne sont pas seulement les 146 chambres qui ont été aménagées de façon très moderne – déjà, dans le hall, les hôtes sont reçus par des sièges et lampes aux dimensions impressionnantes et des énormes bouquets de fleurs. L'art est présent sur les hauts plafonds. Le restaurant donne sur la terrasse, où les repas sont servis en été. Enfin, une petite extravagance : la piscine de 20 mètres est logée dans l'espace de l'ancienne salle des trésors où étaient gardées les pierres précieuses.

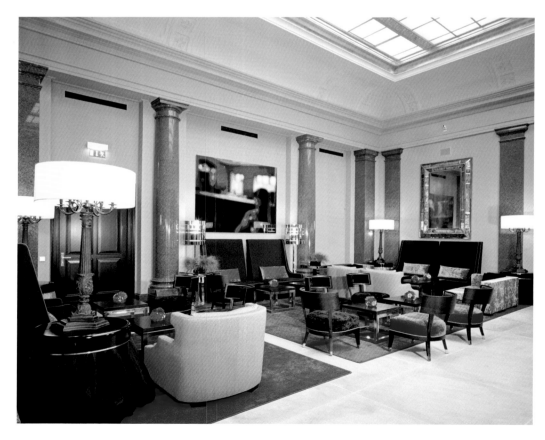

From the long bar counter, guests have a view of the Bebelplatz.

Vom langen Tresen an der Bar überblickt man den Bebelplatz.

Depuis le long comptoir, on survole du regard la place Bebel.

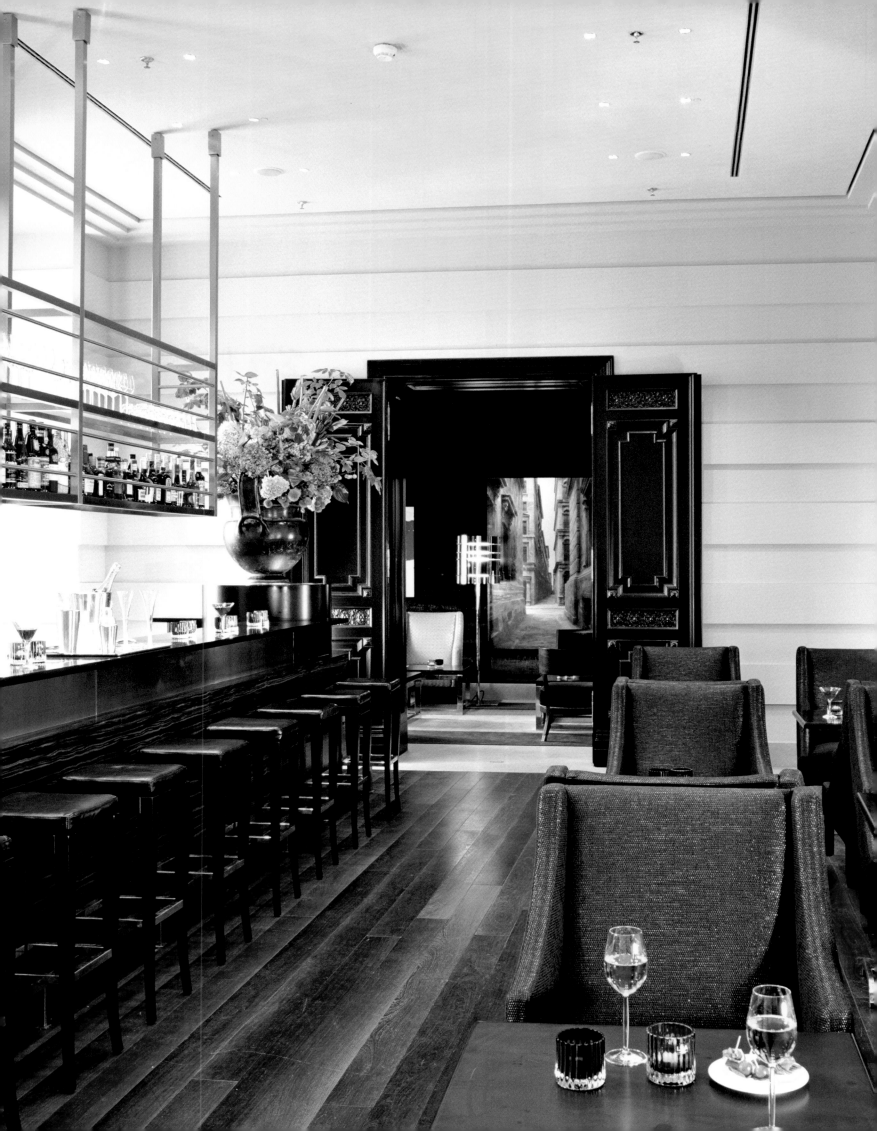

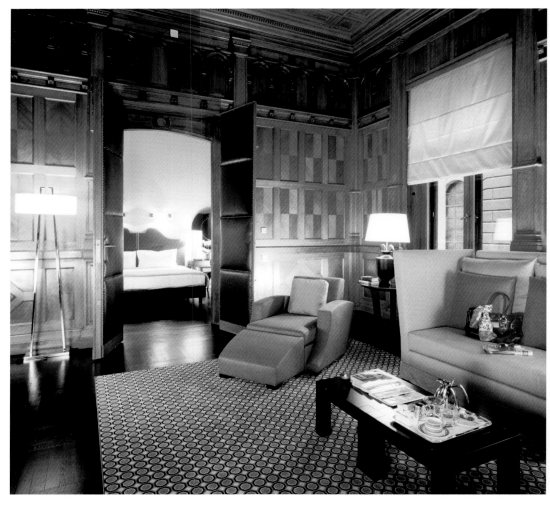

Rooms are decorated in Mediterranean colors such as earth, blue and red tones.

Die Zimmer sind geprägt durch mediterrane Erd-, Rot- und Blautöne.

Des chambres aux tons méditerranéennes : ocre, rouge et bleu.

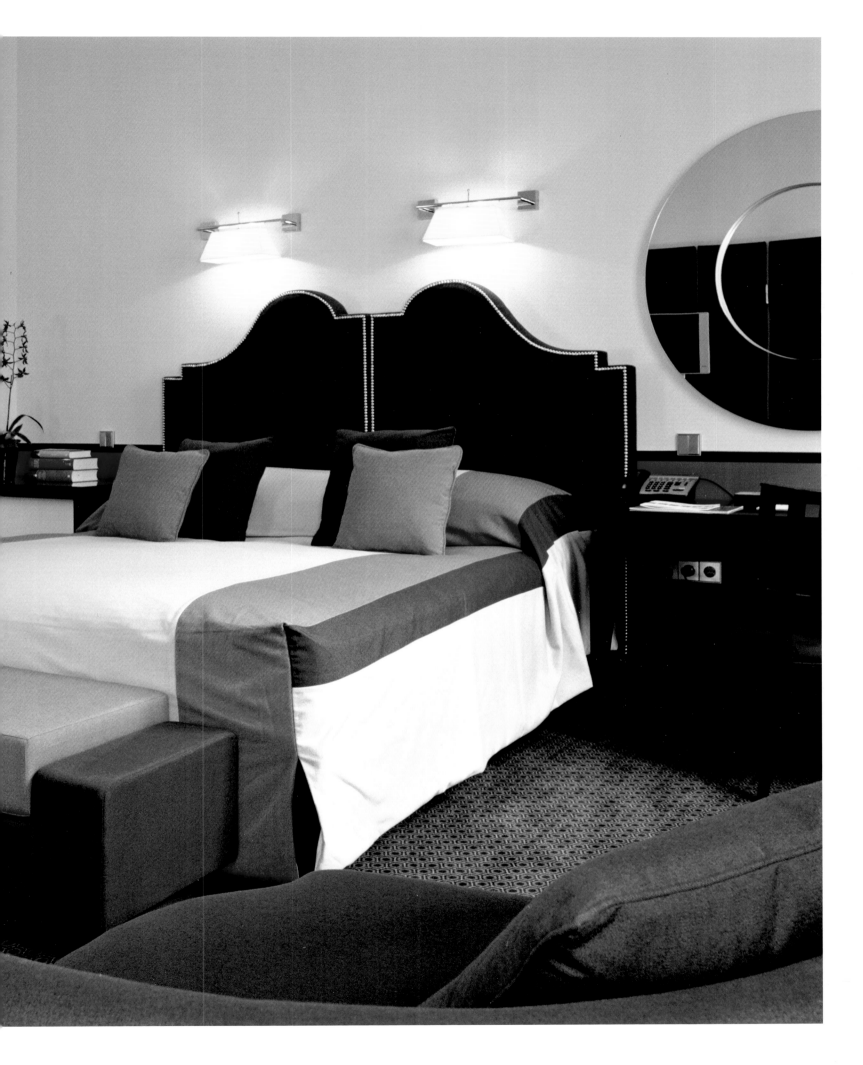

Gräflicher Park Hotel & Spa

Bad Driburg, Germany

Situated in a large park at the gates of Teutoburg Forest, the Gräflicher Park Hotel & Spa was established 225 years ago. The 135 rooms and suites of this four-star hotel are decorated with different stylistic elements and colors and much attention to detail. Since the reopening with a new concept and the refurbishment in 2007, the complex features a 16.000-square-feet spa. Lawn-tennis, golf and opportunities for hunting complete the services.

Eingebettet in einen großen Park vor den Toren des Teutoburger Walds liegt seit mehr als 225 Jahren das Gräflicher Park Hotel & Spa. Die 135 Zimmer und Suiten des Vier-Sterne-Superior-Hotels sind in verschiedenen Stilrichtungen und Farben mit viel Liebe zum Detail eingerichtet. Seit der Wiedereröffnung mit neuem Konzept und der Renovierung im Jahr 2007 befindet sich auch ein 1500 Quadratmeter großes Spa in der Anlage. Rasentennis, Golf und Jagdmöglichkeiten ergänzen das Angebot.

Situé dans un immense parc, Gräflicher Park Hotel & Spa se trouve, depuis plus de 225 ans, à l'entrée de la forêt de Teutberg. Les 135 chambres et suites de l'hôtel quatre étoiles sont aménagées dans différents styles et couleurs, avec un goût prononcé du détail. Depuis la réouverture allant de pair avec un nouveau concept et les rénovations en 2007, l'hôtel est doté d'un grand spa de 1500 mètres carrés. Possibilité de pratiquer le tennis sur gazon, le golf et la chasse.

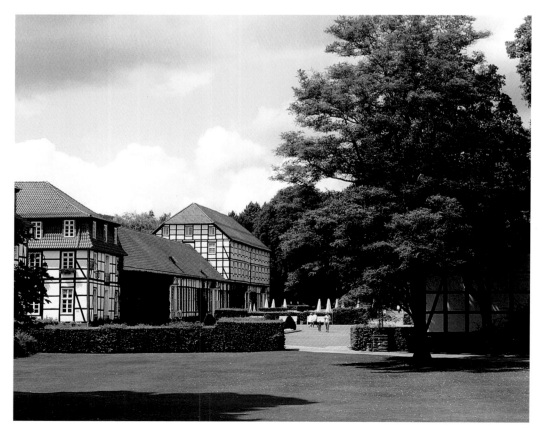

The Gräflicher Park Hotel & Spa estate is situated amidst a large garden.

Inmitten eines großen Parks liegt das Anwesen Gräflicher Park Hotel & Spa.

Au cœur d'un grand jardin se situe la propriété Gräflicher Park Hotel & Spa.

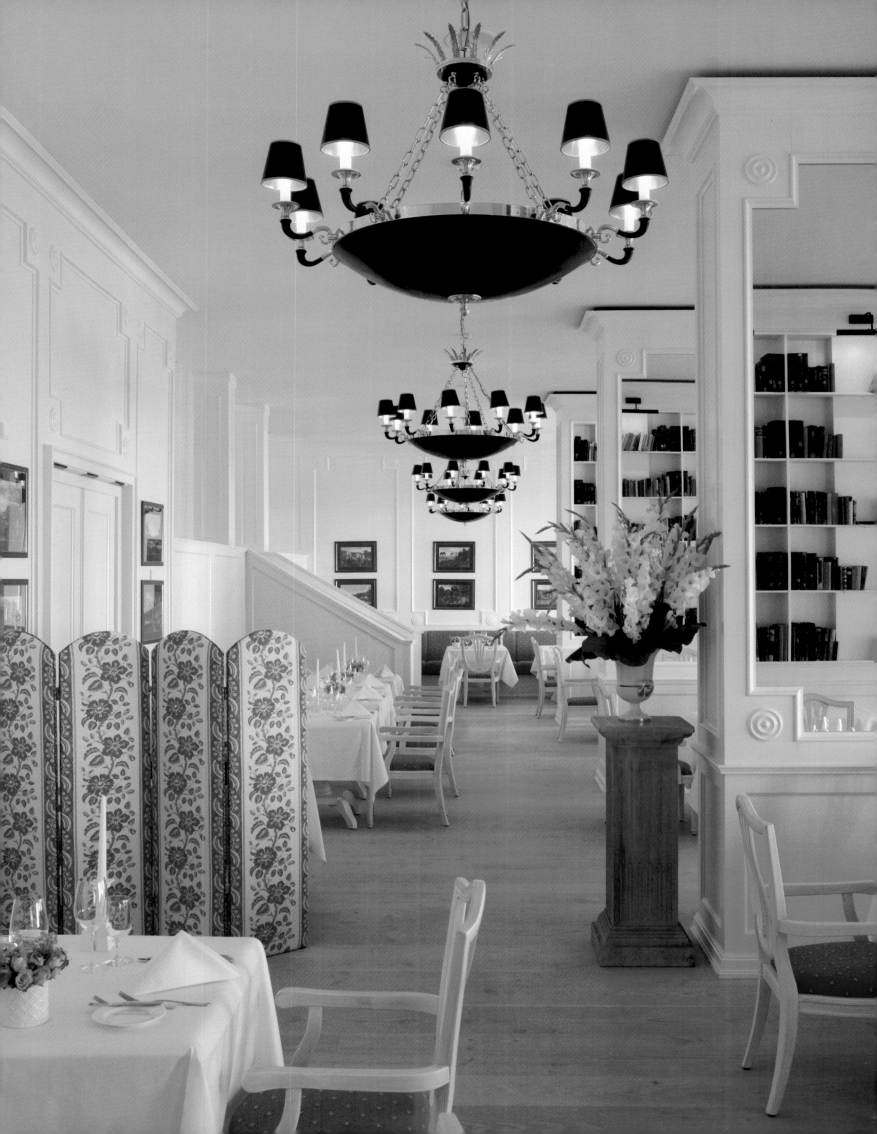

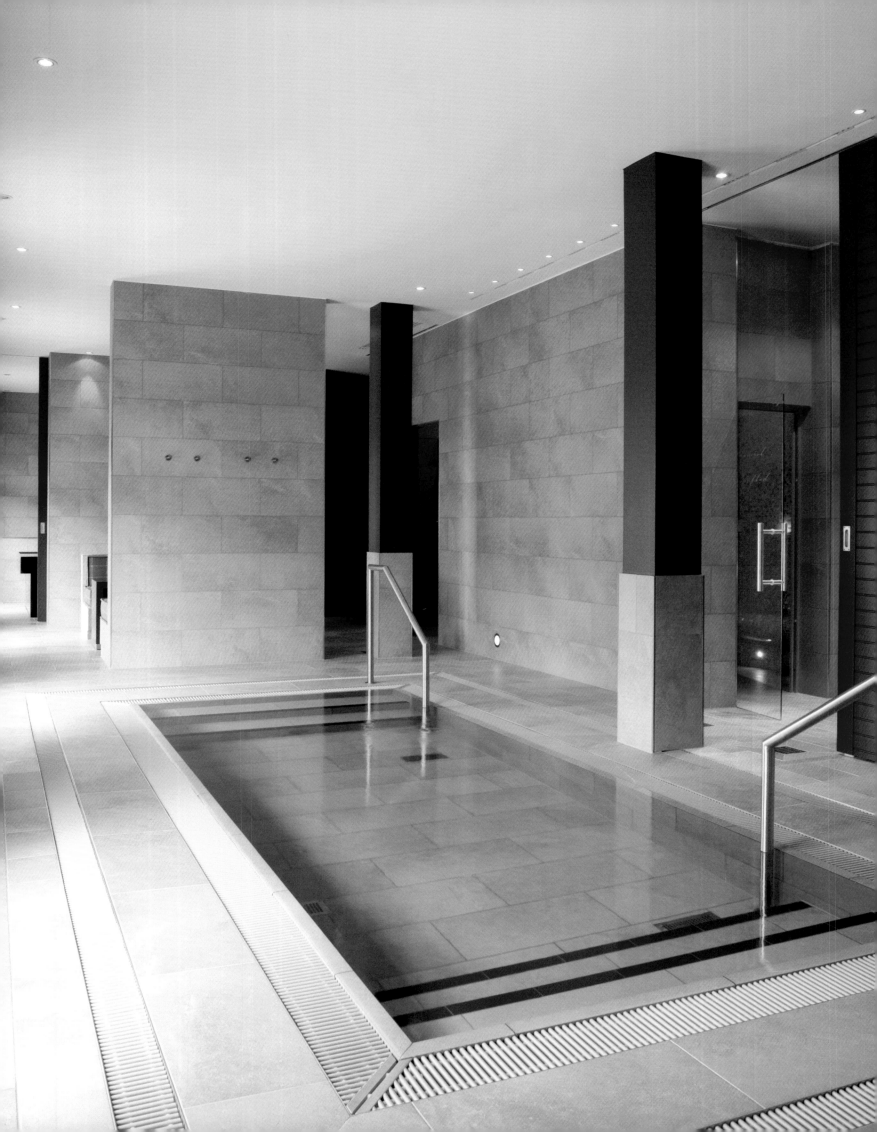

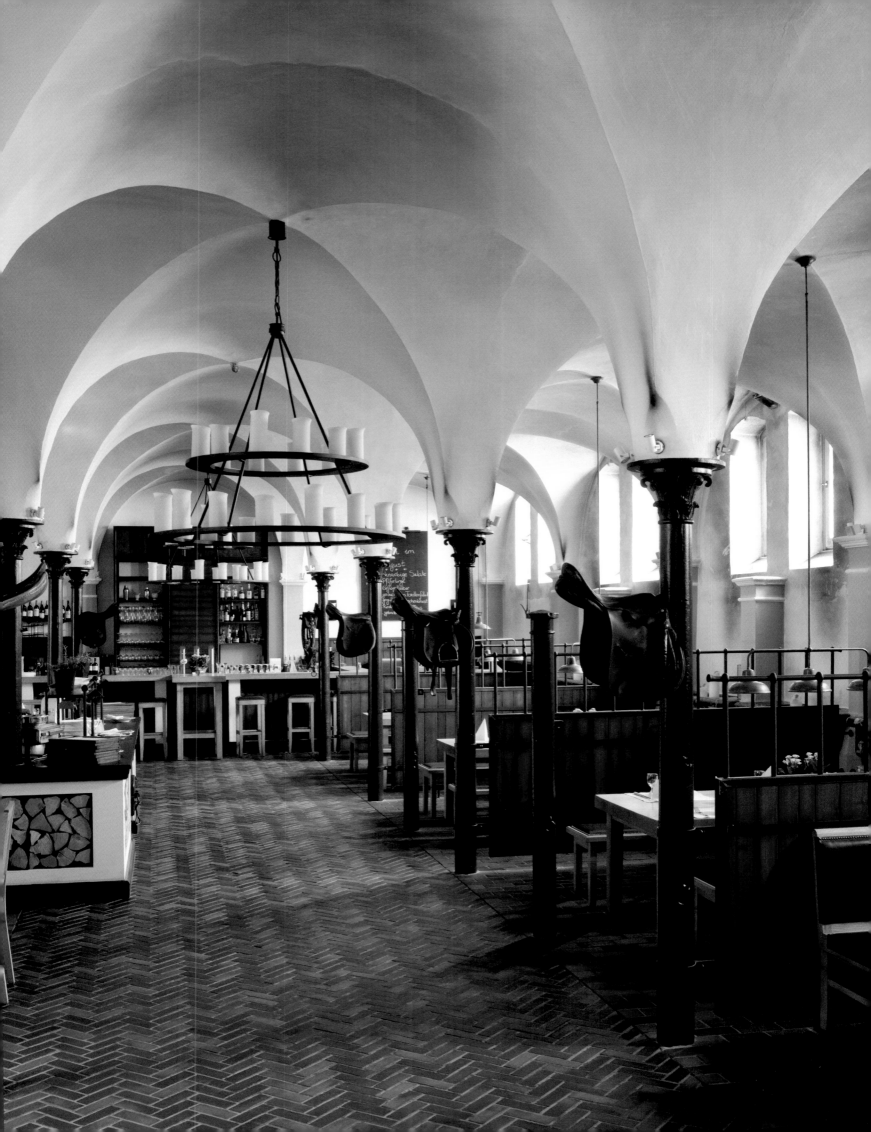

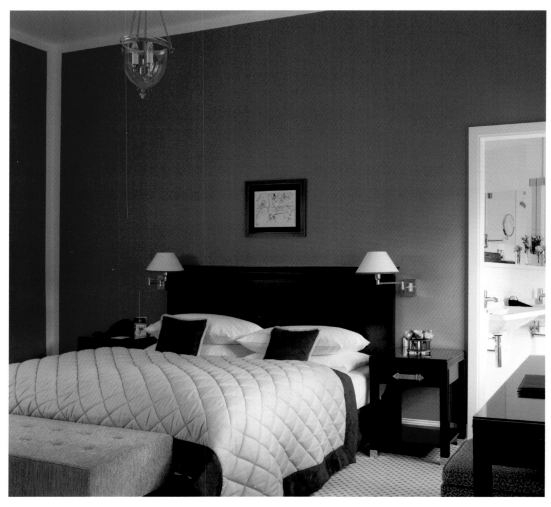

Friendly colors give the rooms in the spa a pleasant tone.

Freundliche Töne verleihen den Zimmern und Räumen im Spa eine warme Note.

Les tons accueillants donnent aux chambres et pièces dans le spa un aspect chaleureux.

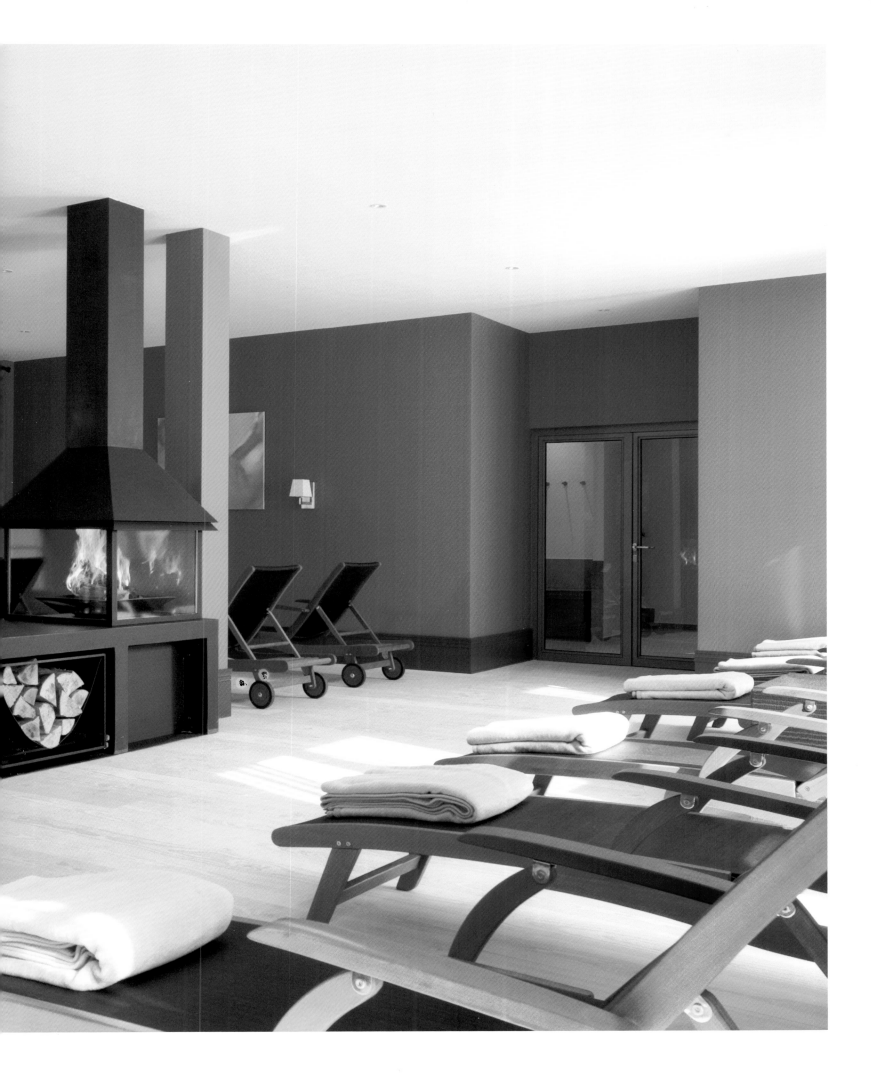

Villa Kennedy
Frankfurt, Germany

The first luxury hotel of the Rocco Forte Collection opened in Germany in 2006 exhibits what otherwise characterizes the hotels of the British investor: noble materials, paired with a certain urban understatement. Elegance, which never appears opulent, but tends towards the sophisticated. The heart of the 163 room hotel including 29 suites is the historical Villa Speyer built in 1904, to which three new wings were added grouped around a peaceful green inner-courtyard featuring a terrace.

Das erste, 2006 eröffnete, Luxushotel der Rocco Forte Collection in Deutschland zeigt, was auch sonst die Hotels des britischen Investors auszeichnet: edle Materialien, gepaart mit einem gewissen urbanen Understatement. Eleganz, die nie opulent, sondern eher anspruchsvoll anmutet. Kernstück des 163 Zimmer-Hotels inklusive 29 Suiten ist die historische, 1904 erbaute, Villa Speyer, die drei neue Flügelanbauten bekam, die sich um einen begrünten ruhigen Innenhof mit Terrasse gruppieren.

Le premier hôtel de luxe de la Collection Rocco Forte en Allemagne, inauguré en 2006, fait aussi état de ce qui caractérise toujours les hôtels de cet investisseur britannique : des matériaux nobles, combinés à un certain minimalisme urbain ; une élégance qui n'est jamais opulente, mais plutôt distinguée. Le cœur de cet hôtel de 163 chambres et 29 suites est la Villa Speyer, construite en 1904, à laquelle ont été ajoutées trois ailes nouvelles disposées autour de la cour intérieure calme et arborée avec sa terrasse.

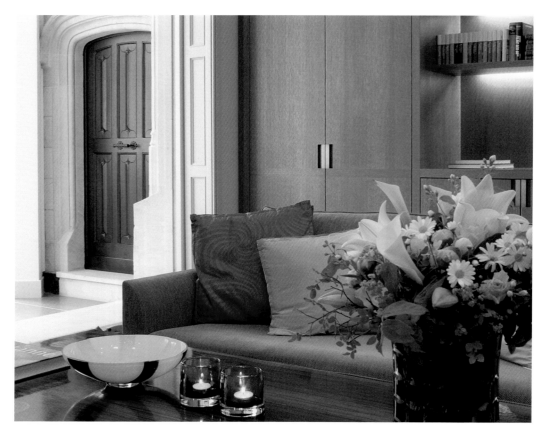

This luxurious hotel is partly located in the tradition-steeped Villa Speyer.

Ein Teil des luxuriösen Hotels ist in der traditionsreichen Villa Speyer untergebracht.

Riche en tradition, la Villa Speyer abrite une partie de cet hôtel luxueux.

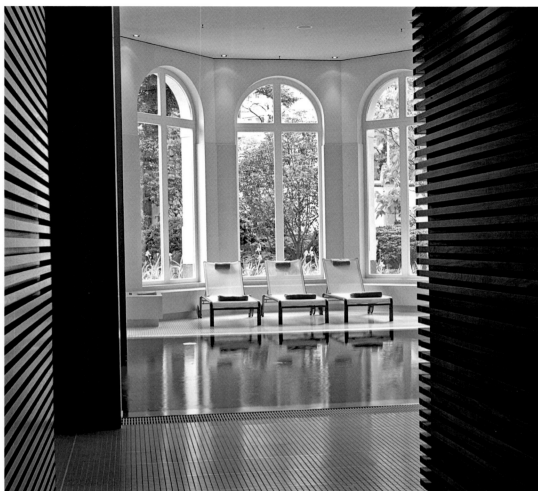

The pool, the sauna and various treatments cater to your need for recreation.

Pool, Sauna und Anwendungen sorgen für Erholung.

Piscine, sauna et traitements synonymes de détente.

Mandarin Oriental Munich

Munich, Germany

The credo of the architect Ralf Claussen while redesigning the former ballroom building was: "The historical character of the neo-renaissance construction must remain intact." Thus, French and Italian marble, cherry and ebony wood dominate the appearance of the hotel. The guests particularly enjoy the exquisite dishes of one of the Munich's five leading gourmet restaurants based here.

Das Credo des Architekten Ralf Claussen bei der Umgestaltung des ehemaligen Ballhauses lautete: „Der historische Charakter des Neo-Renaissance-Baus muss bewahrt bleiben." So dominieren französischer und italienischer Marmor, Kirsch- und Ebenholz das Erscheinungsbild des Hotels. Die Gäste genießen insbesondere die edlen Speisen eines der fünf führenden und hier beherbergten Gourmet-Restaurants Münchens.

Le credo que l'architecte Ralf Claussen s'est approprié lors de l'aménagement de cet ancien édifice de danse est le suivant : « Le caractère historique du bâtiment du style néo-renaissance doit être préservé. » Ainsi, le marbre français et italien, les bois de merisier et d'ébène dominent l'aspect de cet hôtel. Les hôtes apprécient particulièrement les mets raffinés de l'un des cinq meilleurs restaurants gastronomiques de Munich, situé dans les murs de l'hôtel.

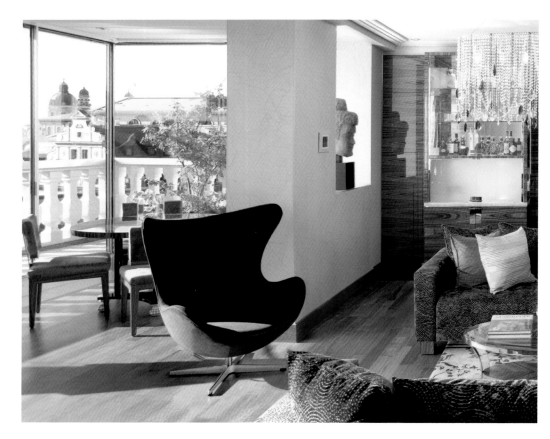

From many rooms, guests can enjoy the vista of the cupola roofs of the city.

Aus vielen Räumen genießt man den Blick auf die Kuppeln der Stadt.

Beaucoup de pièces donnent sur les coupoles de la ville.

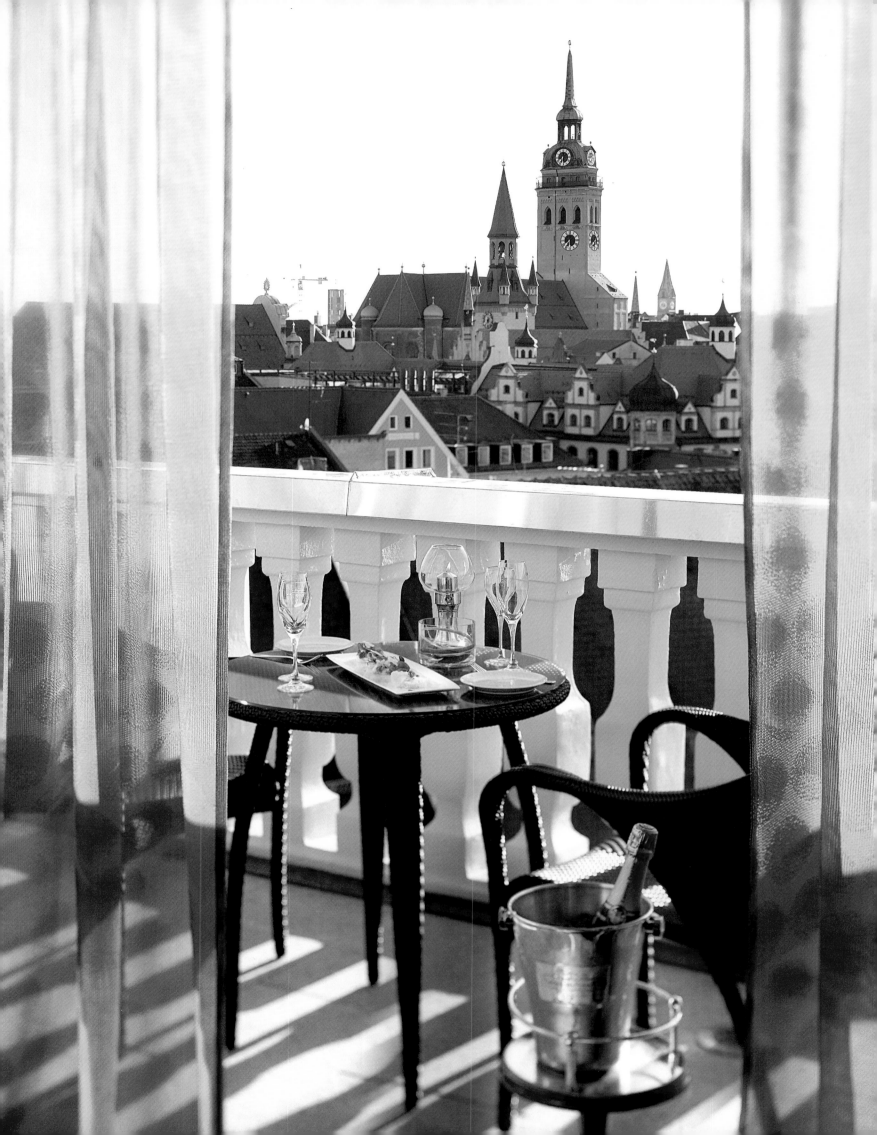

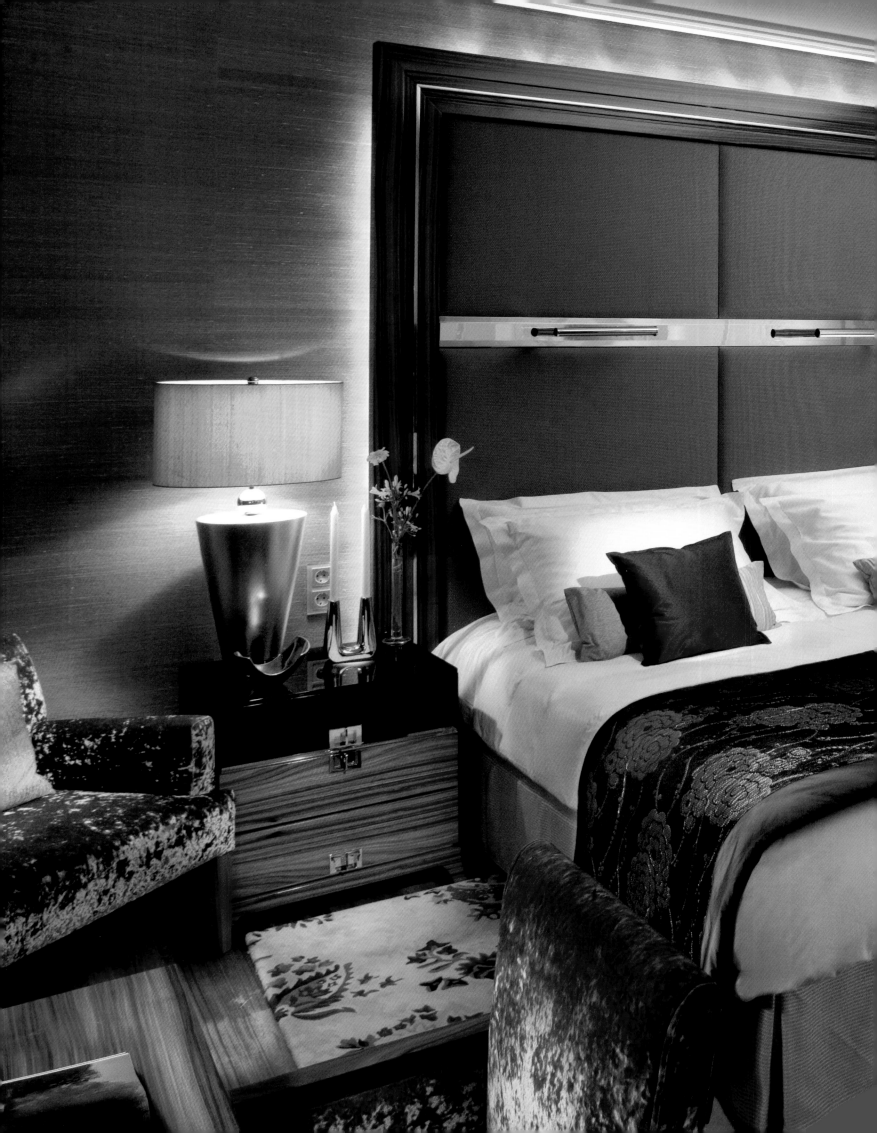

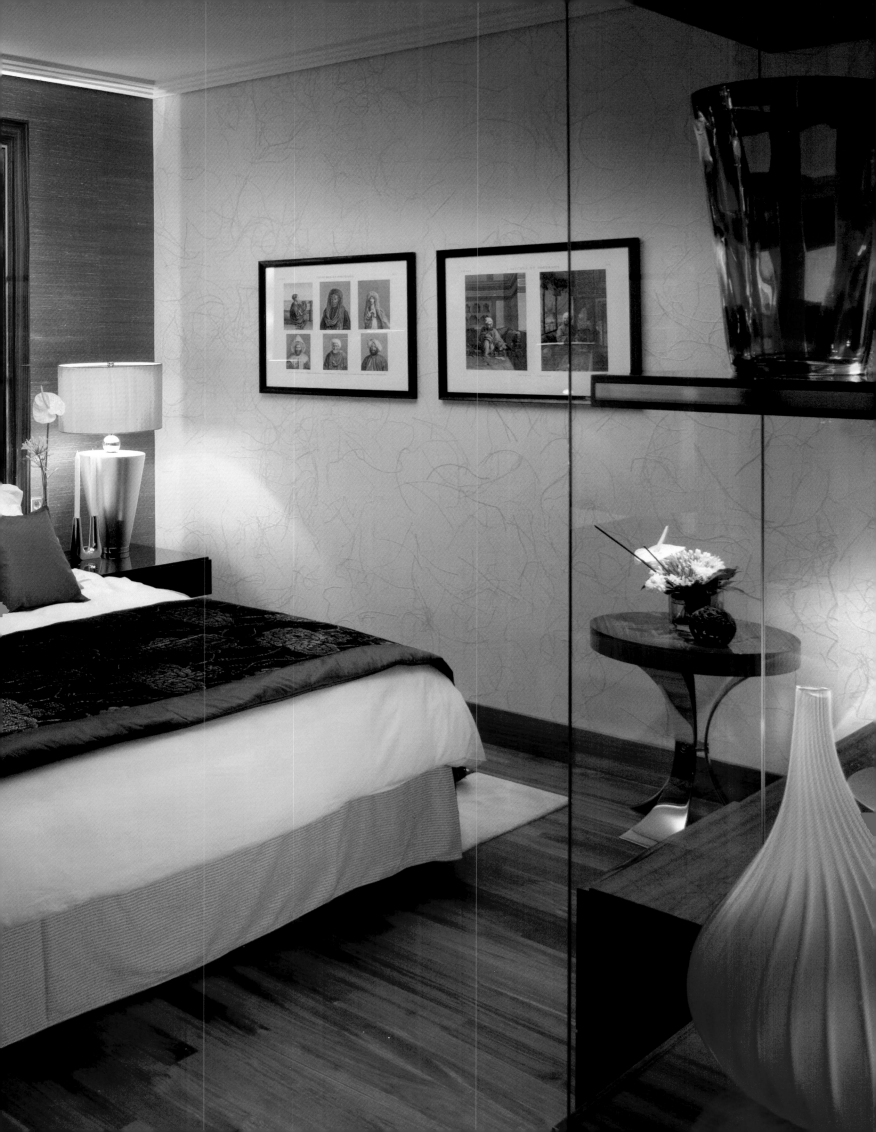

Bayerischer Hof

Munich, Germany

The Hotel Bayerischer Hof in Munich was established in 1841 and can therefore boast a long-standing tradition. Guests are accommodated in the 373 rooms with a flawless service and cordial hospitality before they leave for a tour of Munich in all its cultural diversity. For gourmets, the Bayerischer Hof has much to offer: there are different restaurants and bars to choose from, guests can decide if they prefer Bavarian specialties or Mediterranean cuisine in the "Garden-Restaurant." After a long day, guests can get pampered in the spa.

Bereits im Jahr 1841 wurde der Bayerische Hof im Zentrum Münchens eröffnet und kann sich deshalb einer langen Tradition rühmen. In 373 luxuriösen Zimmern werden die Gäste mit tadellosem Service und herzlicher Gastfreundschaft empfangen, bevor sie Münchens reichhaltiges kulturelles Angebot wahrnehmen können. Kulinarisch versorgt sie der Bayerische Hof: Mehrere Restaurants und Bars stehen den Gästen zur Auswahl, ob bayerische Spezialitäten oder mediterrane Küche im „Garden-Restaurant". Im Spa können sich die Gäste verwöhnen lassen.

Le Bayerischer Hof a ouvert ses portes en 1841 dans le centre de Munich, c'est ainsi qu'il peut se vanter d'appartenir à une longue tradition. Les 373 chambres luxueuses reçoivent les hôtes, auxquels sont réservés un service irréprochable et un accueil chaleureux, avant qu'ils ne partent à la découverte des richesses culturelles de Munich. Du point de vue culinaire, le Bayerischer Hof s'occupe copieusement de ses hôtes : ils peuvent choisir entre plusieurs restaurants et bars selon leurs préférences, que celles-ci se portent sur des spécialités bavaroises ou sur une cuisine méditerranéenne, servie dans le « Garden-Restaurant ». De plus, l'hôtel est doté d'un spa où les hôtes peuvent plonger dans un univers de détente.

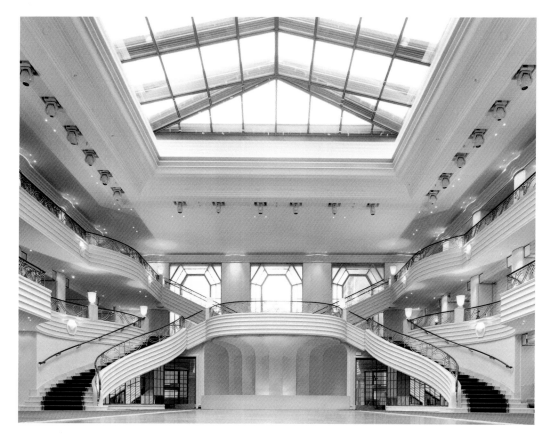

From the spacious atrium, guests can walk up to the rooms upstairs.

Vom großzügigen Atrium geht es hinauf zu den Zimmern.

Un vaste atrium dessert les chambres situées à l'étage supérieur.

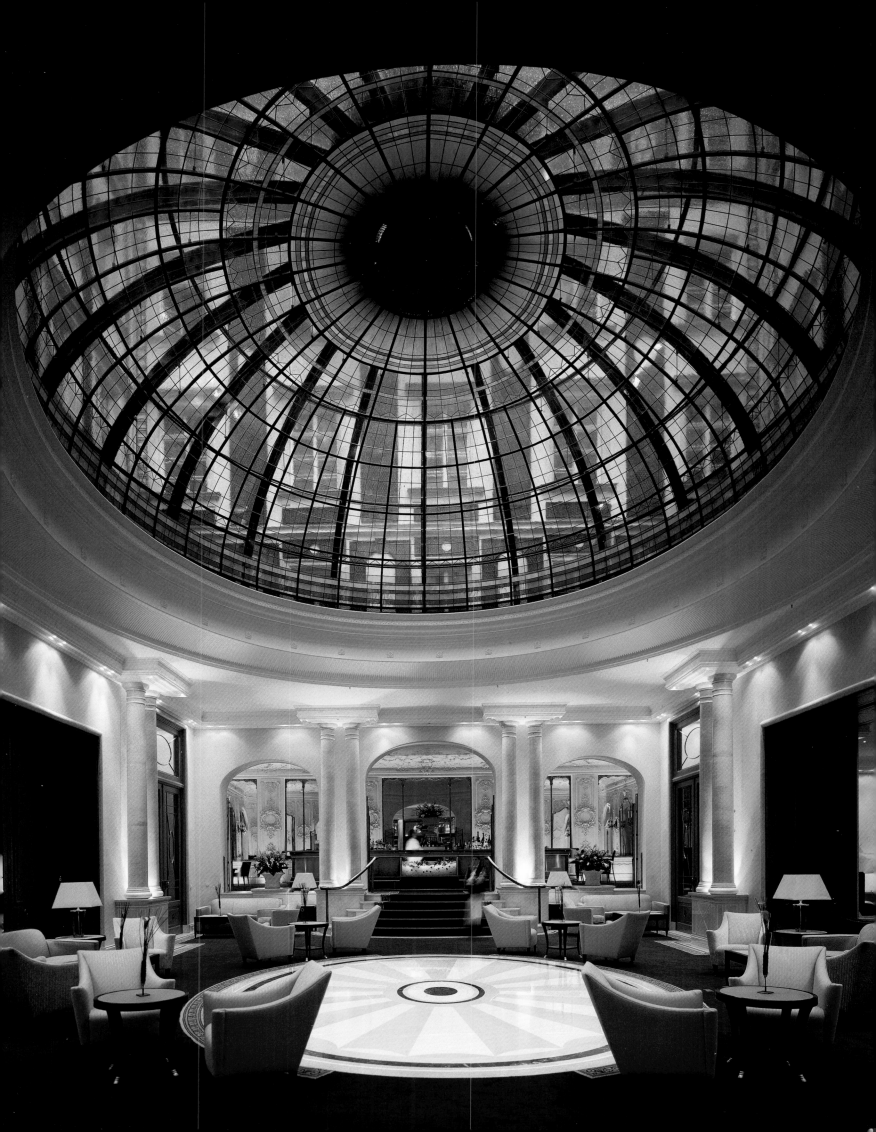

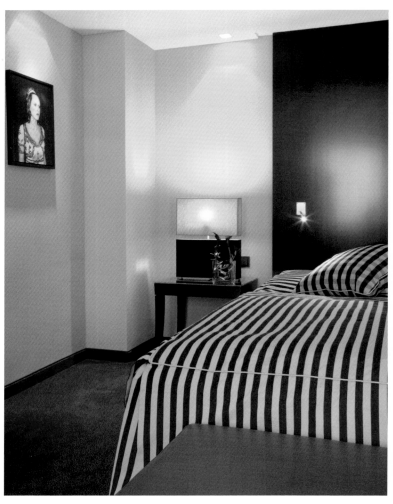
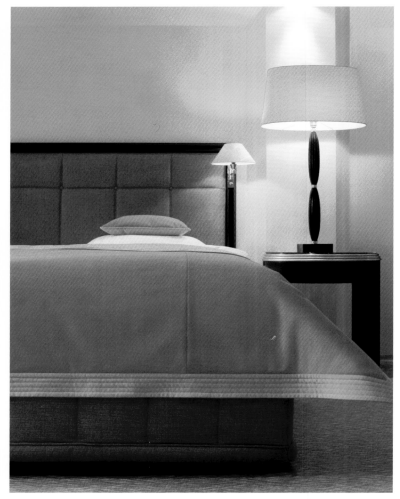
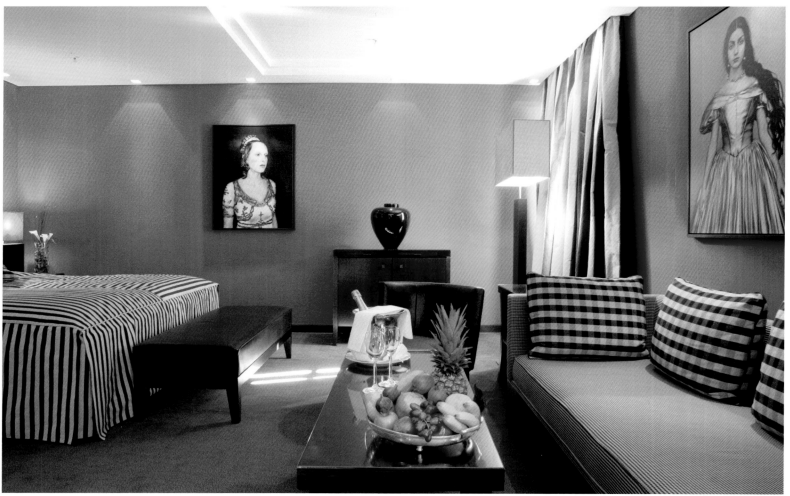

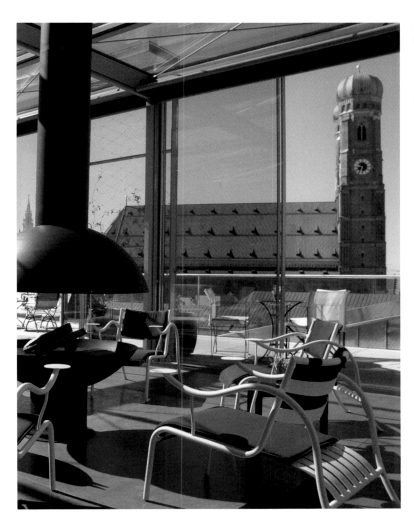

Guests can enjoy the great vista of the Church of Our Lady from the bar and the roof terrace.

Den Blick auf die Frauenkirche genießt man von Bar und Dachterrasse.

Le bar et la terrasse sur le toit pour profiter de la vue sur la cathédrale Notre-Dame.

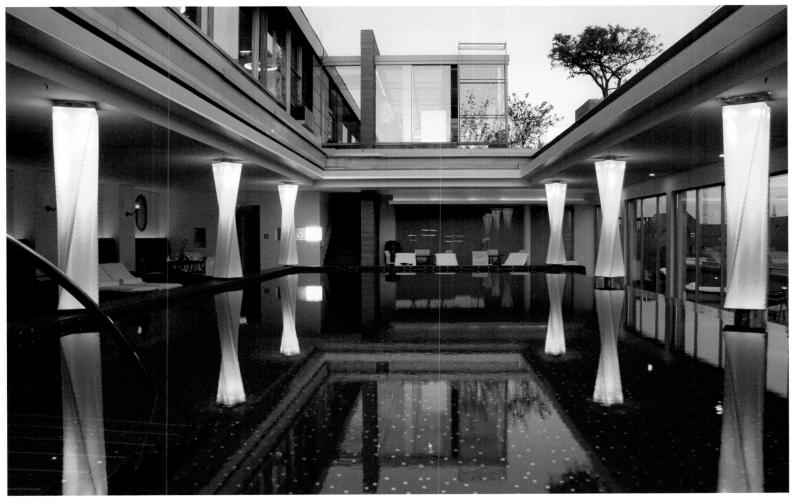

Hotel Josef

Prague, Czech Republic

The Hotel Josef, established in 2002, consists of two buildings, the Orange and the Pink House. It is located near the Jewish quarter of the city. The same trendy colors have not only been used for the room numbers in the two buildings, but they also dominate the modern interior design of most of the 109 rooms. None of the rooms looks alike; and often enough guests will find a bathtub in the middle of the room, only separated by a see-through glass wall. A vegetated courtyard and a roof terrace belong to the many assets of this hotel.

Aus zwei Gebäuden besteht das im Jahr 2002 erbaute Hotel Josef in der Nähe des jüdischen Viertels: das Orange und das Rosa Haus. In diesen Farben sind die Zimmernummern der jeweiligen Gebäude gestaltet, und auch in den meisten der 109 modern eingerichteten Räume dominieren diese poppigen Töne. Keiner sieht aus wie der andere, zudem sind oftmals die Bäder in die Zimmer verlegt und nur durch eine transparente Glaswand abgeschirmt. Ein begrünter Innenhof und eine Dachterrasse gehören ebenfalls zu den Vorzügen des Hotels.

L'hôtel Josef, construit en 2002 dans les environs du quartier juif de Prague, se compose de deux édifices : la maison orange et la maison rose. C'est dans ces couleurs qu'ont été conçus les numéros des chambres de chaque édifice. La plupart des 109 chambres à l'aménagement moderne est dominée par des couleurs voyantes. Aucune ne ressemble à l'autre et souvent, les salles de bains sont disposées directement dans la chambre, seulement isolées d'une paroi en verre transparente. Une cour intérieure verdoyante et une terrasse sur le toit constituent les avantages supplémentaires de l'hôtel.

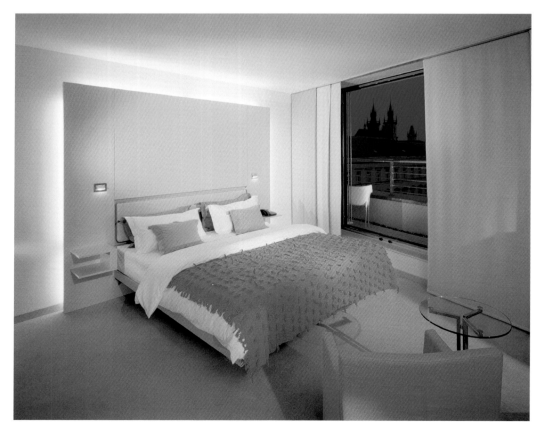

One of the two buildings is characterized by the extensive use of the color orange.

Orange prägt eines der beiden Häuser des Hotels.

Dans l'une des deux maisons c'est bien l'orange qui est à l'honneur.

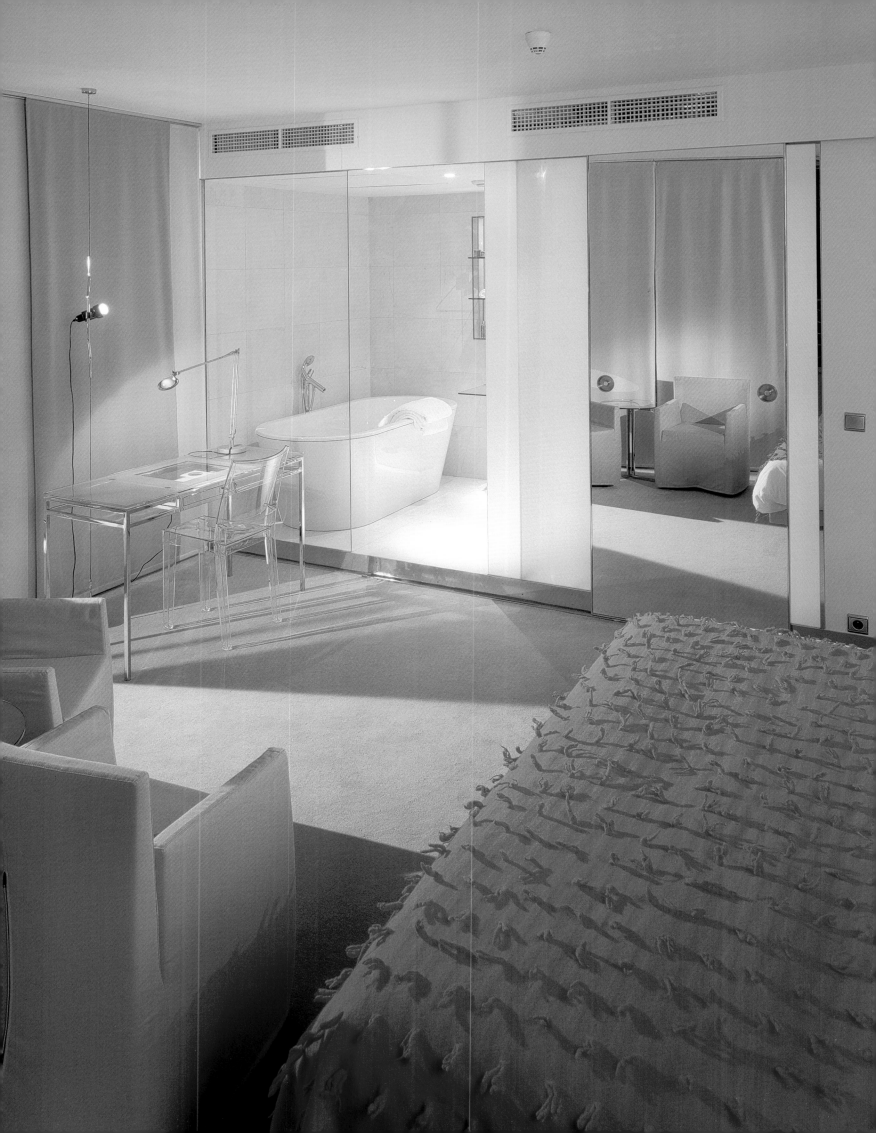

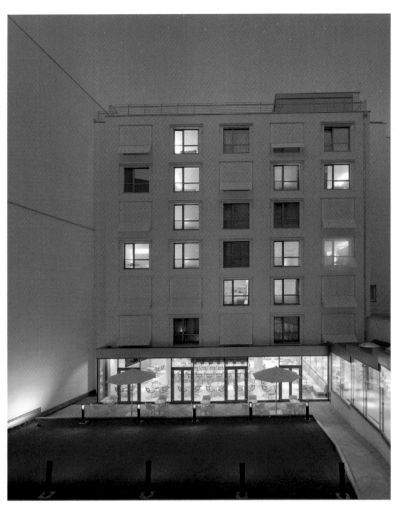
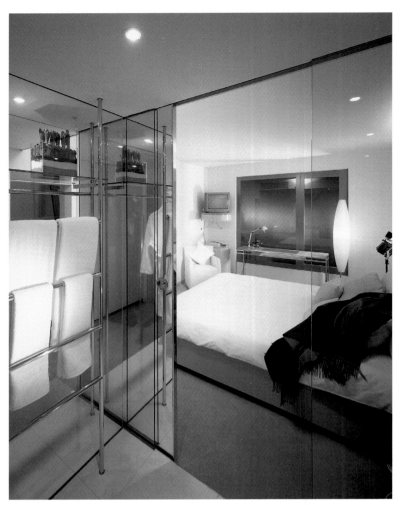
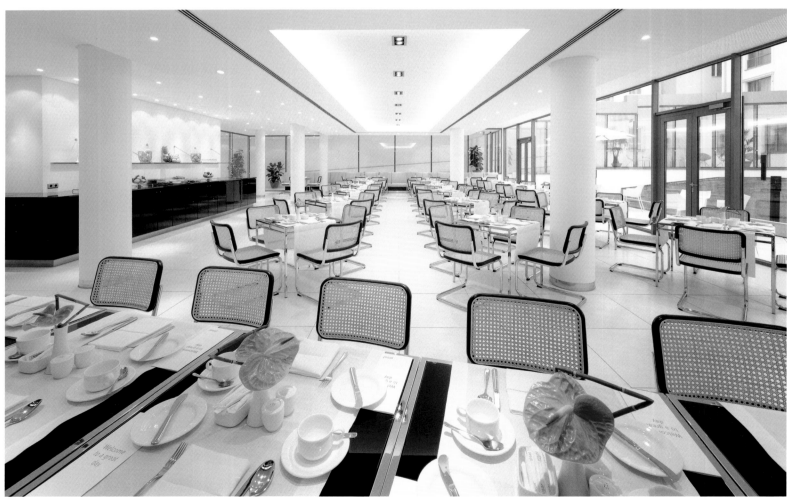

The bar and the restaurant are decorated in radiant white.

Die Bar und das Restaurant strahlen in Weiß.

Le bar et le restaurant rayonnent en blanc.

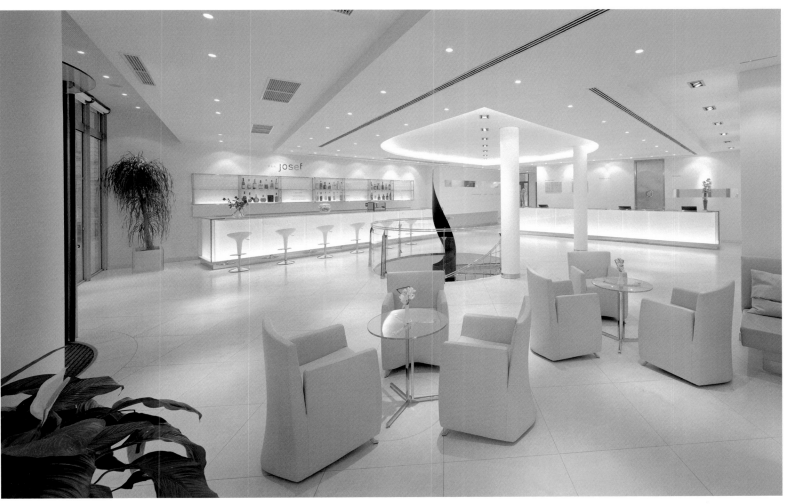

Schloss Fuschl

Salzburg, Austria

Idyllically situated by the Fuschlsee, the five-star hotel Schloss Fuschl used to be the location, where the Sissi movies where shot. The historic 15th-century buildings accommodate 104 rooms and suites, in addition to that there are six lake houses ("Seehäusl") with a private terrace and access to the lake. Two restaurants serve either Austrian specialties or a fusion of European and Asian cuisine. The hotel boasts a remarkable art collection: in the suites and the common rooms, more than 170 paintings of old masters can be gazed at.

Idyllisch am Fuschlsee liegt das Fünf-Sterne-Hotel Schloss Fuschl, in dem einst die Sissi-Filme gedreht wurden. In den historischen Gebäuden aus dem 15. Jahrhundert sind 104 stilvoll eingerichtete Zimmer und Suiten untergebracht. Außerdem gibt es noch sechs „Seehäusl" mit eigener Terrasse und direktem Zugang zum See. In zwei Restaurants werden entweder österreichische Spezialitäten oder europäisch-asiatische Kreationen serviert. Sehenswert ist die Kunstsammlung: Mehr als 170 Alte Meister zieren die Wände der Suiten und Gemeinschaftsräume.

C'est dans un cadre idyllique, près du lac Fuschl, que se situe l'hôtel cinq étoiles Schloss Fuschl dans lequel on a tourné quelques scènes des films de Sissi. Ces bâtiments historiques, datant du XVème siècle, abritent 104 chambres et suites aménagées avec style, ainsi que six maisonnettes « Seehäusl » disposant d'une terrasse privée et d'un accès direct au lac. Dans les deux restaurants, on sert soit des spécialités autrichiennes, soit une cuisine créative d'origine européenne ou asiatique. À elle-seule, la remarquable collection d'objets d'art vaut le détour : plus de 170 chefs d'œuvres ornent les murs des suites et des salons communs.

The restaurant "Imperial" offers European-Asian cuisine with a view of the lake.

Das Restaurant „Imperial" bietet europäisch-asiatische Küche und Blick auf den See.

Le restaurant « Imperial » offre une cuisine euro-asiatique ainsi qu'une vue sur le lac.

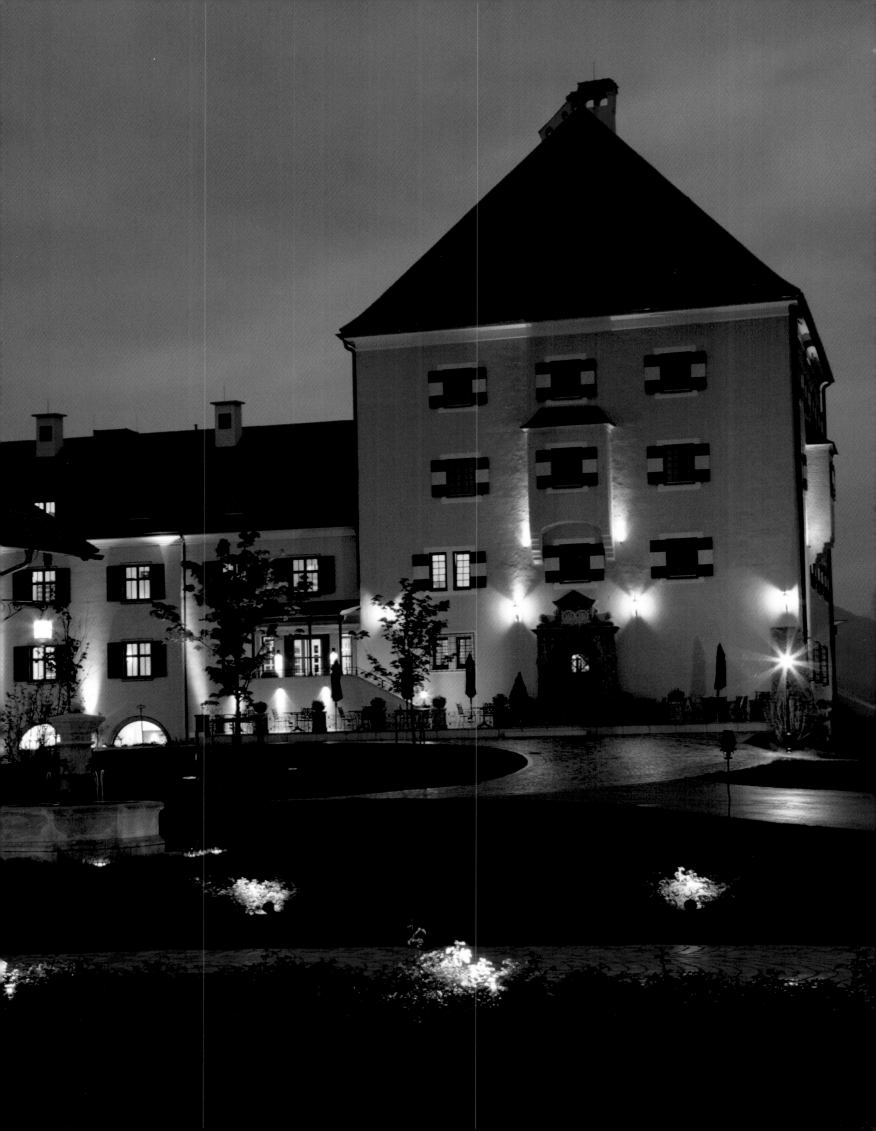

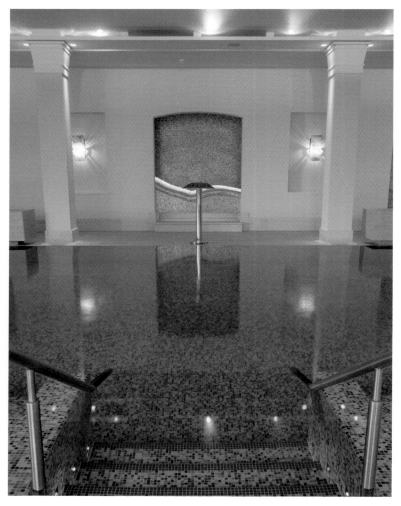
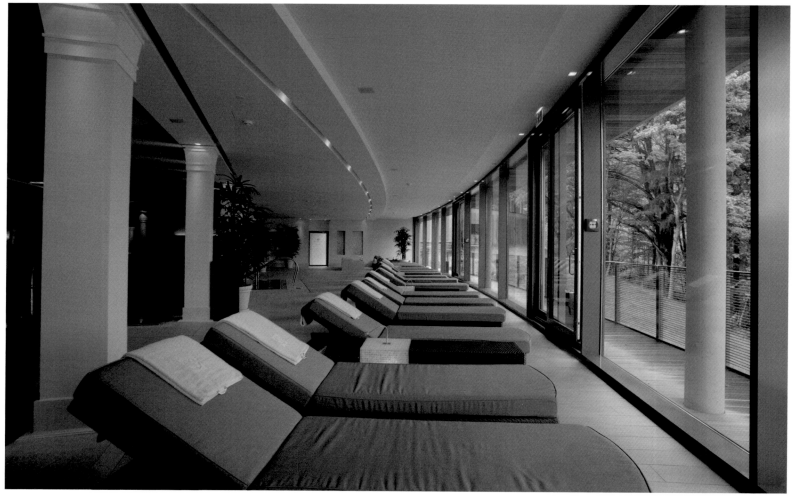

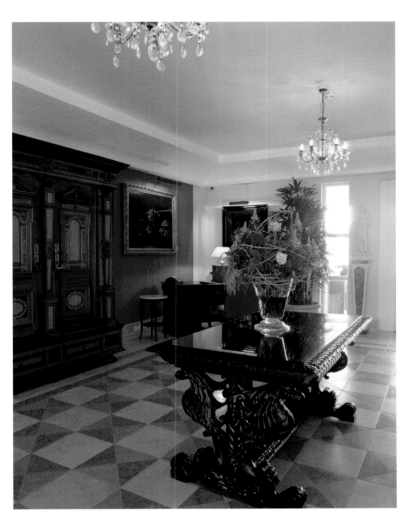

The walls of the historic rooms are adorned with paintings of old masters.

In den historischen Räumen schmücken zahlreiche Alte Meister die Wände.

Dans les pièces historiques, de nombreuses œuvres de maîtres anciens ornent les murs.

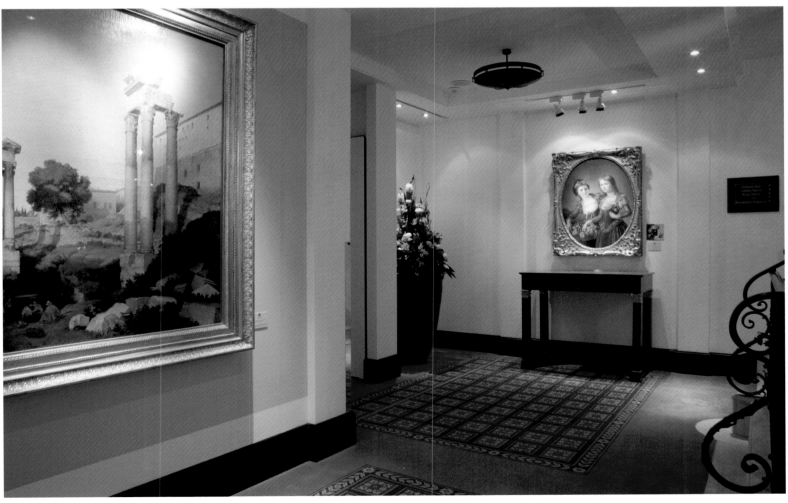

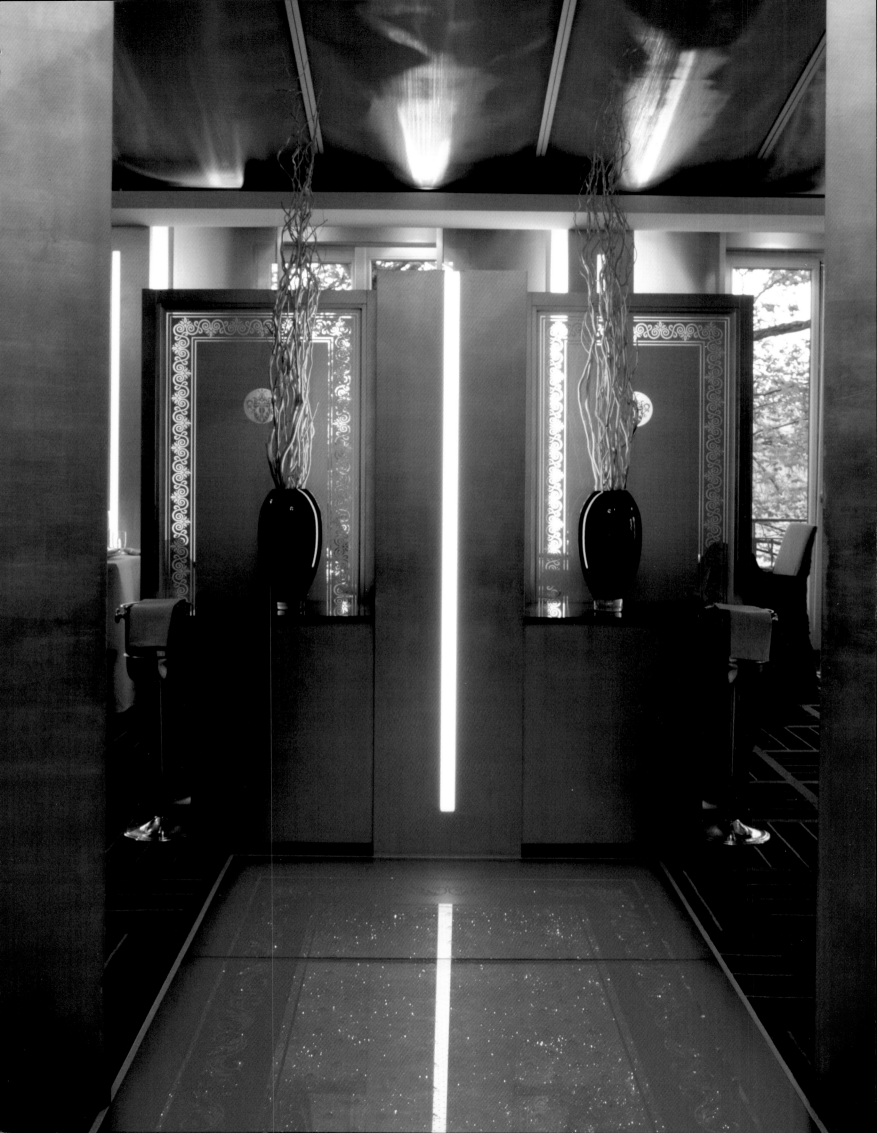

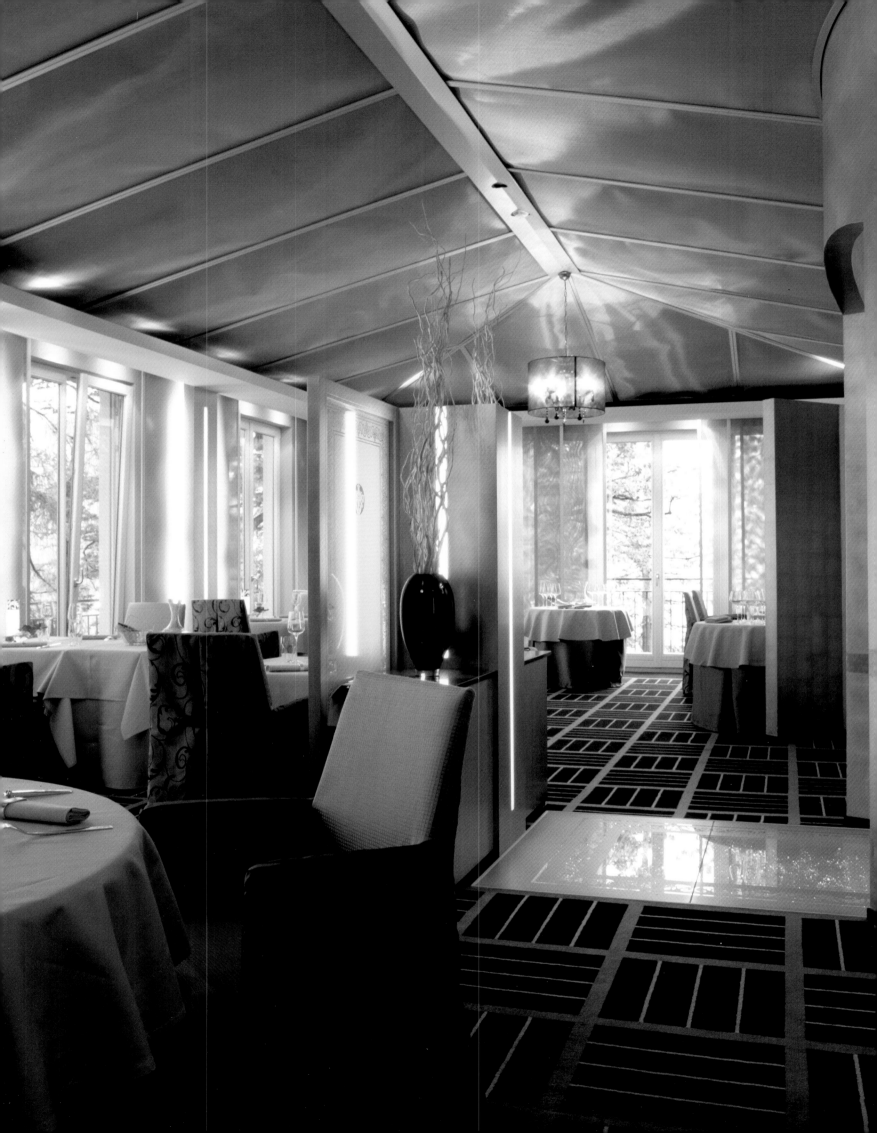

Palais Coburg Residenz

Vienna, Austria

After three years of restoration, the palace built by Ferdinand of Saxe-Coburg & Gotha between 1840 and 1845 stands out as an exquisite gem of a hotel in the heart of Vienna's historical center. The splendor of the neo-classical rooms with their gilded stuccowork and gorgeous crystal chandeliers was deliberately contrasted with simple architectural details. The mere 35 suites are individually arranged in different styles and furnished with the most up-to-date technical equipment.

Als kostbares Hoteljuwel präsentiert sich das in den Jahren 1840–1845 von Ferdinand von Sachsen-Coburg-Gotha erbaute Palais im Herzen der Wiener Altstadt nach einer drei Jahre dauernden Restaurierung. Bewusst wurde der Prunk in den neoklassizistischen Räumen mit ihren vergoldeten Stuckaturen und prachtvollen Kristalllüstern mit schlichten Baudetails kontrastiert. Die nur 35 Suiten sind individuell in unterschiedlichen Stilrichtungen gestaltet und mit moderner Technik ausgestattet.

Le palais construit dans les années 1840–1845 par Ferdinand de Saxe-Coburg et Gotha dans le cœur de la vielle ville de Vienne se présente après trois années de restauration comme un joyau. Le faste des pièces néoclassiques avec leurs stucs dorés et leurs magnifiques lustres en cristal constitue un contraste voulu avec la sobriété de certains détails de construction. Les quelque 35 suites ont été réalisées individuellement dans différents styles et pourvues des équipements techniques les plus modernes.

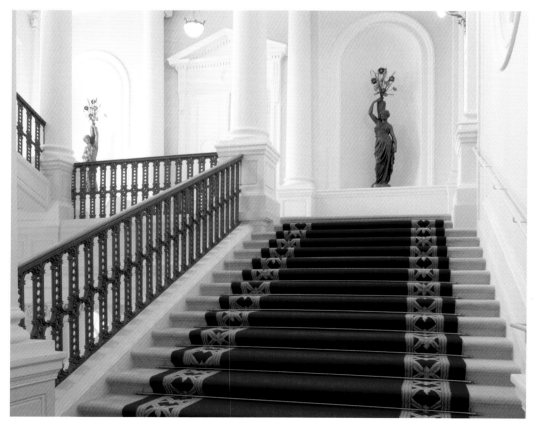

The **19th-century** palais was carefully restored.

Das Palais aus dem 19. Jahrhundert wurde sorgfältig restauriert.

Le palais du XIXème siècle a été soigneusement restauré.

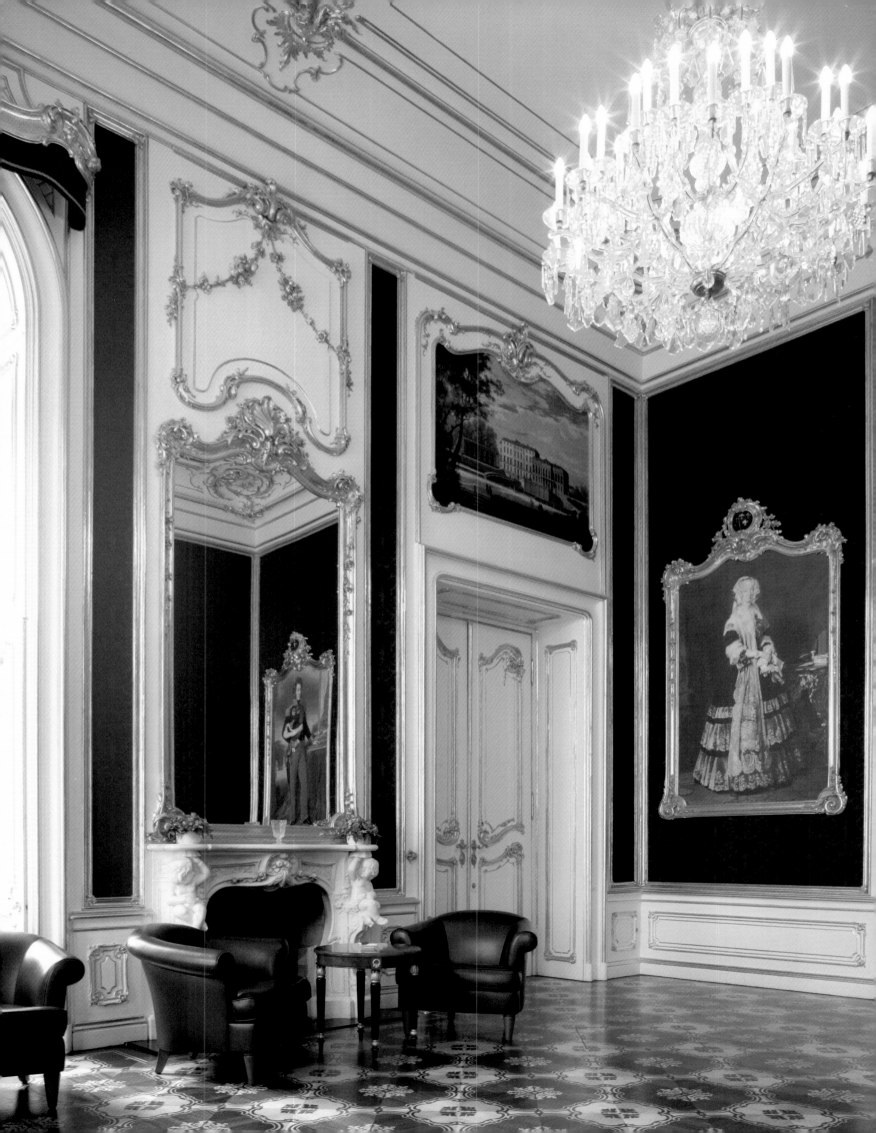

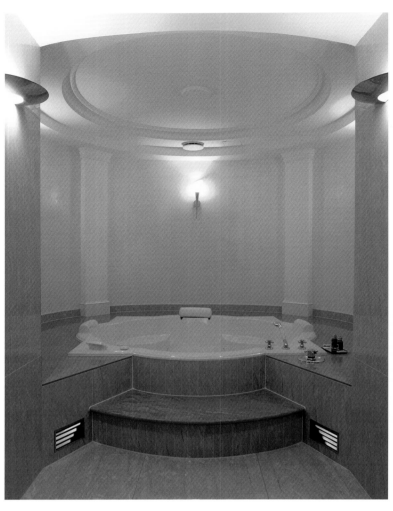

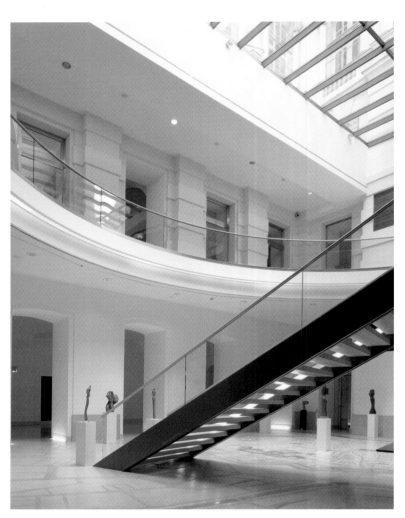

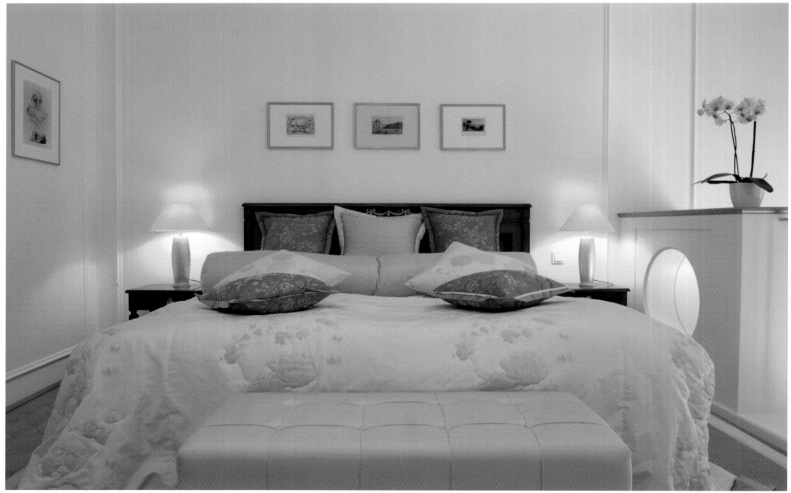

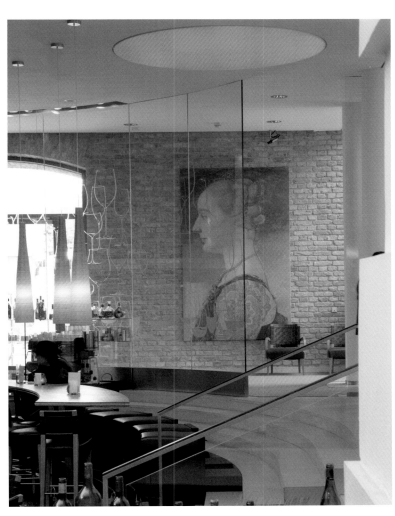

The bar is a popular hangout.

Die Bar ist ein beliebter Treffpunkt.

Lieu de rendez-vous apprécié : le bar.

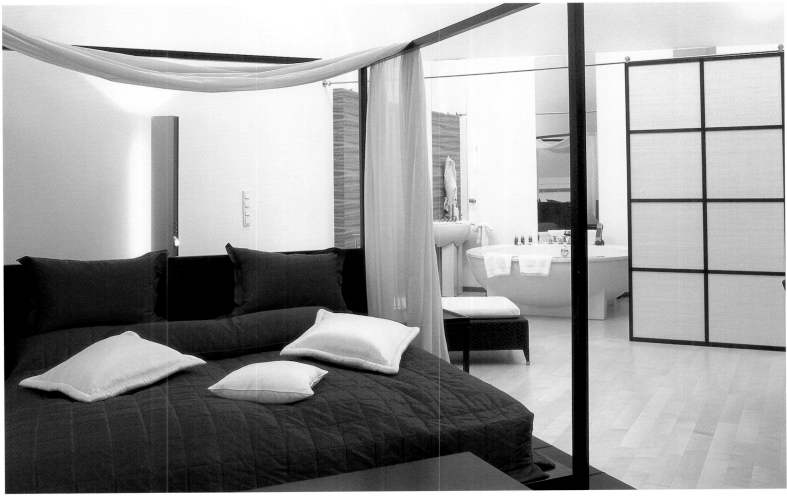

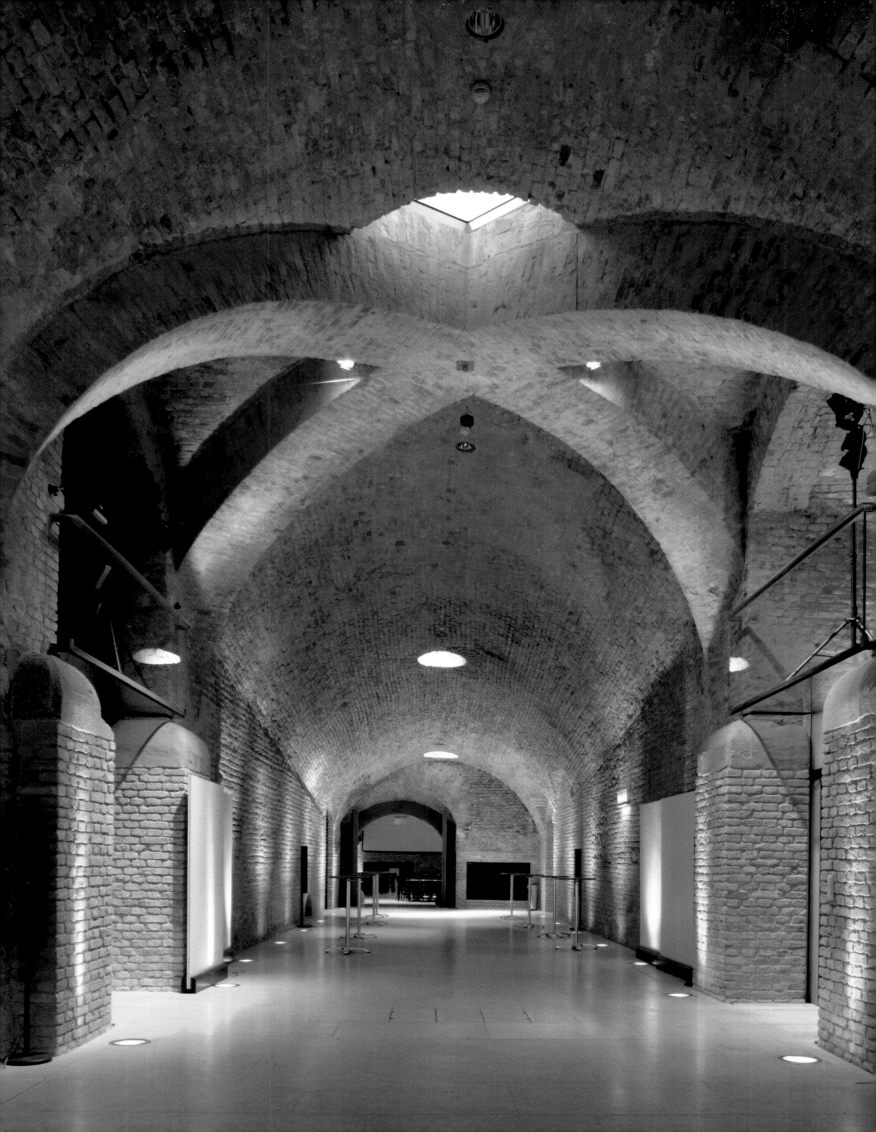

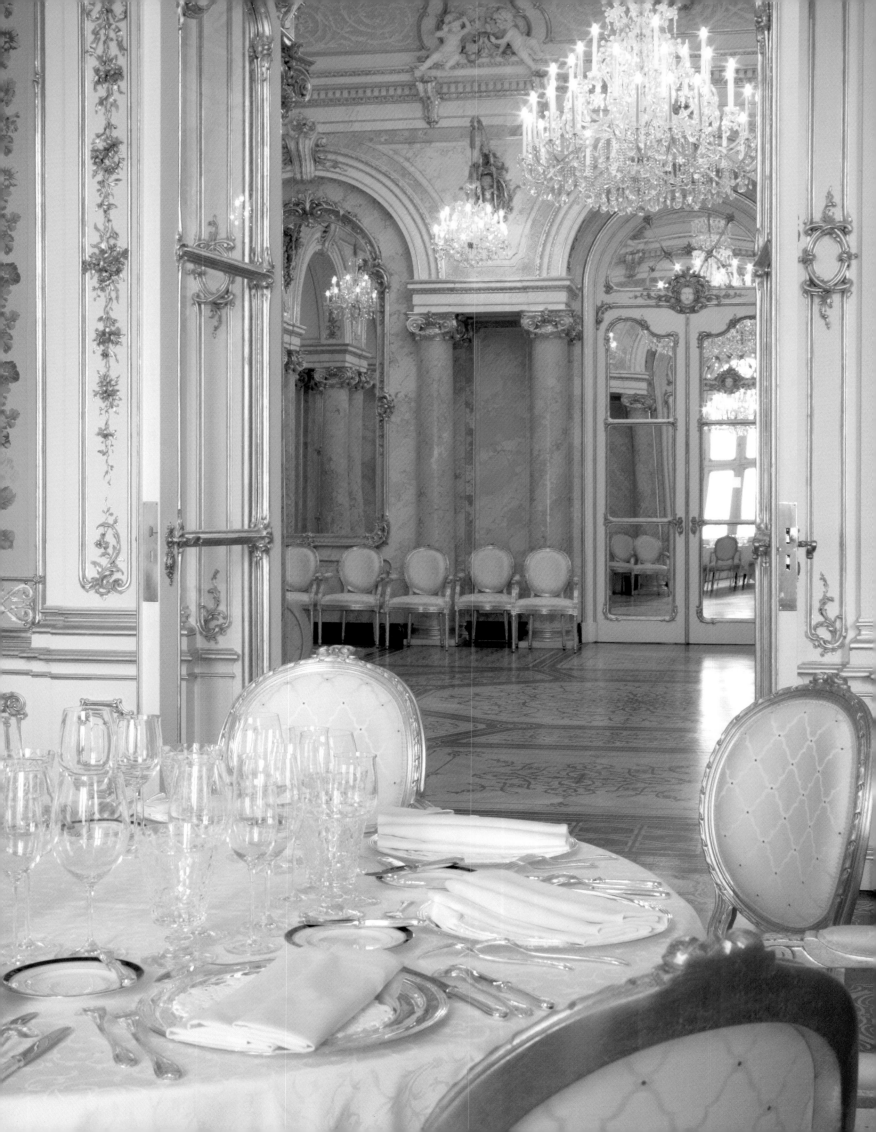

Imperial
Vienna, Austria

On the occasion of the world's fair in Vienna, the noble hotel was opened by Emperor Franz Josef I himself on April 28th, 1873. It is obvious that this was always a place where the rich and powerful met. And even today, all official visitors to Austria stay in this luxury hotel. 138 rooms and 32 suites offer enough space to sit back and relax after strenuous negotiations. Valuable antiques and an opulent collection of paintings endow the hotel with atmosphere reminiscent of 19th-century Vienna.

Kaiser Franz Josef I. höchstpersönlich eröffnete am 28. April 1873 das Nobelhotel anlässlich der Weltausstellung in Wien. Klar, dass es immer ein Ort gewesen ist, wo sich Reiche und Mächtige trafen. Auch heute noch residieren alle Staatsgäste Österreichs in der Luxusherberge. 138 Zimmer und 32 Suiten bieten genügend Platz, um sich nach anstrengenden Verhandlungen gemütlich zurückzulehnen. Wertvolle Antiquitäten und eine üppige Gemäldesammlung verleihen dem Haus eine Atmosphäre, die an das Wien des 19. Jahrhunderts erinnert.

L'empereur François Joseph Ier en personne inaugura le 28 avril 1873 cet hôtel de luxe dans le cadre de l'exposition universelle de Vienne. Il a bien sûr toujours été un lieu de rencontre des riches et des puissants. Aujourd'hui encore tous les hôtes d'état d'Autriche sont logés entre ses murs luxueux. 138 chambres et 32 suites offrent l'espace nécessaire pour se détendre après de difficiles négociations. Des antiquités précieuses et une grande collection de tableaux confèrent à l'hôtel une ambiance qui rappelle la Vienne du XIXème siècle.

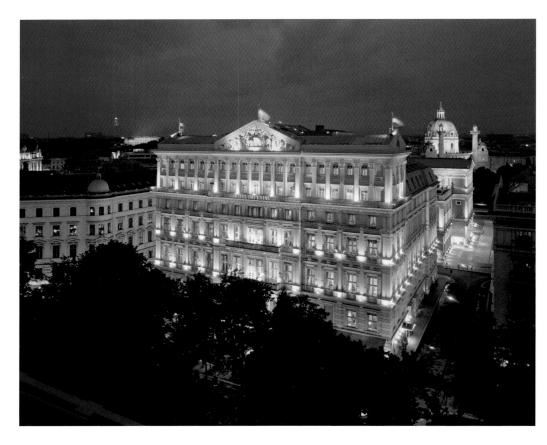

A majestic sight: the Imperial on the Ring Boulevard of Vienna.

Majestätisch erhebt sich das Imperial an der Wiener Ringstraße.

L'Imperial se dresse majestueusement dans la Ring de Vienne.

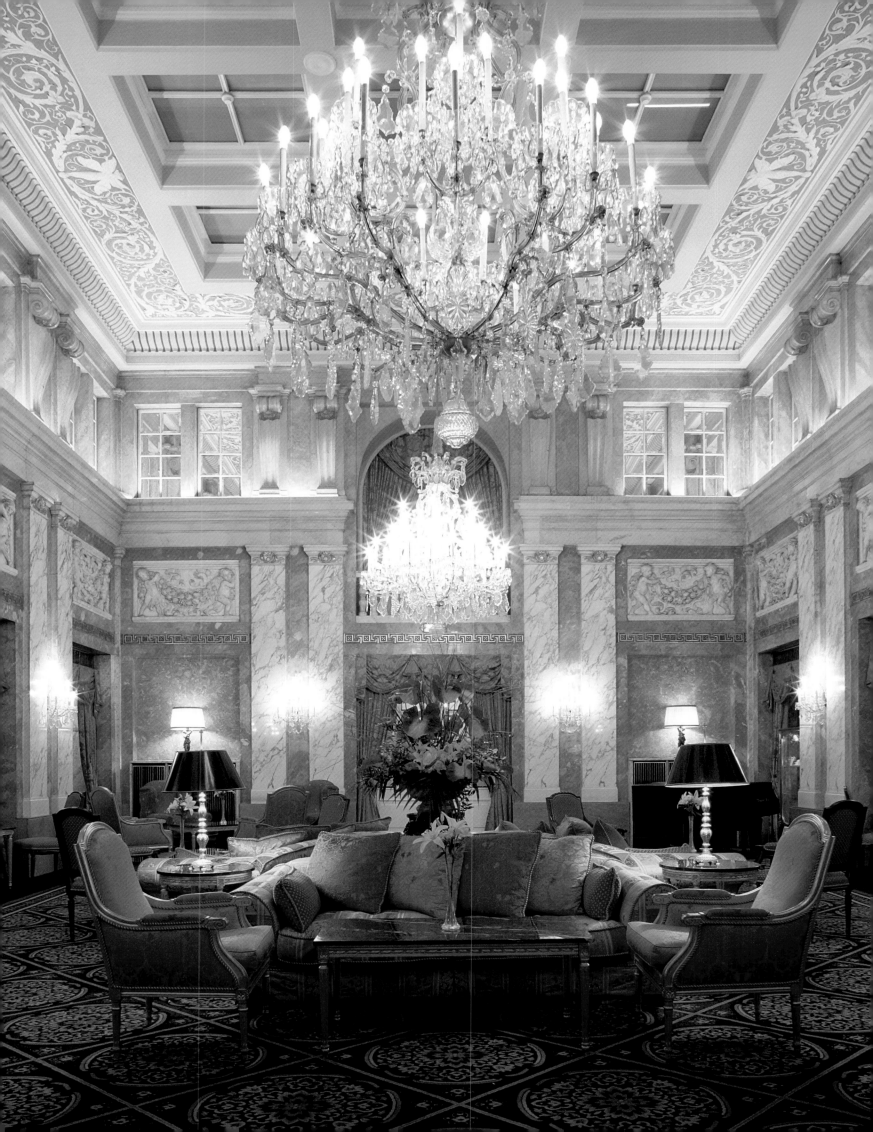

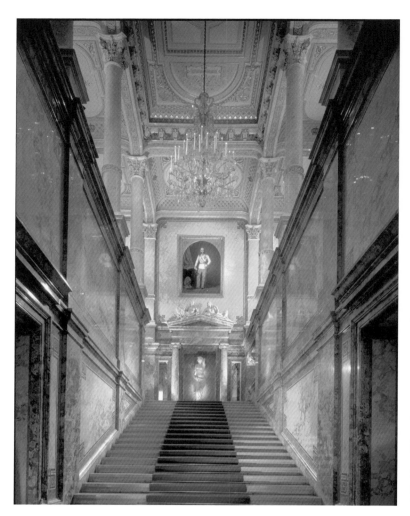

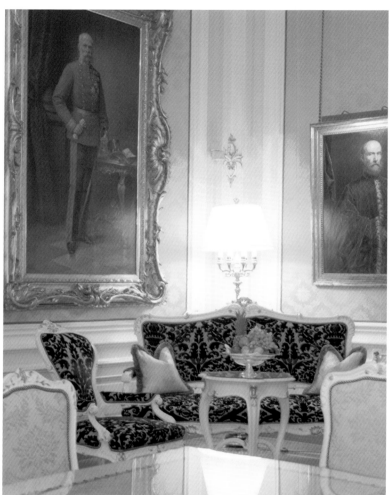

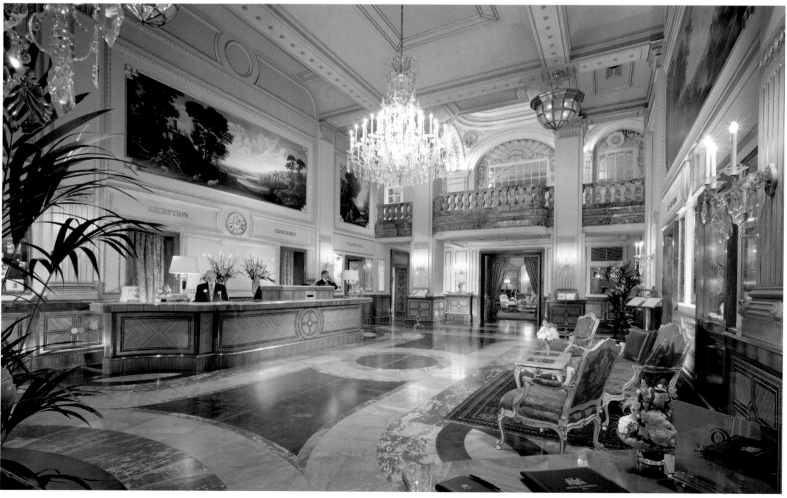

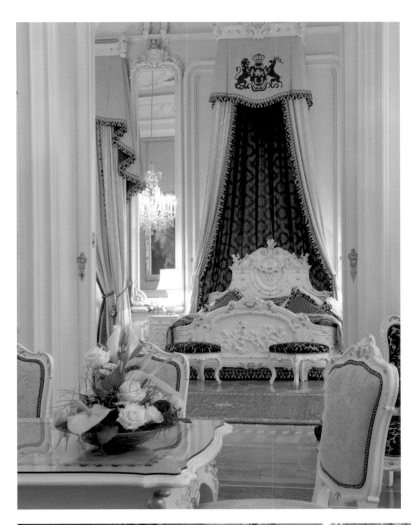

The former residence of a Prince was transformed into a hotel as early as 1873.

Bereits 1873 wurde die ehemalige Prinzenresidenz in ein Hotel umgewandelt.

Dès 1873, l'ancienne résidence princière fut convertie en hôtel.

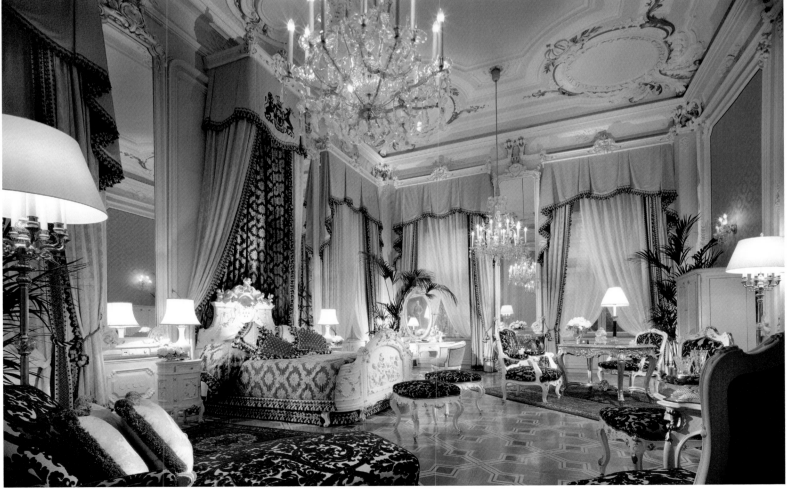

Sacher

Vienna, Austria

The Hotel Sacher is located opposite the State Opera House and within walking distance of the St. Stephen's Cathedral. A renovation in the year 2005, enhancing it with a spa, did not harm the Habsburg charm of this five-star hotel. The 152 rooms are equipped with elegant furniture, selected antiques and precious fabrics. The interior is adorned with a collection of paintings. The two restaurants serve light international cuisine and traditional Viennese dishes, and the Original Sacher-Torte is available in the "Café Sacher."

Gegenüber der Staatsoper und wenige Gehminuten vom Stephansdom entfernt liegt das Hotel Sacher. Ein Umbau im Jahr 2005 konnte dem habsburgischen Charme des Gebäudes nichts anhaben, dafür verfügt das Fünf-Sterne-Hotel nun über einen Spa. Die 152 Zimmer sind mit elegantem Mobiliar, ausgesuchten Antiquitäten und wertvollen Stoffen ausgestattet. Das Innere wird durch eine Gemäldesammlung zusätzlich veredelt. Die beiden Restaurants servieren leichte internationale und traditionelle Wiener Küche; die Original Sacher-Torte gibt es im „Café Sacher".

L'hôtel Sacher est situé en face de l'Opéra national, à quelques minutes à pieds de la Cathédrale Saint-Étienne. Une transformation effectuée en 2005 n'a rien enlevé au charme habsbourgeois de la demeure, au contraire, l'hôtel cinq étoiles est maintenant doté d'un spa. Les 152 chambres sont équipées d'un mobilier élégant, d'antiquités choisies et de fins tissus. Une collection de tableaux ennoblit encore davantage l'intérieur. Les deux restaurants servent une cuisine internationale légère et des plats traditionnels viennois. Au « Café Sacher ». on sert, bien entendu, l'originale « Sacher-Torte ».

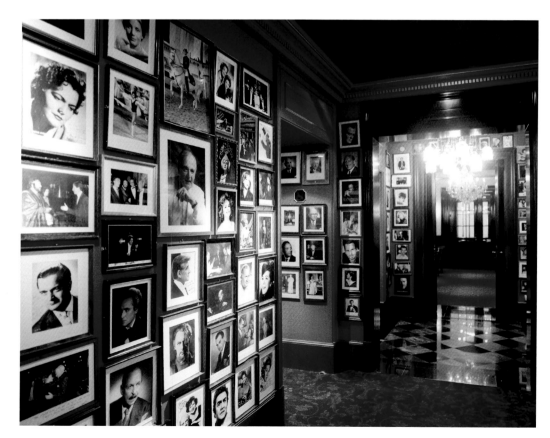

The Hotel Sacher has already accommodated many celebrities.

Viele berühmte Persönlichkeiten haben schon im Hotel Sacher logiert.

De nombreuses célébrités ont séjourné dans cet hôtel.

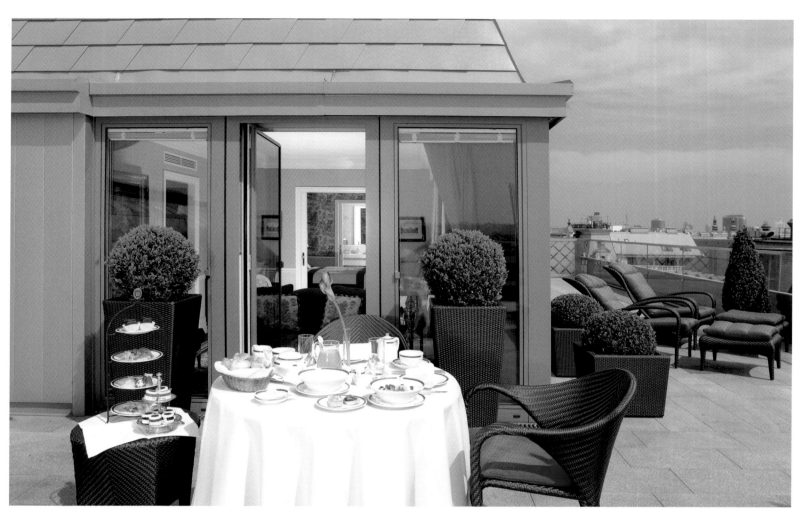

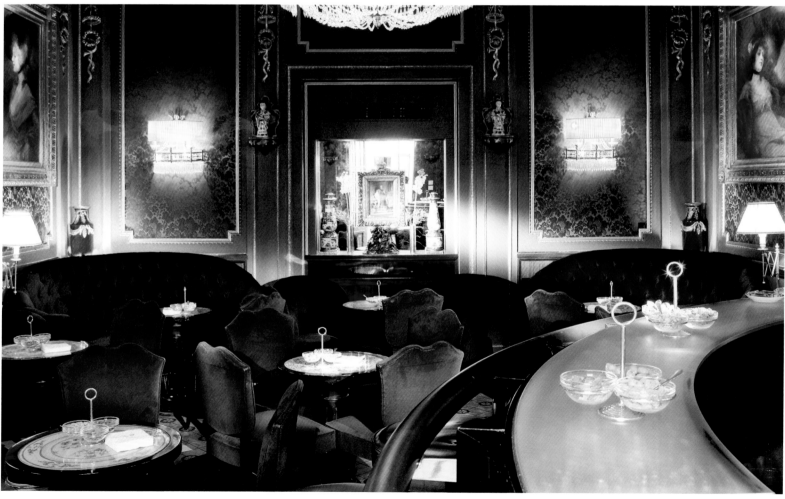

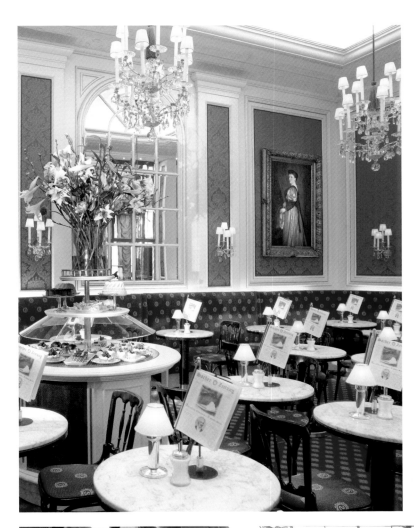

In the fancy café, the Original Sacher-Torte is served.

Im stilvollen Café wird die Original-Sacher-Torte serviert.

Aménagé avec beaucoup de style, le café propose l'original « Sacher-Torte ».

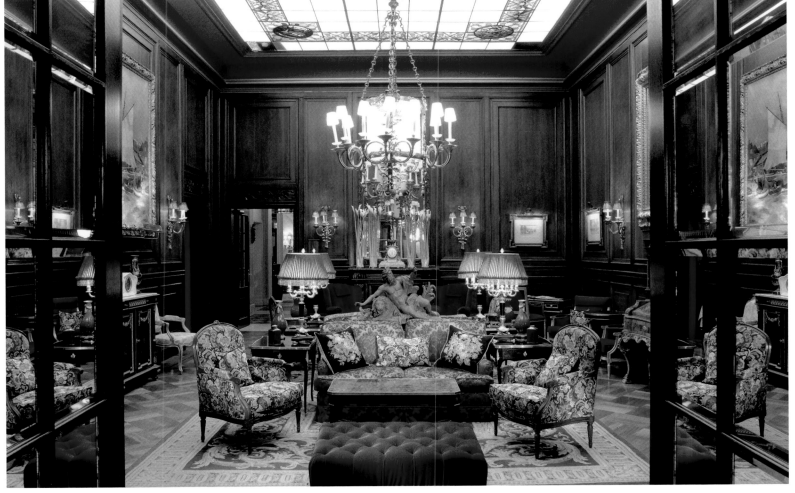

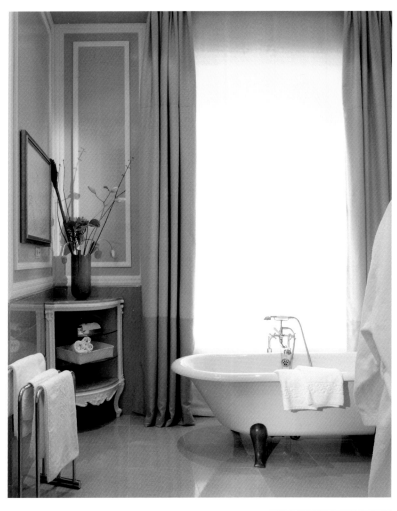
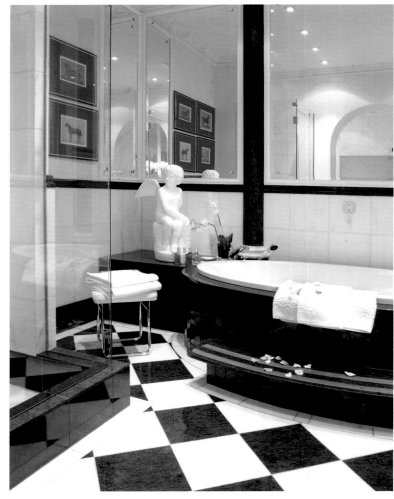
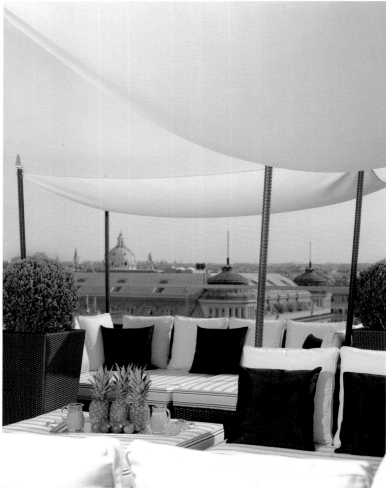
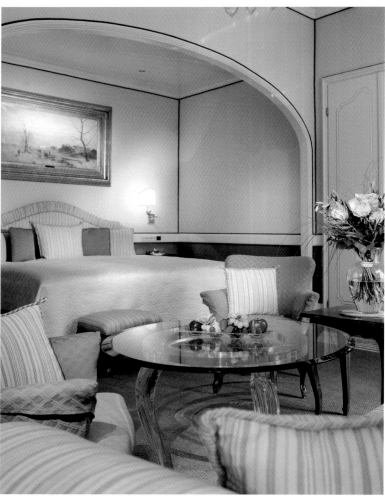

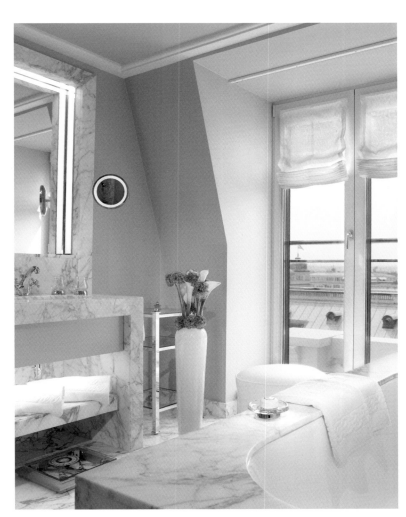

From many rooms, guests can enjoy the view of the State Opera House or the Albertina.

Von vielen Zimmern genießt man den Blick auf Staatsoper oder Albertina.

De nombreuses chambres offrent une vue imprenable sur l'Opéra national et l'Albertina.

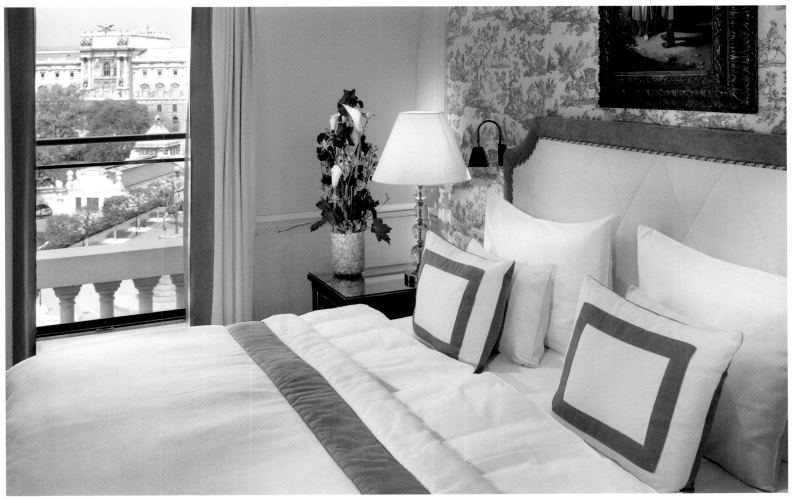

La Réserve Genève
Hotel & Spa
Geneva, Switzerland

Star designer Jaques Garcia takes guests in the hotel's 102 unusual rooms on a "static journey." The setting amidst a green park on the eastern bank of Lake Geneva and the interplay of vegetation and water inspired him to his idea of designing the lobby-lounge in the style of an African safari lodge: heavy, brown leather armchairs, brightly colored parrots, old leather suitcases and an elephant presiding majestically above it all. In contrast, the 6,500-square-foot spa is kept entirely in cream-white.

Auf eine „immobile Reise" nimmt Stardesigner Jaques Garcia die Gäste des ungewöhnlichen 102-Zimmer-Hotels mit. Die Lage inmitten eines grünen Landschaftspark am Ostufer des Genfer Sees, das Zusammenspiel von Vegetation und Wasser inspirierte ihn zu seiner Idee, die Lobby-Lounge wie eine afrikanische Safari-Lodge zu gestalten: schwere braune Ledersessel, knallbunte Papageien, alte Lederkoffer und über allem thront ein Elefant. Im Kontrast dazu ist der 2000 Quadratmeter große Spa ganz in Cremeweiß gehalten.

Le célèbre designer Jaques Garcia invite les visiteurs de cet hôtel insolite de 102 chambres à un « voyage immobile ». Son emplacement au milieu d'un parc naturel vert sur la rive orientale du lac de Genève et le jeu de la végétation et de l'eau lui donnèrent l'idée d'aménager le lobby-salon en safari-lodge africain : fauteuils de cuir marrons et imposants, perroquets aux couleurs vives, vieilles valises en cuir. Un éléphant trône au-dessus du tout. Le spa de 2000 mètres carrés a été entièrement conservé en blanc crème en vue de réaliser un contraste.

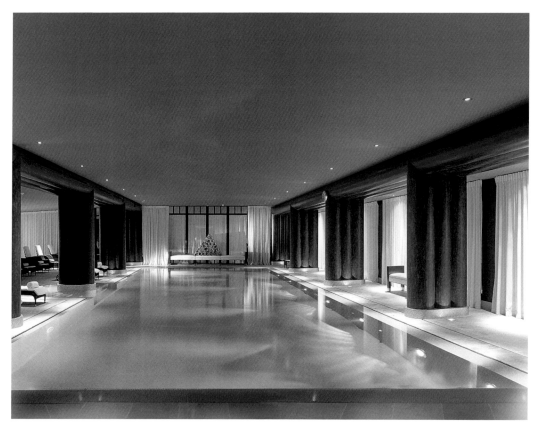

Friendly colors, soft blankets and opulent drapes make for a cozy ambience.

Freundliche Farben, weiche Decken und großzügige Vorhänge schaffen ein behagliches Wohngefühl.

Des couleurs accueillantes, des couvertures douillettes et des rideaux généreux créent une atmosphère des plus agréables.

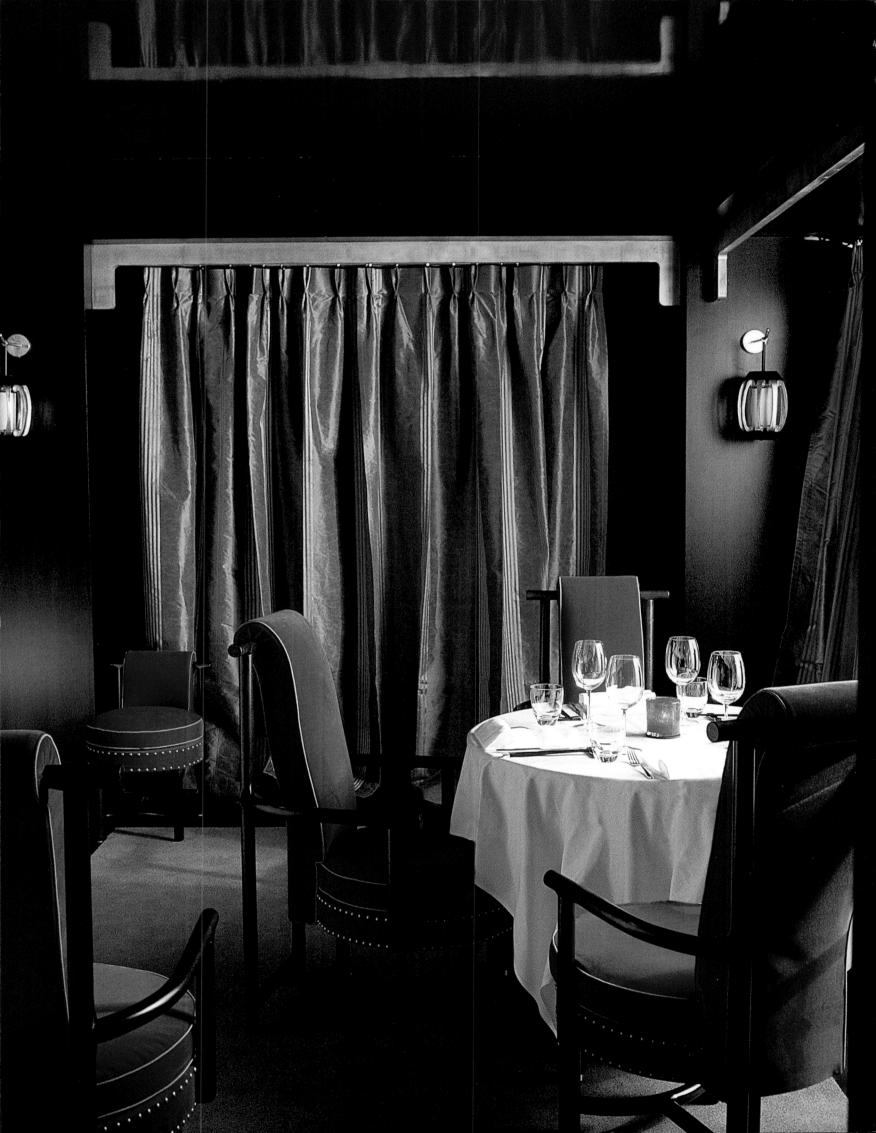

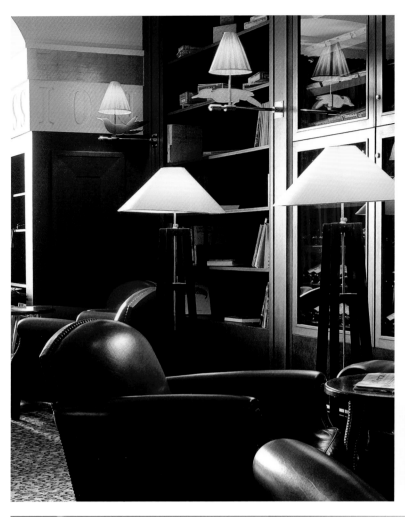

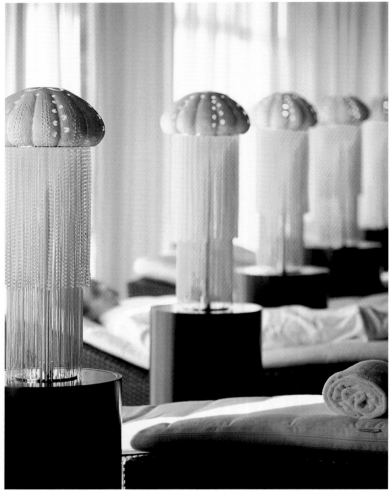

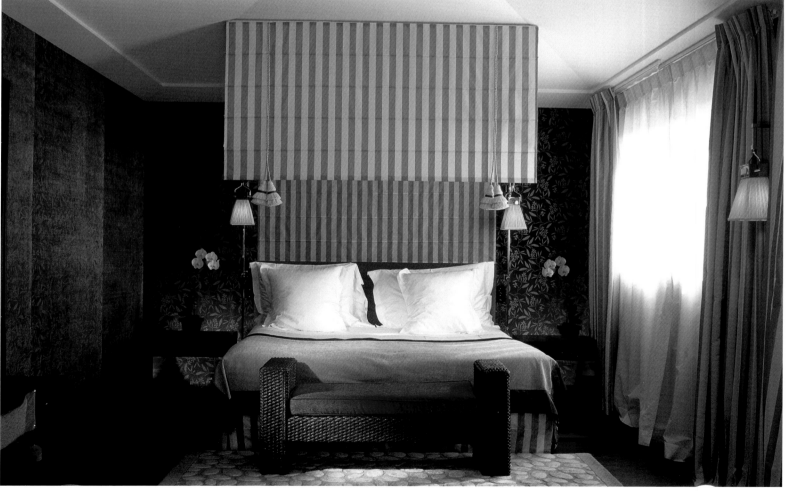

In the evening, a DJ entertains the guests with his music in the lounge.

In der Lounge sorgt abends ein DJ für musikalische Unterhaltung.

Le soir, un DJ est aux manettes pour assurer le divertissement musical dans le lounge.

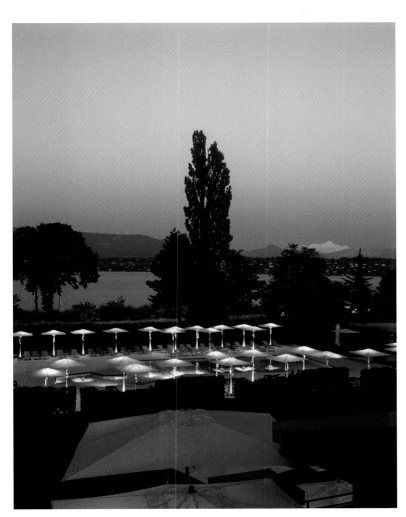

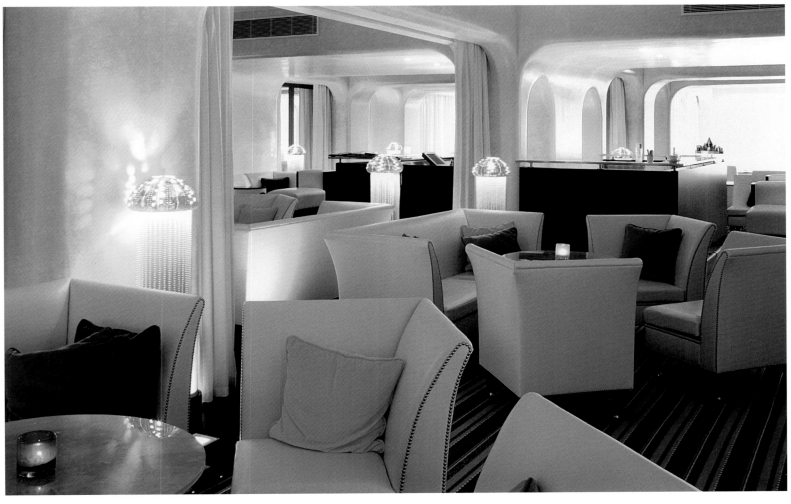

PALACE Luzern

Lucerne, Switzerland

The PALACE Luzern hotel is situated directly by the Lake Lucerne. This belle époque-style building comprises 136 individually arranged, well-lit rooms; from most of these rooms guests have a gorgeous view of the lake, the mountains or the city of Lucerne. Materials, shapes and colors in the rooms harmonize perfectly; in the lobby, modern furniture contrasts with opulent tapestries, the black-and-white marble floor and a sumptuous chandelier. Japanese gardens were added to the entrance of Palace spa, which opened in 2005.

Direkt am Luzerner See liegt das Hotel PALACE Luzern. 136 individuelle, helle Zimmer sind in dem Gründerzeitgebäude untergebracht. Von den meisten genießt man den Blick auf den See, die Berge oder die Luzerner Altstadt. Materialien, Formen und Farben sind in den Zimmern harmonisch aufeinander abgestimmt; in der Lobby stehen moderne Möbel im Kontrast zu üppigen Wandteppichen, dem schwarz-weißen Marmorboden und einem großen Kronleuchter. Japanische Gärten ergänzen den Eingangsbereich des im Jahr 2005 eröffneten Palace Spas.

L'hôtel PALACE Luzern donne directement sur le lac de Lucerne. Les 136 chambres personnalisées, aux teintes claires, se trouvent dans le bâtiment de la Belle Epoque. La plupart d'entre elles offre une vue enivrante sur le lac, les montagnes et la vieille ville lucernoise. Matériaux, formes et couleurs sont harmonieusement coordonnés. Dans le hall, des meubles modernes contrastent avec les tapis muraux aux motifs somptueux, le sol en marbre noir et blanc et l'énorme lustre. Des jardins japonais complètent l'entrée du spa Palace, ouvert depuis 2005.

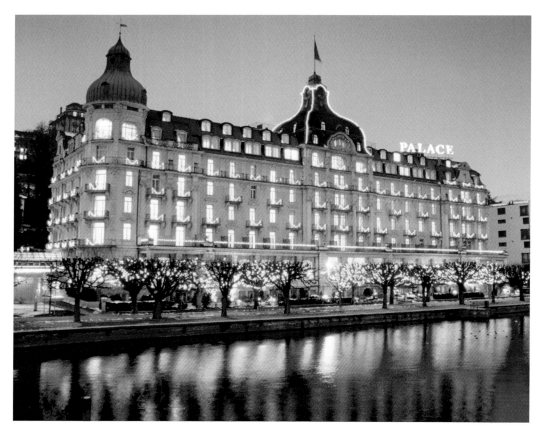

The facade of the PALACE Luzern is a real eye-catcher.

Die Fassade des PALACE Luzern ist ein Blickfang.

La façade de l'hôtel PALACE Luzern est un accroche-regard.

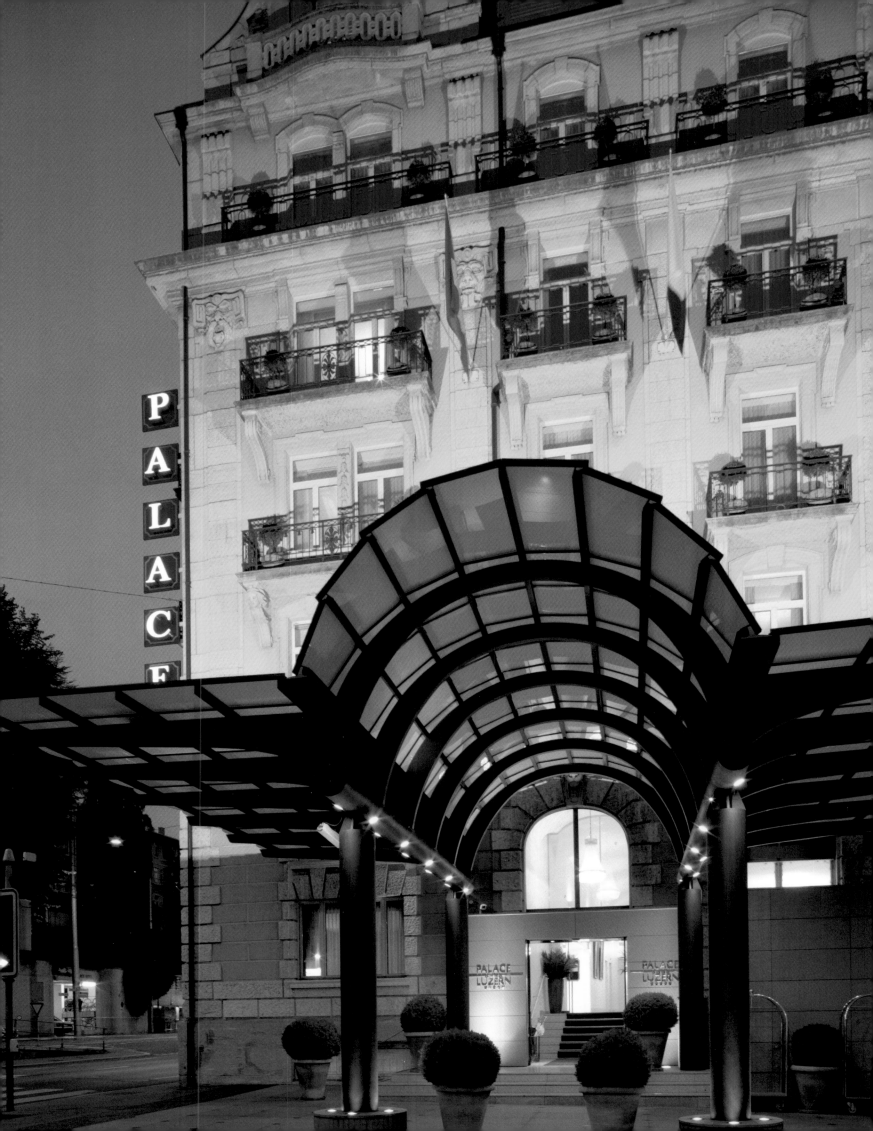

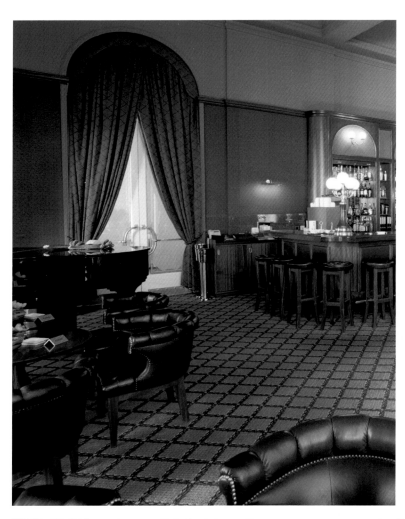

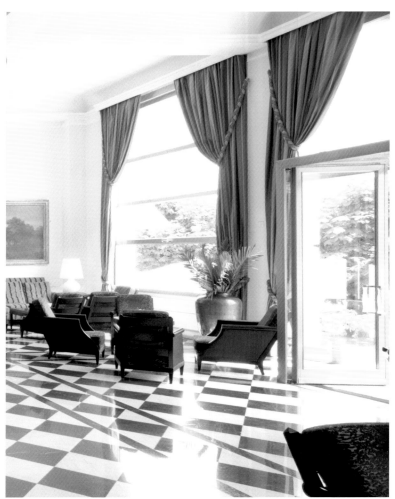

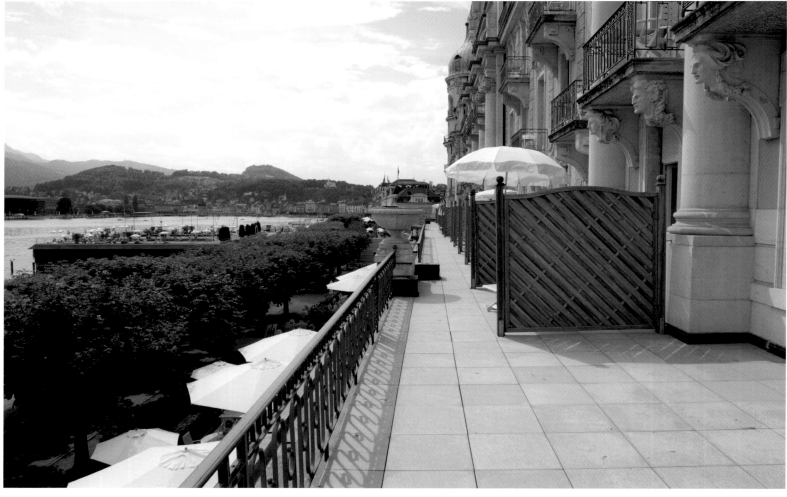

The restaurant "Jasper" is specialized in aromatic, Mediterranean cuisine.

Das Restaurant „Jasper" hat sich auf eine aromareiche, mediterrane Küche spezialisiert.

Le restaurant « Jasper » s'est spécialisé dans la cuisine méditerranéenne riche en arômes.

Widder
Zurich, Switzerland

The Widder Hotel is situated in a quiet and central area of Zurich's Old Town. It consists of nine historic town houses that are connected by different stairways and courtyards. In the common rooms, impressive furniture and art objects of Le Corbusier, Mies van der Rohe and Ray Eames can be found; in the 49 rooms of this hotel there are even more pieces of famous artists to gaze at. For a culinary experience, guests can choose from several restaurants. The hotel bar is particularly popular among locals, too.

Ruhig und zentral in der Zürcher Altstadt liegt das Widder Hotel. Es erstreckt sich über neun historische Wohnhäuser, die durch Treppen und Innenhöfe miteinander verbunden sind. In den Gemeinschaftsräumen beeindrucken Möbel und Objekte unter anderem von Le Corbusier, Mies van der Rohe und Ray Eames; und auch in den 49 Zimmern und Suiten sind Werke großer Künstler ausgestellt. Um sich kulinarisch verwöhnen zu lassen, stehen dem Gast mehrere Restaurants zur Verfügung. Ein beliebter Zürcher Treffpunkt ist zudem die Bar des Hauses.

L'hôtel Widder est situé dans une zone tranquille et centrale de la vieille ville de Zurich. Il s'étend sur neuf édifices historiques reliés entre eux par des escaliers et des cours intérieures. Dans les salles communes se trouvent des meubles et des objets impressionnants signés entre autre Le Corbusier, Mies van der Rohe et Ray Eames. De même, dans les 49 chambres et suites sont exposées les œuvres de grands artistes. Afin de gâter les hôtes d'un point de vue culinaire, plusieurs restaurants sont mis à leur disposition. De plus, le bar de la maison est un lieu de rendez-vous très prisé à Zurich.

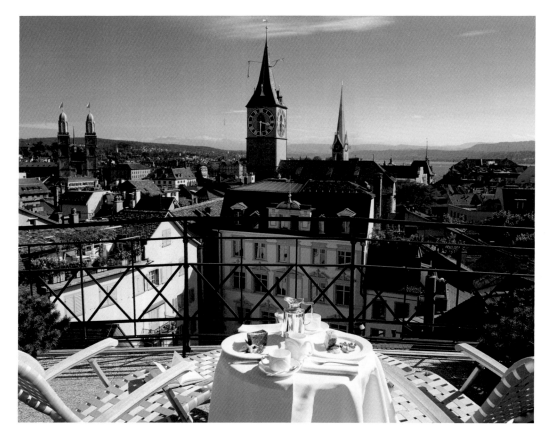

From the hotel's roof, guests have a view of the city and Lake Zurich.

Vom Dach des Hotels öffnet sich der Blick auf die Stadt und den Zürich-See.

Depuis le toit de l'hôtel, on a une vue sur la ville et le lac de Zurich.

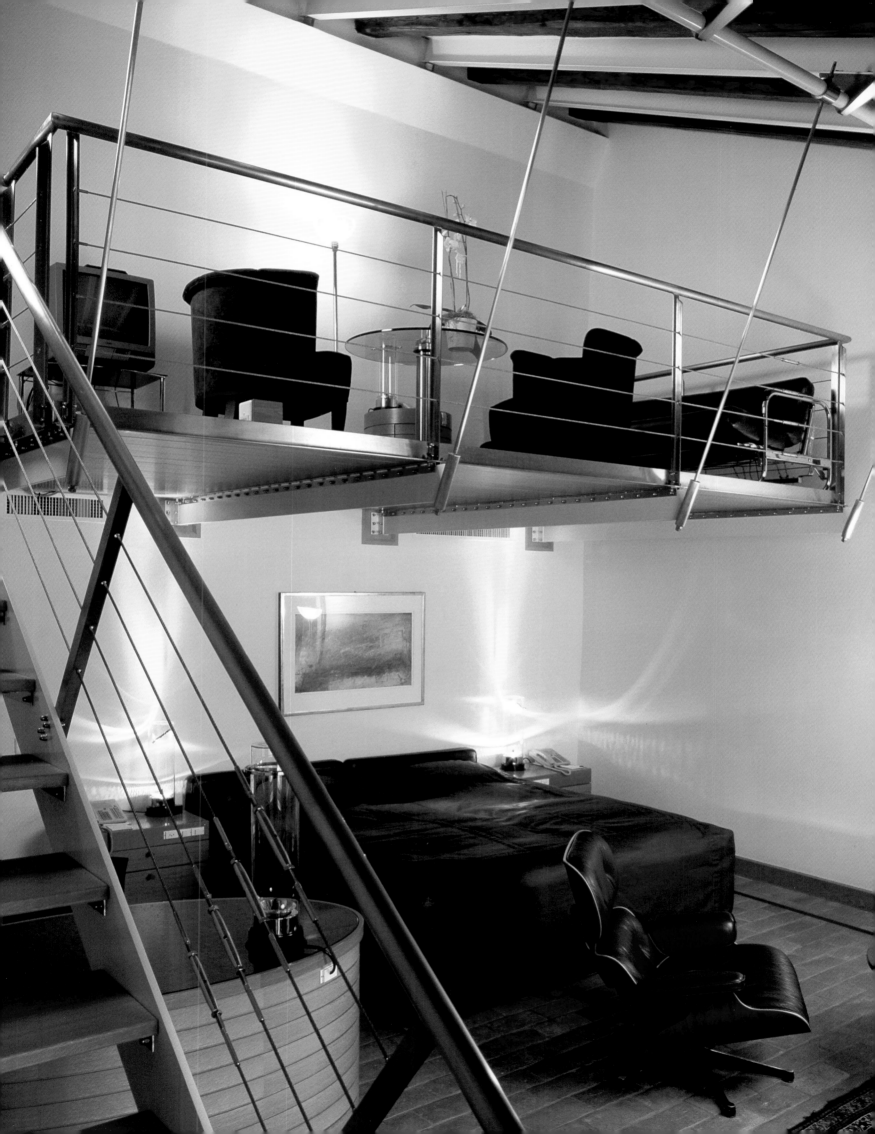

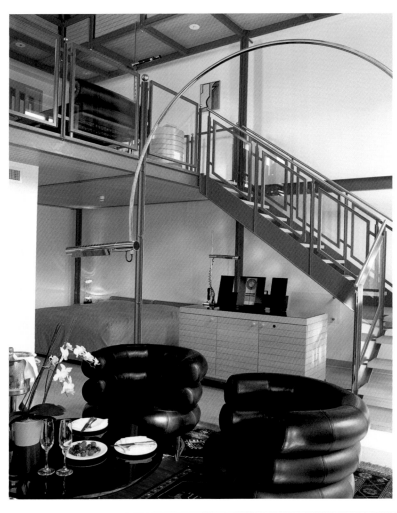
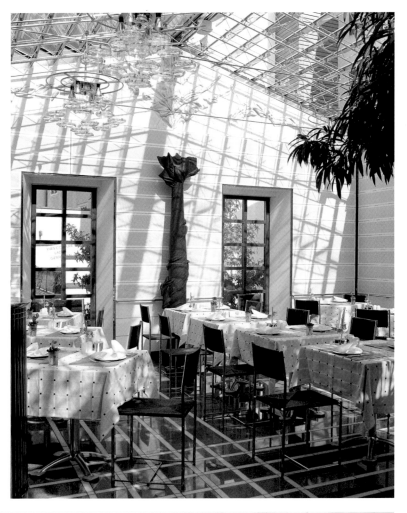
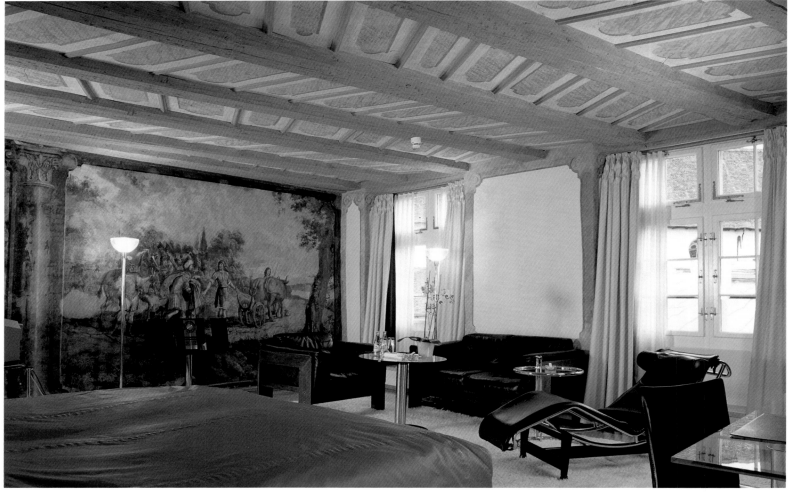

Guests can enjoy contemporary design in the entire hotel, even in the fitness area.

Zeitgenössisches Design begleitet den Gast bis in den Fitness-Raum.

Un design contemporain accompagne les hôtes jusque dans la salle de remise en forme.

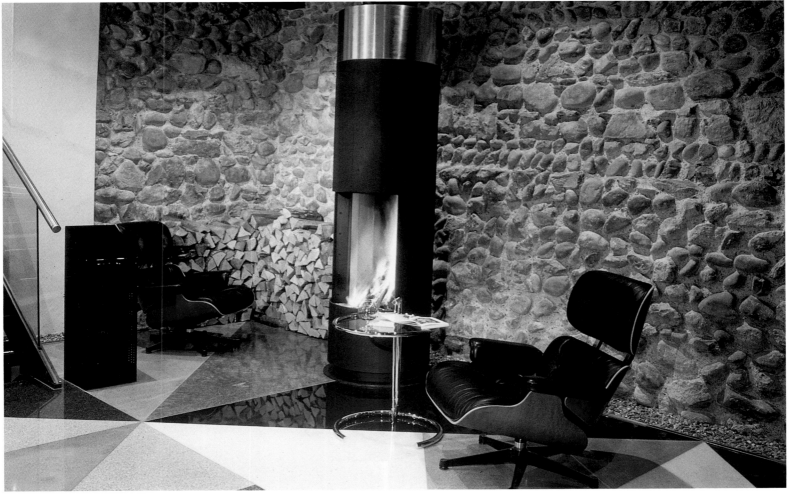

Hotel Martinez

Cannes, France

The Hotel Martinez is a true eye-catcher on the palm-lined Croisette in Cannes. 412 tastefully arranged rooms, many of which have a view of the ocean or the surrounding hills are spreading over seven floors. On the first floor, guests will find the repeatedly awarded two-star Michelin restaurant "La Palme d'Or," which is decorated in a way to render homage to the movies. The Martinez is, after all, an important spot during the annual film festival. The private sandy beach in front of the building and the Spa Martinez invite the guests to unwind.

Ein wahrer Blickfang an der mit Palmen bestandenen Croisette in Cannes ist das Hotel Martinez. Auf sieben Stockwerken finden 412 stilvoll eingerichtete Zimmer Platz, viele davon mit Blick zum Meer oder auf die umliegenden Hügel. Im ersten Stock liegt das mehrfach ausgezeichnete Zwei-Sterne Michelin Restaurant „La Palme d'Or", das mit seiner Einrichtung dem Kino huldigt. Schließlich ist das Martinez jedes Jahr bei den Filmfestspielen eine wichtige Anlaufstelle. Der private Sandstrand vor dem Haus und das Spa Martinez laden zur Entspannung ein.

Sur la célèbre Croisette de Cannes et ses rangées de palmiers, l'hôtel Martinez constitue un véritable accroche-regard. Il compte 412 chambres distribuées sur sept étages et aménagées avec style, dont beaucoup ont vue directe sur la mer ou sur les collines environnantes. Au premier étage se trouve le restaurant « La Palme d'Or », récompensé à plusieurs reprises avec deux étoiles au guide Michelin, qui, par sa décoration, représente un hommage au cinéma. En effet, le Martinez n'est-il pas également un point de rencontre important tous les ans lors du festival de Cannes ? La plage privée située devant l'hôtel et le Spa Martinez invitent à la détente.

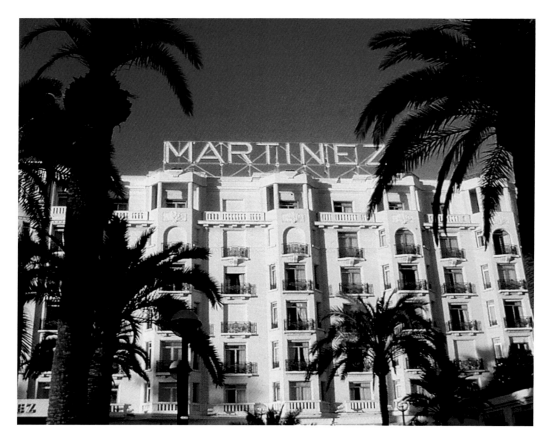

The striking architectural style of Hotel Martinez exudes timeless elegance.

Von außen besticht das Hotel Martinez durch zeitlose architektonische Eleganz.

De l'extérieur, l'hôtel Martinez séduit par son indémodable élégance architecturale.

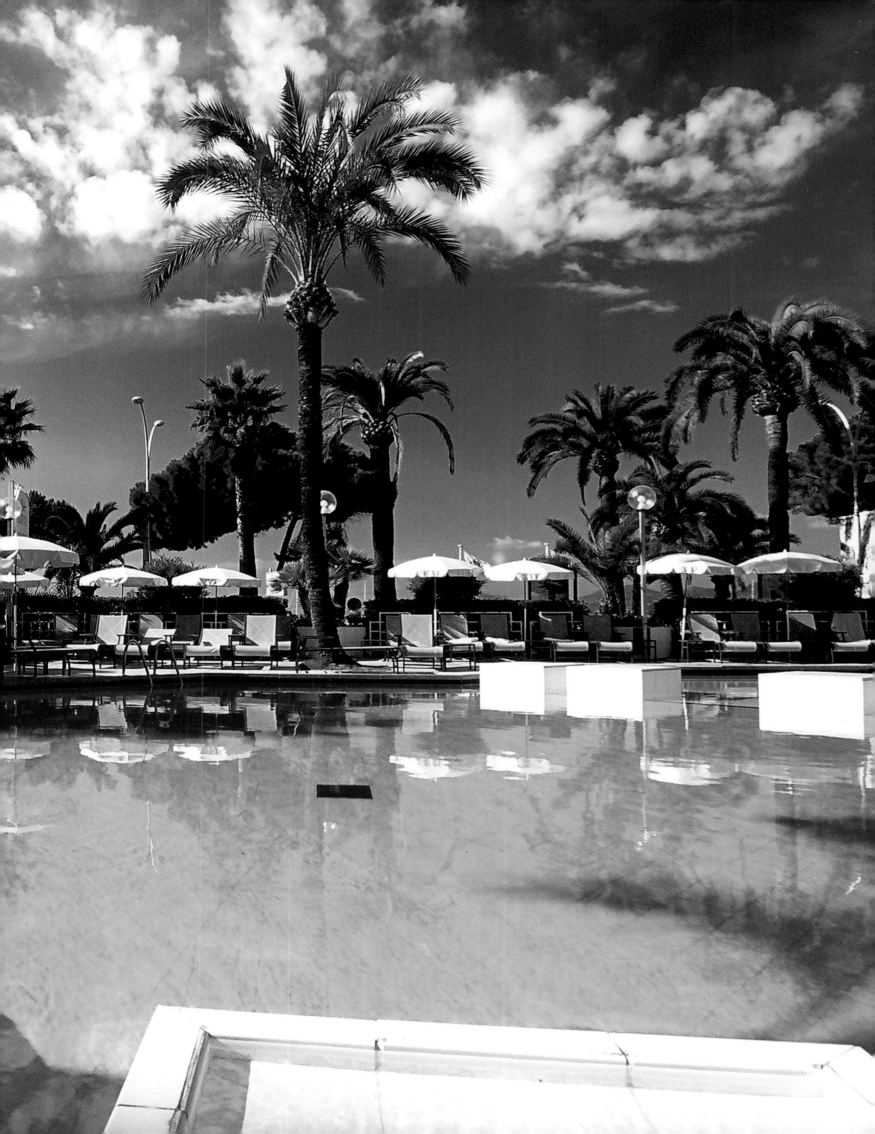

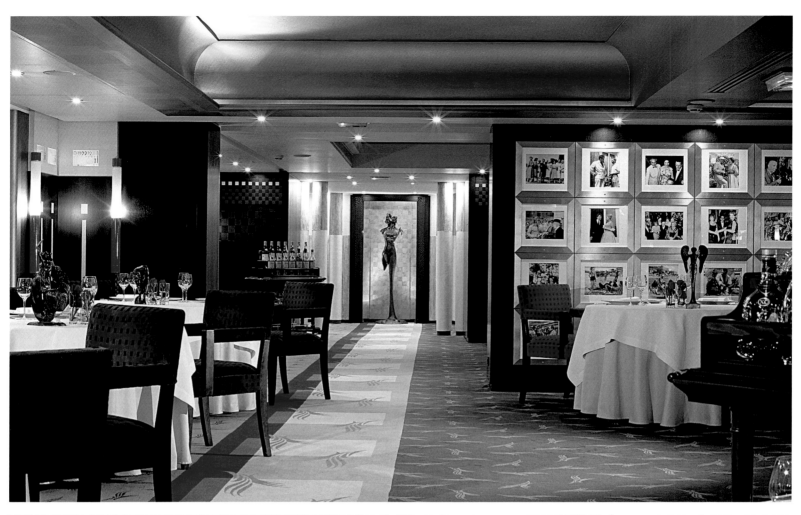

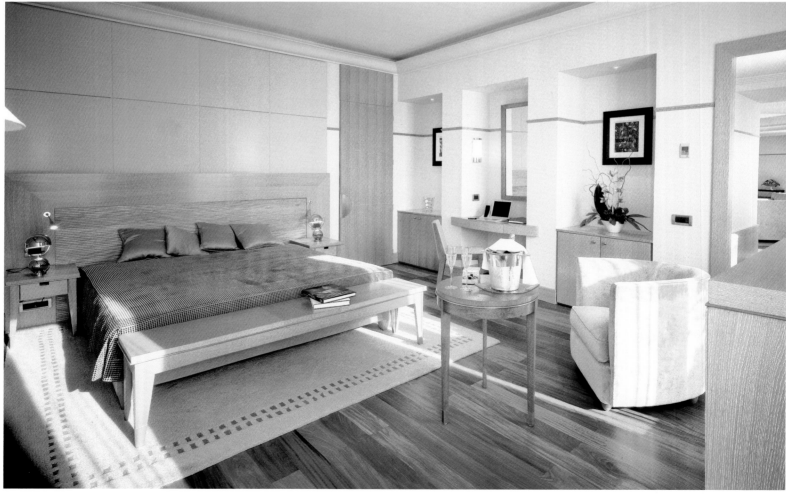

In the Martinez, guests can choose between the beach and the pool.

Strand oder Pool – im Martinez hat der Gast die Wahl.

Plage ou piscine – dans le Martinez, l'hôte a le choix.

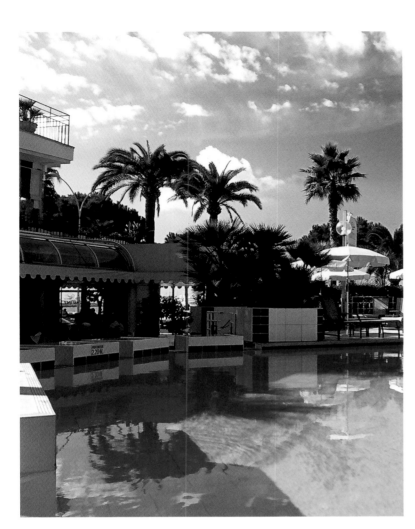

Murano Resort

Paris, France

"When sleeping is not enough"—a motto that reflects the requirements of the hotel. The design hotel, which was opened in spring 2004, knows how to radiate casual and debonair glamour. All the rooms are individually furnished, dominated by a modern purism. The sesame of the suites opens by fingerprint. Before this, a futuristic elevator brings the guests to the right floor. As dazzling as it is tasteful: the bar and restaurant of the urban resort.

„When sleeping is not enough" – ein Motto, das den Anspruch des Hauses widerspiegelt. Das Designhotel, das im Frühjahr 2004 eröffnete, versteht lässig-schönen Glanz zu verströmen. Alle Räume sind individuell eingerichtet, dominiert von einem modernen Purismus. Per Fingerabdruck öffnet sich der Sesam der Suiten. Zuvor bringt die Gäste ein futuristischer Aufzug in den richtigen Stock. Ebenso schillernd wie geschmackvoll: Bar und Restaurant des Stadt-Resorts.

« When sleeping is not enough » – Une devise conforme à son image. Cet hôtel design inauguré au printemps 2004 répand une ambiance d'élégance belle et décontractée. Toutes les chambres ont été conçues individuellement et équipées avec un purisme contemporain. Les hôtes ouvrent leurs suites à l'aide de leurs empreintes digitales, après avoir accédé à leur étage grâce à un ascenseur futuriste. Le bar et le restaurant de l'hôtel allient glamour et modernisme.

In the middle of the Marais quarter, the Murano Resort captivates with its avant-garde design.

Mitten im Marais-Viertel besticht das Murano Resort durch avantgardistisches Design.

En plein cœur du quartier du Marais, le Murano Resort brille par son design avant-gardiste.

Plaza Athénée
Paris, France

The popular Parisian interior designer Patrick Jouin redesigned the "Bar du Plaza." Ever since, it has been a must for Parisian society and a crowd-puller for the legendary hotel. This deluxe establishment, founded in 1911, is situated on Avenue Montaigne, surrounded by trendy boutiques, fine restaurants and businesses. Despite comprehensive renovation, one can still perceive the radiance of times gone by in the Plaza Athénée. Furniture and accessories in the hotel are reminiscent of the classical French style. A few of the 750-square-feet deluxe suites offer an idyllic view of the garden.

Der angesagte Pariser Designer Patrick Jouin gestaltete die „Bar du Plaza" neu. Seitdem ist sie eine Muss-Adresse für die Pariser Gesellschaft und ein Aushängeschild des legendären Hotels. Die 1911 in Betrieb genommene Luxusherberge liegt an der Avenue Montaigne, umgeben von Trendboutiquen, feinen Restaurants und Geschäftshäusern. Trotz einer umfangreichen Sanierung ist im Plaza Athénée der Glanz vergangener Zeiten zu spüren. Möbel und Accessoires im Hotel greifen den klassischen, französischen Stil auf. Einige der 70 Quadratmeter großen Deluxe-Suiten bieten einen idyllischen Blick in den Garten.

Patrick Jouin, un designer parisien renommé, a remanié le « Bar du Plaza ». Depuis lors, cette adresse est un must pour la société parisienne et sert d'image de marque à cet hôtel légendaire. Cette résidence de luxe, qui a ouvert ses portes en 1911, se trouve dans l'avenue Montaigne, entourée de boutiques au top de la tendance, de restaurants fins et d'immeubles de bureaux. Malgré les travaux d'assainissement de très grande envergure qui y ont été effectués, on ressent au Plaza Athénée la splendeur du passé. Les meubles et accessoires à l'intérieur de l'hôtel reprennent le style classique français. Certaines des grandes Suites de Luxe, d'une superficie de 70 mètres carrés, offrent une vue idyllique sur le jardin.

The elegant Plaza Athénée is situated by the famous Avenue Montaigne.

An der berühmten Avenue Montaigne liegt das elegante Plaza Athénée.

L'élégant Plaza Athénée se situe sur la célèbre avenue Montaigne.

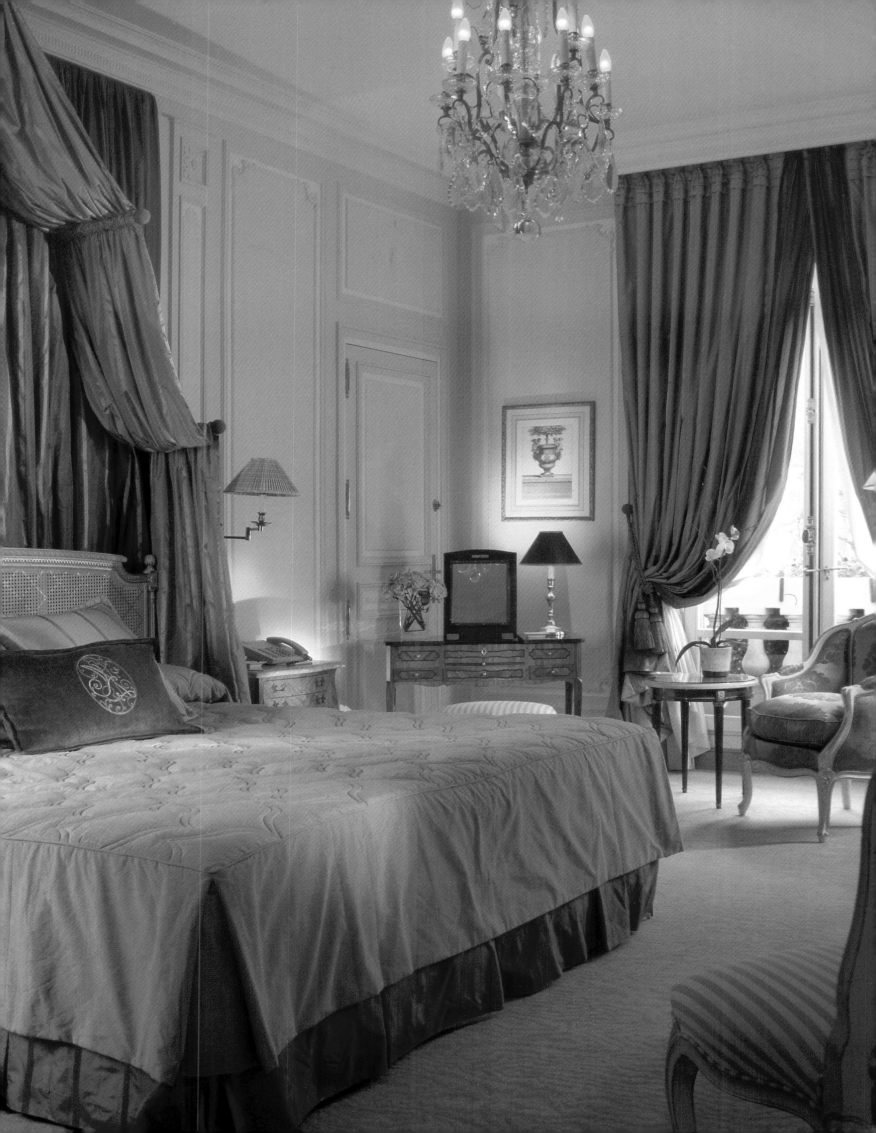

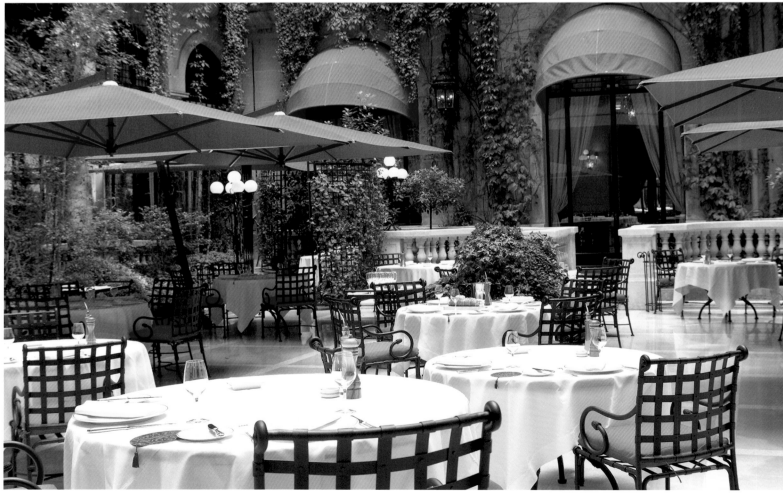

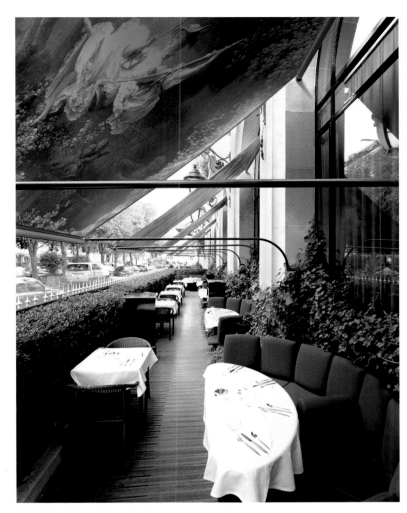

In the restaurant, guests can enjoy the cooking of famed chef Alain Ducasse.

Im Restaurant des Hauses wirkt Meisterkoch Alain Ducasse.

Le maître cuisinier Alain Ducasse est à l'œuvre dans le restaurant.

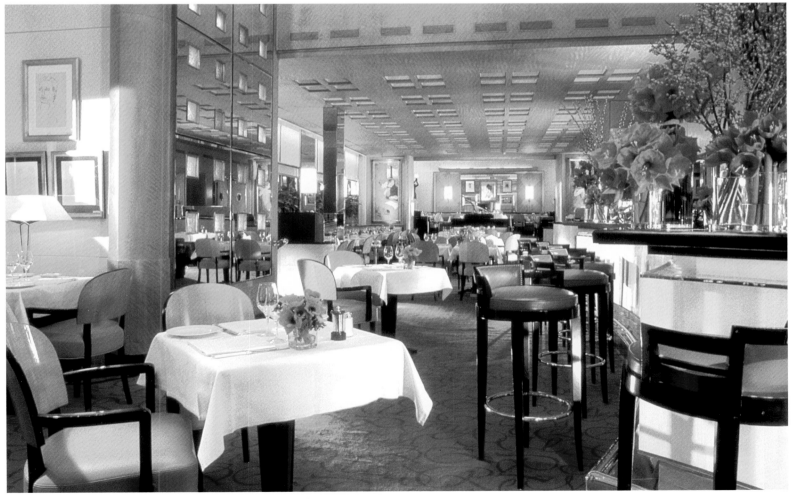

Le Meurice

Paris, France

For over two centuries already, Le Meurice can be found on the list of the world's most outstanding hotels. No wonder! The hotel resembles a palace and this can be felt from the foyer up to the very last corners of the upper floor. The style from the era of Louis XVI dominates the interior, but the hotel understands the art of facing modern demands. The 2,300-square-feet large "Belle Étoile"-Suite with its 360-degree panoramic view of Paris is unparalleled.

Mehr als zwei Jahrhunderte schon findet Le Meurice in der Liste der weltweit herausragenden Hotels Erwähnung. Das Haus gleicht einem Palast. Das ist vom Foyer bis in die letzten Winkel der obersten Etage zu spüren. Der Stil aus der Zeit Ludwig XVI. beherrscht das Interieur, doch das Haus versteht es, sich den Ansprüchen der Moderne zu stellen. Ihresgleichen sucht die 210 Quadratmeter große Belle Etoile-Suite mit ihrem 360-Grad-Panorama über Paris.

Depuis plus de deux siècles déjà, Le Meurice figure dans la liste des meilleurs hôtels du monde. Il n'y a rien de surprenant ! L'hôtel ressemble à un palais, et cela se sent du foyer jusqu'au dernier recoin du dernier étage. Le style de l'époque Louis XVI domine l'intérieur, mais le bâtiment a su s'adapter aux exigences modernes. La suite « Belle Etoile » de 210 mètres carrés, depuis laquelle on bénéficie d'une vue panoramique à 360 degrés sur Paris, n'a pas son égal.

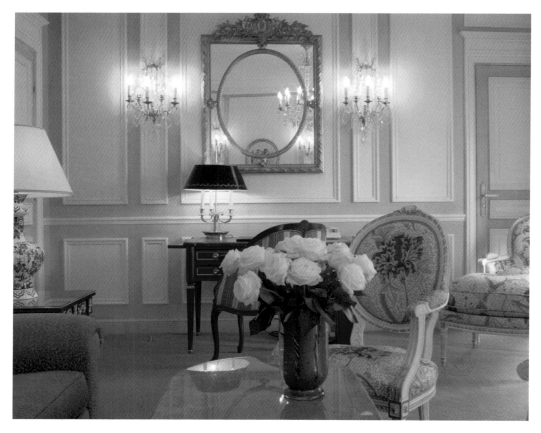

The restaurant with the tessellated floor offers first class French cuisine.

Das Restaurant mit Mosaikboden serviert erstklassige französische Küche.

Dans le restaurant au sol en mosaïque, on sert une succulente cuisine française.

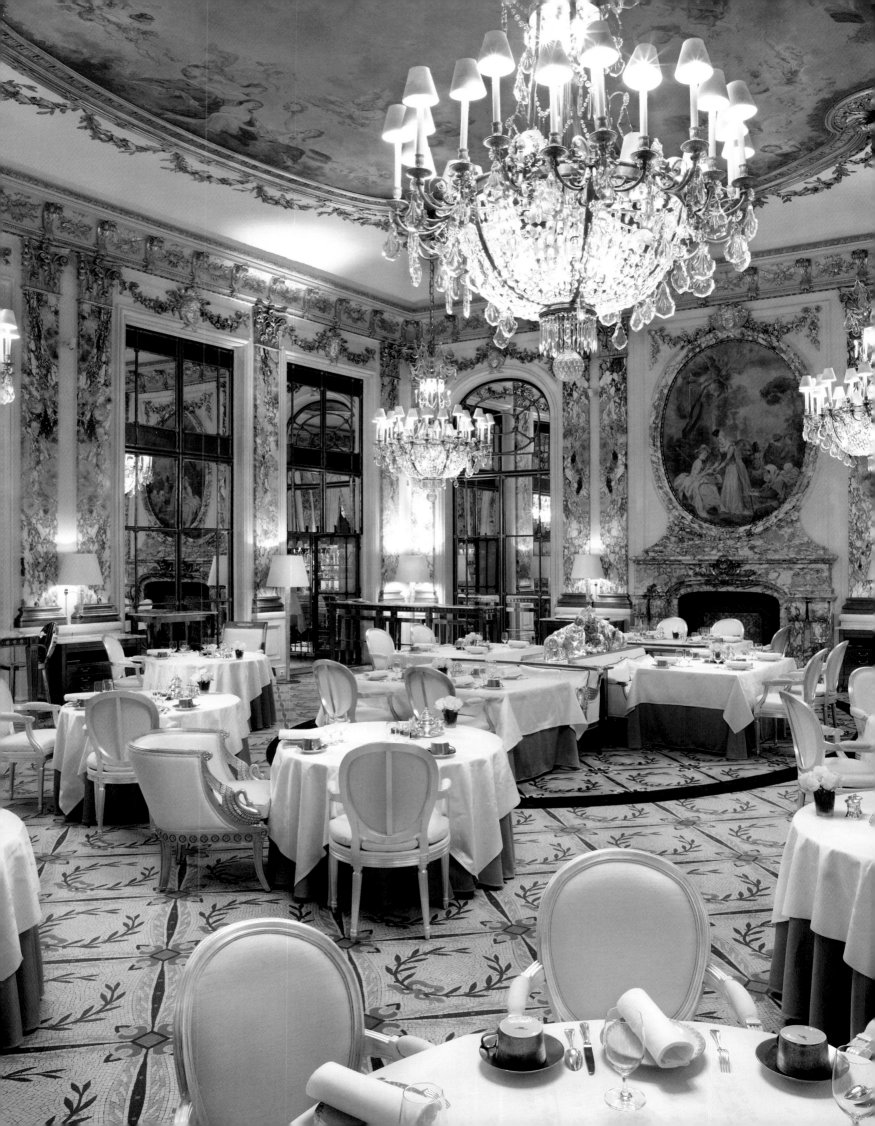

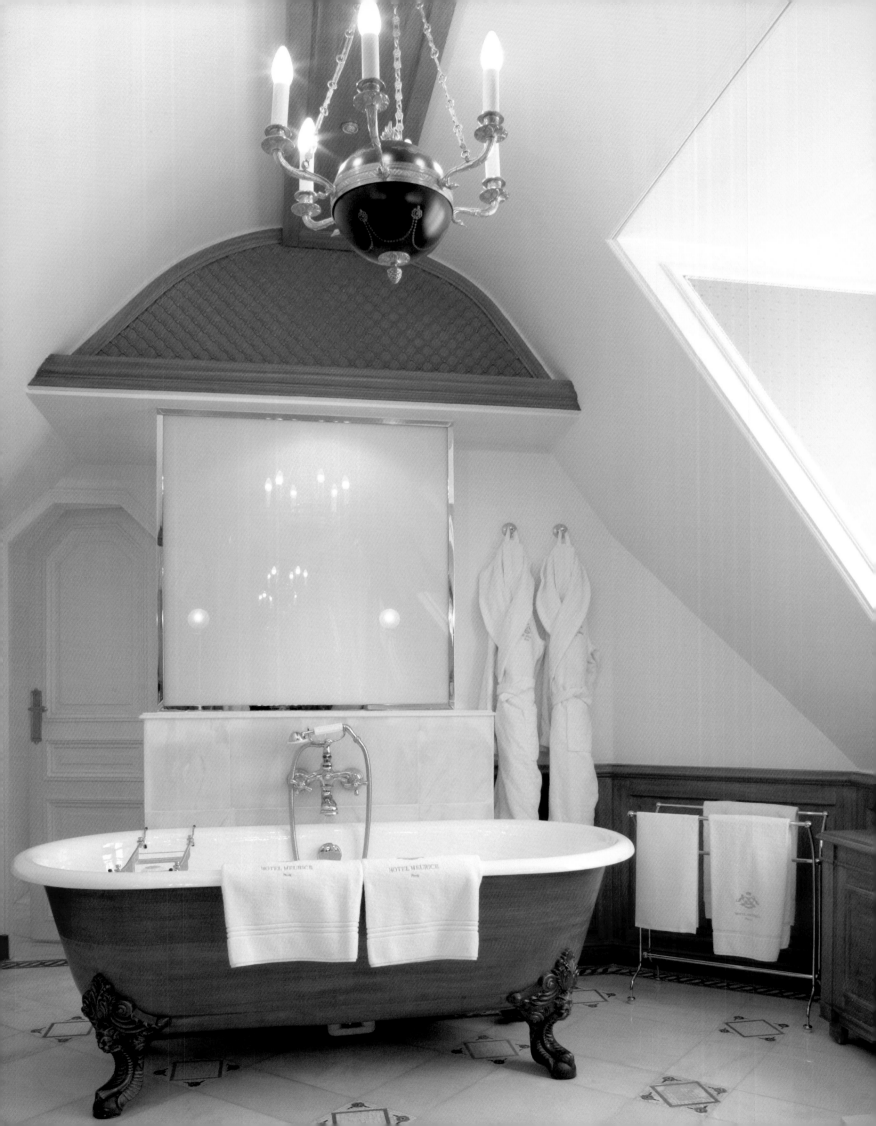

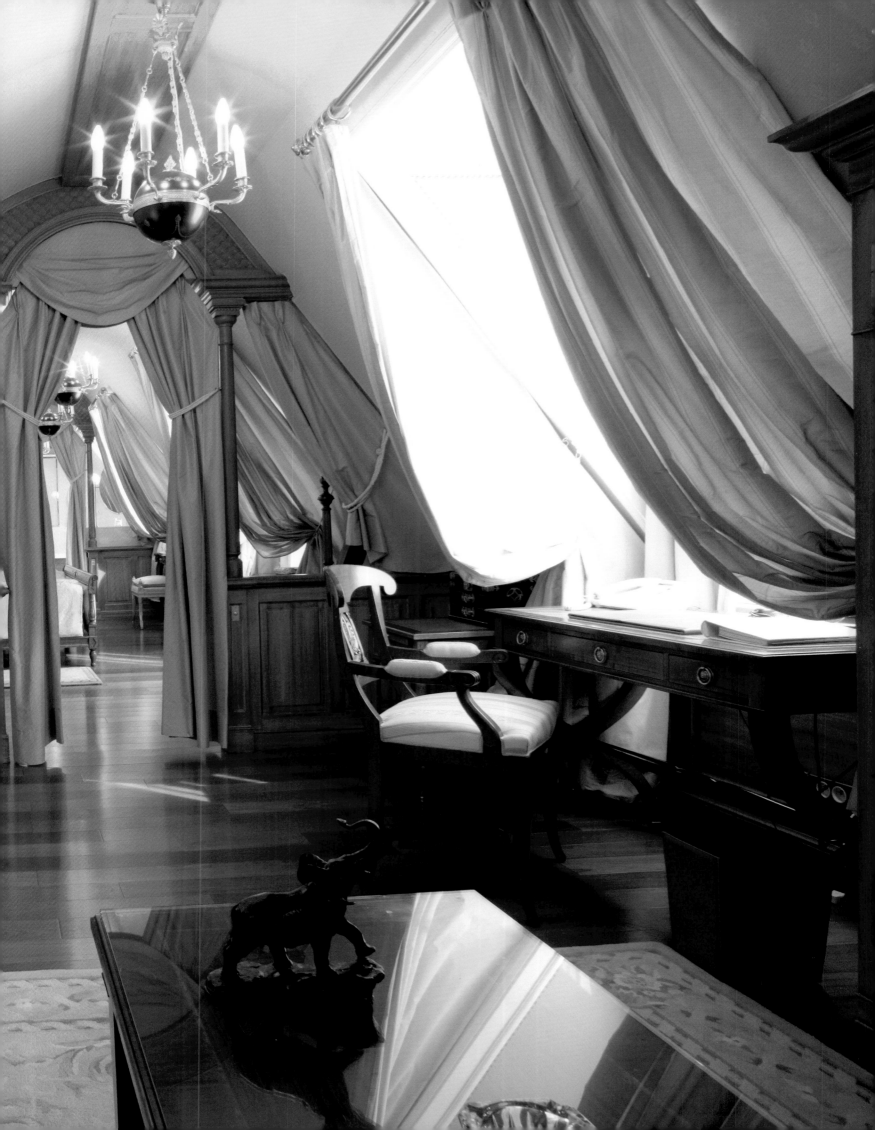

Danieli
Venice, Italy

The palazzo of the Danieli, near St. Marcus Square, dates back to the 14th century. The interior of the hotel takes guests back into time as well: artfully woven carpets, chandeliers made of Murano glass and arched slabs, adorned with gold leaf grant the Danieli a touch of the historic elegance. Not to forget: the splendid atrium, by which the 225 rooms and suites are accessible. The "Terrazza Danieli" restaurant with views of the lagoon and the Adriatic sea, serves traditional Venetian cuisine with innovative Mediterranean and Oriental touches.

Aus dem 14. Jahrhundert stammt der Palazzo des Hotel Danieli in der Nähe des Markusplatzes. Auch das Innere versetzt den Besucher in eine andere Zeit zurück: Kunstvoll gewobene Teppiche, Kronleuchter aus Murano-Glas und Deckengewölbe mit goldenem Blattschmuck verleihen dem Hotel Danieli historische Eleganz. Nicht zu vergessen: das glanzvolle Atrium, von dem aus man zu den 225 Zimmern und Suiten gelangt. Das Restaurant „Terrazza Danieli", von dem aus man Ausblicke auf die Lagune und das Adriatische Meer genießt, serviert traditionelle venezianische Küche mit innovativen, mediterranen und orientalischen Akzenten.

Situé non loin de la place Saint Marc, le palais de l'hôtel Danieli date du XIVème siècle. La décoration intérieure plonge le visiteur dans un autre temps : des tapis tissés avec brio, des lustres en verre de Murano, des plafonds voûtés ornés de feuilles d'or font toute l'élégance empreinte d'histoire de l'hôtel Danieli. La demeure possède un atrium splendide à partir duquel on accède aux 225 chambres et suites. Dans le restaurant « Terrazza Danieli » depuis lequel on peut profiter de vues superbes sur la lagune et la mer adriatique, on sert des platsvénitiens traditionnels agrémentés de nouveautés méditerranéennes et orientales.

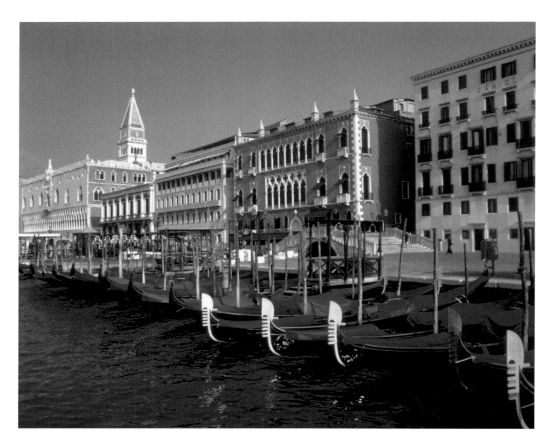

Due to its distinctive red facade, the Danieli can already be recognized from far away.

An seiner roten Fassade ist das Danieli schon von weitem zu erkennen.

Le Danieli se signale par sa façade rouge que l'on voit de loin.

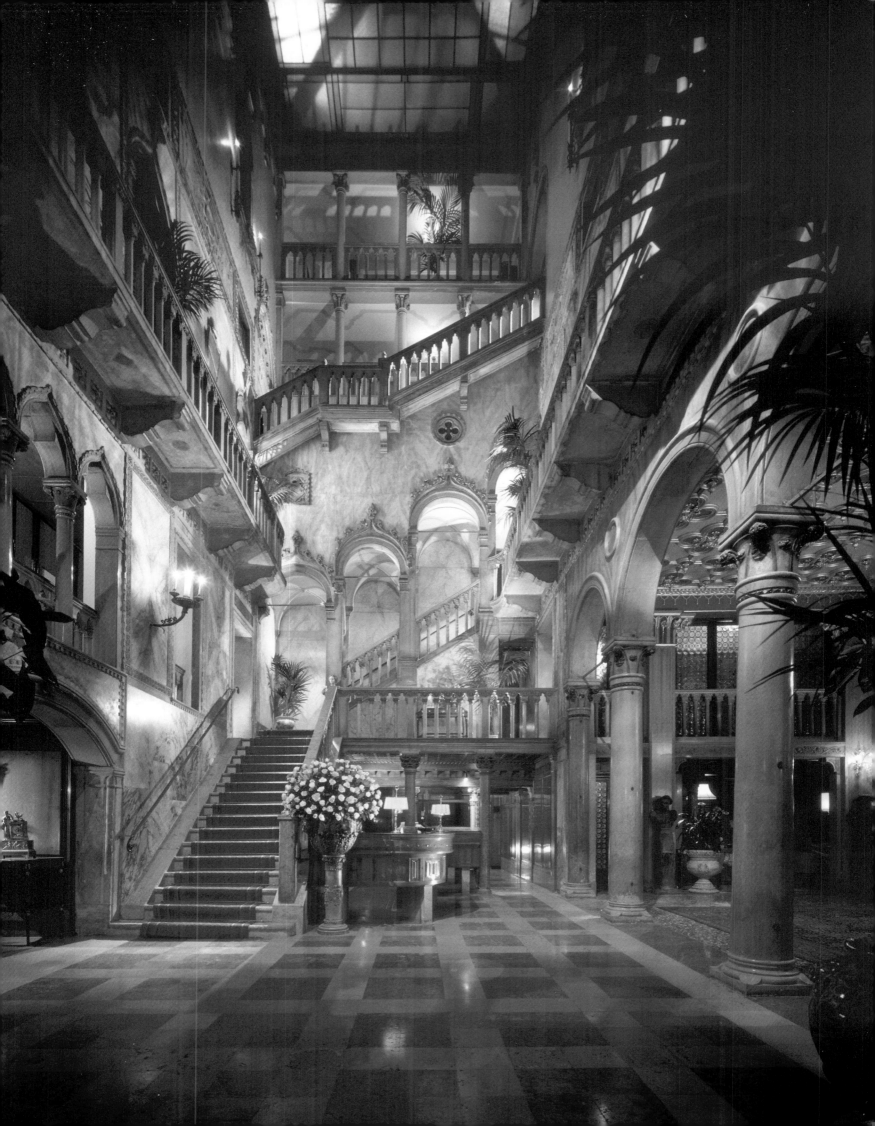

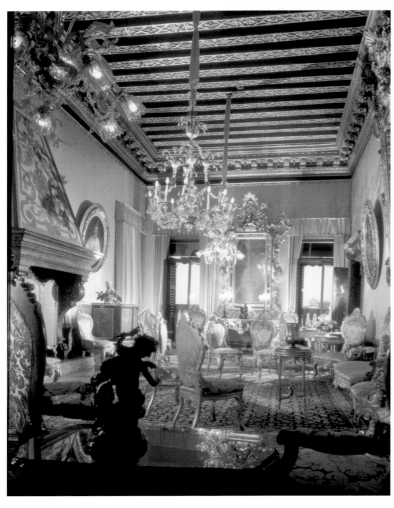
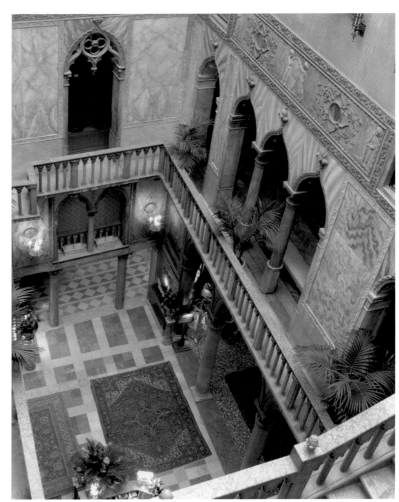
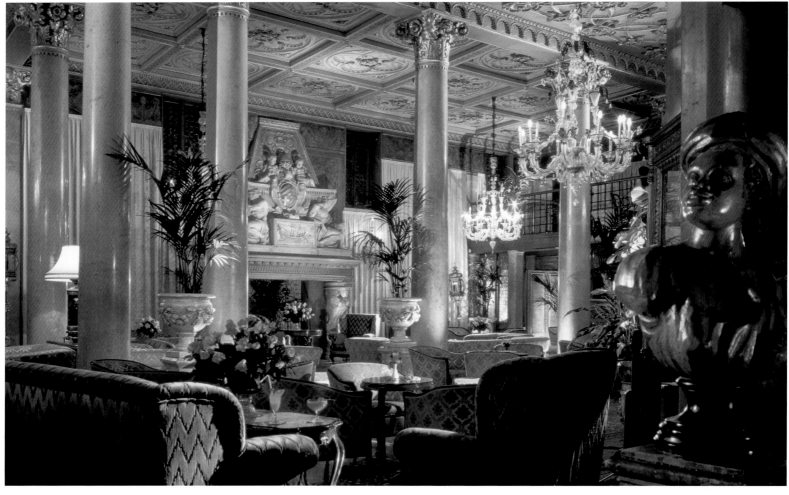

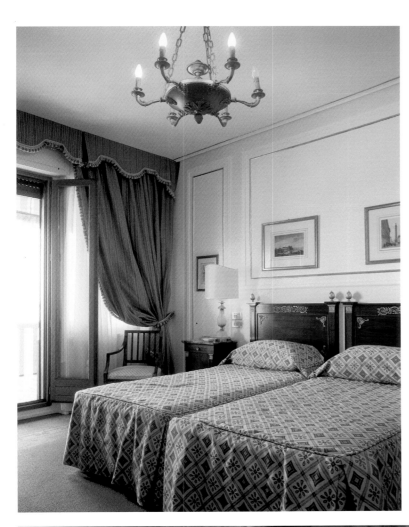

The 225 rooms and suites spread over the three wings of the palazzo.

Die 225 Zimmer und Suiten verteilen sich auf drei Flügel des Palazzo.

Les 225 chambres et suites se répartissent sur les trois ailes du palais.

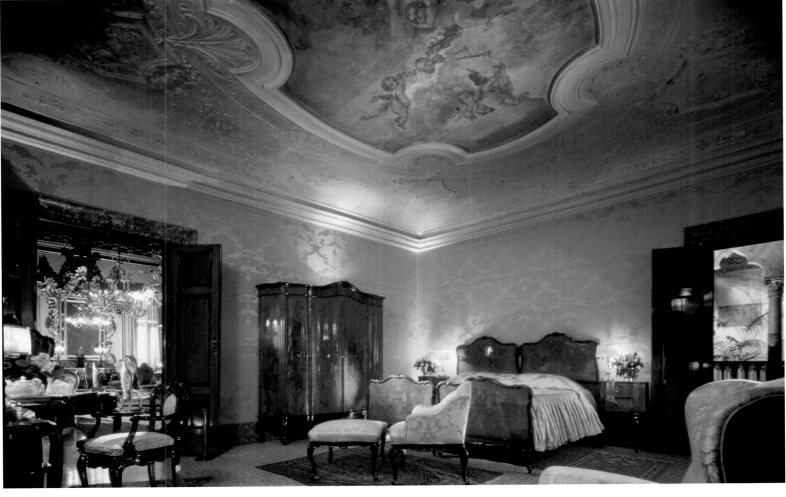

Riva Lofts
Florence, Italy

The Architect Claudio Nardi and his daughter Alice had been rebuilding an old factory near the old town of Florence for years. The result of this effort is Riva Lofts—a residence with nine studios in different sizes, all with puristic design and an elegant arrangement. Some of these studios also have private terraces or panoramic windows offering views to the Arno river and the city. The common cross vaulted living room with library and fireplace, an outdoor swimming pool and the bikes can be used by all guests.

Jahrelang hat der Architekt Claudio Nardi mit seiner Tochter Alice eine alte Fabrik in der Nähe der Florentiner Altstadt umgebaut. Daraus sind die Riva Lofts mit neun Studios in unterschiedlichen Größen entstanden, allesamt puristisch und elegant eingerichtet. Einige verfügen über eine eigene Terrasse oder über große Panoramafenster mit Blick auf den Arno und die Dächer der Stadt. Ein großzügiger Salon mit Kreuzgewölben, Bibliothek und Kamin sowie ein Außenschwimmbad stehen allen Gästen offen. Wer möchte, kann im Hotel auch Fahrräder leihen.

Pendant des années, l'architecte Claudio Nardi et sa fille se sont attachés à transformer une ancienne manufacture dans les environs de la vieille ville florentine. C'est ainsi que sont nées les Riva Lofts, dont les neuf suites, aux diverses superficies, ont été aménagées dans un style à la fois épuré et élégant. Elles disposent d'une terrasse privée ou bien d'immenses fenêtres panoramiques offrant une vue plongeante sur l'Arno ou bien la ville. Un grand salon à voûtes d'arêtes, doté d'une bibliothèque et d'une cheminée ainsi qu'une piscine extérieure et des bicyclettes sont à la disposition des hôtes.

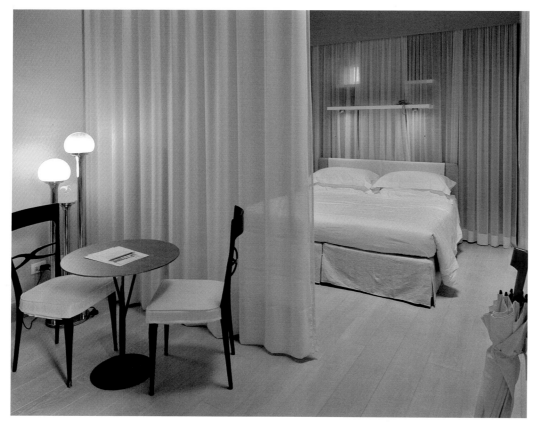

The Riva Lofts distinguish themselves with light colors and clear lines.

Helle Farben und klare Linien charakterisieren die Riva Lofts.

Des couleurs claires et des lignes limpides caractérisent les Riva Lofts.

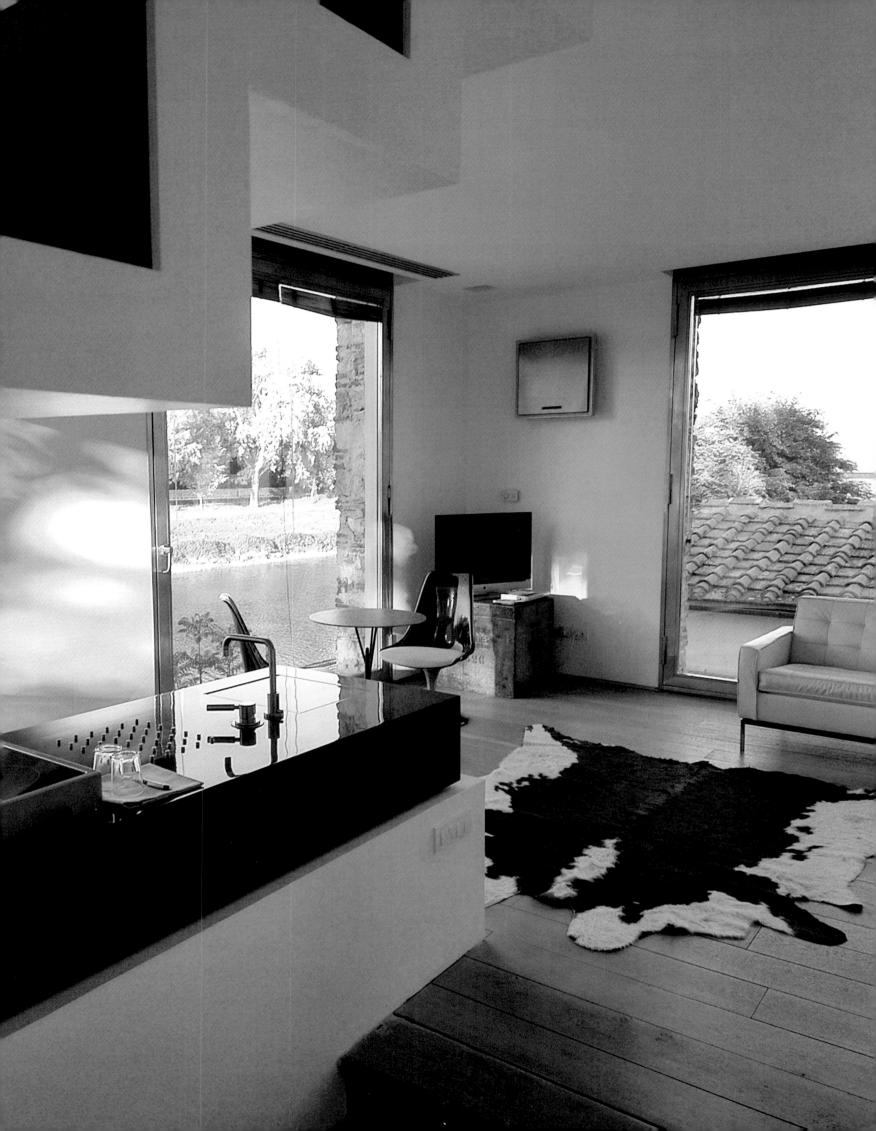

Bulgari
Milan, Italy

The design metropolis of Milan constitutes the choice of exclusive jeweler, Bulgari, for the location of his first hotel. Within walking distance of Milan's La Scala in the historic quarter of Brera and nestled in a 43,000-square-foot garden, the luxury hotel perfectly reflects the philosophy of this brand. Only heavy, precious materials were used: black marble from Zimbabwe, bronze and gold mosaics for the indoor pool. In the spa, a special lighting effect creates a particularly relaxing atmosphere.

Die Design-Metropole Mailand hat sich das exklusive Juweliershaus Bulgari als Standort für sein erstes Hotel erkoren. In Gehweite zur Mailänder Scala im historischen Stadtteil Brera, eingebettet in einen 4000 Quadratmeter großen Garten, spiegelt das Luxushotel die Philosophie der Marke wider. Verarbeitet wurden nur schwere, kostbarste Materialien: schwarzer Marmor aus Simbabwe, Bronze, Goldmosaiken für den Innenpool. Im Spa sorgt eine spezielle Lichttechnik für eine besonders entspannende Atmosphäre.

Pour son premier hôtel, le bijoutier de luxe Bulgari a choisi Milan, métropole du design. A quelques minutes de marche de la Scala, dans le quartier historique de la ville Brera, intégré dans un jardin de 4000 mètres carrés, cet hôtel de luxe reflète parfaitement la philosophie de la marque. Seuls des matériaux imposants et extrêmement précieux ont été retenus : marbre noir du Zimbabwe, bronze, mosaïques en or pour la piscine intérieure. Dans le spa, une technique de lumière spéciale crée une atmosphère particulièrement reposante.

In the lobby, a floral white couch contrasts with the black granite and Burmese teakwood.

Ein blütenweißes Sofa kontrastiert in der Lobby mit schwarzem Granit und burmesischem Teakholz.

Dans le hall, un canapé d'un blanc éclatant contraste avec le granit noir et le teck de Birmanie.

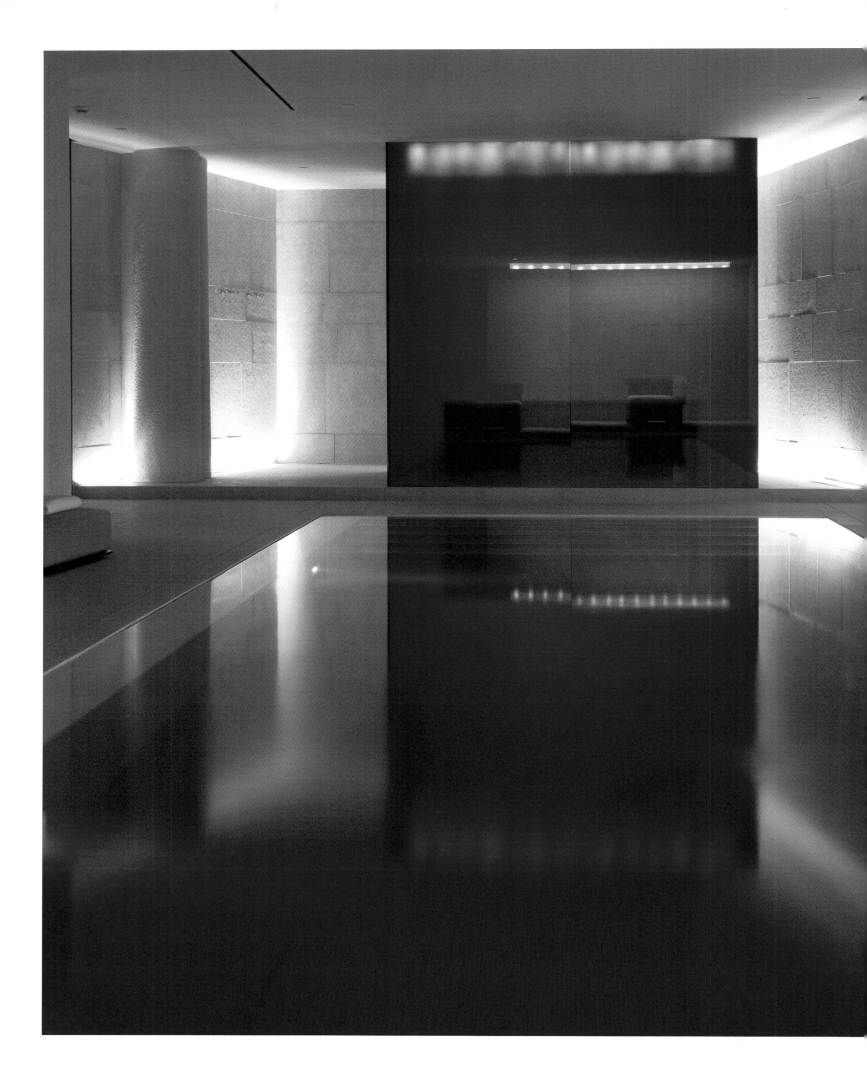

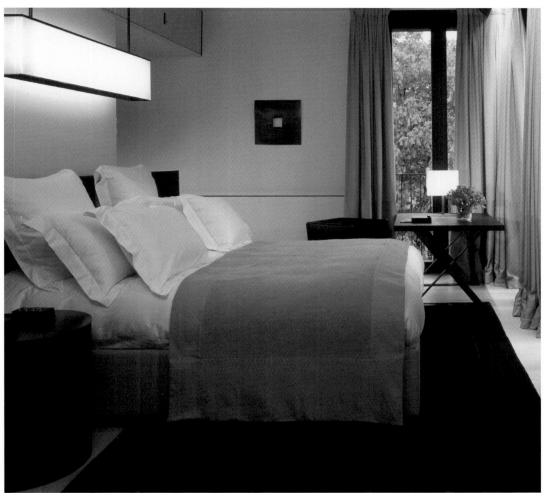

Simple elegance: the wellness area made of glass and marble.

Schlichte Eleganz: der Wellness-Bereich in Glas und Marmor.

Élégance simple : l'espace wellness en verre et en marbre.

The Chedi Milan

Milan, Italy

The Chedi Milan combines Western and Asian elements. The influences from the Far East are not only visible in the 250 tastefully decorated rooms but also in the restaurant, where Italian dishes are refined with Asian ingredients. Guests appreciate this hotel's discreet service and hospitality and can also choose to stay in one of the hotel's affiliated apartments. In early 2008, the spa was opened. The city center is accessible via bus or streetcar.

The Chedi Milan vereint westliche und asiatische Elemente. Aber nicht nur in den 250 modern und stilvoll eingerichteten Zimmern erkennt man die Einflüsse aus dem Fernen Osten – auch im Restaurant wird die italienische Küche mit asiatischen Kreationen verfeinert. Für Gäste, die den dezenten Service und die Gastfreundlichkeit des Hauses zu schätzen wissen, bietet sich ein Aufenthalt in einem der zum Hotel gehörenden Apartments an. Anfang 2008 wurde das Spa eingeweiht. Bus und Tram bringen die Gäste ins Zentrum.

The Chedi Milan est un hôtel alliant l'Occident et l'Orient. Mais l'influence de l'Extrême-Orient n'est pas seulement présente dans les 250 chambres à l'aménagement moderne et stylé. Au restaurant également, on affine la cuisine italienne de créations asiatiques. Pour ceux qui savent apprécier le service discret et l'accueil chaleureux de la maison, il est aussi possible de réserver un séjour dans l'un des appartements faisant partie de l'hôtel. Le spa de l'hôtel a été inauguré début 2008. Un réseau de trams et de bus relie les visiteurs au centre ville.

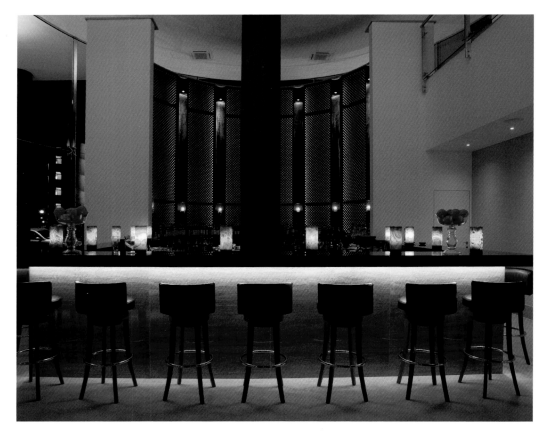

The entire decoration of the Chedi is characterized by Asian elements.

Asiatische Elemente ziehen sich durch die gesamte Einrichtung des Chedi.

Des influences asiatiques parcourent l'ensemble de l'aménagement du Chedi.

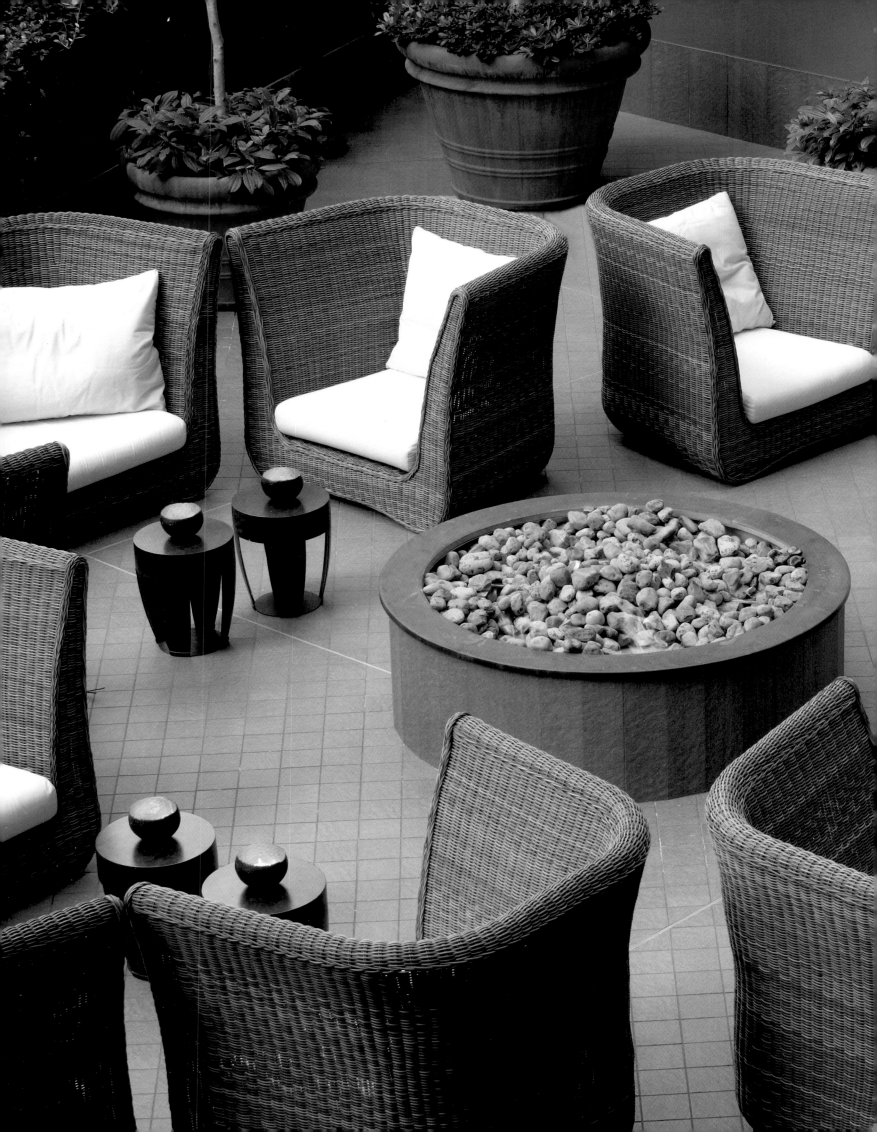

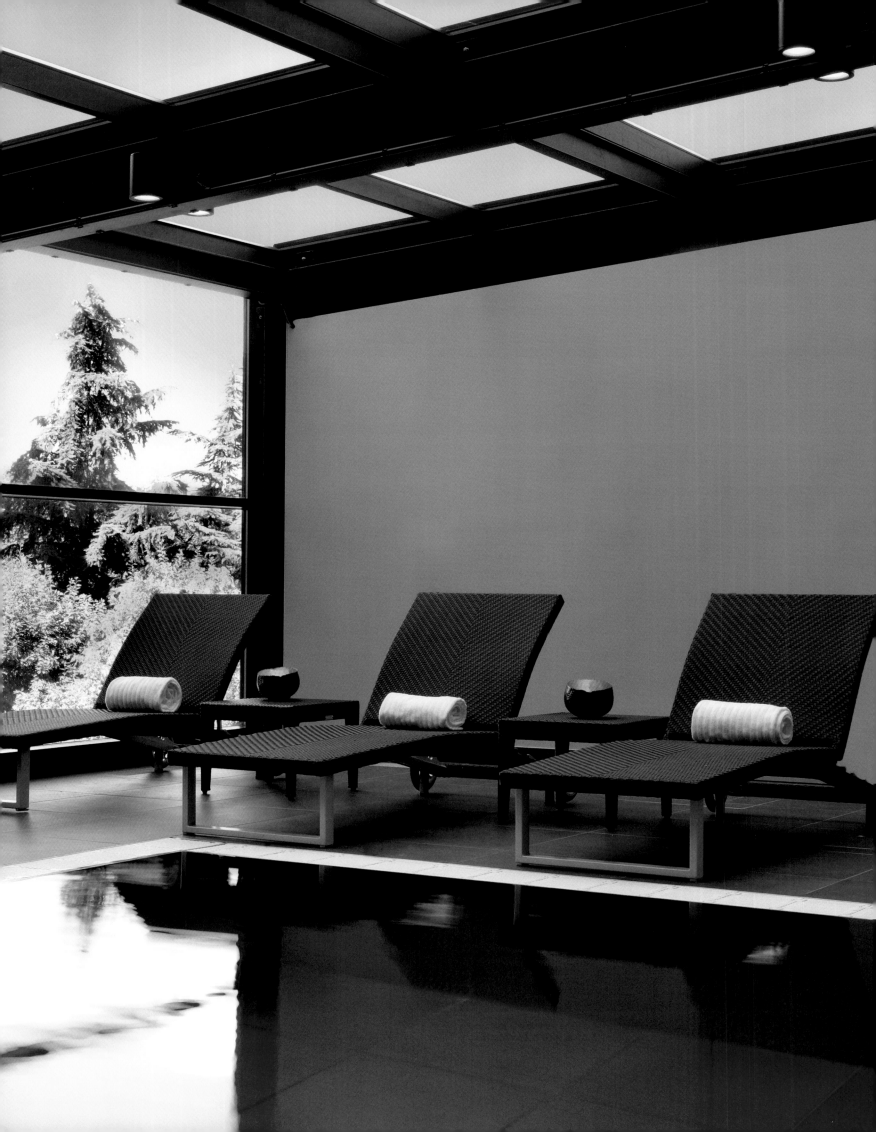

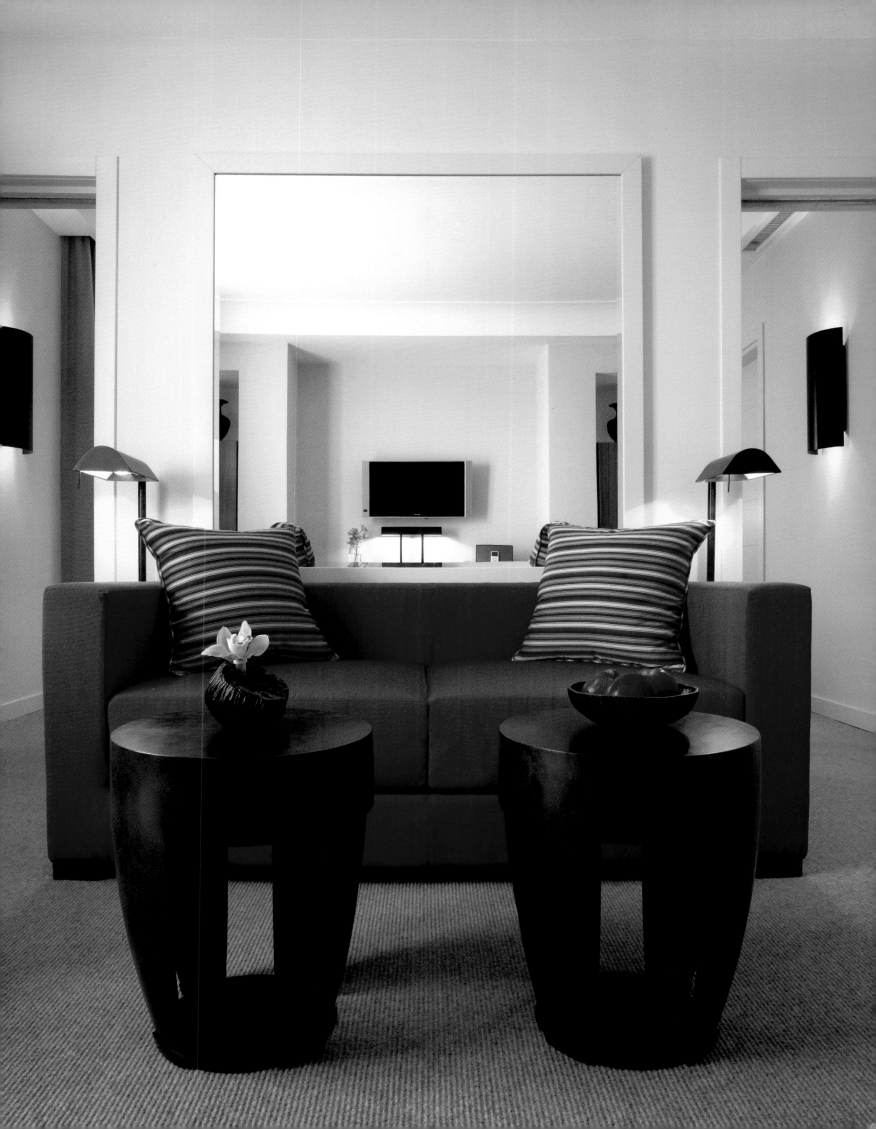

Town House Galleria

Milan, Italy

Located in the heart of the historic Galleria Vittorio Emanuele II, the Town House Galleria has 25 individually arranged suites, spreading over two floors. The sumptuously adorned windows and hand-painted arched slab were carefully restored. Because the hotel is being approved the first seven-star hotel of the world, the service is of course flawless. Every suite is attended by its own butler; and a personal driver for shopping sprees in Milan is also available.

Zentraler geht es nicht: Im Herzen der historischen Galleria Vittorio Emanuele II liegt das Town House Galleria. 25 individuell eingerichtete Suiten verteilen sich auf zwei Ebenen. Die prunkvoll eingefassten Fenster und die handbemalte, gewölbte Decke wurden sorgfältig restauriert. Und weil das Haus als das erste offizielle Sieben-Sterne-Hotel der Welt anerkannt ist, lässt auch der Service keine Wünsche offen: Jede Suite wird von einem Butler betreut, für Shoppingtouren in Mailand steht ein Chauffeur zur Verfügung.

Vous ne pourrez pas trouver plus central : c'est au cœur de la galerie historique Galleria Vittorio Emanuele II que se trouve le Town House Galleria. Les 25 suites, aménagées de façon personnalisée, se répartissent sur deux étages. Les fenêtres joliment encadrées et le plafond voûté peint à la main ont été soigneusement restaurés. Et parce que la maison est le premier hôtel auquel on a officiellement attribué sept étoiles, le moindre de vos désirs sera réalisé : chaque suite a son propre majordome et, pour vos tours de shopping, un chauffeur est mis à votre disposition.

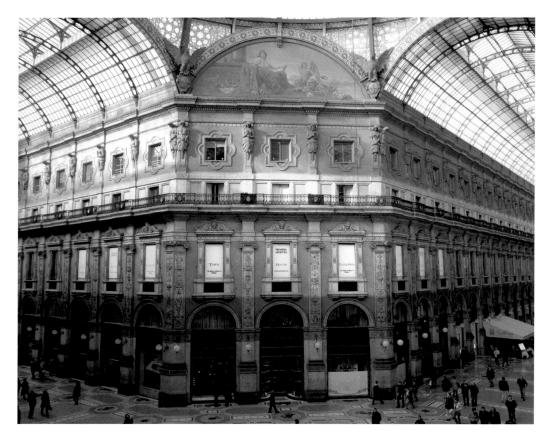

The Town House Galleria is situated in the middle of the historic shopping arcade built in the year 1876.

Das Town House Galleria liegt inmitten der historischen Einkaufspassage von 1876.

L'hôtel Town House Galleria se situe au cœur de la galerie marchande historique de 1876.

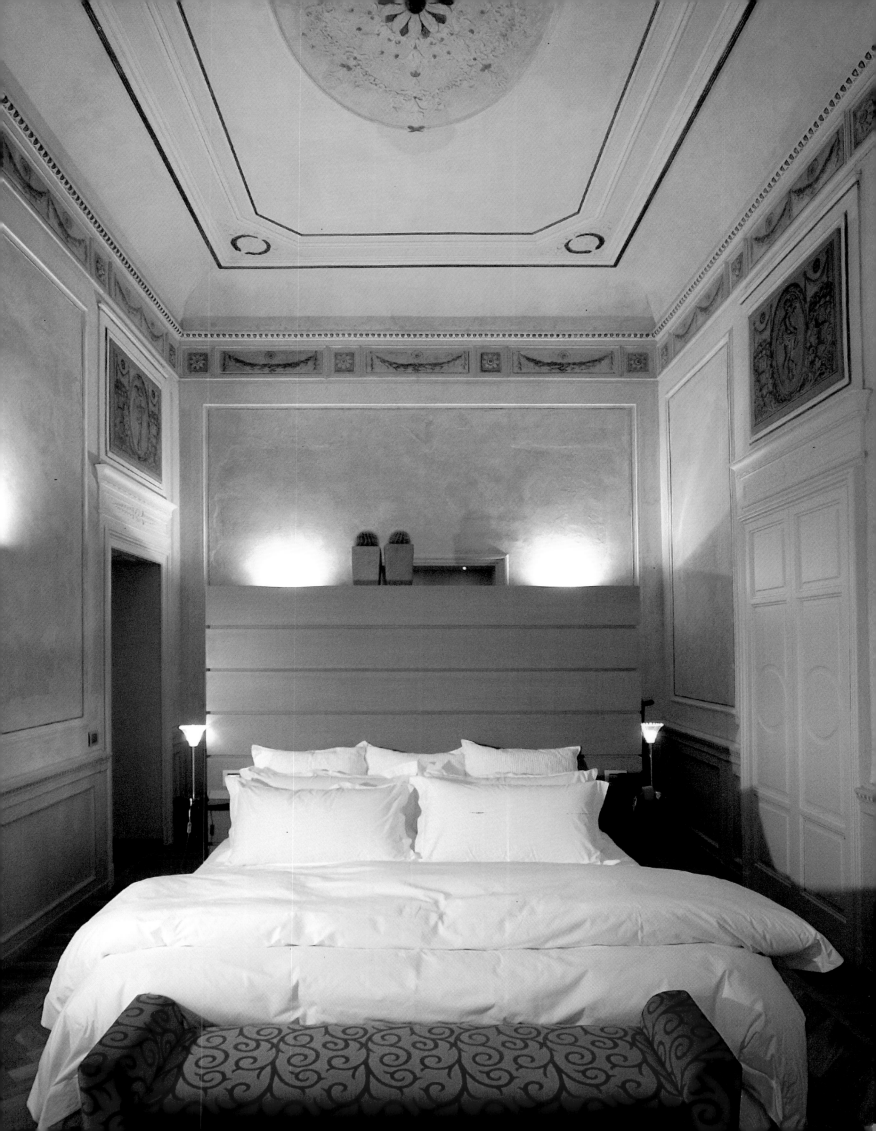

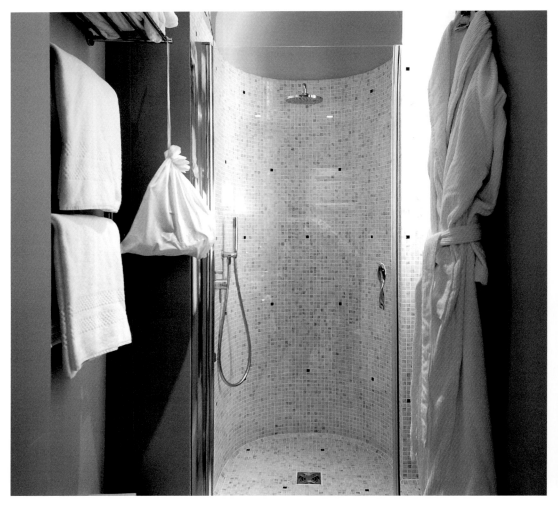

The bathrooms are adorned with marble and tesserae.

Die Bäder sind mit Marmor und Mosaiksteinchen verkleidet.

Les salles de bains sont recouvertes de marbre et de mosaïques.

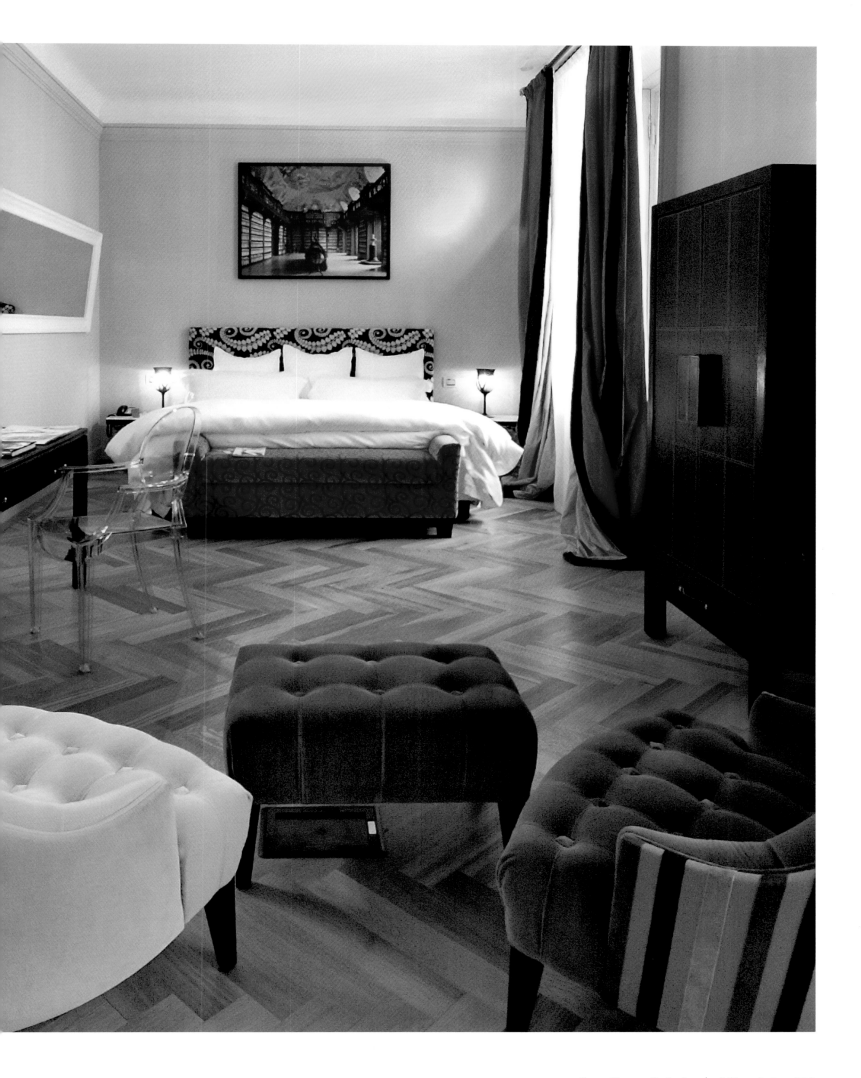

Exedra
Rome, Italy

Situated directly at the Piazza della Repubblica and opposite the ancient Diocletian thermae, the five-star hotel Exedra was established in a 19th-century palazzo. Soft lighting and warm, golden colors dominate the interior of the hotel, which is always decorated with fresh flowers: The 238 rooms, on the other hand, have a quite contemporary design. From the bar or the swimming pool on the roof terrace guests, can enjoy an unobstructed view across the heart of the Eternal City.

Direkt an der Piazza della Repubblica und gegenüber den antiken Diokletians-Thermen liegt das Fünf-Sterne-Hotel Exedra in einem Palazzo aus dem 19. Jahrhundert. Zartes Licht und warme, goldene Farben prägen das stets mit frischen Blumen dekorierte Innere. Die 238 Zimmer sind dagegen modern eingerichtet. Von der Bar und dem Schwimmbad auf der Dachterrasse genießt man einen unverstellten Blick auf das Zentrum der Ewigen Stadt.

L'hôtel cinq étoiles Exedra, aménagé dans un palais datant du XIXème siècle, se situe sur la Piazza della Repubblica, juste en face des thermes antiques de Dioclétien. Des lumières tamisées, des teintes chaleureuses et dorées caractérisent l'intérieur, lequel est en permanence orné de fleurs fraîches. Les 238 chambres sont, par contre, aménagées de façon assez moderne. Là, du bar et de la piscine sur la terrasse au toit vous apprécierez une vue incomparable sur le centre de la Ville éternelle.

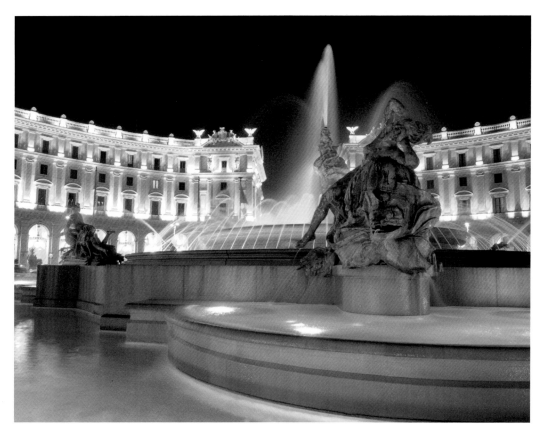

A gleam by the Piazza della Repubblica: the Exedra.

An der Piazza della Repubblica erstrahlt das Exedra.

Piazza della Repubblica, voilà où brille l'Exedra.

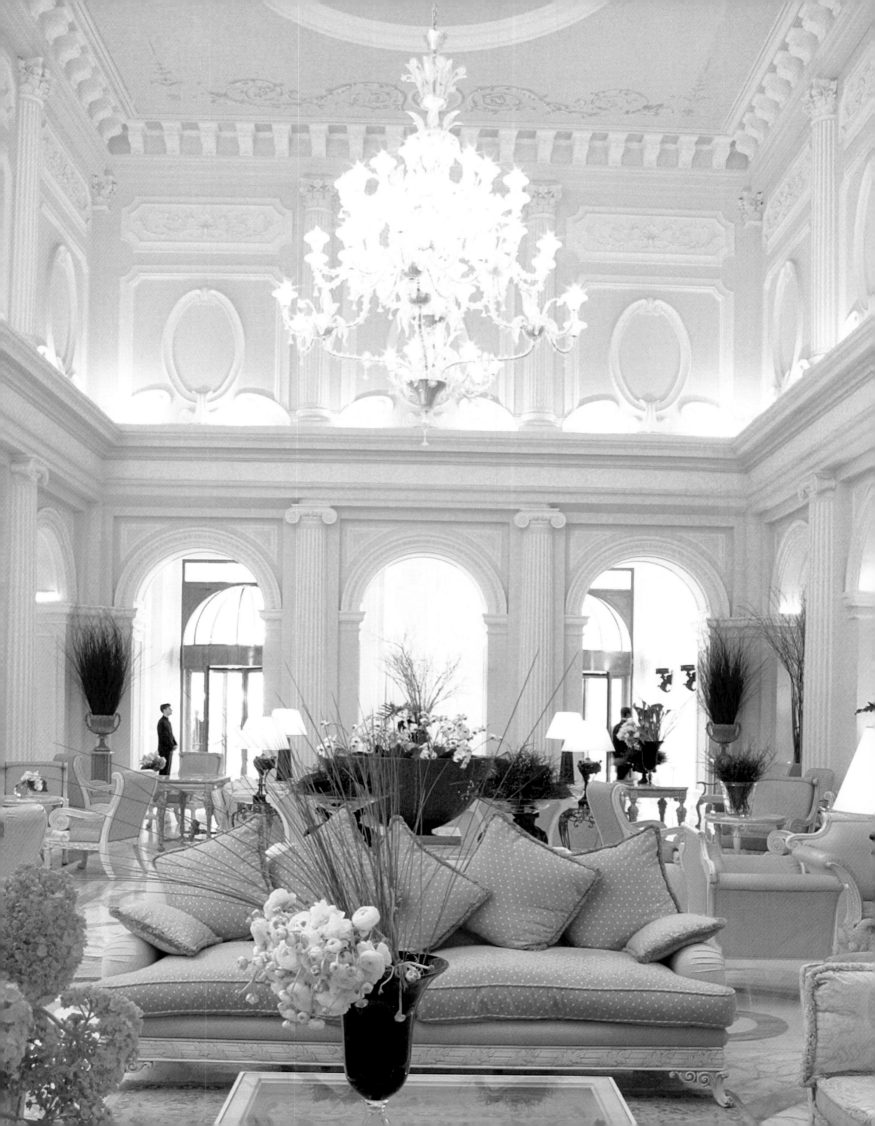

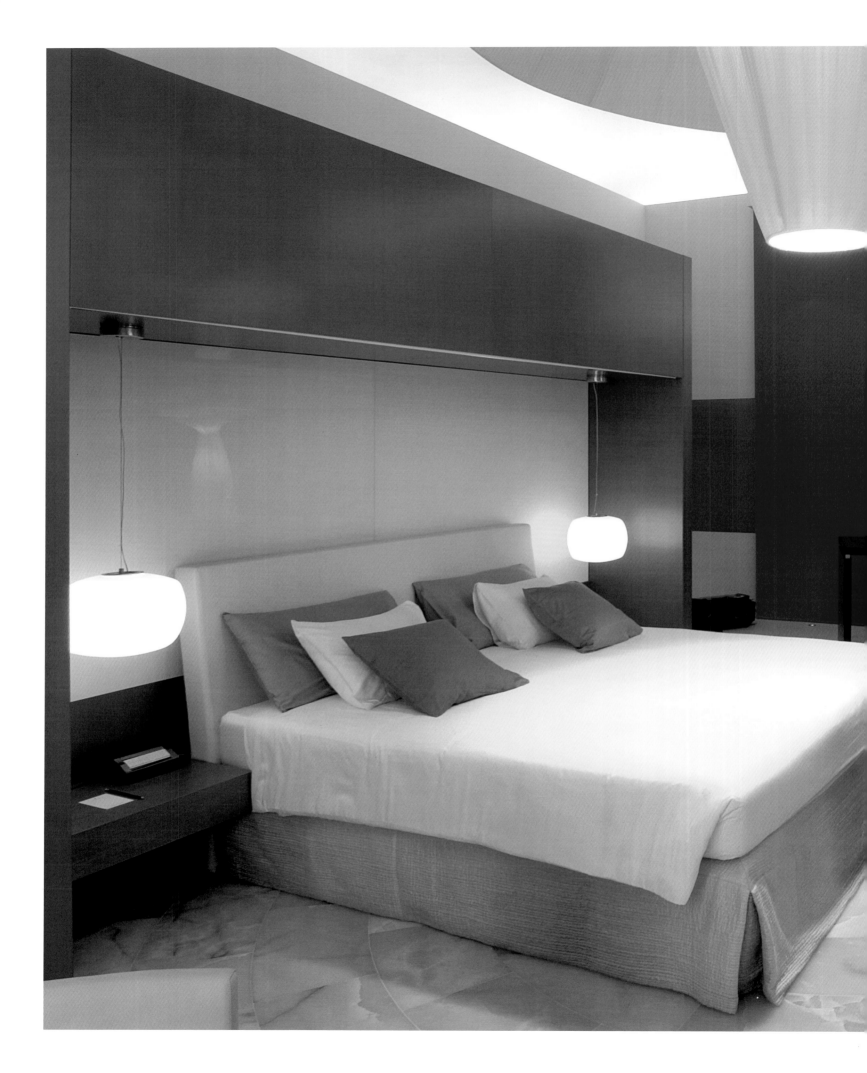

In the spacious rooms, an elegant atmosphere is created by selected Italian furniture.

Ausgesuchte italienische Möbel sorgen in den großen Zimmern für ein elegantes Ambiente.

Dans les chambres spacieuses, de fins meubles italiens créent une atmosphère élégante.

Hotel de Russie

Rome, Italy

Near the Spanish Steps in the center of Rome but nevertheless in a quiet area, is the location of the Hotel de Russie. On the back of this five-star hotel, there is a secluded garden, where meals are served in the summer. In the light-flooded interior of the house, materials and colors, added by contemporary sculptures, have been carefully complemented. Some of the 122 rooms have a terrace or a balcony with a view of the busy Piazza del Popolo. The bathrooms are adorned with mosaic tiles.

Ganz in der Nähe der Spanischen Treppe im Zentrum Roms und trotzdem absolut ruhig liegt das Hotel de Russie. Das Fünf-Sterne-Haus hat auf seiner Rückseite einen geschützten Garten, in dem im Sommer das Essen serviert wird. Im lichtdurchfluteten Innern des Hauses sind Materialien und Farben sorgfältig aufeinander abgestimmt und durch moderne Skulpturen ergänzt. Einige der 122 Zimmer verfügen über eine Terrasse oder über einen Balkon zur belebten Piazza del Popolo hinaus; die Bäder sind mit Mosaiken gestaltet.

L'hôtel de Russie est un hôtel absolument calme même s'il se situe en plein centre de Rome, près des escaliers espagnols. De plus, cet hôtel cinq étoiles possède de l'autre côté du bâtiment un jardin protégé où, en été, sont servis les repas. À l'intérieur de l'édifice baigné de lumière, l'alliance soigneusement choisie de matériaux et de teintes côtoie des sculptures modernes. Quelques-unes des 122 chambres disposent d'une terrasse ou d'un balcon donnant sur la vivante Piazza del Popolo. Les salles de bains sont ornées de mosaïques.

Some of the rooms, decorated in light colors, have a separate balcony.

Einige der hell eingerichteten Zimmer haben einen eigenen Balkon.

Quelques-unes des chambres aménagées aux tons clairs disposent de leur propre balcon.

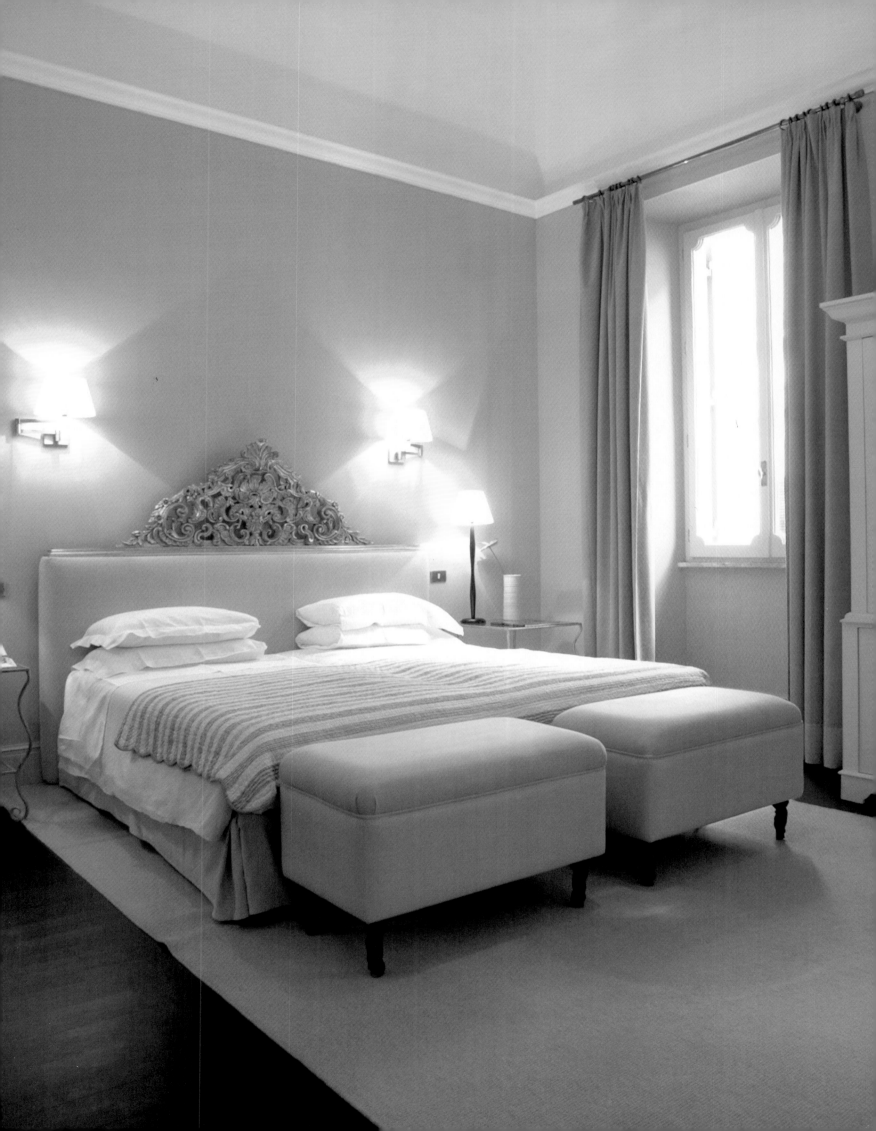

Hotel Raphaël
Rome, Italy

The Hotel Raphaël is within walking distance of the busy Piazza Navona. Its entrance is, however, quite hard to find because the facade is overgrown with ivy. Inside, the hotel boasts an almost museum-like arrangement: among other objects of art, a precious collection of Picasso ceramics belongs to the very own treasures of the hotel. Some of the 54 rooms were designed by the star architect Richard Meier. Some of the rooms have a balcony, but the roof terrace offers the best vista of the roofs and domes of the eternal city.

Nur wenige Schritte von der belebten Piazza Navona entfernt liegt das Hotel Raphaël. Allerdings ist sein Eingang wegen der efeubewachsenen Fassade leicht zu übersehen. Im Inneren empfängt den Gast eine fast schon museale Einrichtung: Sogar eine wertvolle Sammlung von Keramiken Picassos zählt zu den Schätzen des Hauses. Einige der 54 Zimmer sind von Stararchitekt Richard Meier entworfen worden; manche haben einen Balkon. Die beste Aussicht über Dächer und Kuppeln der Ewigen Stadt bietet jedoch die Dachterrasse.

L'Hotel Raphaël se situe à quelques pas seulement de l'animée Piazza Navona. Vous pourrez cependant facilement ne pas en voir l'entrée à cause de sa façade entièrement recouverte de lierre. À l'intérieur vous attend un décor digne d'un musée : une collection de céramiques de Picasso fait même partie des trésors de la maison. Quelques-unes des 54 chambres ont été conçues par le célèbre architecte Richard Meier ; certaines disposent d'un balcon. C'est cependant la terrasse panoramique sur le toit de l'hôtel qui offre la meilleure vue sur les toits et les coupoles de la Ville éternelle.

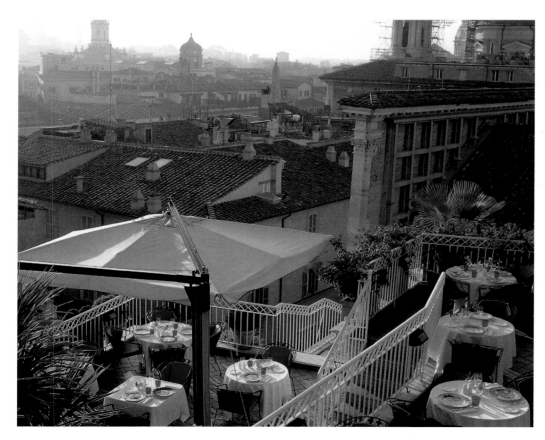

The restaurant on the roof terrace offers an impressive vista of Rome.

Das Restaurant auf der Dachterrasse gewährt einen eindrucksvollen Blick über Rom.

Le restaurant sur la terrasse de toit offre une vue impressionnante sur Rome.

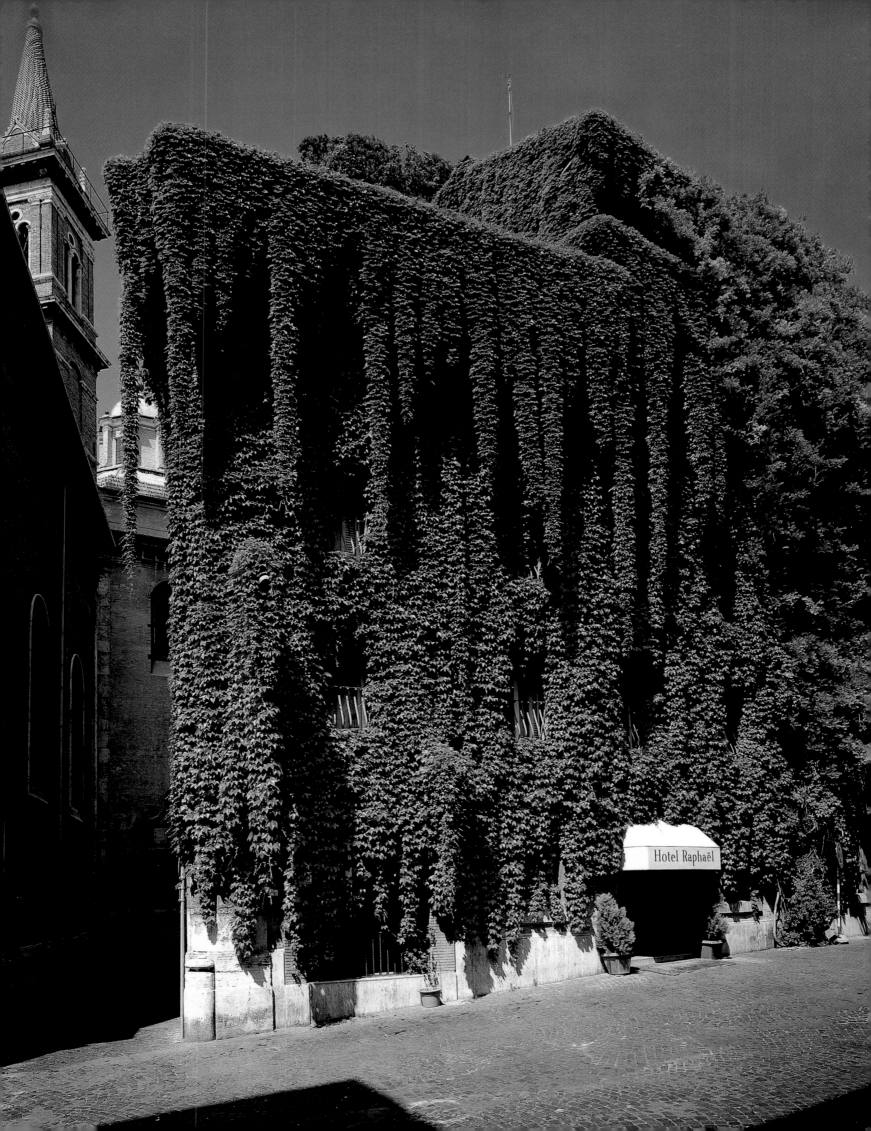

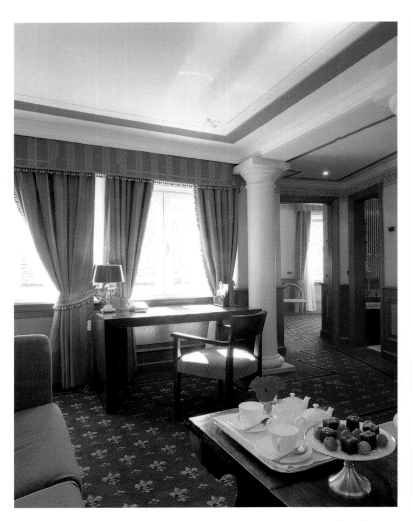
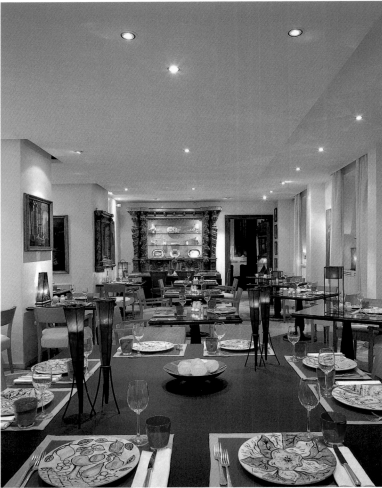
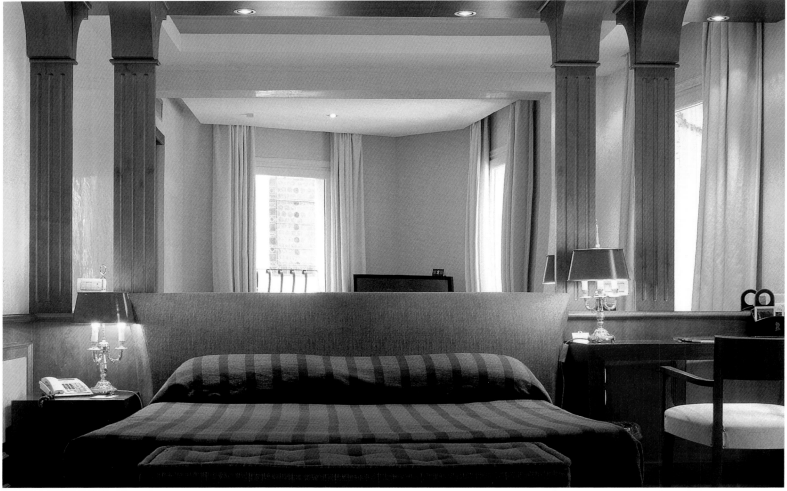

The rooms on the third floor of the hotel were designed by the architect Richard Meier.

Die Zimmer im dritten Stock des Hotels hat der Architekt Richard Meier entworfen.

Les chambres au troisième étage ont été conçues par l'architecte Richard Meier.

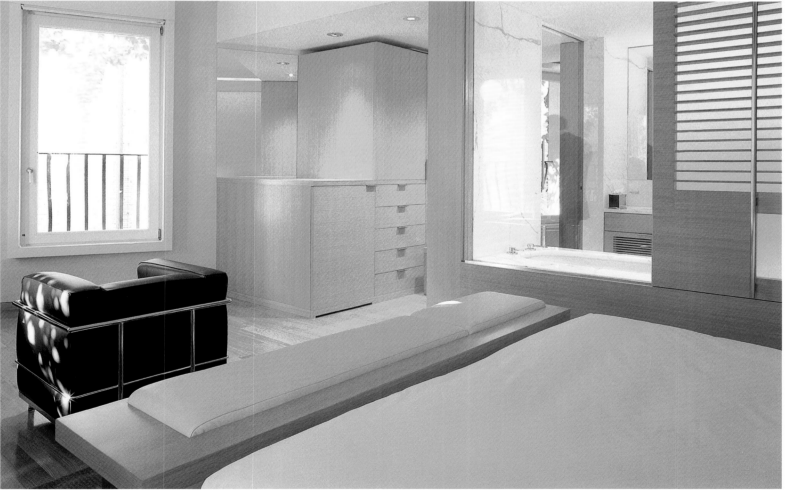

Palacio del Bailio

Cordoba, Spain

Located right in the middle of Cordoba's Old Town, the Palacio del Bailio was established in a 16th-century palace. In the 1980s, this castle was declared a World Heritage Site because of remains of the Roman times in the courtyard, Moorish archways, impressive frescos and precious paintings in 53 rooms which were carefully restored and complemented by the elegant furniture in natural colors. It is a successful symbiosis of the past and the present.

Mitten in Cordobas Altstadt liegt das Hotel Palacio del Bailio in einem ehemaligen Palast aus dem 16. Jahrhundert. Dieser wurde in den Achtziger Jahren zum Weltkulturerbe erklärt, und das nicht ohne Grund: Überreste aus der Römerzeit im Innenhof, maurische Bogengänge sowie große Fresken und wertvolle Gemälde in den 53 Zimmern wurden sorgfältig restauriert und durch stilvolle Möbel in Naturtönen ergänzt – eine gelungene Symbiose aus Vergangenheit und Gegenwart.

En plein cœur de la vieille ville de Cordoue se situe l'hôtel Palacio del Bailio, aménagé dans un ancien palais datant du XVIème siècle. Celui-ci fut, dans les années 80, déclaré patrimoine mondial culturel et ce, à juste titre : vestiges datant de l'époque romaine, arcades mauresques, grandes fresques et peintures de grande valeur furent soigneusement restaurés dans les 53 chambres et complétés par des meubles de style aux teintes naturelles – une symbiose réussie entre passé et présent.

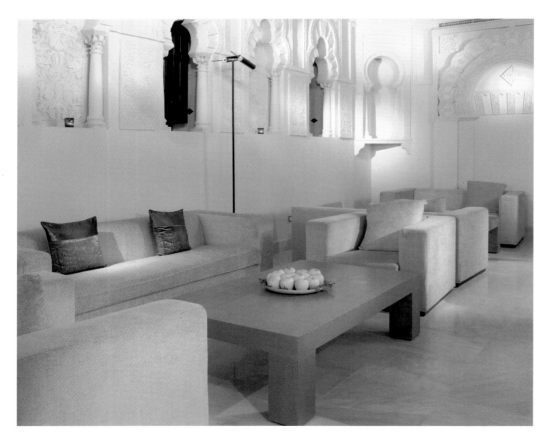

Moorish archways extend throughout the whole property.

Maurische Bogengänge ziehen sich durch das gesamte Anwesen.

Les arcades mauresques, élément récurrent de la propriété.

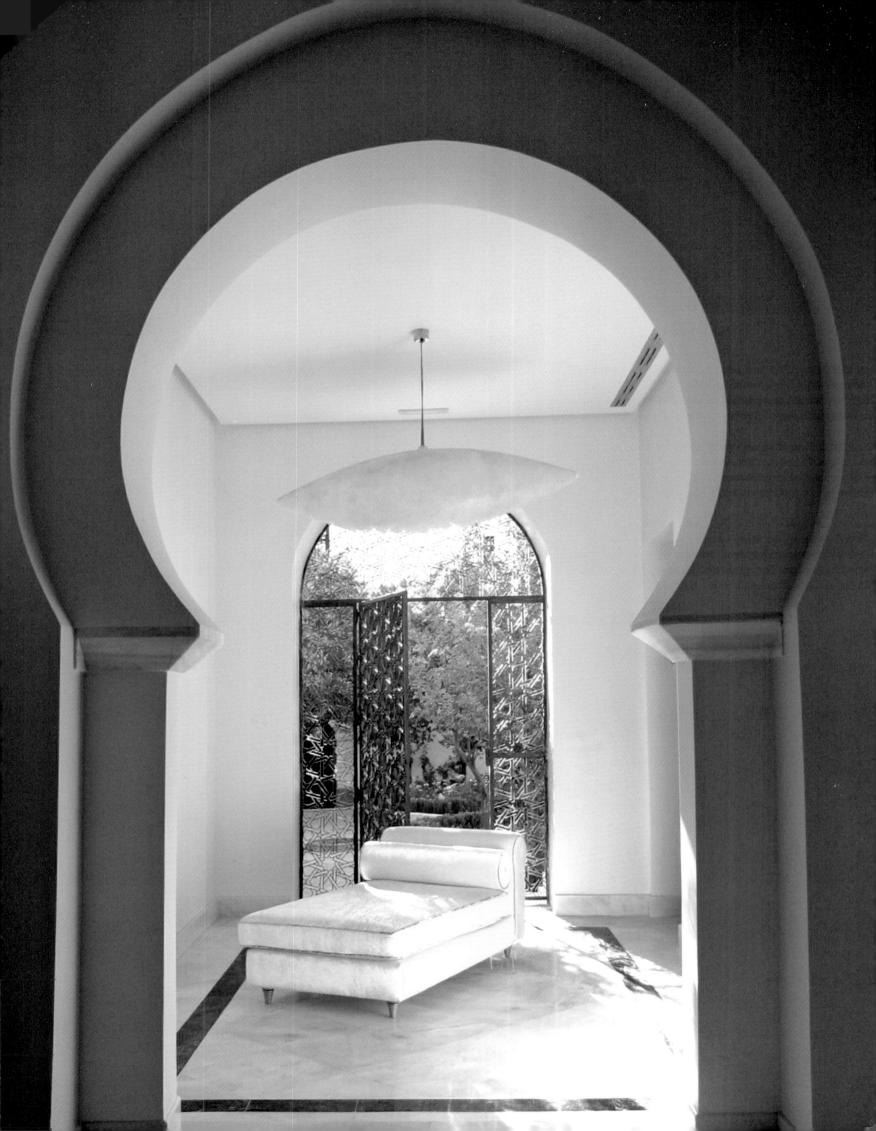

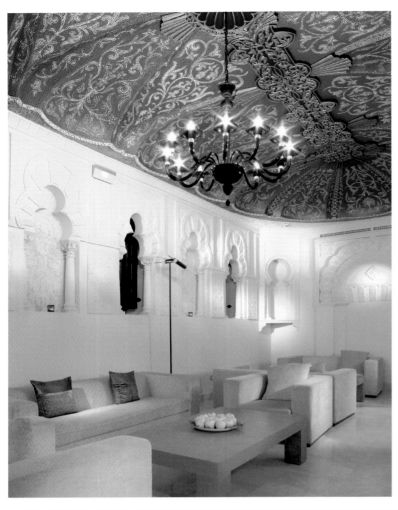

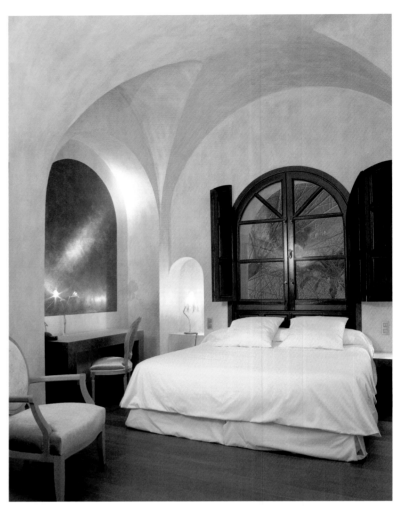

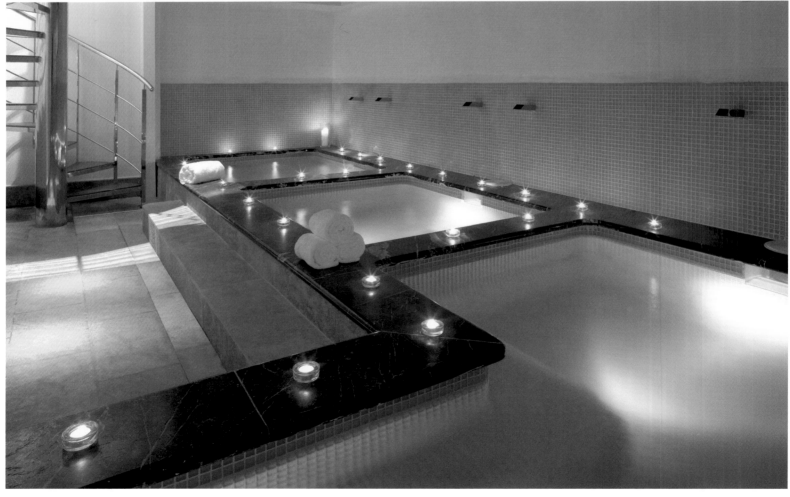

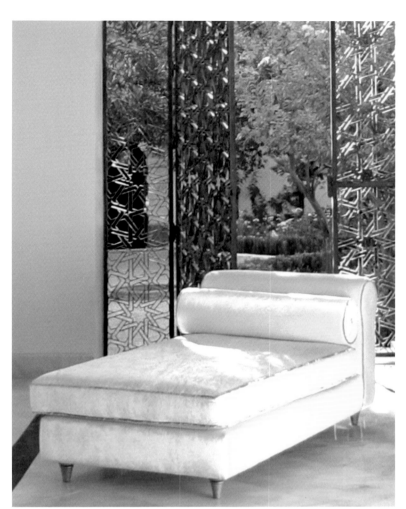

Classy private rooms with a view of the garden await their guests.

Zum Garten hin warten stilvolle Séparées auf die Gäste.

Vers le jardin, des chambres privées au style remarquable attendent les hôtes.

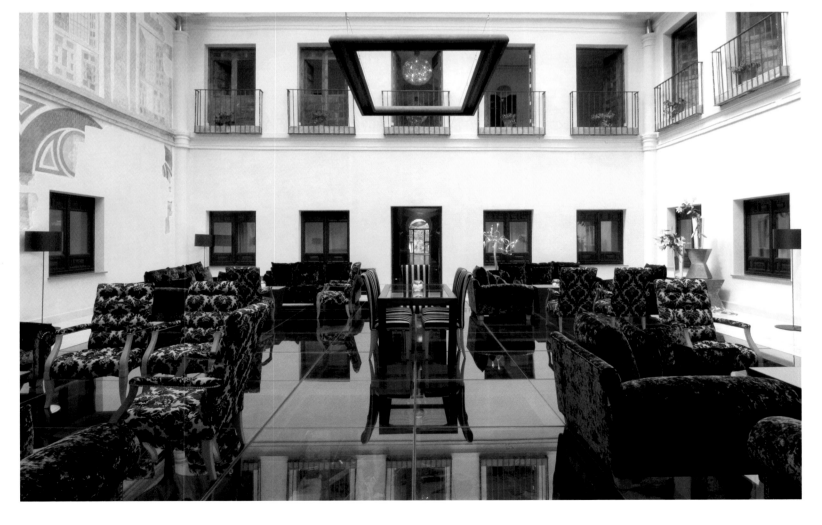

Casa Fuster
Barcelona, Spain

The art nouveau palace Casa Fuster, established in 1908, had been carefully restored in order to be opened up as a five-star hotel in the year 2000. A mixture of traditional and contemporary arrangements characterizes the hotel's interior and its 96 rooms; clean lines and warm colors provide a harmonic ambience. The property is situated on the highest point of the modernistic residential and business district Eixample. From the roof terrace, guests are offered a fantastic view across the city all the way to the ocean. A small swimming pool is situated on the roof as well.

Liebevoll war der im Jahr 1908 gebaute Jugendstilpalast „Casa Fuster" restauriert worden, um im Jahr 2000 als Fünf-Sterne-Hotel wieder seine Pforten zu öffnen. Eine Mischung aus traditioneller und moderner Einrichtung beherrscht das Innere und die 96 Zimmer; klare Linien und warme Farben schaffen eine harmonische Atmosphäre. Auf dem höchsten Punkt des modernistischen Wohn- und Geschäftsviertels Eixample gelegen, eröffnet sich dem Gast von der Dachterrasse aus eine weite Sicht über die Stadt bis zum Meer. Auf dem Dach befindet sich ein kleines Schwimmbad.

Le palais style art nouveau Casa Fuster, construit en 1908, a été restauré avec amour afin de pouvoir ouvrir ses portes en 2000 comme hôtel cinq étoiles. Une alliance entre aménagement traditionnel et moderne marque l'intérieur et ses 96 chambres, où des lignes claires et des teintes chaleureuses créent une atmosphère des plus harmonieuses. Situé au point culminant du quartier résidentiel et d'affaires moderniste de l'Eixample, l'hôtel offre à son visiteur une vue panoramique sur la ville et la mer du haut de la terrasse de son toit, où se trouve, de plus, une petite piscine.

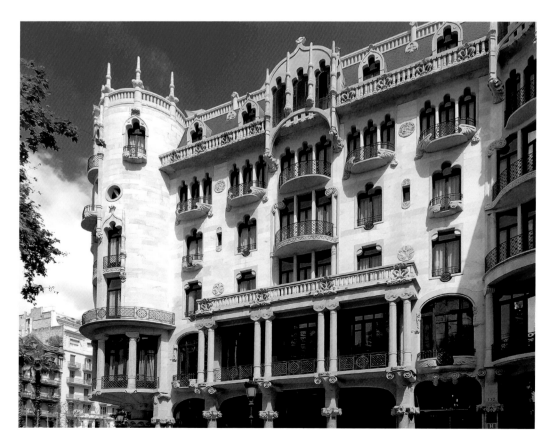

The art nouveau building of the Casa Fuster stands under preservation order.

Das Jugendstil-Gebäude der Casa Fuster steht unter Denkmalschutz.

Le bâtiment style art nouveau de l'hôtel Casa Fuster est classé monument historique.

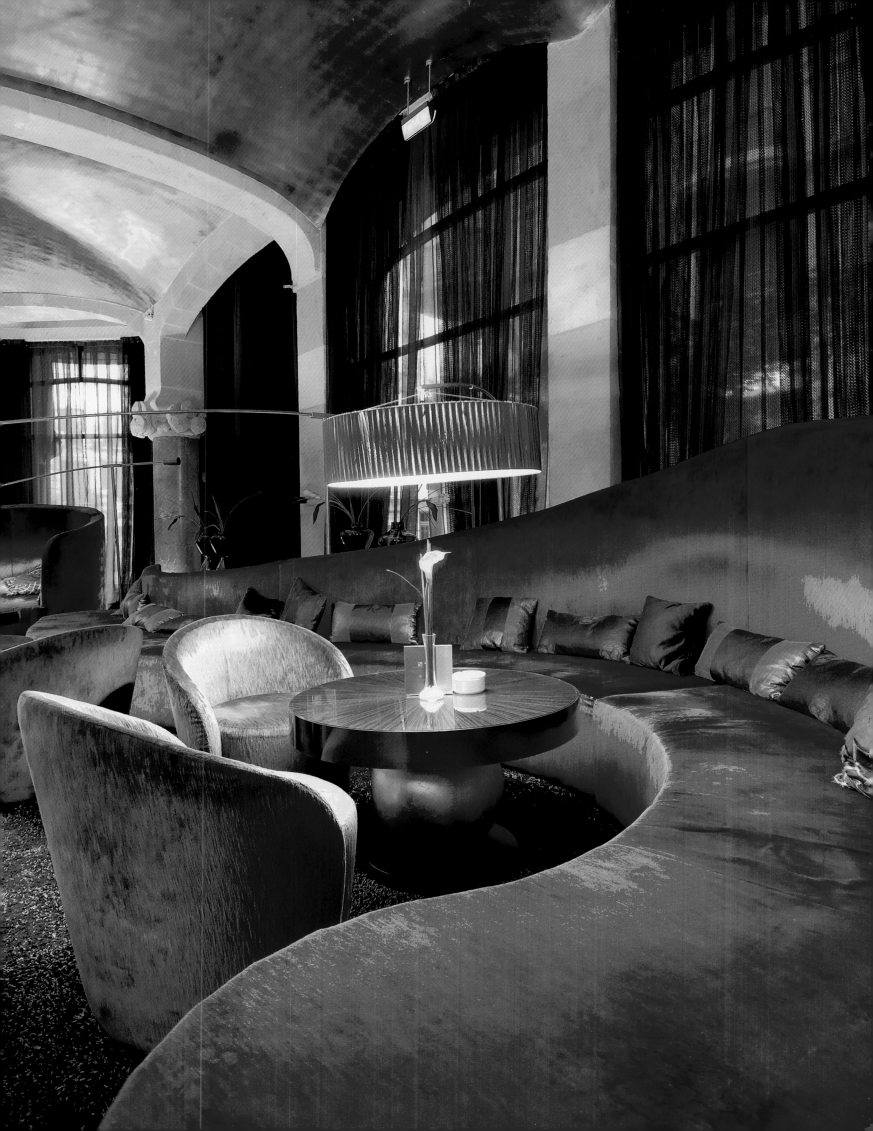

In all 96 rooms, natural colors convey a feeling of comfort.

Naturfarben sorgen in den 96 Zimmern für ein angenehmes Wohngefühl.

Si l'on s'y sent à l'aise, c'est aussi grâce aux couleurs naturelles dans les 96 chambres.

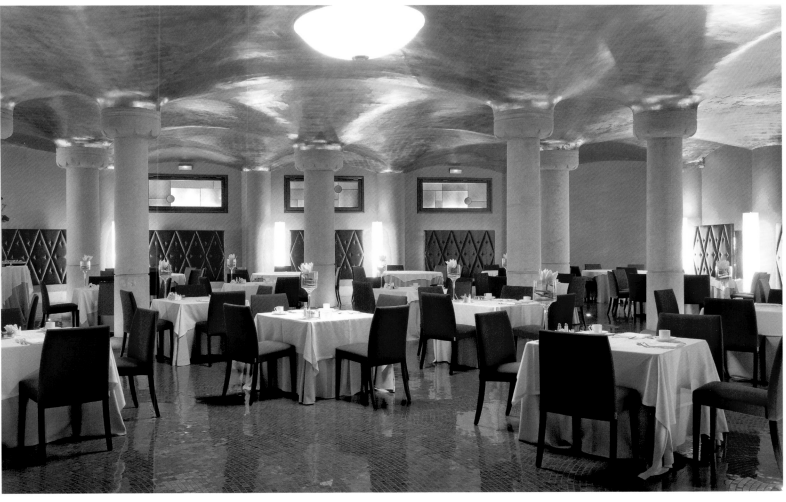

H1898
Barcelona, Spain

The H1898 on the promenade La Rambla is an immediate eye-catcher: the facade of the former 19th-century trading house was restored with attention to detail. The 169 rooms convince guests with their elegant style, combining colonial style with contemporary shapes and materials. Some rooms have a private swimming pool or a garden. Public swimming pools for all guests are located in the vaulted cellar and on the roof, a perfect place to start the day: with a view of Barcelona.

Bereits von außen ist das Hotel 1898 an der Promenade La Rambla ein Blickfang: detailgenau wurde die Fassade des einstigen Handelshauses aus dem 19. Jahrhundert restauriert. Die 169 Zimmer überzeugen mit elegantem Design, das den kolonialen Stil mit modernen Formen und Materialien verbindet. Einige verfügen über ein privates Schwimmbad oder einen Garten. Für alle Gäste gibt es zudem Schwimmbäder im Gewölbekeller und auf dem Dach. Dort kann man auch den Tag beginnen – mit Blick auf Barcelona.

Déjà de l'extérieur, le H1898, situé sur la promenade de La Rambla est un accroche-regard. La façade de l'ancienne maison de commerce datant du XIX^{ème} siècle a été minutieusement restaurée. Les 169 chambres ravissent par leur élégant design qui combine un style colonial avec des formes et des matériaux modernes. Certaines chambres disposent d'une piscine privée ou d'un jardin. Par ailleurs, d'autres piscines sont mises à la disposition de tous les hôtes, que ce soit dans la cave voûtée ou sur le toit. C'est de là-haut que vous pouvez commencer votre journée, avec une vue sur Barcelone.

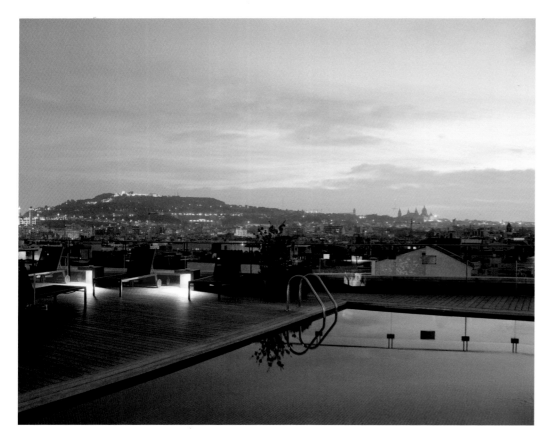

Swimming with a view: the pool on the roof terrace.

Baden mit Ausblick: Der Pool auf der Dachterrasse.

Baignade avec vue : la piscine sur la terrasse de toit.

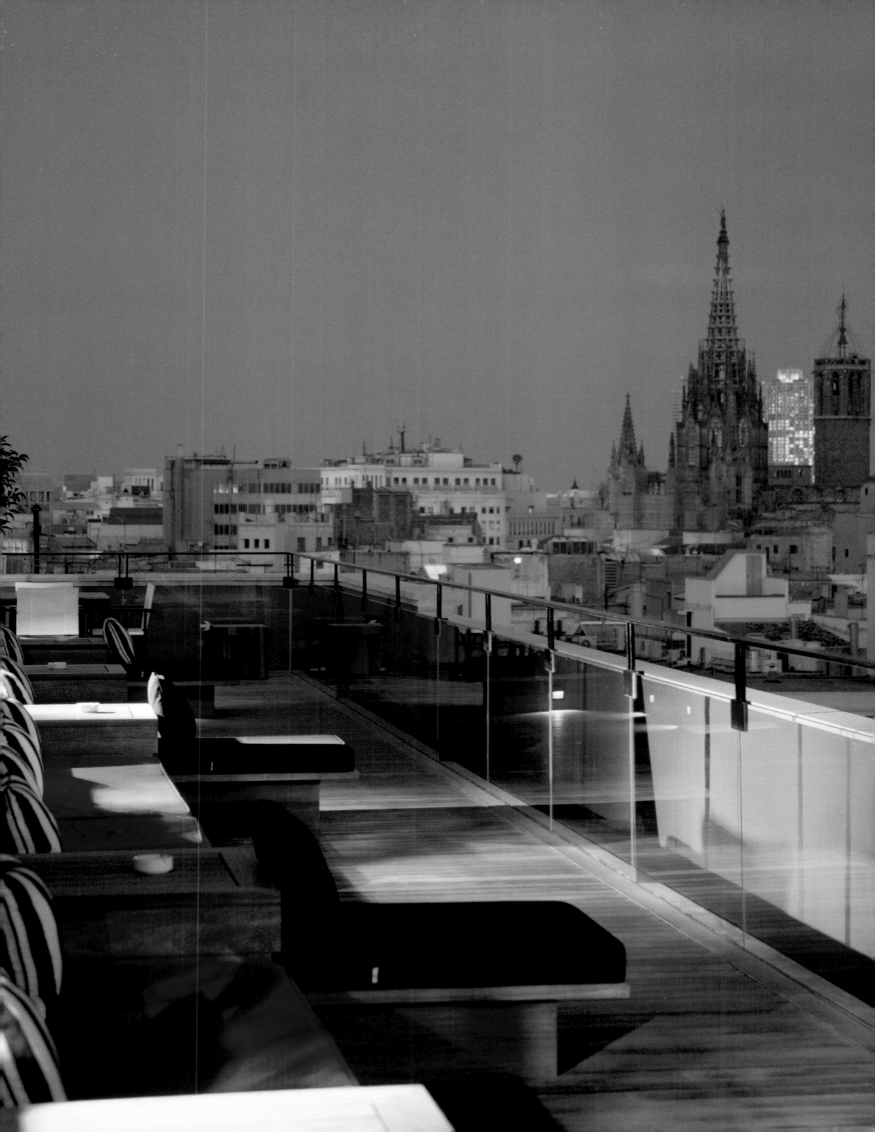

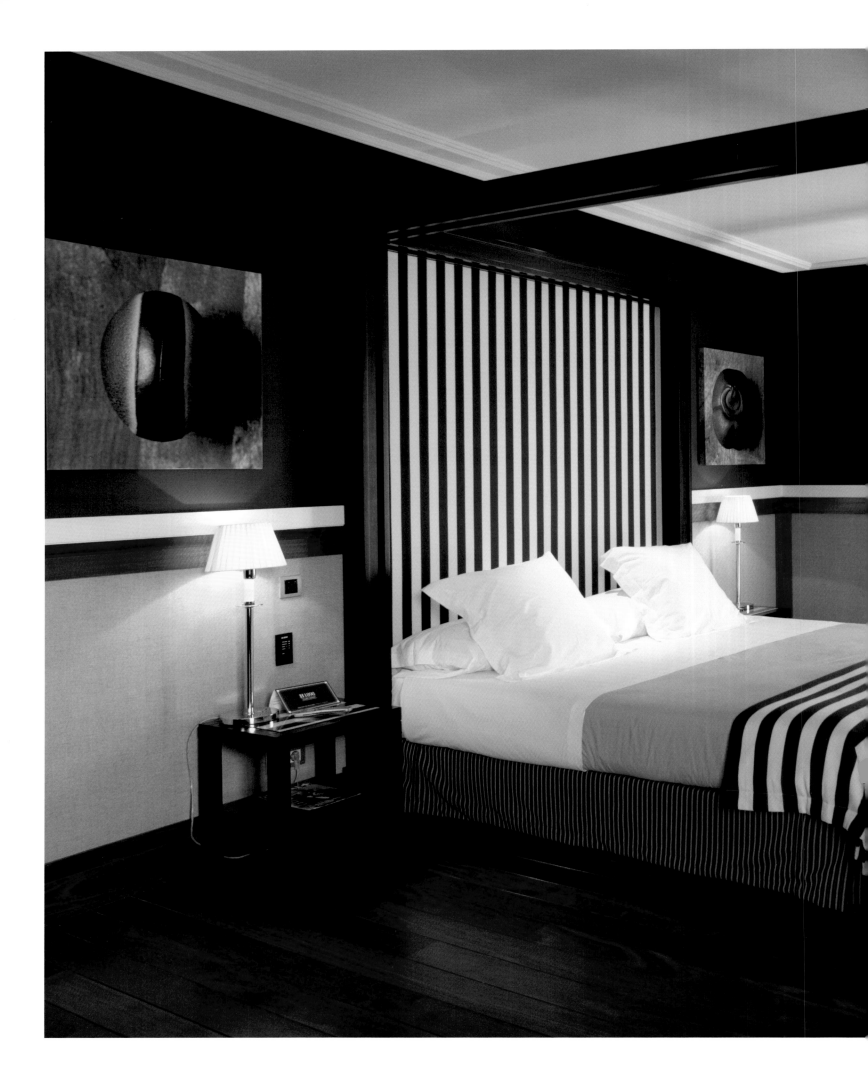

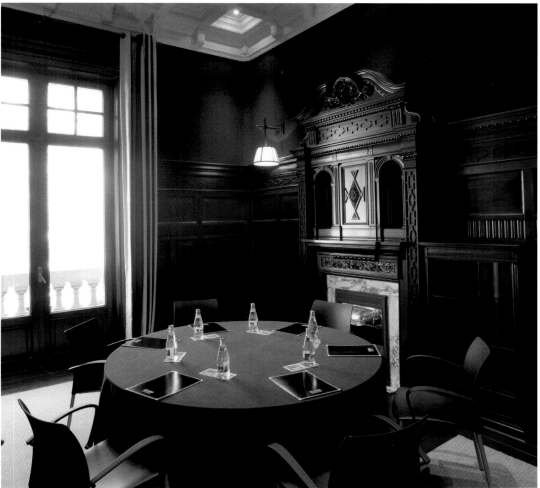

Clean, contemporary design is combined with colonial style.

Klares modernes Design wird mit kolonialem Stil kombiniert.

Design clair et moderne allié à un style colonial.

Palacio de los Patos
Granada, Spain

The Palacio de los Patos in Granada consists of two buildings: a 19th-century city palace and a modern building, clad with milkily gleaming alabaster slabs. In the light-flooded interior, white marble stairs lead to the 42 rooms with timber floor boards and contemporary furniture. After excursions to the cathedral or to the world famous Alhambra, guests can enjoy the rest of the day either by dining in the restaurant or unwinding in the Arabic Gardens.

Aus zwei Gebäuden besteht das Palacio de los Patos in Granada: aus einem Stadtpalast aus dem 19. Jahrhundert und aus einem modernen Gebäude, das mit milchig schimmernden Alabasterplatten verkleidet ist. Im lichtdurchfluteten Inneren führen weiße Marmorstufen zu den 42 mit Holzdielen ausgelegten und mit modernen Möbeln eingerichteten Zimmern. Nach Ausflügen zur Kathedrale oder zur weltberühmten Alhambra kann man den Tag im Restaurant oder in den Arabischen Gärten stilvoll und entspannt ausklingen lassen.

Le Palacio de los Patos à Grenade est composé de deux bâtiments : l'un étant un ancien palais de la ville datant du XIXème siècle, l'autre un bâtiment moderne habillé de dalles d'albâtre aux reflets laiteux miroitants. A l'intérieur inondé de lumière, un escalier en marbre blanc vous mène aux 42 chambres équipées de meubles modernes agrémentés de planchers en bois. Après les visites de la Cathédrale et de la célèbre Alhambra, vous pouvez finir la journée de façon stylée et détendue au restaurant ou dans les jardins arabes.

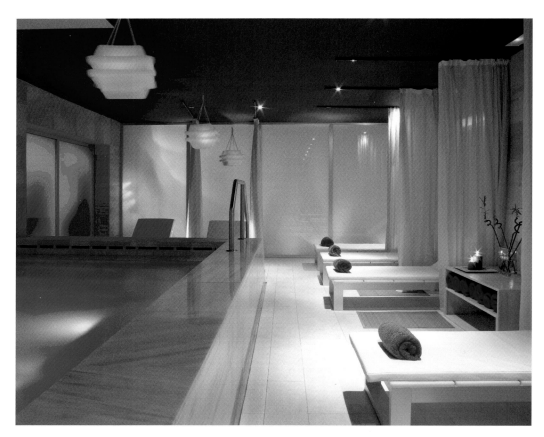

The wellness area is located in the new building, which is clad in alabaster.

Der Wellness-Bereich befindet sich im mit Alabaster verkleideten Neubau.

L'espace wellness se trouve dans le bâtiment neuf aux murs revêtus d'albâtre.

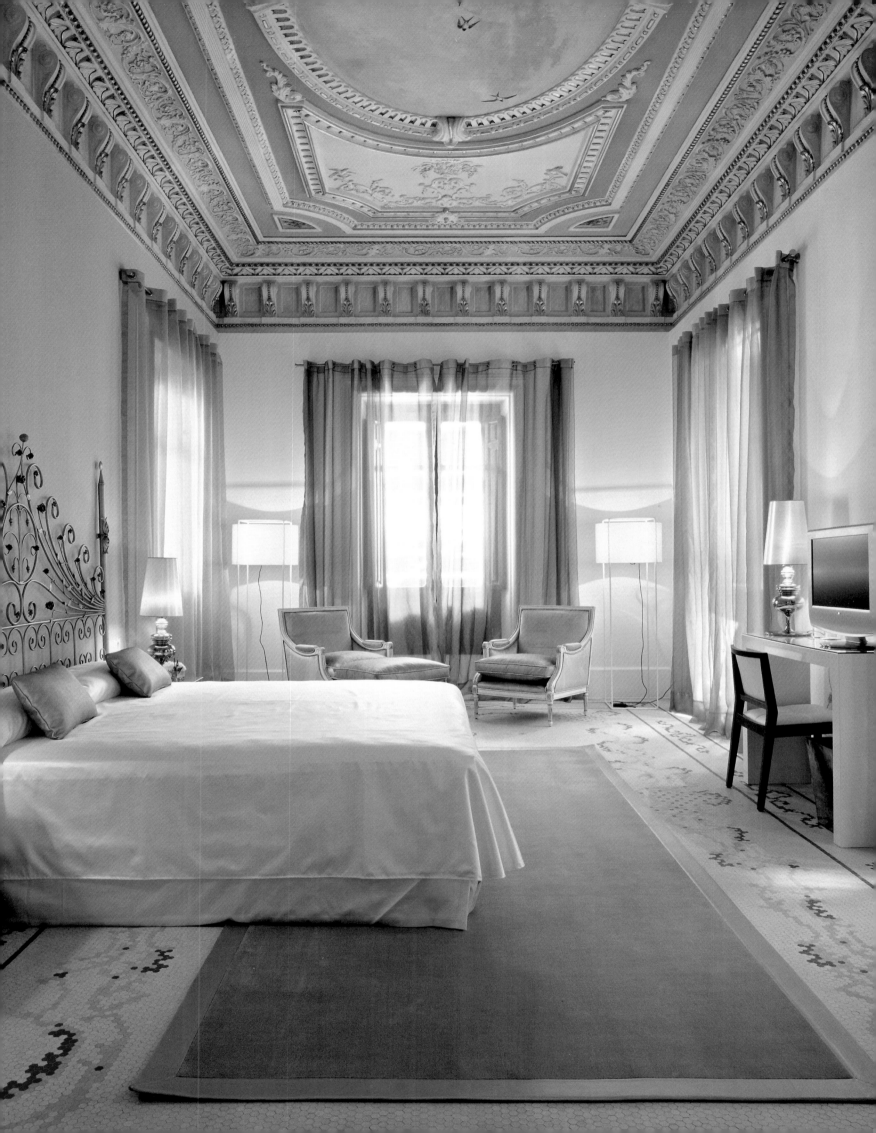

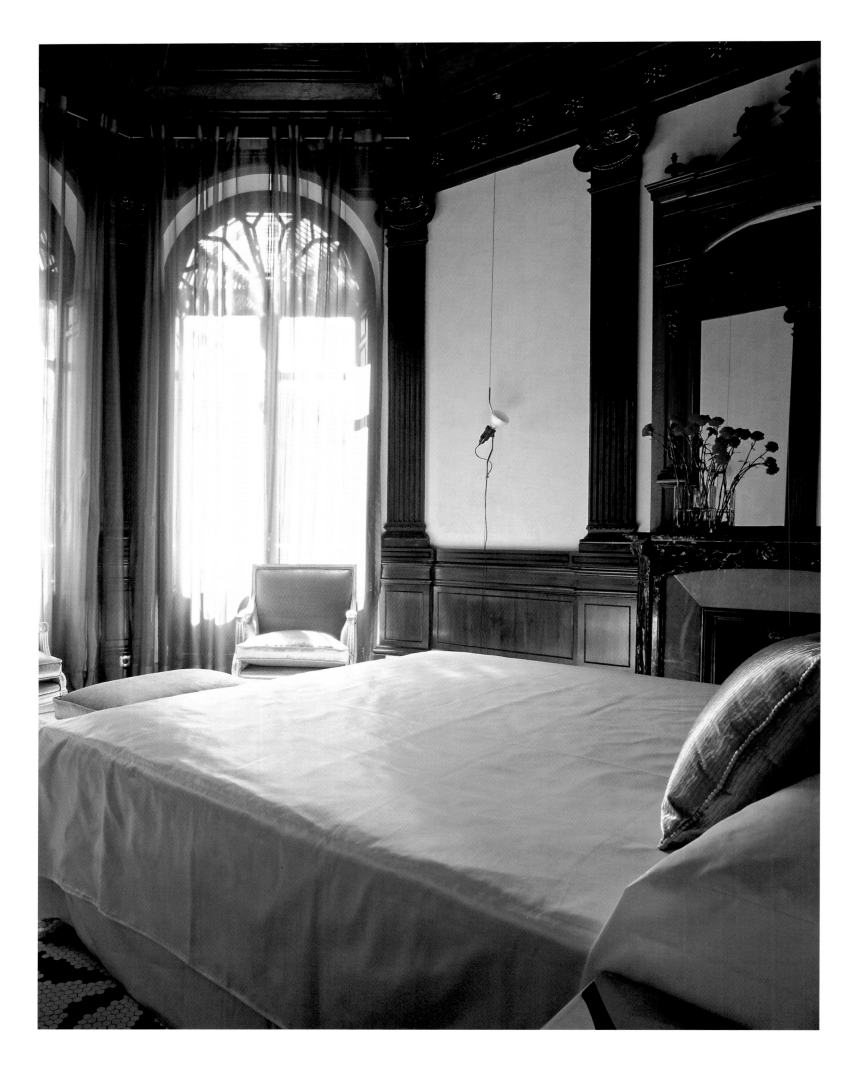

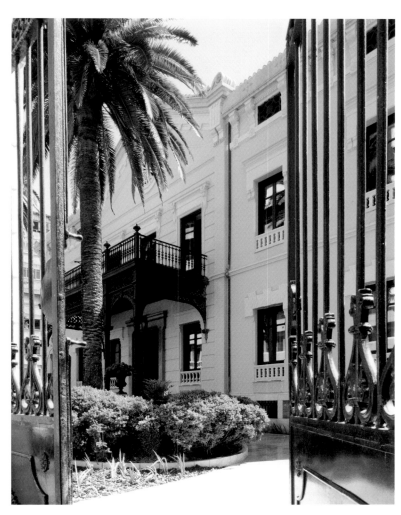

Behind big cast iron doors, palms line the driveway to the hotel.

Hinter großen gusseisernen Toren schmücken Palmen den Weg zum Hotel.

Derrière de grandes portes en fonte, le chemin menant à l'hôtel est bordé de palmiers.

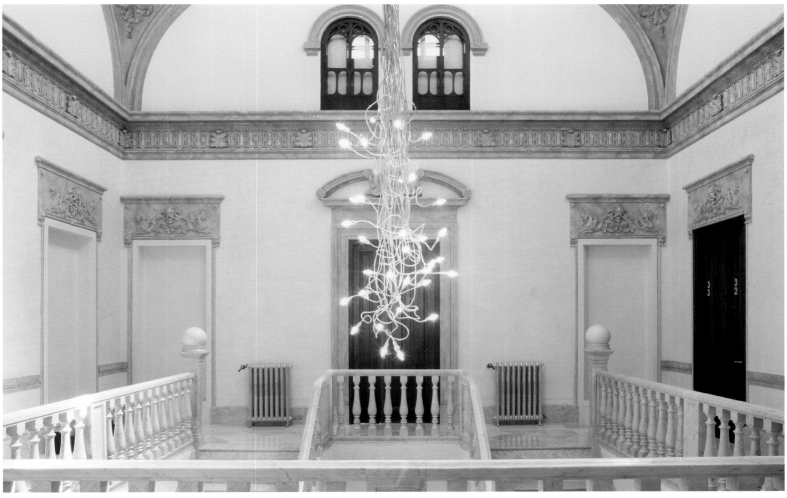

Maricel

Mallorca, Spain

This property seems to hover between the sea and the sky, therefore it is named Maricel. Seamless transitions—this pretty much sums up the style of this five-star hotel. Contemporary influences were carefully integrated into the stately architecture of the past-century appeal. Raw materials, clear forms and colors are the main aspects of the 29 rooms' decoration. In front of the windows, verandas with spotless white pillows are reserved for selected customers.

Zwischen Meer und Himmel scheint das Designhotel zu liegen, und so erklärt sich auch sein Name: Maricel. Übergänge, die zu fließen scheinen – so lässt sich insgesamt der Stil des Fünf-Sterne-Hotels beschreiben. In die aus früheren Jahrhunderten übernommene herrschaftliche Architektur wurden schonend moderne Einflüsse integriert. Rohe Materialien, klare Formen und Farben bestimmen das Mobiliar in den 29 Zimmern. Vor den Fenstern warten Verandazonen mit strahlend weißen Kissen auf ein ausgesuchtes Publikum.

L'hôtel design semble flotter entre la mer et le ciel, d'où son nom Maricel qui semble les évoquer tous deux. Passages fluides entre divers mondes : c'est ainsi que l'on pourrait globalement décrire le style de cet hôtel cinq étoiles. Des influences modernes ont été intégrées avec délicatesse à la splendide architecture datant des siècles précédents. Matières brutes, lignes et couleurs nettes définissent le mobilier des 29 chambres aux fenêtres s'ouvrant sur des vérandas dont les coussins d'une blancheur éblouissante accueillent un visiteur distingué.

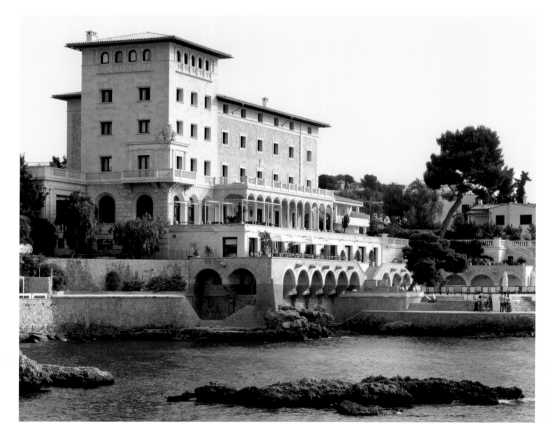

The former villa majestically stands above the bay.

Die ehemalige Villa thront über der Bucht.

L'ancienne villa qui domine la baie.

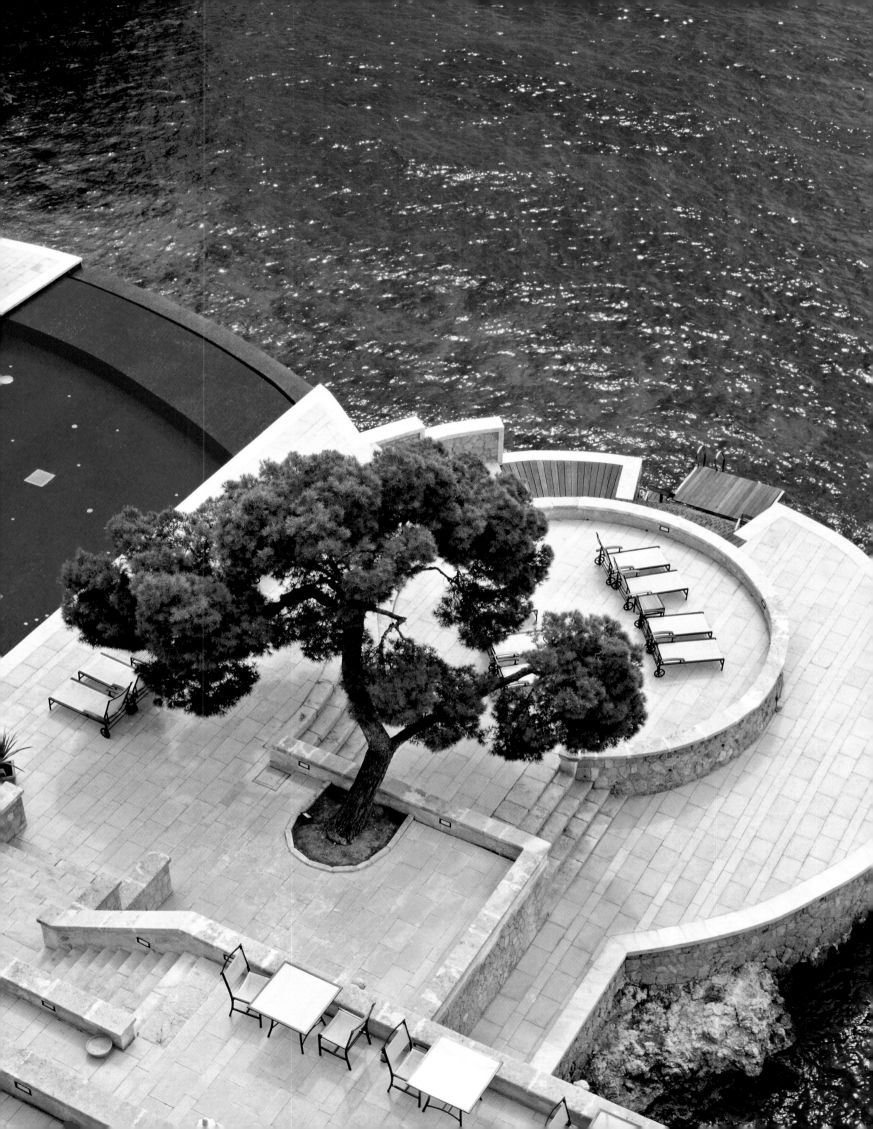

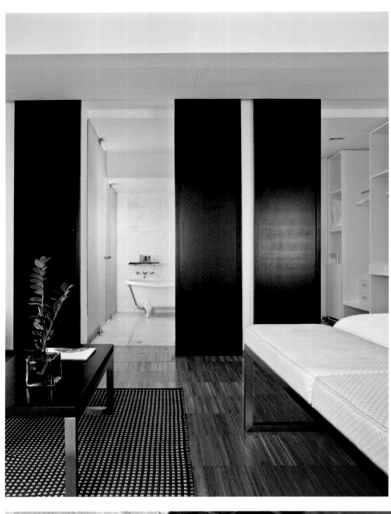
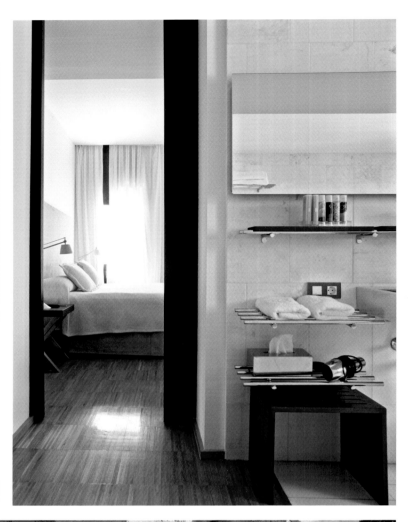
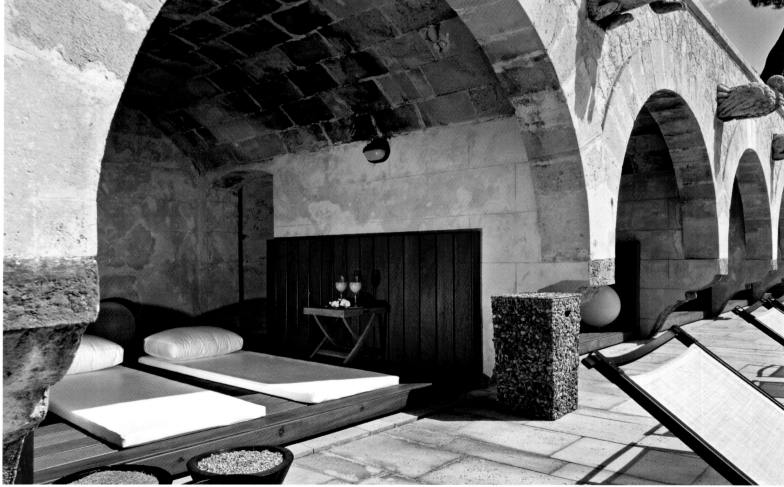

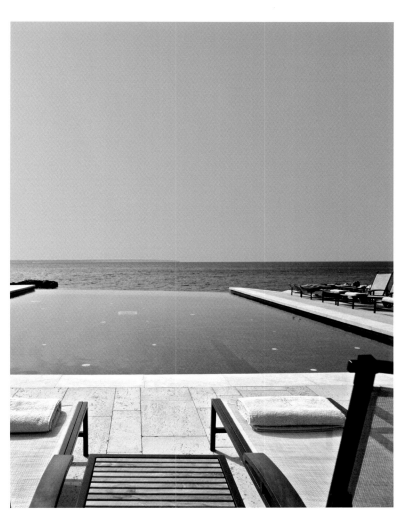

The pool of the hotel blends into the sea.

Der Pool des Hauses ragt über das Meer hinaus.

La piscine avec la mer en contrebas.

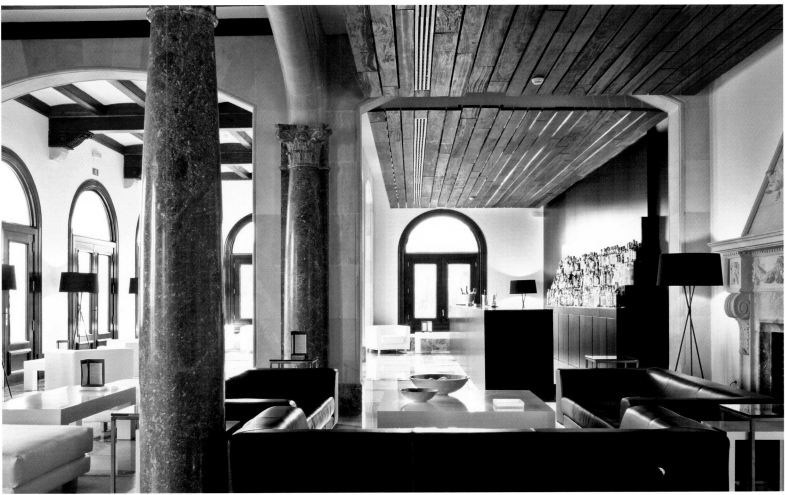

Portixol

Mallorca, Spain

Located by a small harbor at the Eastern gates of Palma, this hotel's interior, its 20 rooms and the restaurant are characterized by a contemporary design, friendly colors and much light. The restaurant serves international cuisine with Asian influences, which suites not only the taste of the guests but of the locals as well. From the restaurant, as well as from most rooms and the terrace with swimming pool, guests have a beautiful view of the ocean and the harbor. For excursions to the nearby downtown of Palma, bicycles are at the guests' disposal.

Vor den östlichen Toren Palmas liegt das Hotel Portixol an einem kleinen Hafen. Modernes Design, helle freundliche Farben und viel Licht kennzeichnen die Lobby, die 20 Zimmer und das Restaurant. Hier wird internationale Küche mit asiatischen Einflüssen serviert, die auch den Einheimischen gut schmeckt. Außerdem genießt man von dort – wie auch von den meisten Zimmern und der Terrasse mit dem Schwimmbad – eine hübsche Sicht über Meer und Hafen. Für Ausflüge ins nahe Zentrum Palmas stellt das Hotel Fahrräder zur Verfügung.

L'hôtel Portixol se situe aux portes de Palma, à l'est, à côté d'un petit port. Un design moderne, des couleurs claires et accueillantes et beaucoup de lumière caractérisent le style du hall, des 20 chambres et du restaurant. Ici, on sert une cuisine internationale avec des influences asiatiques, aussi appréciée par les habitants de l'île. De plus, depuis le restaurant, comme depuis presque chaque chambre et la terrasse équipée d'une piscine, vous bénéficiez d'une vue admirable sur la mer et le port. Pour vos promenades dans le proche centre de Palma, l'hôtel met des vélos à votre disposition.

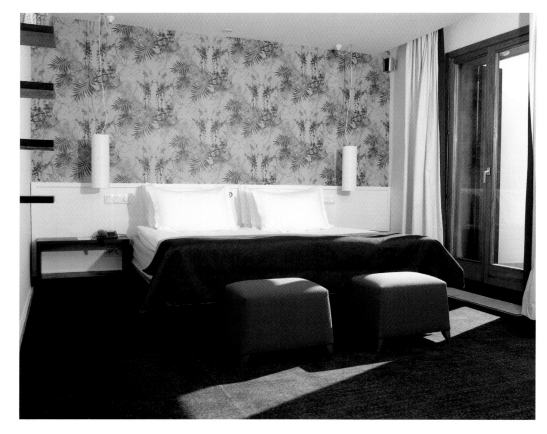

Rooms and back porch are characterized by Mediterranean colors.

Mediterrane Farben kennzeichnen Zimmer und Terrasse.

Chambres et terrasse se caractérisent par des couleurs méditerranéennes.

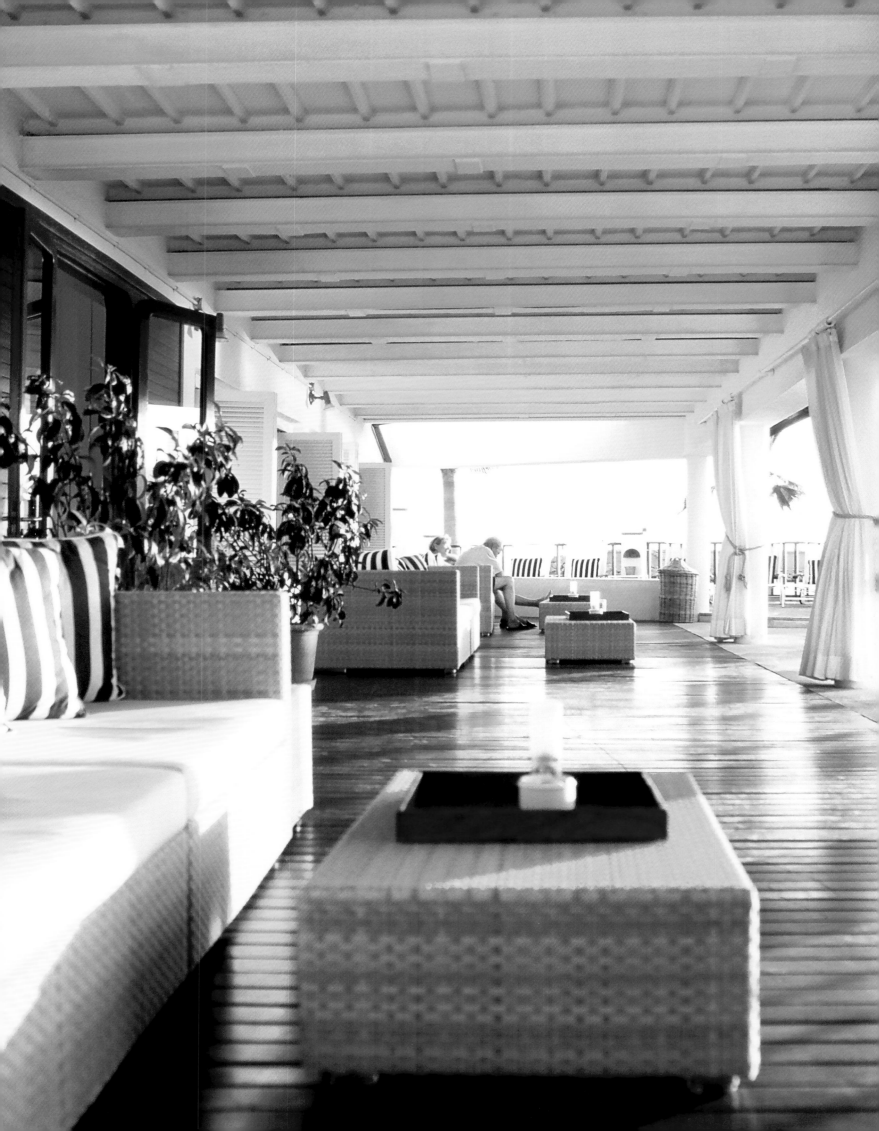

Puro

Mallorca, Spain

Situated in an old palace right in the middle of Palma de Majorca's old town, the 26 rooms of this modern hotel combine light colors and clean lines with appealing ethnic elements. Nevertheless, the Puro is not known for its interior design but rather for its ambience and restaurant with its fusion of Mediterranean and Asian cuisine. Within only a short time, it has become one of Palma's hot spots, just like the bar in the hotel's ground floor, where the Palma party crowd can have fun until dawn.

Mitten in der Altstadt von Palma de Mallorca liegt dieses moderne Hotel in einem alten Schloss. Helle Töne und klare Linien werden in den 26 Zimmern mit ansprechenden Ethno-Elementen kombiniert. Doch bekannt ist das Puro nicht nur für seine Inneneinrichtung, sondern auch für seine Atmosphäre und sein Restaurant, das eine Mischung aus mediterraner und asiatischer Küche serviert. Es ist innerhalb kurzer Zeit zu einem Hot spot in Palma geworden – genauso wie die Bar im Erdgeschoss, in der sich bis zum Morgen die Palmeser Szene tummelt.

Au cœur de la vieille ville de Palma de Majorque se trouve cet hôtel moderne, aménagé dans un ancien château. Dans les 26 chambres, on a combiné des éléments ethniques attrayants à des tons clairs et des lignes nettes. Le Puro est certes connu pour son agencement intérieur mais surtout pour son ambience et son restaurant qui propose une cuisine méditerranéenne et asiatique. En très peu de temps, il est devenu une référence cotée à Palma, tout comme le bar au rez-de-chaussée, où toute l'île vient se déhancher jusqu'au petit matin.

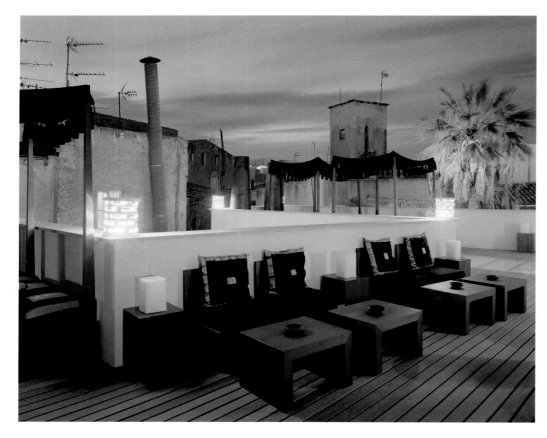

The terrace of the Puro is a popular hangout, even among locals.

Ein beliebter Treffpunkt ist die Terrasse des Puro auch bei den Einheimischen.

La terrasse du Puro est un lieu très apprécié, même des majorquins.

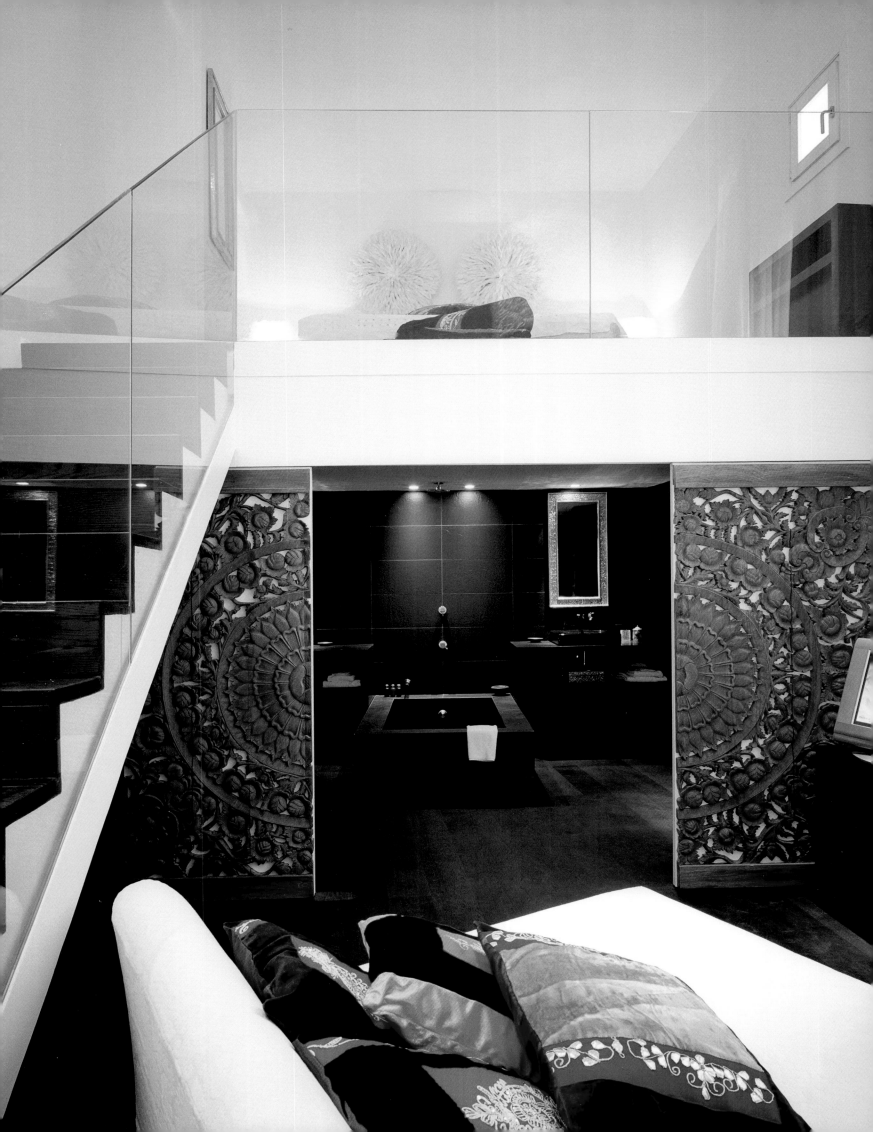

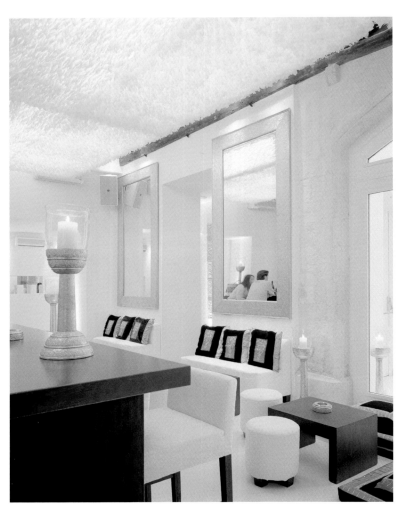
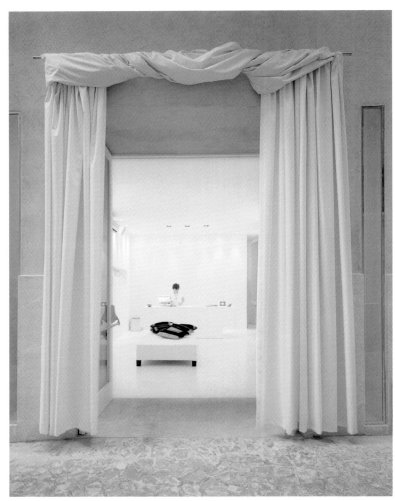
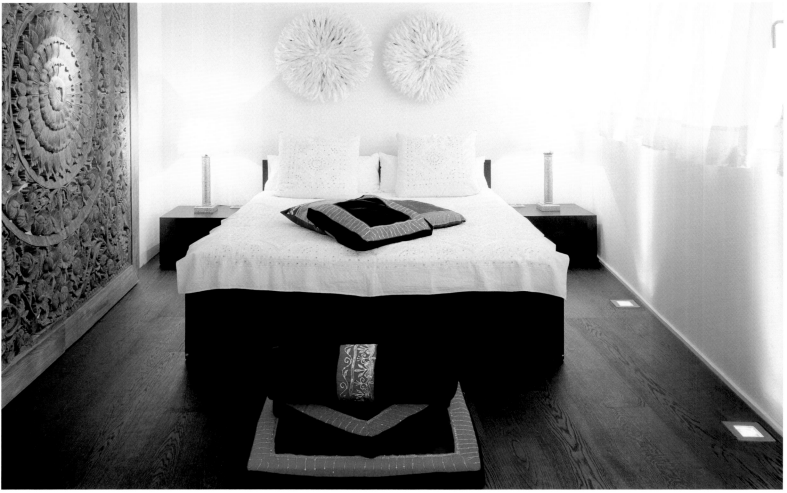

Guests could hardly find a residence closer to the center of Palma.

Näher können Besucher dem Zentrum Palmas kaum sein.

Difficile d'être encore plus près du centre de Palma.

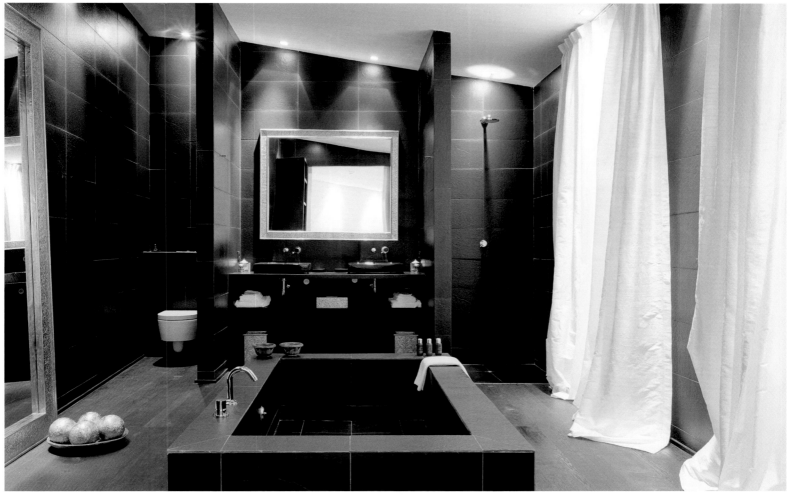

Santo Mauro
Madrid, Spain

Once the palace of the Marquis of Santo Mauro, nowadays an elegant hotel in the center of Madrid, near the Paseo de la Castellana. The splendid construction from the 19th-century was renovated in 1999 and now combines classical French style with contemporary elements. In the elegant rooms of the once palace library, the restaurant "Santo Mauro" offers local specialties and a broad selection of top-class international wines.

Einst der Palast des Marquis von Santo Mauro, heute ein elegantes Hotel im Zentrum von Madrid, nahe des Paseo de la Castellana. Die prachtvolle Anlage aus dem 19. Jahrhundert wurde 1999 renoviert und kombiniert jetzt klassischen französischen Stil mit zeitgenössischen Elementen. In den eleganten Räumen der ehemaligen Palastbibliothek bietet das Restaurant „Santo Mauro" einheimische Spezialitäten und eine umfangreiche Auswahl internationaler Spitzenweine an.

C'était autrefois le palais du Marquis de Santo Mauro, c'est aujourd'hui un hôtel élégant dans le centre de Madrid, à proximité du Paseo de la Castellana. Cet ensemble magnifique du XIXème siècle a été rénové en 1999 et associe maintenant avec succès le style classique français à des éléments modernes. Dans les salles élégantes de l'ancienne bibliothèque du palais, le restaurant « Santo Mauro » propose des spécialités locales et un grand choix de vins internationaux de première qualité.

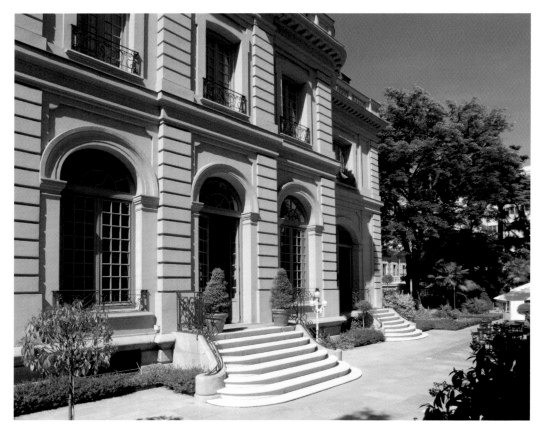

The hotel is centrally located and is yet an escape from the trouble of the city.

Das Hotel liegt zentral und gewährt dennoch Ruhe vor dem Trubel der Stadt.

Quoique central, cet hôtel respire le calme. Le bruit de la ville est fermé dehors.

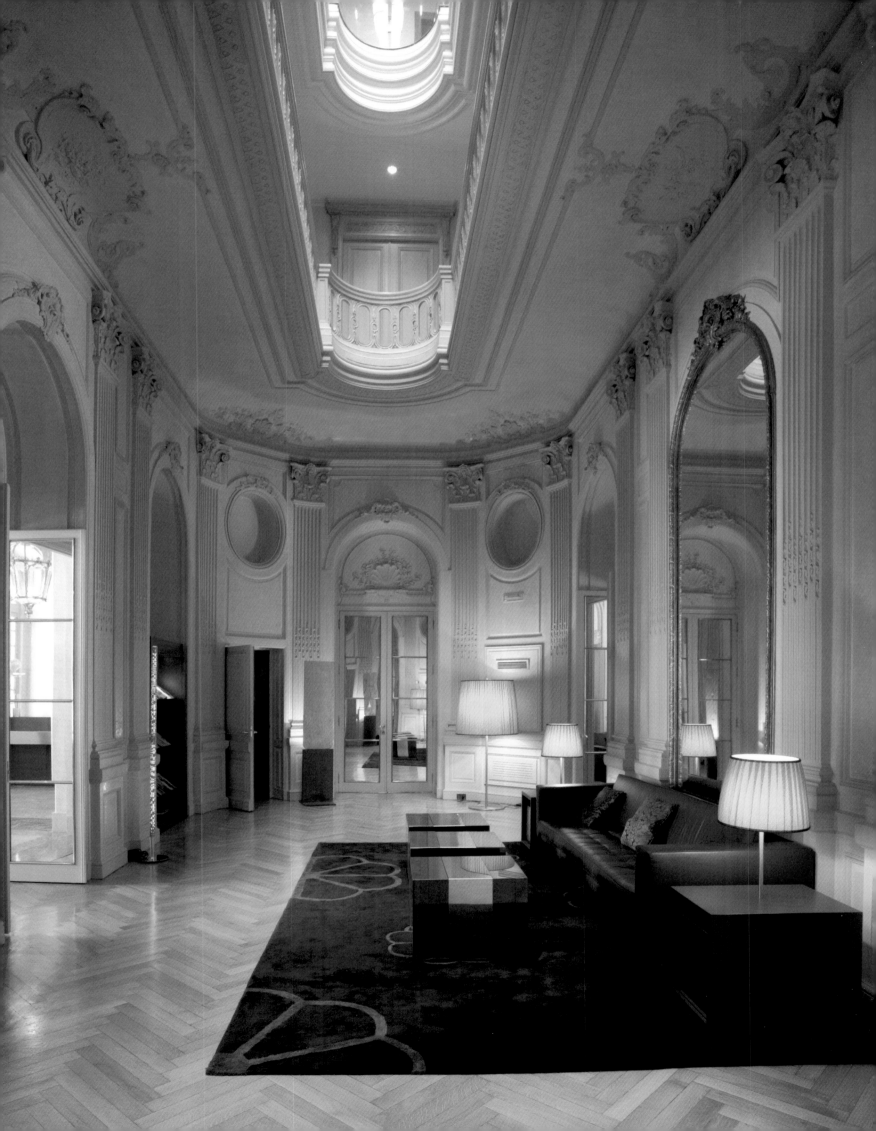

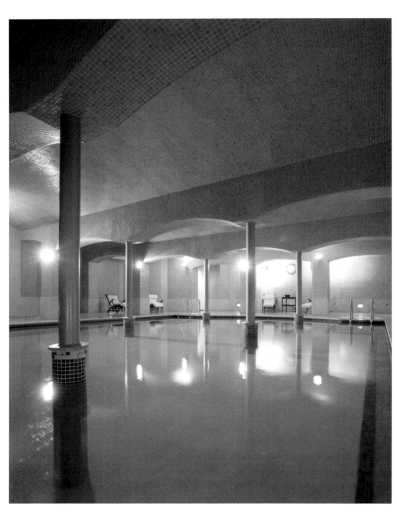

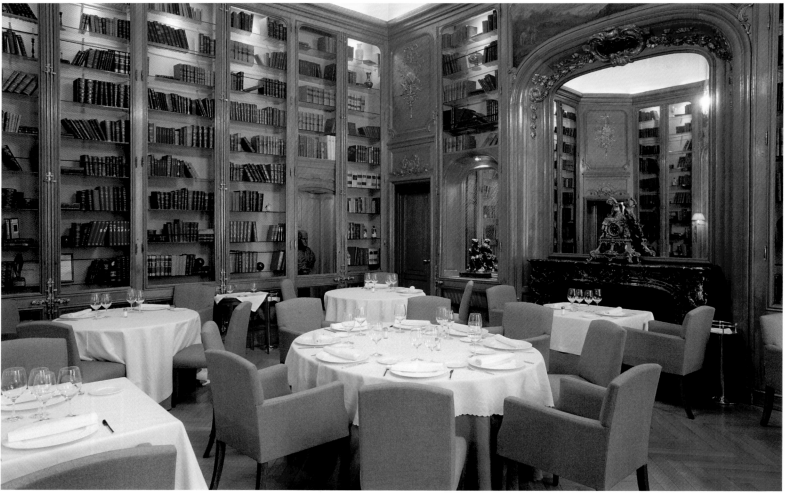

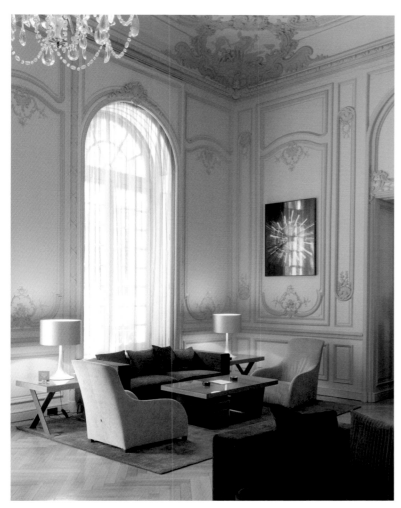

The simple furniture emphasizes the antique engravings and stucco works.

Schnörkellose Möbel bringen die antiken Gravuren und Stuckaturen zur Geltung.

Des meubles épurés mettent en valeur les gravures et les stucs antiques.

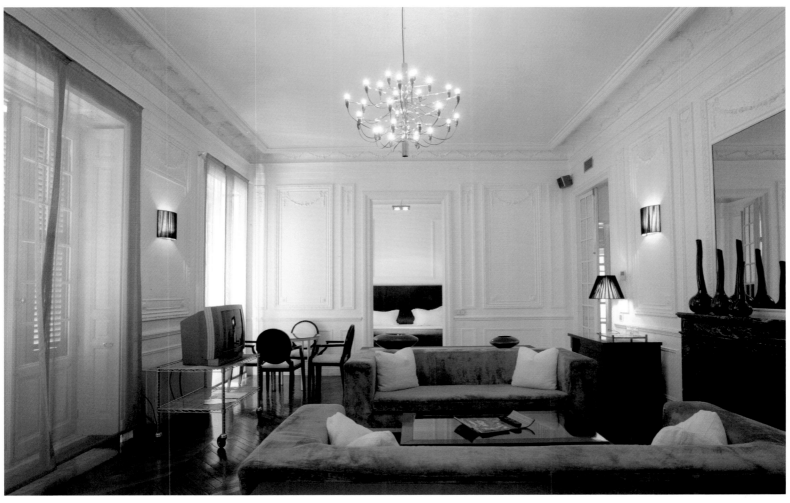

Ritz
Madrid, Spain

Many significant luxury hotels of the world bear the name Ritz. And since Madrid did not want to lag behind London and Paris, King Alfonso XIII initiated the construction of this baroque palace hotel, which was opened in 1910. The impressive facade only offers a preview of the equally pompous interior: 137 rooms and 30 suites, each featuring an individual design. The renowned restaurant "Goya" in the hotel is an attraction for all senses in its own right.

Viele bedeutende Luxushotels der Welt tragen den Namen Ritz. Und da Madrid den Vorbildern aus London und Paris nicht nachstehen wollte, stieß König Alfons XIII. die Errichtung dieses barocken Palasthotels an, das 1910 eröffnet wurde. Die imposante Fassade gibt dabei nur einen Vorgeschmack auf die nicht minder pompöse Innenwelt: 137 Zimmer und 30 Suiten, die individuell ausgestaltet sind. Eine eigene Attraktion für alle Sinne ist das viel gerühmte Restaurant „Goya" im Haus.

De nombreux grands hôtels de luxe portent le nom de Ritz. Comme Madrid ne voulait pas céder le pas aux modèles de Londres et de Paris, le Roi Alfonso XIII a lancé la construction de ce palace baroque, qui a été inauguré en 1910. La façade impressionnante ne constitue qu'un avant-goût de son intérieur non moins fastueux : 137 chambres et 30 suites, toutes aménagées individuellement. Le fameux restaurant « Goya », situé dans l'hôtel, est déjà par lui-même une attraction pour les sens.

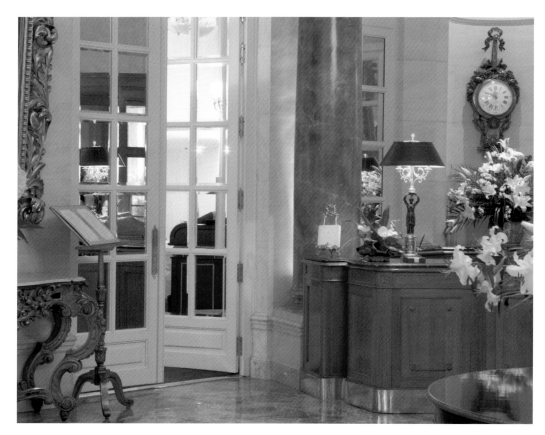

The Ritz convinces with its timeless elegance on the inside as well as on the outside.

Innen wie außen überzeugt das Ritz durch seine zeitlose Eleganz.

A l'intérieur comme à l'extérieur, le Ritz se distingue par son élégance intemporelle.

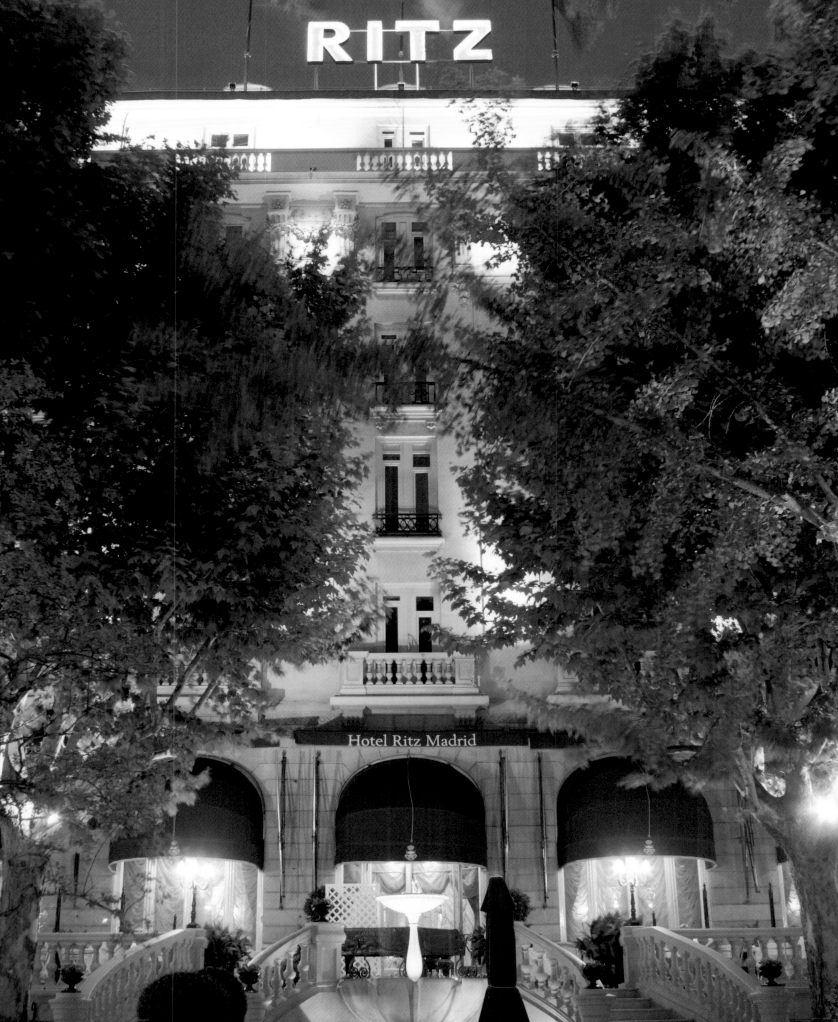

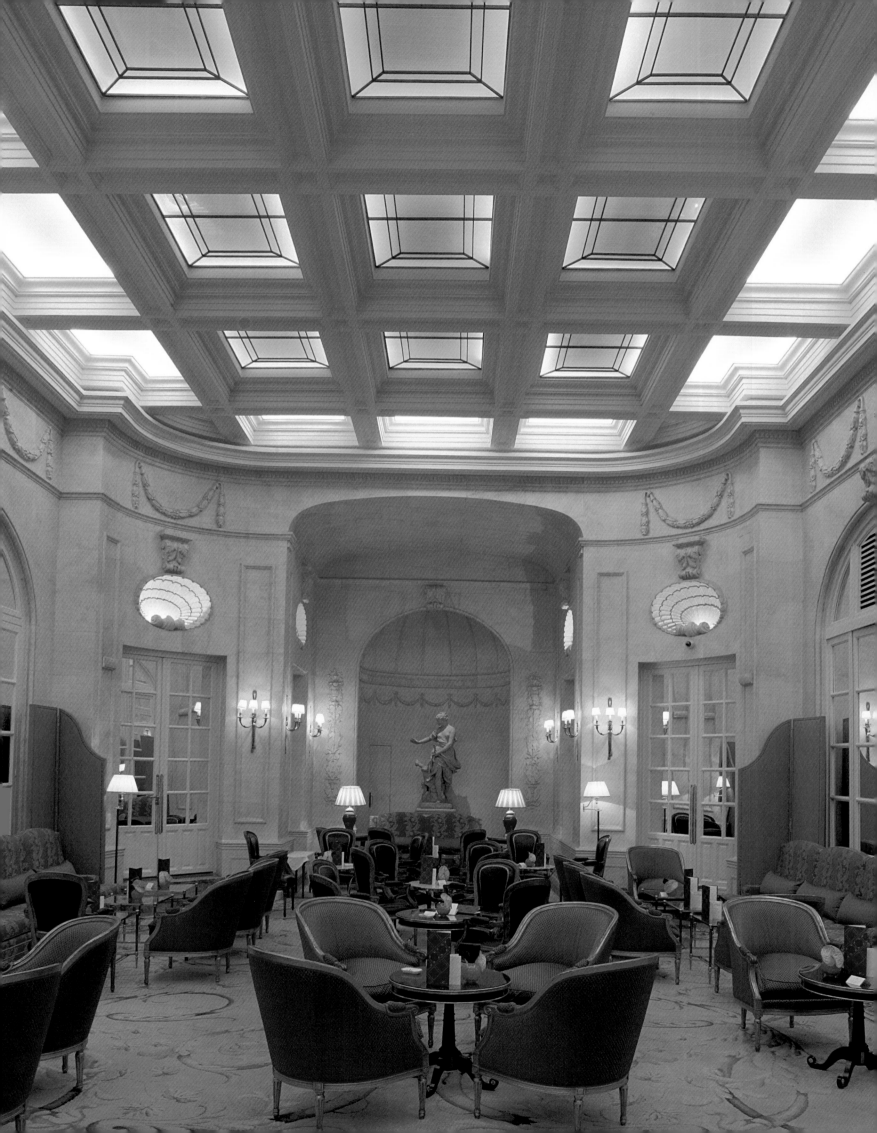

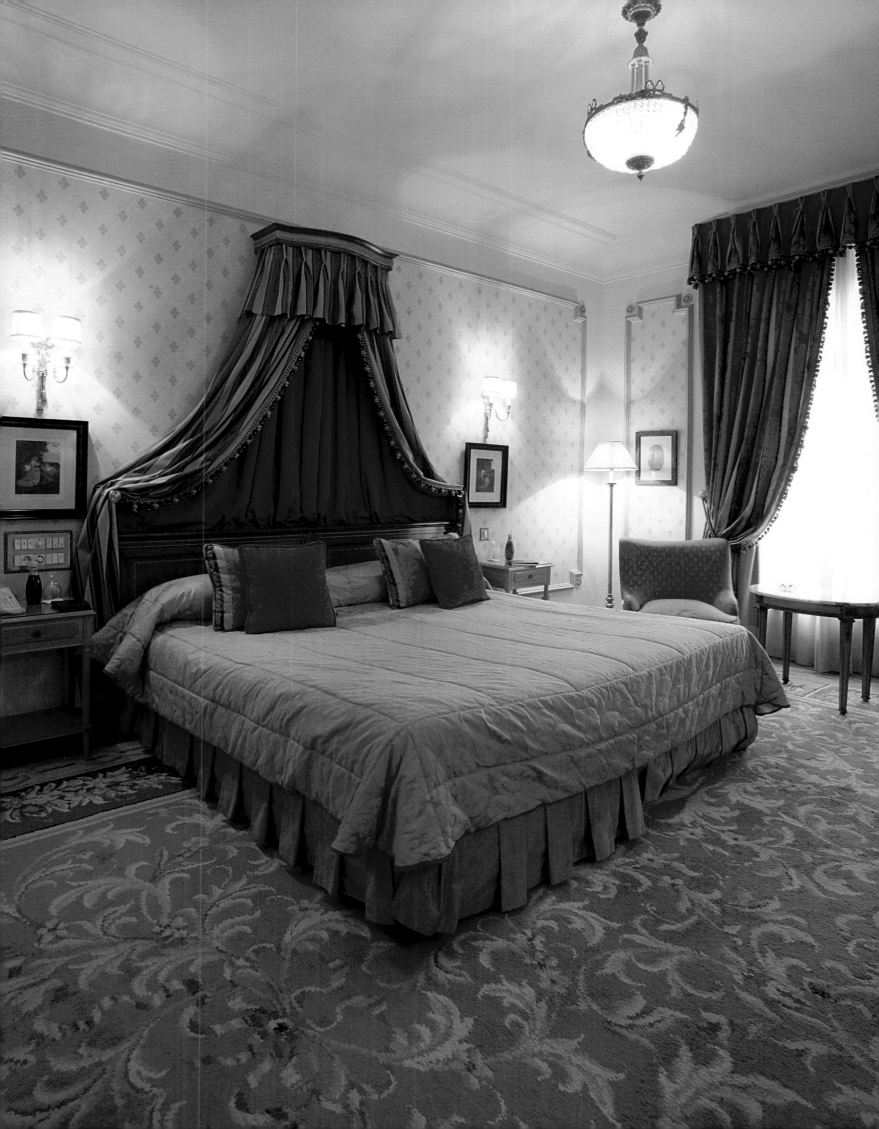

Hotel AC Palacio del Retiro

Madrid, Spain

The AC Palacio del Retiro is situated opposite the Retiro Park and within a short distance of Madrid's most famous museums such as the Prado or the Thyssen-Bornemisza Museum. Established in 2004, this exclusive hotel behind an early 20th-century facade welcomes its guests with a friendly service. The interior is characterized by stucco works, frescos and contemporary stylistic elements. All of the 50 rooms are individually decorated, and have a modern touch. The hotel's own restaurant serves creative Mediterranean cuisine.

Gegenüber dem Retiro-Park und unweit der berühmtesten Museen Madrids, wie dem Prado oder dem Thyssen-Bornemisza Museum, liegt das AC Palacio del Retiro. Hinter der Fassade aus dem frühen 20. Jahrhundert erwartet den Gast seit der Eröffnung im Jahr 2004 ein exklusives Hotel mit freundlichem Service. Das Innere prägen Stuck- und Freskenarbeiten sowie zeitgenössische Stilelemente. Jedes der 50 Zimmer ist individuell und modern eingerichtet. Das hoteleigene Restaurant serviert kreative mediterrane Küche.

L'hôtel AC Palacio del Retiro est situé en face du parc Retiro et non loin des musées les plus célèbres de Madrid, comme le Prado ou le musée Thyssen-Bornemisza. Depuis son ouverture en 2004, un hôtel select au personnel amical attend ses hôtes derrière une façade datant du début du XXème siècle. L'intérieur est orné de fresques et de stucs ainsi que d'éléments de styles plus contemporains. Chacune des 50 chambres est aménagée de façon moderne tout en ayant une touche personnalisée. Le restaurant de l'hôtel sert une cuisine méditerranéenne créative.

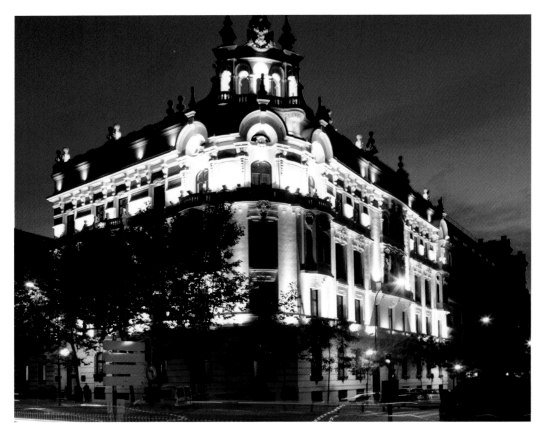

The early 20th-century building stands under preservation order.

Das denkmalgeschützte Gebäude stammt aus dem frühen 20. Jahrhundert.

Le bâtiment classé monument historique date du début du XXème siècle.

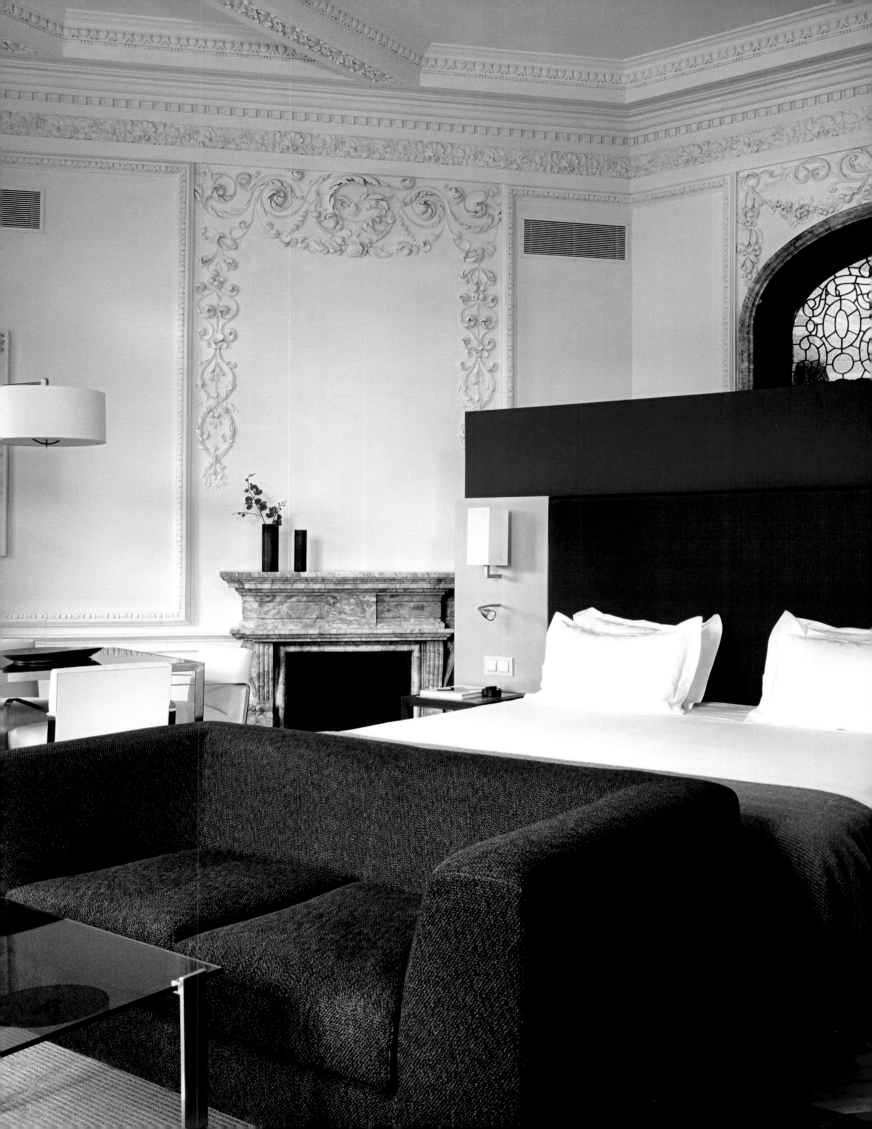

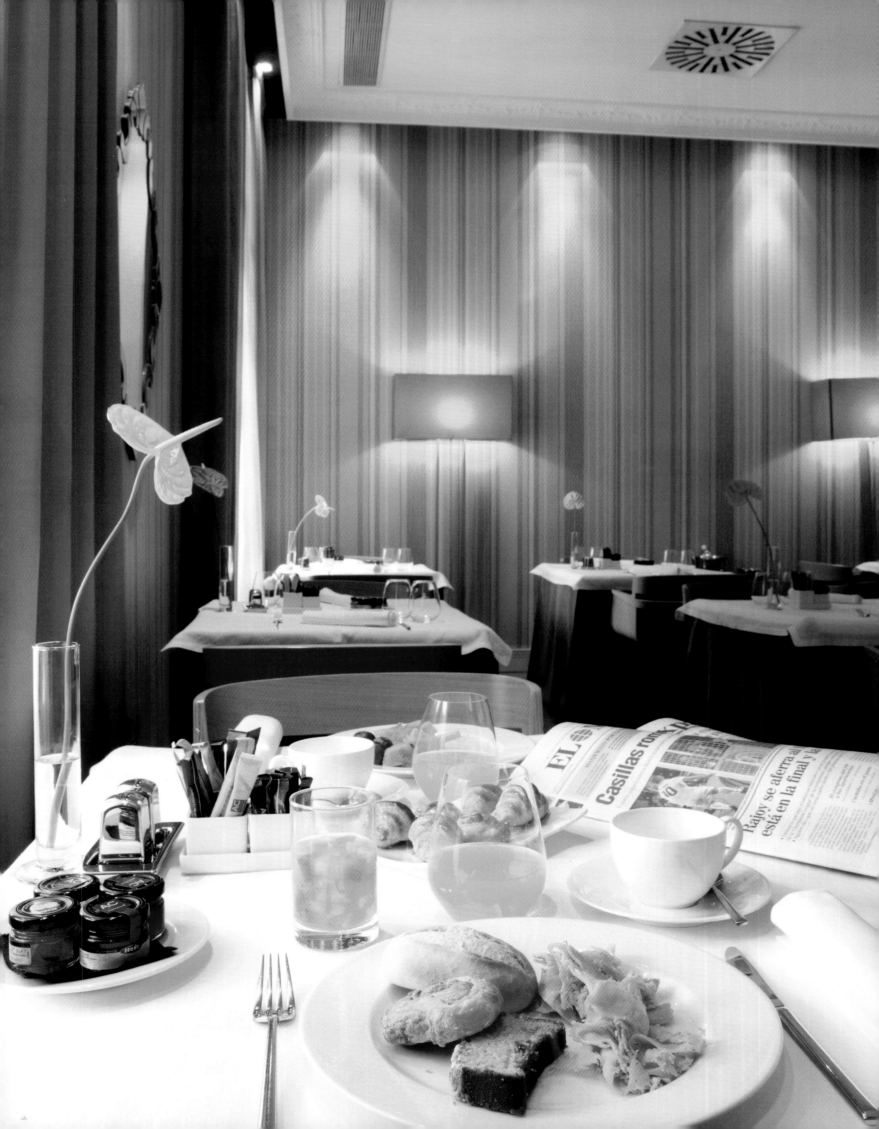

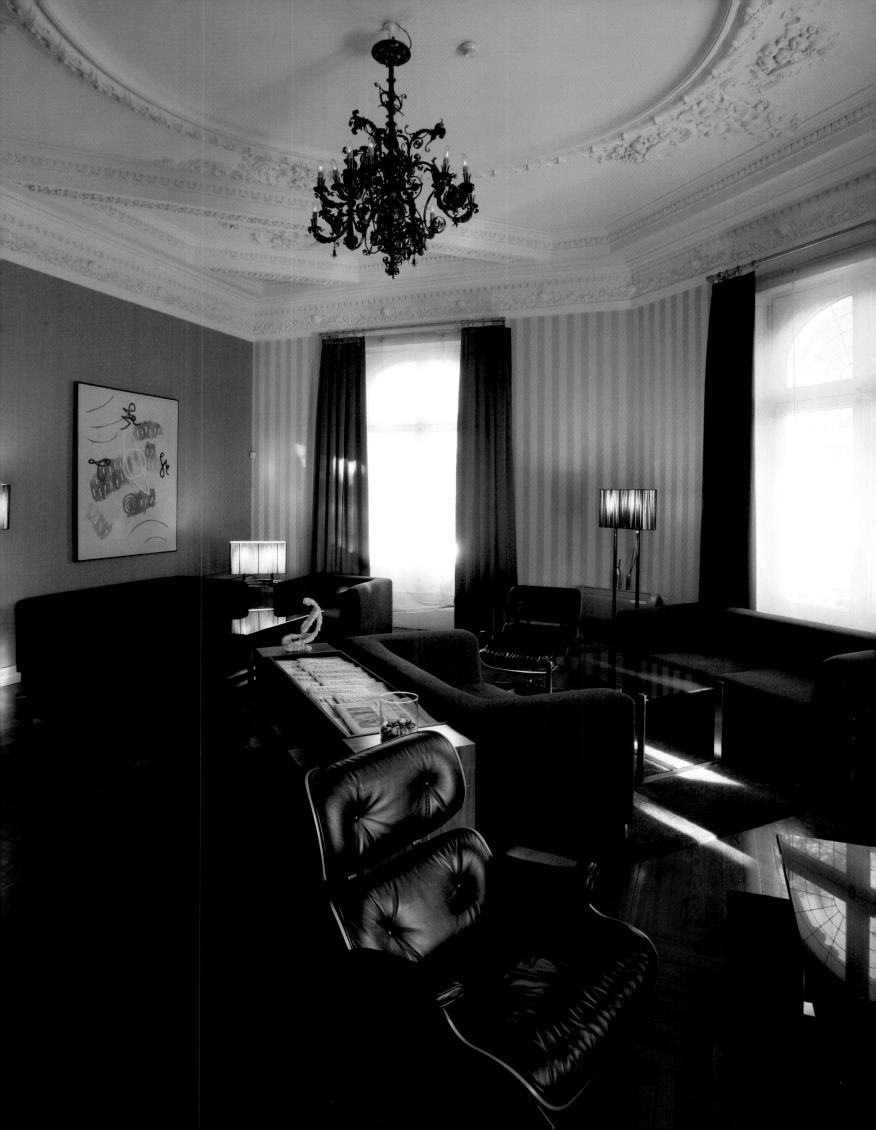

Grande Bretagne

Athens, Greece

Only a select number of hotels are surrounded by as many myths as this so called "kingly box" in the middle of Athens. Since its opening in 1874, the dignified hotel has accommodated just about all the kings, presidents and rulers that the previous century had to offer. In 2003 the aged magnificent building underwent a thorough renovation. Since then, a modern spa and wellness offer awaits the guests.

Nur wenige Hotels umranken so viele Mythen wie diese sogenannte „königliche Box" mitten in Athen. Denn das ehrwürdige Haus beherbergte seit seiner Eröffnung im Jahre 1874 so ziemlich alles an Königen, Präsidenten und Herrscherinnen, die das letzte Jahrhundert hervorbrachte. 2003 erfuhr der in die Jahre gekommene Prunkbau eine Generalsanierung. Seitdem warten moderne Spa- und Wellnessangebote auf die Gäste.

Peu d'hôtels peuvent se prévaloir d'autant de mythes que cette soi-disant « boîte royale » au centre d'Athènes. Cet hôtel vénérable a hébergé depuis son inauguration en 1874 à peu près toutes les têtes royales, présidentielles et impériales que le dernier siècle a pu générer. Les bâtiments luxueux quelque peu vétustes ont été entièrement rénovés en 2003. Depuis, des installations de spa et de remise en forme modernes sont à la disposition des hôtes.

From the terrace, guests have a magnificent view of the Acropolis.

Von der Terrasse eröffnet sich eine herrliche Aussicht auf die Akropolis.

Depuis la terrasse, on a une vue magnifique sur l'Acropole.

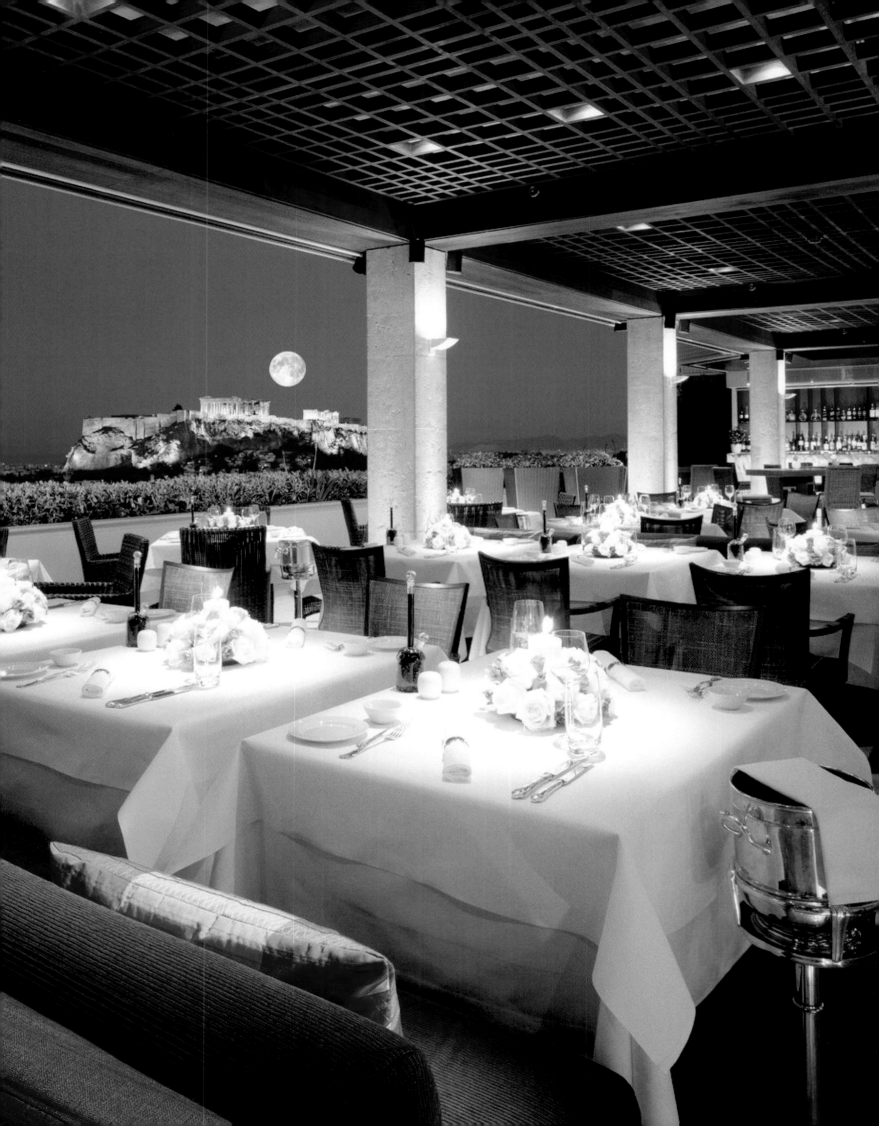

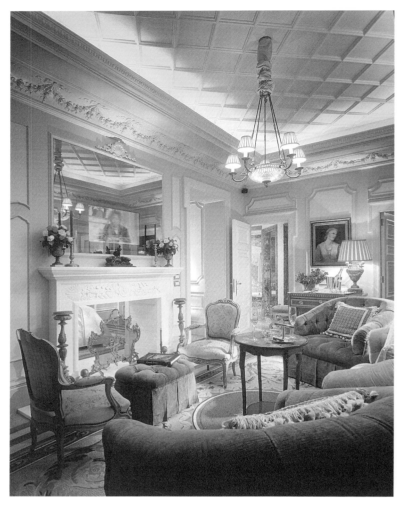

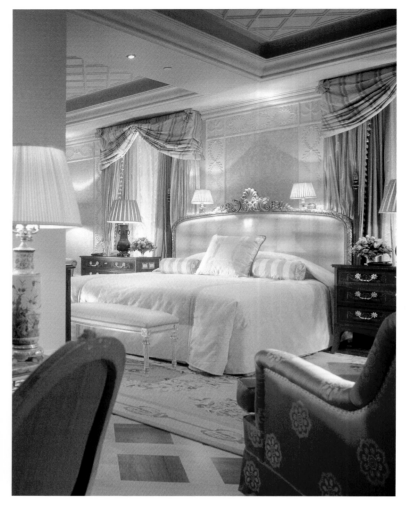

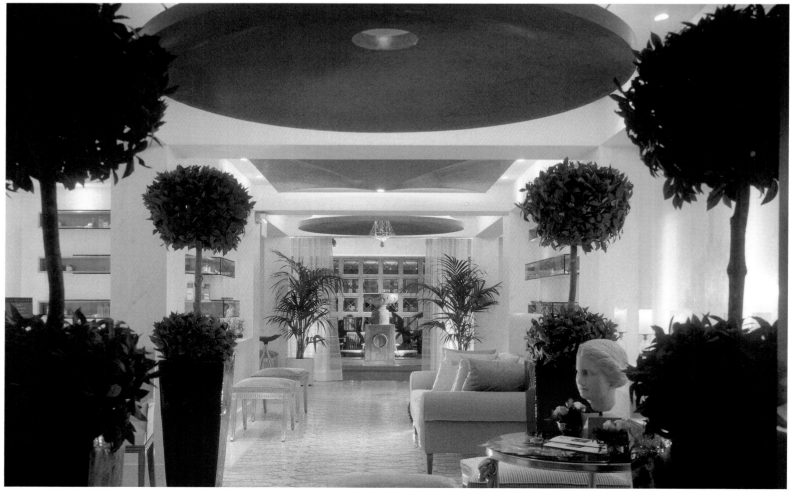

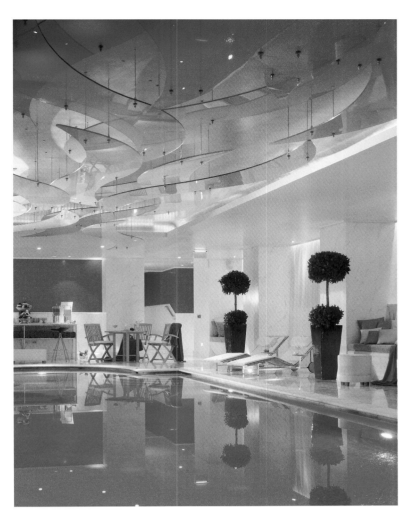

In the wellness area, a sauna, a steam bath, a pool and a pool bar await the guests.

Sauna, Dampfbad, Pool und Pool-Bar erwarten den Gast im Wellness-Bereich.

L'espace wellness offre sauna, hammam, piscine et bar au bord de la piscine.

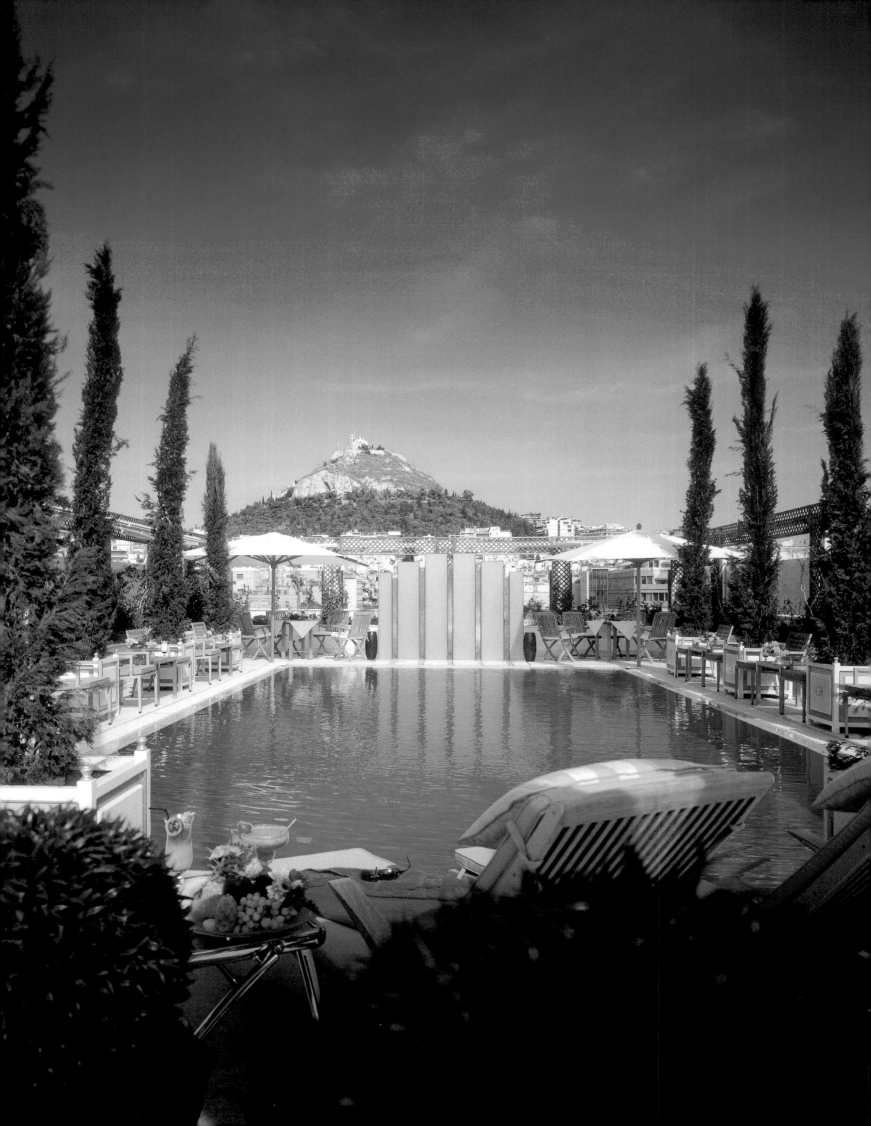

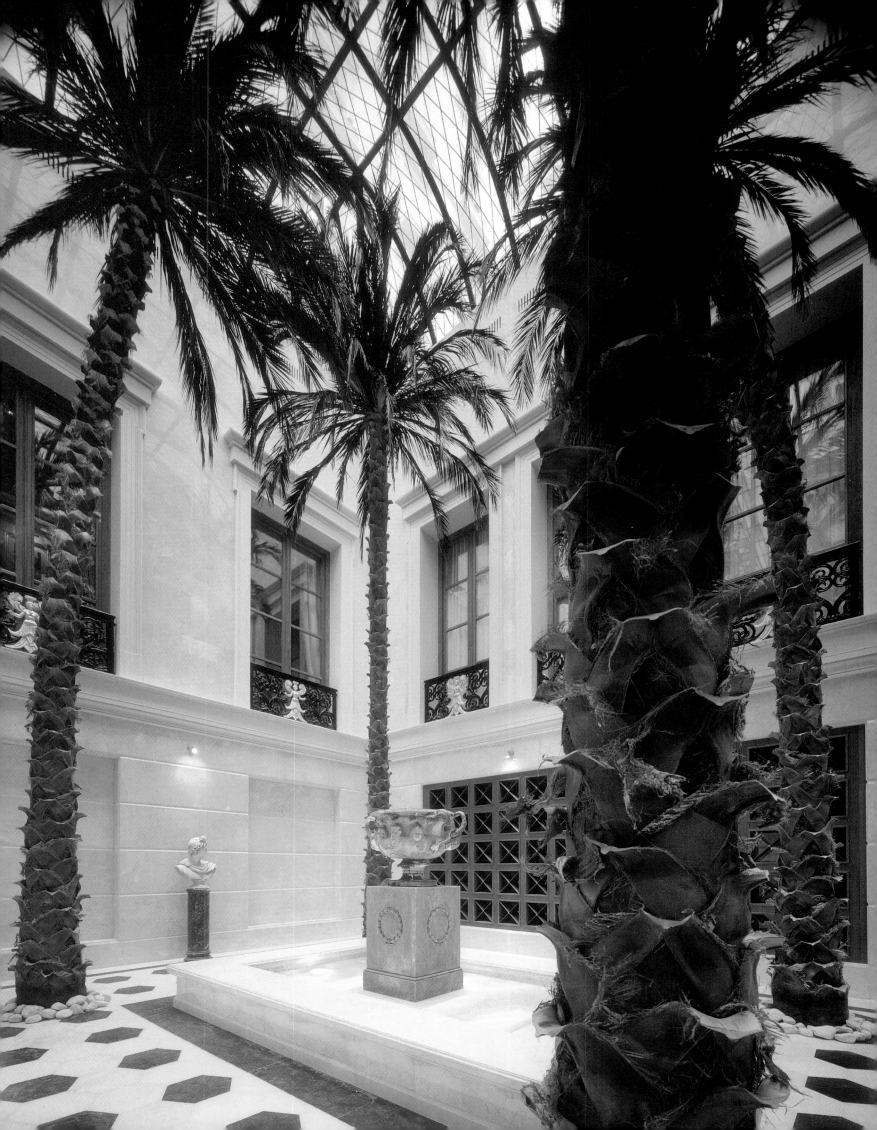

Ciragan Palace Kempinski Istanbul

Istanbul, Turkey

The palace combines rich history. The sultans of Istanbul had their residence here one century ago and the building thus reflects the splendor of a past, but impressive era. With its exposed location on the Bosphorus and the park, which surrounds the palace, the 284 guest rooms and 31 suites offer first-class views. The restaurant "Tugra" is among the world's most famous addresses. The classical Turkish bath is completely made of marble and nacre.

Der Palast hat eine reiche Geschichte. Vor ungefähr einem Jahrhundert residierten hier die Sultane von Istanbul und so spiegelt das Gebäude den Prunk einer zwar verflossenen, gleichwohl eindrucksvollen Zeit wider. Mit der exponierten Lage am Bosporus und dem Park, der den Palast umrahmt, bieten die 284 Gästezimmer und 31 Suiten erstklassige Aussichten. Das Restaurant „Tugra" gehört zu den weltweit berühmten Adressen. Das klassische türkische Bad ist ganz aus Marmor und Perlmutt.

Le palais bénéficie d'une riche histoire. Il y a un siècle, il a servi de résidence aux sultans d'Istanbul, et ses bâtiments reflètent le faste d'une époque révolue, mais néanmoins impressionnante. Grâce à sa situation sur le Bosphore et au parc qui entoure le palais, les 284 chambres et 31 suites offrent des vues extraordinaires. Le restaurant « Tugra » fait partie des meilleures adresses du monde. Les bains turcs traditionnels sont entièrement ornés de marbre et de nacre.

The sumptuous atrium welcomes the guests.

Das prunkvolle Atrium nimmt die Gäste in Empfang.

Un atrium fastueux pour accueillir les hôtes.

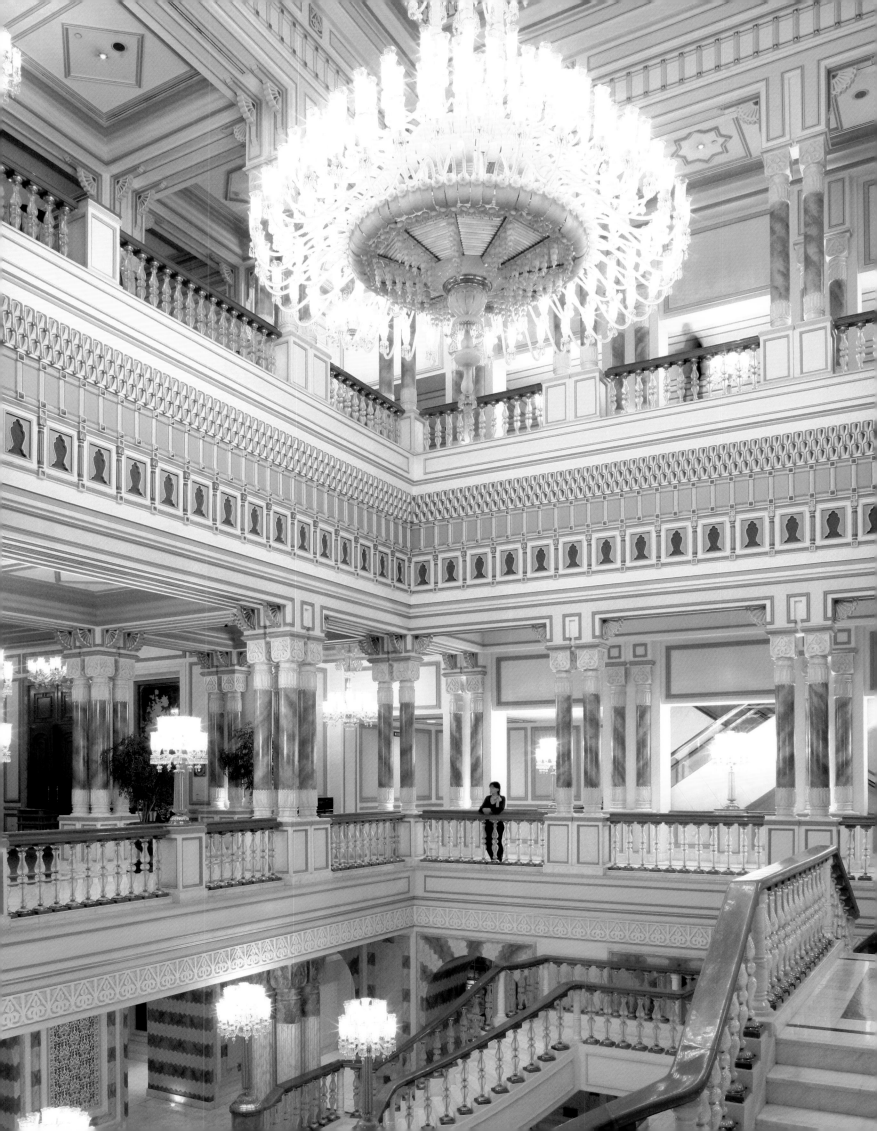

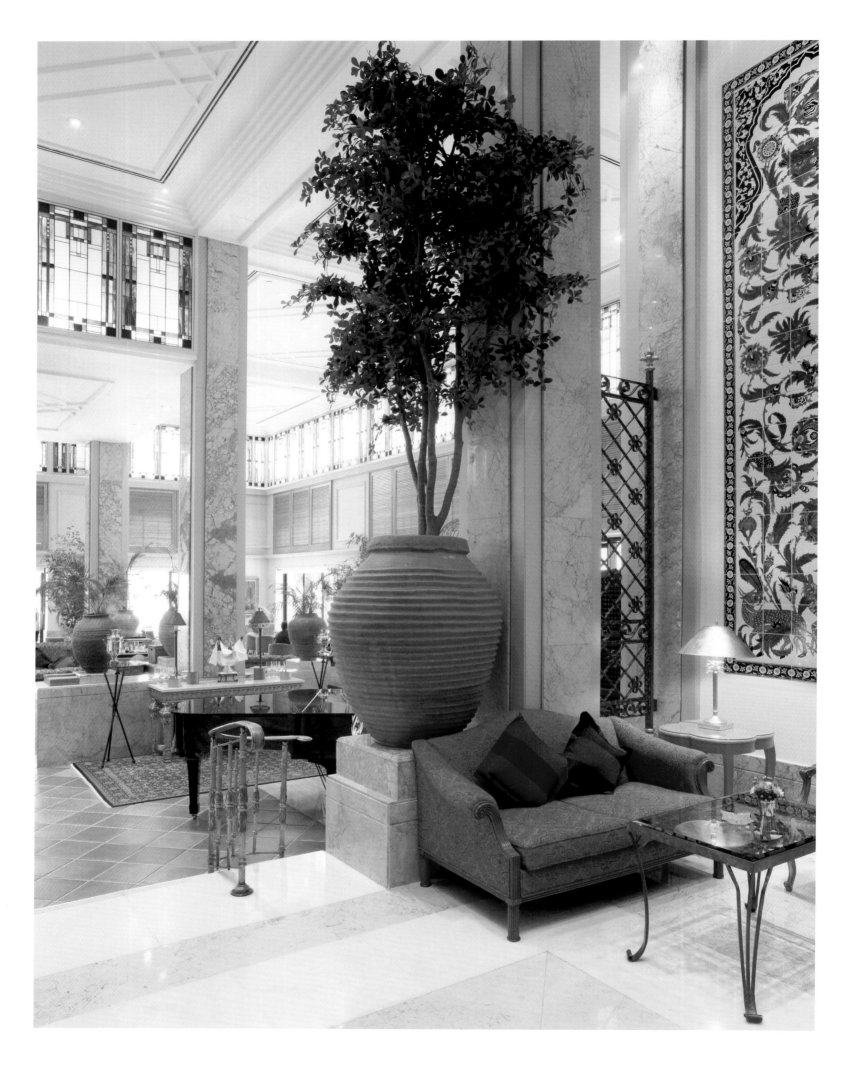

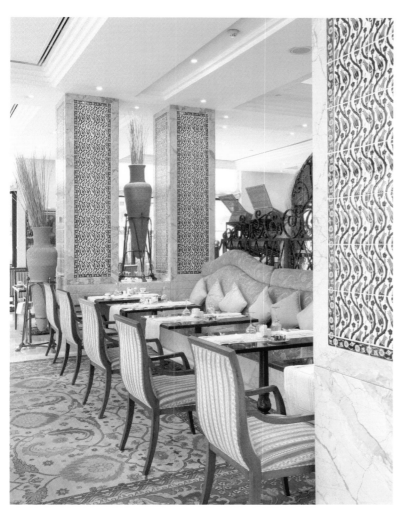

Delicious afternoon tea is served in the "Gazebo Lounge & Restaurant."

Im „Gazebo Lounge & Restaurant" wird köstlicher Nachmittagstee serviert.

L'après-midi, un thé délicieux est servi dans le « Gazebo Lounge & Restaurant ».

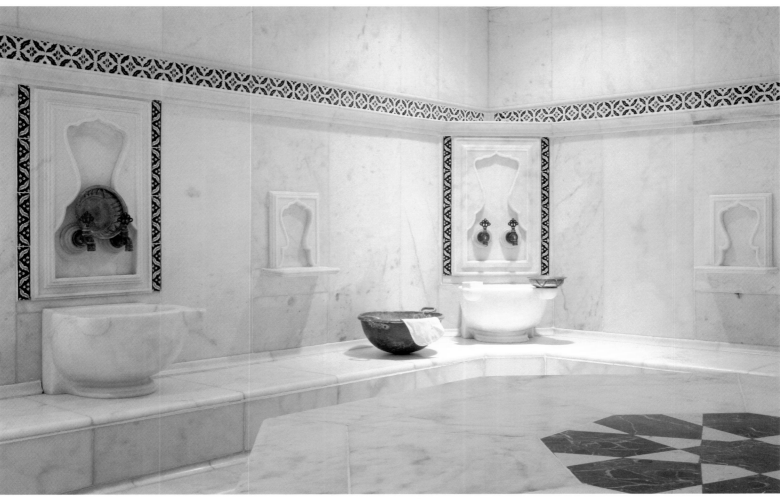

The former Sultan's palace is located alongside the Bosphorus.

Der ehemalige Sultanspalast liegt längs des Bosporus.

L'ancien palais des Sultans se situe le long du Bosphore.

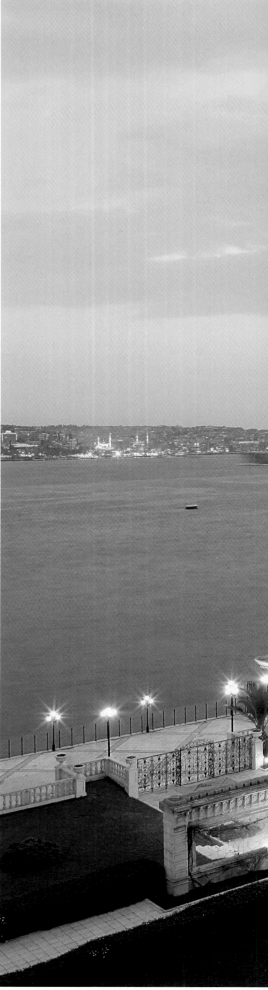

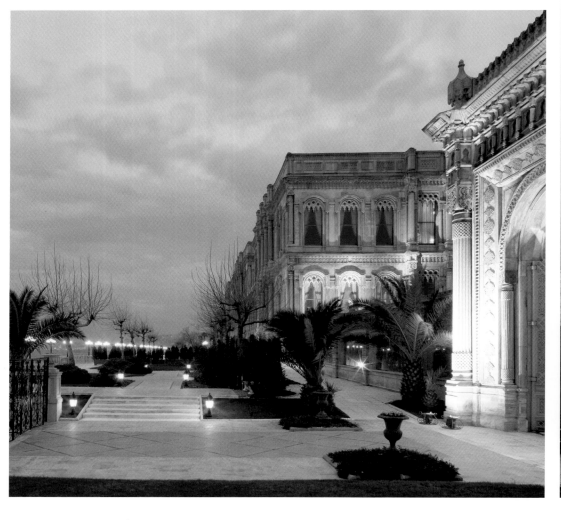

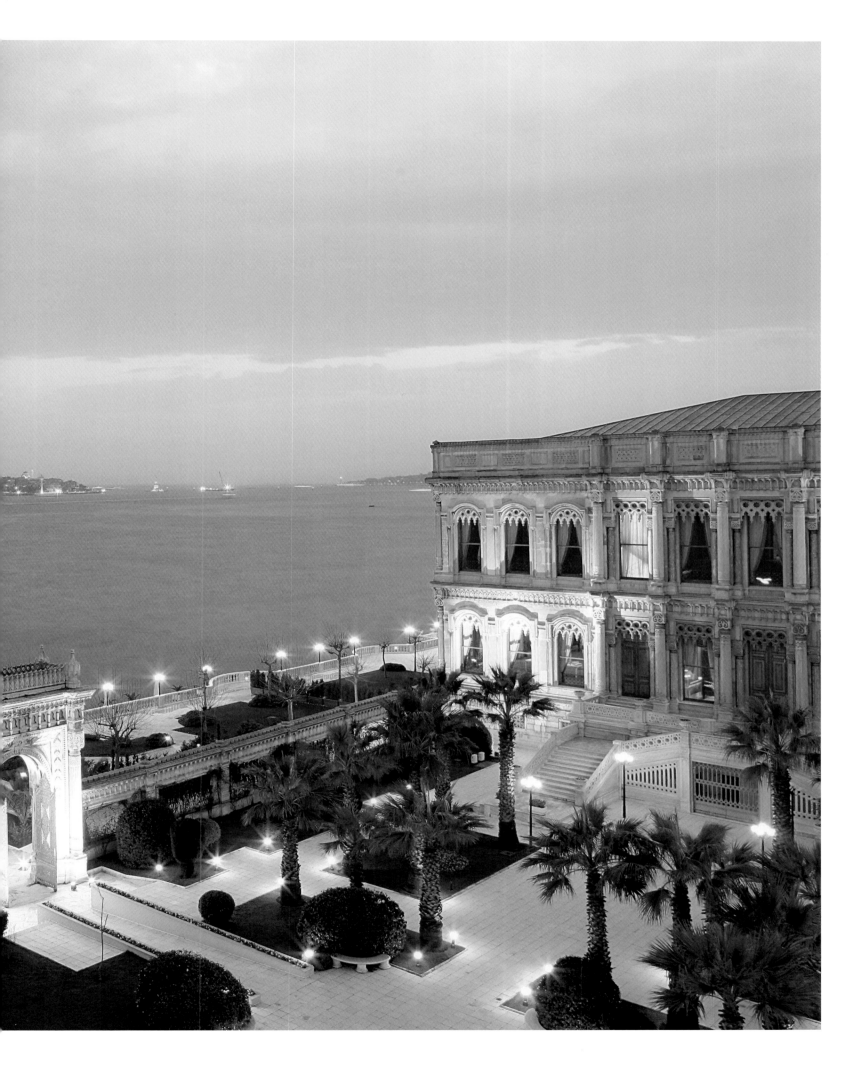

Sumahan on the Water

Istanbul, Turkey

Located directly by the Bosphorus, the strait between Europe and Asia, the Sumahan on the Water is an elegant hotel literally built on the water. This was formerly the location of a 19th-century liquor factory. The architects were able to maintain the original loft character of this place and combine it with modern elements. Guests have a view of the Bosphorus from all of the 20 rooms and the terrace café. The restaurant is famous for its fish specialties.

Direkt am Bosporus, der Meerenge zwischen Europa und Asien, liegt das Sumahan on the Water. Tatsächlich ist das elegante Hotel direkt am Wasser untergebracht, und zwar in einer ehemaligen Schnapsfabrik aus dem 19. Jahrhundert. Den Architekten gelang es, den ursprünglichen Loftcharakter des Gebäudes zu erhalten und mit modernen Elementen zu verbinden. Von jedem der 20 Zimmer wie auch vom Café auf der Terrasse blickt man auf den Bosporus; das Restaurant ist bekannt für seine Fischgerichte.

Le Sumahan on the Water se situe sur les bords du Bosphore, ce détroit qui sépare l'Europe de l'Asie. En effet, l'hôtel élégant a été installé directement au bord de l'eau, et ce, dans une ancienne distillerie datant du XIXème siècle. Les architectes ont réussi à préserver le caractère loft d'origine de l'édifice et à le marier à des éléments modernes. Les hôtes ont vue sur le Bosphore de toutes les 20 chambres, tout comme du café de la terrasse. Par ailleurs, le restaurant de l'hôtel est célèbre pour ses plats de poissons.

The loft character of the former factory has been maintained.

Der Loftcharakter der früheren Fabrik ist erhalten geblieben.

Le style loft de cette ancienne usine a été préservé.

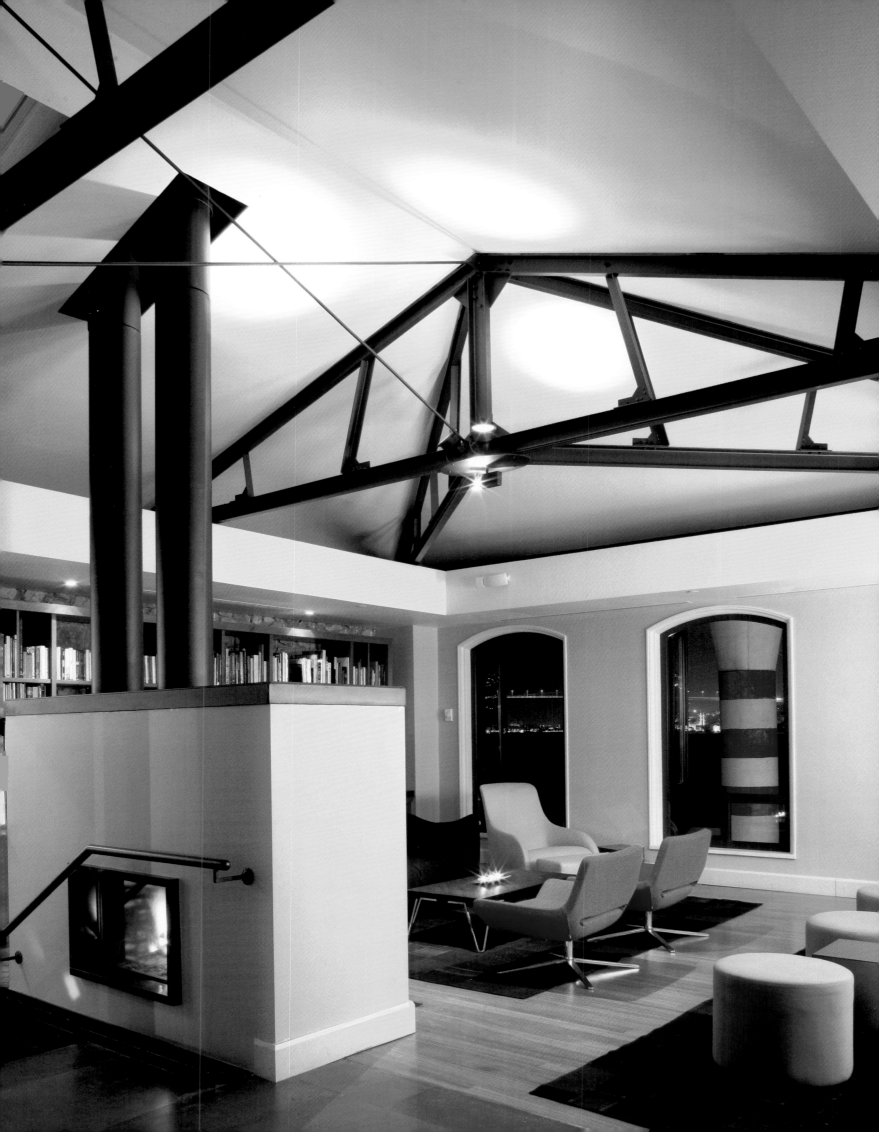

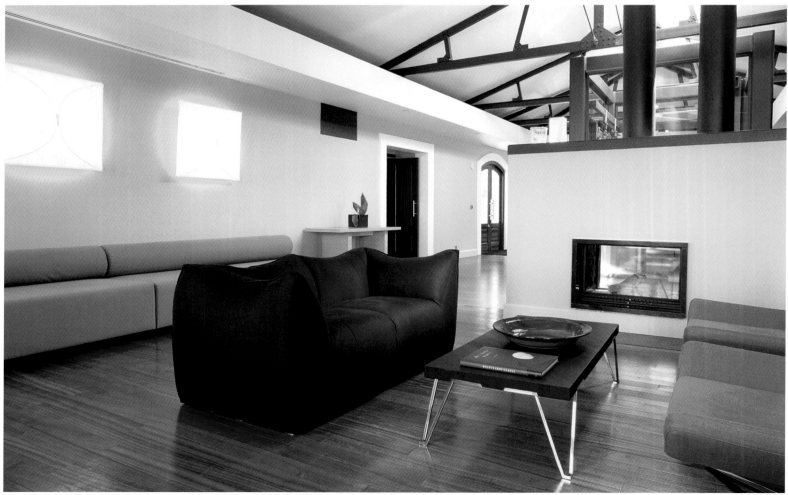

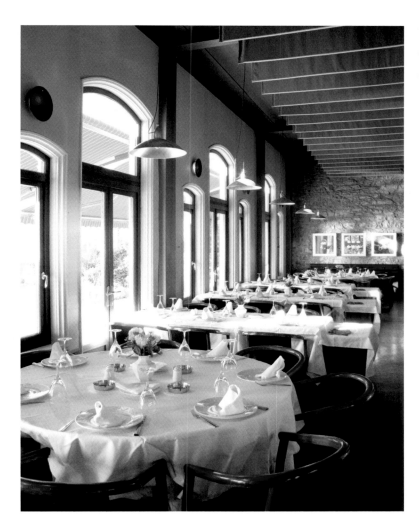

Contemporary furniture was carefully integrated in the rooms' decoration.

Sorgfältig wurde zeitgenössisches Mobiliar in die Räume integriert.

C'est avec soin que les pièces ont été agrémentées de meubles contemporains.

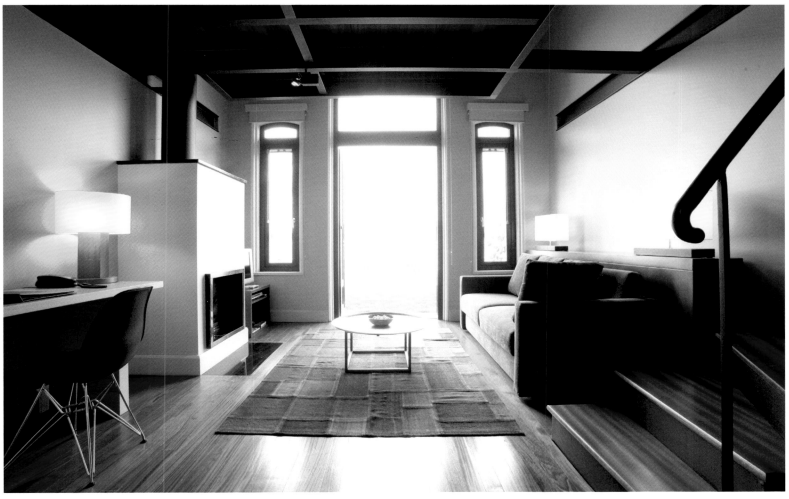

Index

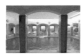
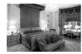
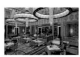
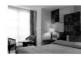
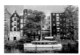
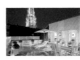
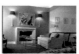

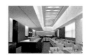
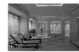
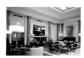

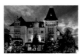

Villa Kennedy
Kennedyallee 70, 60596 Frankfurt, Germany
T +49 69 71 71 20, F +49 69 71 71 22 43 0
www.villakennedy.com

163 rooms, including 28 suites and 1 presidential suite. Restaurant
Gusto, JFK's bar & lounge. 9 daylight meeting rooms. Ballroom. Villa
Spa, fitness. Inner courtyard garden. Located close to the center of
Frankfurt. 20-min drive to Frankfurt International Airport.

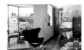

Mandarin Oriental Munich
Neuturmstraße 1, 80331 Munich, Germany
T +49 89 29 09 80, F +49 89 22 25 39
www.mandarinoriental.com

73 rooms including 20 suites and junior suites. Restaurant Mark's
(Michelin star), Mandarin Bar. Outdoor swimming pool on the roof terrace.
Business work station, 3 meeting rooms for up to 120 guests. In the
historic city center within walking distance of the most attractions and
elegant shops.

Bayerischer Hof
Promenadeplatz 2–6, 80333 Munich, Germany
T +49 89 21 20 0, F + 49 89 21 20 906
www.bayerischerhof.de

373 rooms including 60 suites. 6 bars, 4 restaurants: Palais Keller,
Trader Vic's, Garden restaurant, Blue Spa Lounge. Breakfast room. Blue
Spa, designed by Andrée Putmann, with pool, saunas, fitness room, beauty
center, hairdresser with hair spa. 40 conference rooms. Internet, facilities
for disabled, business center. Ballroom for up to 2,500 guests. Located
right in the city center of Munich. Privately managed, internationally
awarded luxury hotel known for its elegant flair, personal service,
cosmopolitan VIP guests, lounge with fireplace, panorama terrace
overlooking the rooftops of Munich's old center, night Club with live
jazz program.

Czech Republic

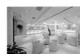

Hotel Josef
Rybná 20, 11000 Prague 1, Czech Republic
T +420 221 700 111, F +420 221 700 999
www.hoteljosef.com

109 rooms with light materials as well as glass baths in 2 houses facing
an inner court. Garden. Conference room, business center. Gym, sauna,
massage room. Garage. Concierge service and guest relations. Located in
the center of Prague, 5 min from the Old Town Square.

Austria

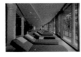

Schloss Fuschl
Schloss Straße 19, 5322 Hof bei Salzburg, Austria
T +43 6229 2253 1500, F +43 6229 2253 1557
www.schlossfuschlresort.at

110 rooms including 39 suites and 6 lake cottages. Schloss Bar, gourmet
restaurant Imperial, Schloss Restaurant, vinothek. Spa. Shop. Fishery.
Vintage cars. Babysitting. Room service, butler on request. Just 12 miles /
20 km to Salzburg city center. The location on a peninsula at Lake Fuschl
is right out of a dream. 170 works of art by old masters worthy of places
in museums underscore the hotel's top class. One of the highlights is the
Sissi Suite in the listed tower with 360 degrees panoramic view of the
lake and the mountains.

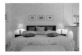

Palais Coburg
Coburgbastei 4, 1010 Vienna, Austria
T +43 1 518 18 0, F +43 1 518 18 100
www.palais-coburg.com

35 suites. Gourmet restaurant Coburg, Coburg Wine Bistro (Garden-
pavilion and Wine Bar). 9 function rooms providing meeting and event
facilities. Concert hall. Palais Coburg also houses The Institute for
Strategic Capital Market, with the Coburg safe deposit facility. Located
in the center of Vienna.

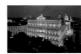

Imperial
Kärntner Ring 16, 1015 Vienna, Austria
T +43 1 501 100, F +43 1 5011 0410
luxurycollection.com/imperial

138 rooms, 32 suites. Bar Maria Theresia, Restaurant Imperial, Café
Imperial. 7 meeting rooms for up to 480 people. Close to the Museum of
Fine Arts, Spanish Riding School and Hofburg Convention Center.

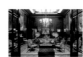

Sacher
Philharmonikerstraße 4, 1010 Vienna, Austria
T +43 1 51 456 0, F +43 1 51 456 810
www.sacher.com

152 rooms including suites. Restaurants Rote Bar, Anna Sacher, Café
Sacher Vienna, Sacher Confiserie and more. Traditional banquet halls.
Sacher Spa, one of the world's most exclusive ones. Modern conference
facilities. Located in the heart of the city, opposite the Opera House and
around the corner from the Spanish Riding School.

Switzerland

La Réserve Genève Hotel & Spa
301, route de Lausanne, 1293 Geneva, Switzerland
T +41 22 959 5959, F +41 22 959 5960
www.lareserve.ch

102 rooms and suites. Spa with 17 treatment rooms, art gym, indoor and
outdoor pool, sauna, hammam, facial and beauty treatments "La Prairie"
and "Cinq Mondes". Located on the right shore of Lake Geneva. 3 miles /
5 km from the center of Geneva, 2 miles / 3 km from the International
Airport.

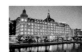

PALACE Luzern
Haldenstraße 10, 6002 Lucerne, Switzerland
T +41 41 416 1616, F +41 41 416 1000
www.palace-luzern.ch

136 light and airy rooms and suites. Restaurants Jasper, Les Artistes,
Palace Bar. Spa opened in 2005, including saunas, steam rooms, lifestyle
showers, ice fountains and much more. 13 meeting and event rooms.
Located in the heart of Switzerland at Lake Lucerne, about 1 hour from
Zurich and Basel airports, 3 hours from Geneva airport.

Widder
Rennweg 7, 8001 Zurich, Switzerland
T +41 44 224 2526, F +41 44 224 2424
www.widderhotel.ch

42 rooms and 7 suites. Widder restaurant and bar, Wirtschaft zur
Schtund. Small technogym. Library. Business center, 8 conference rooms
for up to 200 people. 24 h room service. Concierge. Valet service. Wi-Fi,
interactive B&O screen TV and stereo. Located in the heart of Zurich's old
town, close to the Bahnofstrasse.

France

Hôtel Martinez
73, La Croisette, 06400 Cannes, Côte d'Azur, France
T +33 4 9298 7300, Fax: +33 4 9339 6782
www.hotel-martinez.com

412 rooms and suites. 3 restaurants – 1 with two Michelin stars, piano bar. Heated private pool, private beach club, Spa Martinez, fitness center. Kid's club during July and August. Concierge. Wi-Fi. Located on the famous boulevard de La Croisette. All Penthouse Suites on the seven floors overlook the sea.

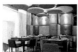

Murano Resort
13, Boulevard du Temple, 75003 Paris, France
T +33 1 4271 2000, F +33 1 4271 2101
www.muranoresort.com

52 rooms and suites. Restaurant with terrace and lounge-bar with live DJ. 2 suites with private heated swimming pools. Fitness center. Located in the Marais quarter.

Plaza Athénée
25, avenue Montaigne, 75008 Paris, France
T +33 1 5367 6665, F +33 1 5367 6666
www.plaza-athenee-paris.com

146 rooms and 45 suites. 3 restaurants, gourmet restaurant Alain Ducasse au Plaza Athénée. Dior Institute. Located in the city center, 10 minutes from Arc de Triomphe and Eiffel Tower, 19 miles / 30 km from Charles-de Gaulle Airport.

Le Meurice
228, rue de Rivoli, 75001 Paris, France
T +33 1 4458 1010, F +33 1 4458 1015
www.lemeurice.com

160 rooms including 23 suites and 16 junior suites. 2 restaurants, bar. Spa, fitness room. Meeting and event facilities for 20 up to 450 people, ceremonial Salon Pompadour. Business center services. Hotel limousine on request. Disabled access. Located in the heart of Paris between Place de la Concorde and the Louvre on Rue de Rivoli, in the fashionable 1st arrondissement.

Italy

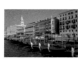

Hotel Danieli
Riva degli Schiavoni 4196, 30122 Venezia, Italy
T +39 041 522 6480, F +39 041 520 0208
www.luxurycollection.com/danieli

186 double rooms, 20 single rooms, 19 suites and junior suites. Restaurant, bar.-Banqueting rooms for up to 350 persons. Only steps away from the Piazza San Marco, the Basilica di San Marco, the Doge's Palace and the Bridge of Sighs.

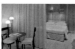

Riva Lofts
Via Baccio Bandinelli 98, 50142 Florence, Tuscany, Italy
T +39 055 71 30 272, F +39 055 71 11 03
www.rivalofts.com

9 studios with independent entrance. Honesty Bar. Outdoor pool, massages on request. 24/7 living room. Babysitting on request. Concierge. Bikes available for guests. Located along the Arno, opposite of Parco delle Cascine. The warm atmosphere in these distinctive spaces is due to an accurate balance amongst modern antiques, as 1950s furniture, old and new materials as wood and Corian, and examples of sophisticated design as the kitchens designed by Claudio Nardi.

Bulgari
Via Privata Fratelli Gabba 7b, 20121 Milan, Italy
T +39 02 805 805 1, F +39 02 805 805 222
www.bulgarihotels.com

58 rooms and suites. Restaurant and bar, lounge. Indoor pool, spa, hammam, fitness center, wellness area. Garden. Personal shopper. Hair and make-up service. 24 h valet parking. Complimentary packing and unpacking service. Located in the heart of Milan, next to the botanical garden. As one might expect from the famous brand, the hotel is the embodiment of the cool passion that typifies Italian design. The surrounding gardens are a favorite place for Milanese to go chill out.

The Chedi Milan
Via Villapizzone 24, Bovisa District, 20156 Milan, Italy
T +39 02 363 1888, F +39 02 363 1870
www.thechedimilan.com

290 rooms and suites, including The Penthouse on 10th floor with panoramic terrace and 40 rooms for long stays. Restaurant (Italian, Indian and Thai cuisine), bar, lounge, The Chedi Club on 6th floor. Gym with covered pool, spa Institut Dominique Chenot. Conference center. Personalized butler service. Shuttle to center. First urban resort in Milan, located in Bovisa district, a 15-minute taxi drive to the center.

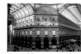

Town House Galleria
Via Silvio Pellico 8, 20121 Milan, Italy
T +39 02 890 582 97, F +39 02 890 582 99
www.townhousegalleria.it

24 rooms and suites. Restaurant La Sinfonia (only for guests), bar. Events, shopping and art planning. Butler assigned to every room. Located in the heart of Milan. It is the only hotel inside the historical Galleria Vittorio Emanuele II built in 1876 and the ultimate luxury destination in Milan with interior design by architect Ettore Mocchetti.

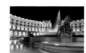

EXEDRA
Piazza della Repubblica 45, 00185, Rome, Italy
T +39 06 489 381, F +39 06 489 380 00
www.boscolohotels.com

240 rooms including 11 junior suites, 3 suites and executive suites, 1 presidential suite. 2 exclusive restaurants. Rooftop terrace with infinity pool. Spa. Modern business center. Located in the center of Rome near the Piazza della Repubblica and Basilica degli Angeli. Breakfast is served on the rooftop terrace that overlooks Fountain of the Naiads.

Hotel de Russie
Via del Babuino 9, 00187 Rome, Italy
T +39 06 328 881, F +39 06 32 888 888
www.hotelderussie.it

122 rooms including 34 suites. Restaurant, bar. De Russie Wellness Zone with hydropool, saltwater Jacuzzi, sauna, Turkish steam bath, beauty treatments and gym with personal trainers. Features a beautiful courtyard, a Butterfly Oasis in terraced gardens that run up the Pincio hill. 4 meeting rooms for up to 90 people. Located between the Spanish Steps and Piazza del Popolo.

Raphaël Hotel
Largo Febo 2, Piazza Navona, 00186 Rome, Italy
T +39 06 682 831, F+39 06 687 8993
www.raphaelhotel.com

Rooms, suites and apartments—some of them have a private terrace, executive Richard Meier floor. Restaurant and roof garden. Fitness center. Meeting facilities, Sala Pantheon for up to 40 people. Library. Centrally located, just 65 ft. / 20 m from famous Piazza Navona.

Spain

Palacio del Bailío
Ramírez de las Casas de Deza, 10–12, 14001 Córdoba, Andalucía, Spain
T +34 957 498 993, F +34 957 498 994
www.hospes.com

50 rooms, 2 suites and 1 big loft suite. Senzone restaurant, tapas bar, lounge bar. Bodyna Spa utilizes ancient treatments, massage, pool and roman baths. Meeting rooms for up to 120 people. Located right in the city center, next to the Cristo de los Faroles statue. Once a grand working palace, this 17th-century building is now host to a charming oasis of luxury and peace in the heart of Córdoba.

Casa Fuster
Passeo de Gracia, 132, Eixample, 08008 Barcelona, Spain
T +34 932 553 000, F +34 932 553 002
www.hotelcasafuster.com

75 rooms, 21 suites. 2 restaurants, Café Vienés, situated on the ground floor. Rooftop pool, Jacuzzi. 10 meeting rooms for up to 300 people. This luxury hotel has long been on the list of top hotels in Spain. Originally a private residence, the building was the most expensive mansion in Barcelona when completed in 1911. Just steps away from the world-famous Passeo de Gracia.

H 1898
La Rambla, 109, Ciutat Vella, 08002 Barcelona, Spain
(Entrance via C/Pintor Fortuny)
T +34 935 529 552, F +34 935 529 550
www.hotel1898.com

169 rooms and 3 suites with terrace and pool. Spa, gym, outdoor
swimming pool, solarium. 7 colonial meeting rooms, 1 fully equipped
business center. Library. Located in the heart of Barcelona at La Rambla.

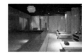

Palacio de los Patos
Solarillo de Gracia, 1, 18002 Granada, Andalucía, Spain
T +34 958 535 790, F +34 958 536 968
www.hospes.com

42 rooms including five suites. Senzone restaurant, Bodyna spa, massage
& treatments, pool, Jacuzzi, sauna and Turkish bath. Meeting rooms for up
to 60 people. Located in the historic and business center of Granada.
This former palace is now one of Granada's most intriguing boutique
hotels. The spectacular 19th-century building has been transformed into a
grand palace for the 21st century by combining it with a new design
building with an impressive alabaster facade. Each room is a balance
of contemporary and classical, each with plasma televisions, large
bathrooms and free internet. The Arabian garden is a great place to find
a quiet moment.

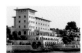

Maricel
Calle d'Andratx, 1, 07184 Calvià, Mallorca, Spain
T +34 971 707 744, F +34 971 707 745
www.hospes.com

29 rooms, Senzone restaurant, Senzone cocktail bar. Pool. Guests can
enjoy one of several signature massage therapies in stone caves by the
Mediterranean Sea. Meeting rooms. Located on the beach side, close to
Palma de Mallorca, 12 miles / 20 km from Palma airport.

Portixol
Calle Sirena, 27, 07006 Palma de Mallorca, Mallorca, Spain
T +34 971 271 800, F +34 971 275 025
www.portixol.com

Opend in 1956 and recently transformed into a luxury destination.
26 rooms, 13 of them with terrace. Full service restaurant, bar. Pool.
Spa. Conference room. Located just outside Palma de Mallorca,
directly at Portixol port.

Puro
Montenegro, 12, 07012 Palma de Mallorca, Mallorca, Spain
T +34 971 425 450, F +34 971 425 451
www.purohotel.com

26 rooms and suites. Patios, rooftop terrace. Opio Restaurant with
Mediterranean & Asian cuisine. Plunge pool, massages. 10-minutes
drive to beach club. Babysitting. Concierge. Located in Palma's old town
La Lonja, next to the historic and shopping districts of Palma.

Santo Mauro
Calle Zurbano, 36, 28010 Madrid, Spain
T +34 913 196 900, F +34 913 085 477
www.hotelacsantomauro.com

51 rooms and suites. Restaurant and lobby bar. Indoor swimming pool,
garden. Fitness center. Butler service. Located in the center of Madrid
close to Paseo de la Castellana.

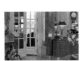

Ritz
Plaza de la Lealtad, 5, 28014 Madrid, Spain
T +34 917 016 767, F +34 917 016 776
www.ritzmadrid.com

137 rooms and 30 suites. Restaurant and garden terrace, two bars,
private dining rooms. Fitness center. Located in the heart of Madrid, close
to the Prado and the Thyssen Museum.

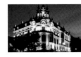

Hotel AC Palacio del Retiro
Alfonso XII, 14, 28014 Madrid, Spain
T +34 915 237 460, F +34 915 237 461
www.ac-hotels.com

50 rooms. Índice restaurant with modern and healthy cuisine. Fitness
center, spa, sauna and massage. 5 meeting rooms with a capacity of up
to 40 people, business facilities, direct and high-speed internet. 24 h
room service. Located in front of the Retiro Park, within the 'golden
triangle' of the Thyssen, Prado and Reina Sofia museums

Greece

Grande Bretagne
Constitution Square, 105–63 Athens, Greece
T +30 210 333 0000, F +30 210 322 8034
www.grandebretagne.gr

265 rooms, 56 suites. GB Roof Garden roof-top restaurant, GB Corner
brasserie, Winter Garden café-style restaurant, Alexander's bar.
GB Spa. Banquet and meeting facilities. Ballroom. Located in the
center of Athens.

Turkey

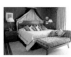

Ciragan Palace Kempinski Istanbul
Ciragan Caddesi 32, Besiktas, 34349 Istanbul, Turkey
T +90 212 326 4646, F +90 212 259 6687
www.ciragan-palace.com

282 rooms and 31 suites. 3 restaurants serving Turkish and international
cuisine, Ciragan Barbecue during summer season, Sultan's Brunch, bar,
wine bar. Health Club, fitness, Turkish bath, beauty. Banqueting and
wedding service. Business center. Located at the Bosporus, 45 minutes
from Istanbul Ataturk Airport.

Sumahan on the Water
Kuleli Cadesi 51 Cengelkoy, 34684 Istanbul, Turkey
T +90 216 422 8000, F +90 216 422 8008
www.sumahan.com

20 rooms and suites with private gardens, almost all have an open
fireplace. 2 restaurants. Wellness center, fitness and massage service.
Meeting room. Babysitting. 24-hours room service. Dry cleaning and
laundry service. Library. Accessible for the disabled. Located on the Asian
shore of the Bosporus. From the lobby, you can have a unique view of the
minarets and domes of the old city of Istanbul as well as of the Ataturk
Bridge that spans the busy strait.

Photo Credits

Roland Bauer	Hotel de Filosoof	30
	Hotel Pulitzer, a Luxury Collection Hotel	34
	Bayerischer Hof	78
	Schloss Fuschl	84
	Murano Resort	122
	Villa Kennedy	66
	Adlon Kempinski	54
	Le Meurice	130, 132, 133
	PALACE Luzern	111, 112
	Sacher	101
Klaus Frahm	SIDE Hotel	50
Michelle Galindo	Hotel AC Palacio del Retiro	196, 199
Gavin Jackson	Claridge's	22
	Ciragan Palace Kempinski Istanbul	206, cover
	Sumahan on the Water	213
Martin Nicholas Kunz	Widder	114
	H1898	170
	Santo Mauro	188
	Ritz	192
Matthias Nero	Puro	184
Beatrice Pediconi Giovanna Piemonti	Exedra	152
Carlo Valentini	Riva Lofts	138

Other photo courtesy

Barasa 2007	The Chedi Milan	144
Bayerischer Hof	Bayerischer Hof	76, 77, 78, 79
Berns Hotel	Berns Hotel	10
Blakes London	Blakes Hotel	14, back cover (top right)
Bulgari	Bulgari	140
Casa Fuster	Casa Fuster	166
Raphaël Hotel	Hotel Raphaël	158
Grande Bretagne	Grande Bretagne	200, back cover (bottom right)

Gräflicher Park Hotel & Spa	Gräflicher Park Hotel & Spa	60, back cover (bottom left)
Hotel Josef	Hotel Josef	80
Hôtel Plaza Athénée	Plaza Athénée	126
Town House Hotels www.townhouse.it	Town House Galleria	148
Hospes Hotels & Moments	Palacio del Bailio	162
	Palacio de los Patos	174
	Maricel	178
Hotel de Rome	Hotel de Rome	56
Hotel Imperial Wien	Imperial	96
Hôtel Martinez	Hotel Martinez	118, back cover (top left)
Hotel Sacher Wien	Sacher	100, 102, 103
La Réserve Genève	La Réserve Genève Hotel & Spa	106
Le Meurice	Le Meurice	131
Louis C. Jacob	Louis C. Jacob	46
Mandarin Oriental, Munich	Mandarin Oriental Munich	72
Hotel AC Palacio del Retiro	Hotel AC Palacio del Retiro	197, 198
PALACE Luzern	PALACE Luzern	110, 113
Palais Coburg	Palais Coburg Residenz	90
Portixol	Portixol	182
Rocco Forte Hotels	(Rocco Forte Collection's) Hotel Amigo	38
Royal Windsor Hotel Grand Place	Royal Windsor Hotel Grand Place	42
Starwood Hotels & Resort	Danieli	134
The Berkeley	The Berkeley	18
The Lanesborough	The Lanesborough	26

Editor	Martin Nicholas Kunz
Editorial Coordination	Elke Roberta Buscher, Katharina Feuer
Introduction by	Elke Roberta Buscher
Text Coordination	Sabine Scholz
Layout	Claudia Maier
Imaging	Jan Hausberg
Translations by	Aristotelis Bassios, Vandee Keeleevand (English)
	Caroline Crepieux, Lisa Caprano, Stéphane Gödde (French)

Editorial project by fusion publishing gmbh, stuttgart . los angeles
www.fusion-publishing.com

Published by teNeues Publishing Group

teNeues Verlag GmbH & Co. KG
Am Selder 37, 47906 Kempen, Germany
Tel.: 0049-(0)2152-916-0, Fax: 0049-(0)2152-916-111
E-mail: books@teneues.de

Press department: arehn@teneues.de
Tel.: 0049-(0)2152-916-202

teNeues Publishing Company
16 West 22nd Street, New York, NY 10010, USA
Tel.: 001-212-627-9090, Fax: 001-212-627-9511

teNeues Publishing UK Ltd.
P.O. Box 402, West Byfleet, KT14 7ZF, Great Britain
Tel.: 0044-1932-403509, Fax: 0044-1932-403514

teNeues France S.A.R.L.
93, rue Bannier, 45000 Orléans, France
Tel.: 0033-2-38541071, Fax: 0033-2-38625340

www.teneues.com

© 2008 teNeues Verlag GmbH + Co. KG, Kempen

ISBN: 978-3-8327-9270-1

Printed in Germany